LOVE AND DEVOTION
From Persia and Beyond

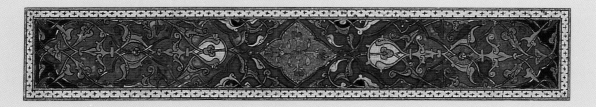

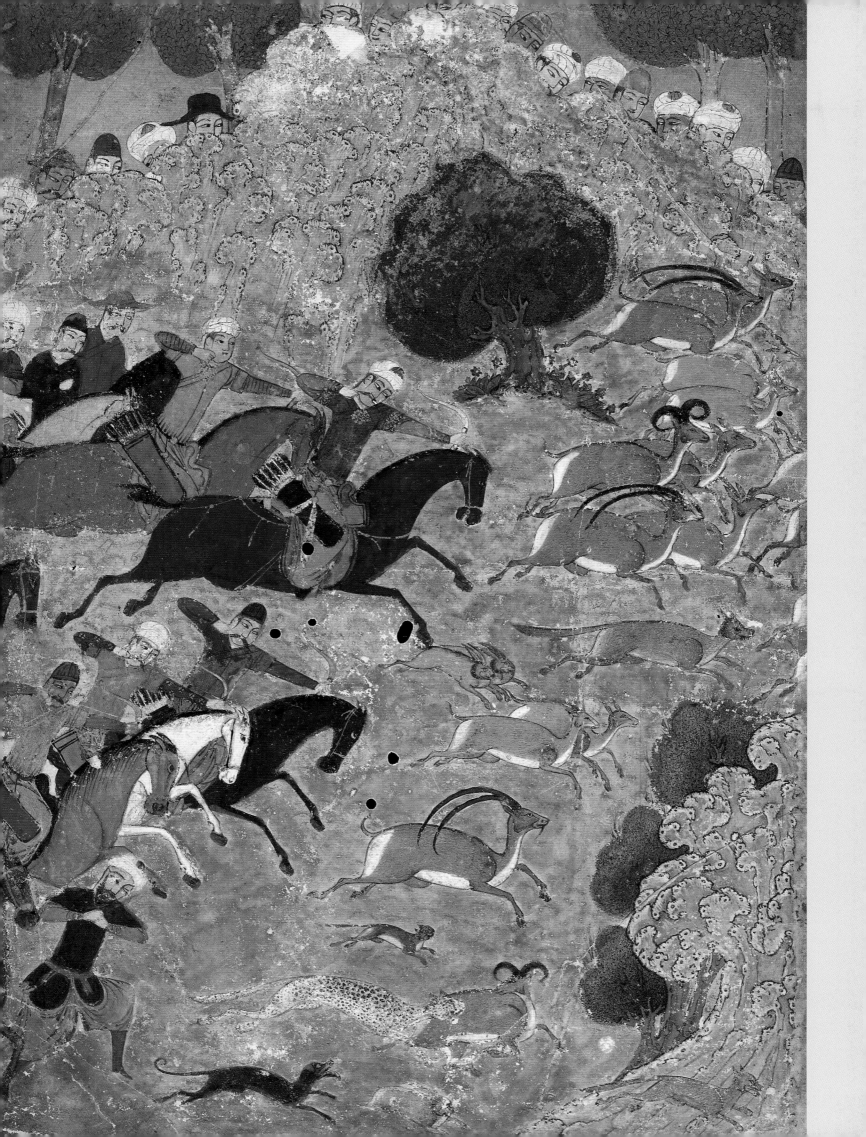

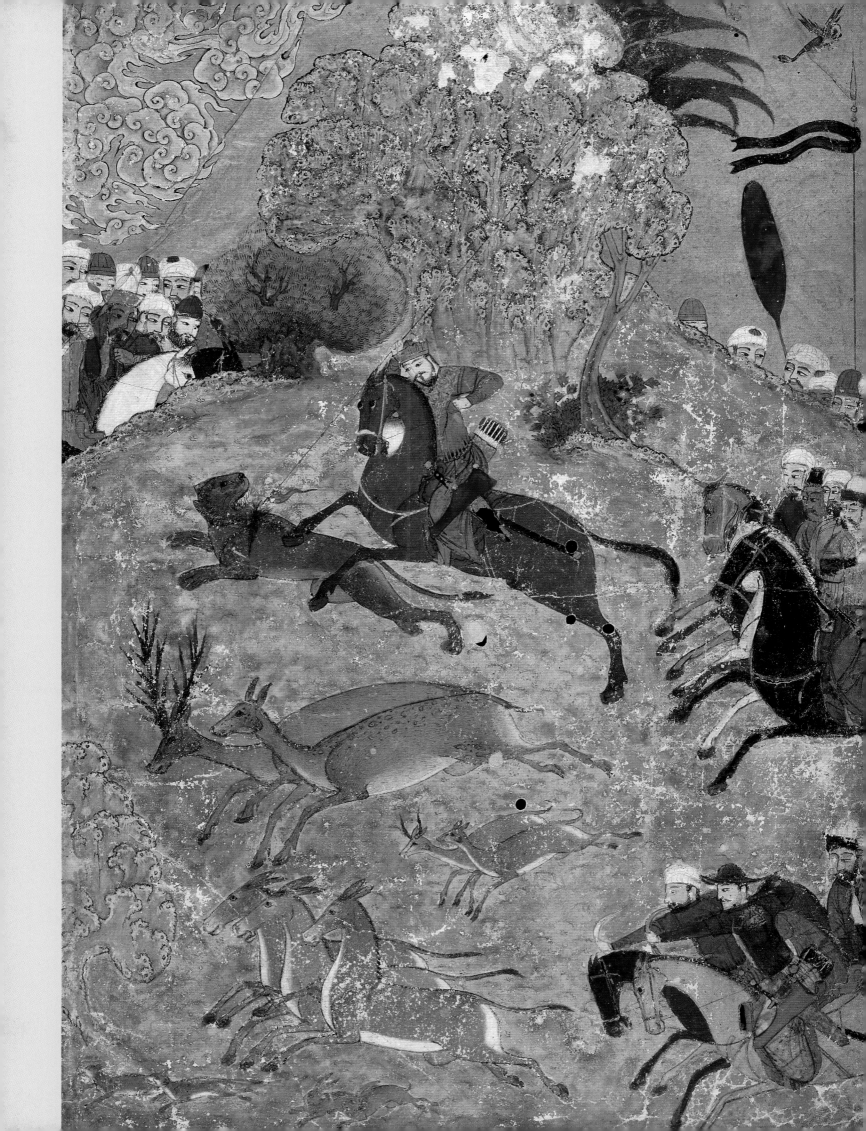

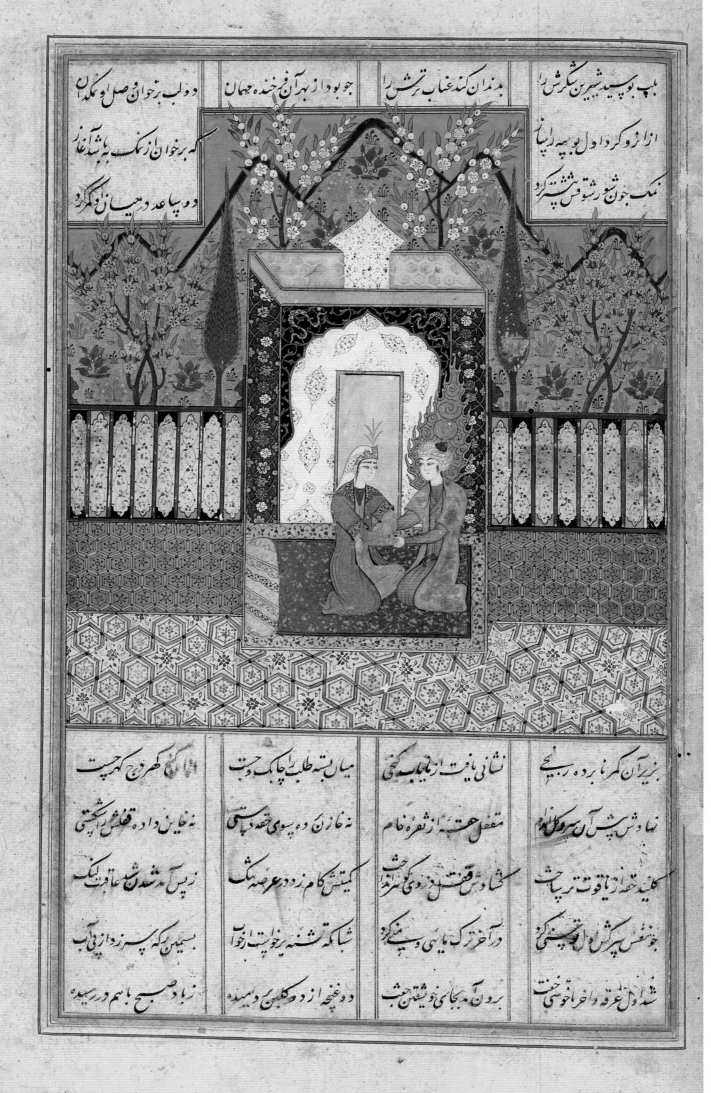

LOVE AND DEVOTION
FROM PERSIA AND BEYOND

Edited by Susan Scollay

Bodleian Library
UNIVERSITY OF OXFORD

State Library
of Victoria

NOTE TO THE READER

Transliteration: The aim of this book is to be accessible to non-specialist readers as well as scholars. To this end, and in line with current practice, a simplified form of transliteration from Persian and Arabic has been followed. There is no standard scheme for the transliteration into English of Persian and other languages written in Arabic script. The system of the *International Journal of Middle Eastern Studies* has been used as a base, but most diacritics have been removed, retaining only the consonants: *ʿayn* (ʿ) and *hamza* (ʾ). Modern Turkish orthography has been used for names, places and citations in Turkish.

Dates: Not all the books and manuscripts mentioned and illustrated in this publication were dated by the mostly anonymous scribes who copied them. Accordingly, those that are inscribed with dates in the Islamic calendar are given their Hegira or AH dates first, with the corresponding Christian calendar AD dates following in parentheses. For example, a Bodleian Library manuscript of the *Majalis al-ʿUshshaq* is dated 959 (1552). The Muslim era is counted as beginning with the Hegira, or migration, of the Prophet Muhammad from Mecca to Medina in 622 of the calendar of the Christian era. The Islamic calendar year is lunar, and thus gains on the solar years of the Christian calendar, making it impossible to calculate the exact equivalent dates in instances where the month is unknown. Some citations for references published in Iran have been converted to AD dates using the Jalali solar calendar currently in use in Iran and Afghanistan. All other dates used in this book can be assumed to be AD, with only those up to the year 1000 noted as such, and with BC dates specified when appropriate.

This publication has been assisted by a grant from
the Gordon Darling Foundation

This edition published in 2012 by the Bodleian Library, Broad Street, Oxford OX1 3BG
www.bodleianbookshop.co.uk
in association with the State Library of Victoria, 328 Swanston Street, Melbourne, Victoria 3000, Australia – slv.vic.gov.au

First published by Macmillan Art Publishing,
a division of Palgrave Macmillan • Macmillan Publishers Australia, 2012
Level 1/15-19 Claremont Street, South Yarra, Victoria 3141, Australia. Telephone: 61 03 9825 1099. Facsimile: 61 03 9825 1010
in association with the State Library of Victoria, 328 Swanston Street, Melbourne, Victoria 3000, Australia – slv.vic.gov.au, and the
Bodleian Library, Broad Street, Oxford OX1 3BG, United Kingdom – www.bodleianbookshop.co.uk

Designed by Jenny Zimmer • Typography and hand-composition by Charles Teuma
Copy edited by Susan Keogh • Map by Chandra Jayasuriya
Image scanning and treatments by Hanno van Dijk • Printed and Bound by Great Wall Printing Company Ltd., Hong Kong.
British Library Catalogue in Publication. A CIP record of this publication is available from the British Library.

pages ii–iii: Ibrahim Sultan hunting. Leaves from a disbound manuscript of Firdausi, *Shahnama*, copied for Ibrahim Sultan, c. 1430, Shiraz.
Bodleian Library, University of Oxford, MS. Ouseley Add. 176, fols. 2r–3v.

page iv: The marriage of Yusuf and Zulaykha. From a manuscript of Jami, *Yusuf u Zulaykha*, dated 1004 (1595).
Bodleian Library, University of Oxford, MS. Elliott 418, fol. 56r.

page viii: Saʿdi entering a learned gathering. From a manuscript of Saʿdi, *Bustan,* c. 1515–20.
Bodleian Library, University of Oxford, MS. Marsh 517, fol. 34r.

ACKNOWLEDGEMENTS

THIS PUBLICATION accompanies exhibitions of the same name in Melbourne and Oxford and is the result of several years of close collaboration between the Bodleian Libraries of the University of Oxford and the State Library of Victoria, Melbourne. Many people have made contributions without which the publication would not have been possible.

All of the specialists whose essays appear here generously accepted the invitation to contribute. Among them Dr Firuza Abdullaeva, Dr Barbara Brend, Dr Stefano Carboni, Dr Nicholas Perkins, Dr Eleanor Sims, Dr Andrew Topsfield and Dr Lâle Uluç shared valuable expertise, contacts and encouragement in the planning stages.

Many others also played key roles in the conception and realisation of the project. At the Bodleian Libraries Dr Sarah E. Thomas, Richard Ovenden and Dr Gillian Evison have all lent their enthusiastic support. The project has also been made possible by the professional care and kind assistance of many at the Bodleian Libraries, both past and present, including James Allan, Dr Bruce Barker-Benfield, Nick Cistone, Dr Samuel Fanous, Lesley Forbes, Sallyanne Gilchrist, Gillian Grant, Colin Harris, Dana Josephson, Doris Nicholson, Madeline Slaven, Alasdair Watson and, in particular, Colin Wakefield who so generously shared his time and knowledge.

In the United Kingdom and Europe, Professor Ros Ballaster, Dr Agustín Coletes Blanco, John Hodgson, Dr Susan Marti, Professor Charles Melville, Dr George Michell, Dr Alison Ohta, Dr Muhammad Isa Waley, Bruce Wannell and Dr Elaine Wright also provided valuable advice and assistance.

In Istanbul, Alexander Dawe, Dr Derya Iner and Dr Ayşin Yoltar-Yıldırım provided expertise and assistance, as did Dr Seyed Mohammad Torabi in Tehran and Dr Sheila Canby in New York.

The Royal Asiatic Society, London; the Metropolitan Museum of Art/Art Resource, New York; the Topkapi Palace Museum, Istanbul; the Chester Beatty Library, Dublin, and Chris Beetles on behalf of the Estate of Robert Stewart Sherriffs, kindly gave permission for the reproduction of significant works in their collections.

The National Gallery of Victoria, the University of Melbourne and the Art Gallery of New South Wales generously lent items from their collections to complement the exhibition at the State Library of Victoria in Melbourne and also allowed their works to be reproduced.

Many past and present staff at the State Library of Victoria have been involved in the realisation of this project, which would not have been possible without the vision and commitment of the past Chief Executive Officer and State Librarian, Anne-Marie Schwirtlich, Shane Carmody, Sue Hamilton, Robert Heather, Michael van Leeuwen, the State Library of Victoria Foundation and the Library Board of Victoria. Other staff members who provided invaluable contributions to the production of the publication include Megan Atkins, Edwina Bartlem, Christine Eid, Ross Genat, Jane Manallack, Peter Mappin, Anat Meiri, Shelley Roberts, Anna Welch, Fiona Wilson and, in particular, Margot Jones. The associated exhibition was curated by Susan Scollay and Clare Williamson, and the project as a whole has been supported by the dedicated efforts of staff in departments including Collection Interpretation, Communications and Marketing, Conservation, Events, Learning Services, Rare Printed Collections and Technology Services.

Others in Australia have assisted and encouraged this project. Dr Mammad Aidani, Professor Aliakbar Akbarzadeh, Houman Bigloo, Carol Cains, Edmund Capon, Dr Robert Gaston, Hamid Homayouni, Dr Adrian Jones, Philip Kent, Jackie Menzies, Jock Murphy, Pamela Pryde, Nasrin Rasoulzadeh, Natalie Seiz, Dr Zahra Taheri and Dr Gerard Vaughan were generous with either access to works for loan, illustration, specialist advice or thoughtful reading of the manuscript as it took shape. Jenny Zimmer and Charles Teuma of Macmillan Art Publishing have ensured that the book has been designed and produced to the highest standards.

The associated exhibition was also made possible by the generous support of the State Library of Victoria Foundation, as well as Arts Victoria, The Asian Arts Society of Australia, the Australia India Institute, the Australian-Iranian Society of Victoria, the Australian National University, Australians Studying Abroad, Avant Card, the City of Melbourne, La Trobe University Art History Alumni, Metro Trains Melbourne, Mirvac Hotels and Resorts, Allan and Maria Myers, Palace Cinemas, Pariya Food, Qantas, Readings, the Sunderberg Bequest, Tourism Victoria, the Turkish Consulate General, the University of Melbourne, V/Line and Zetta Florence.

And lastly and most importantly, the generous financial support and ongoing interest of the Gordon Darling Foundation in the research and realisation of this publication is gratefully acknowledged.

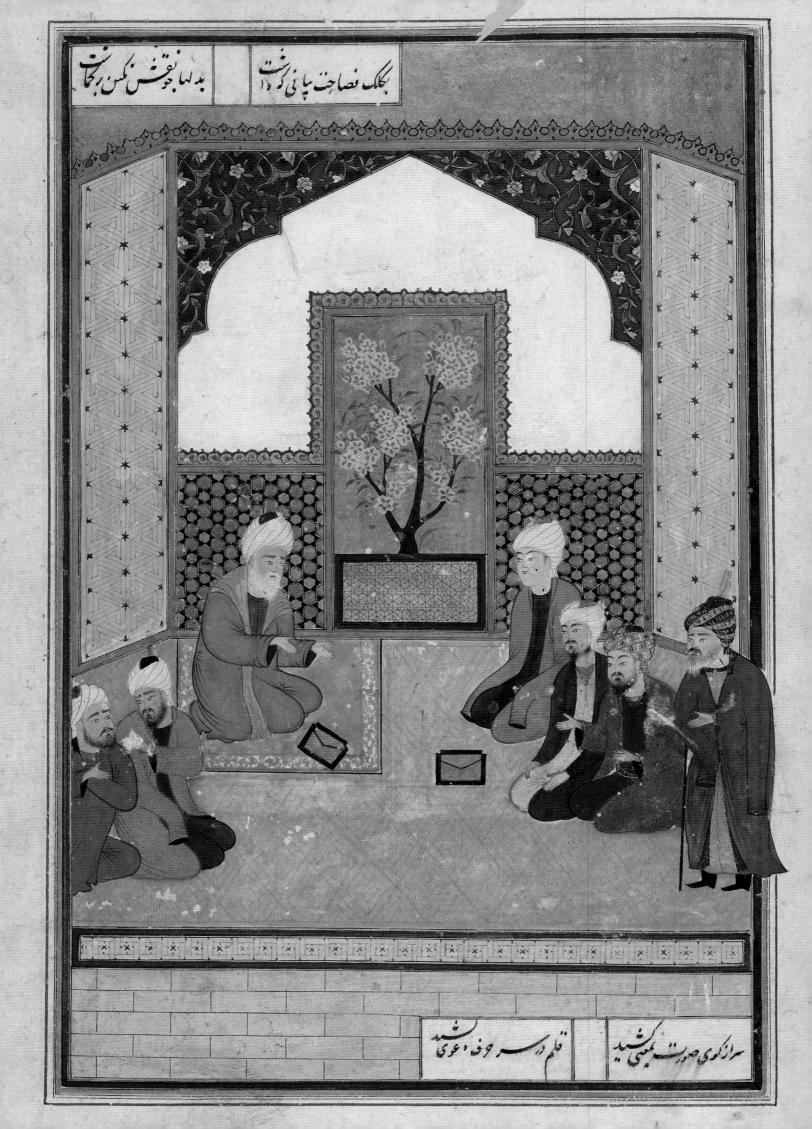

CONTENTS

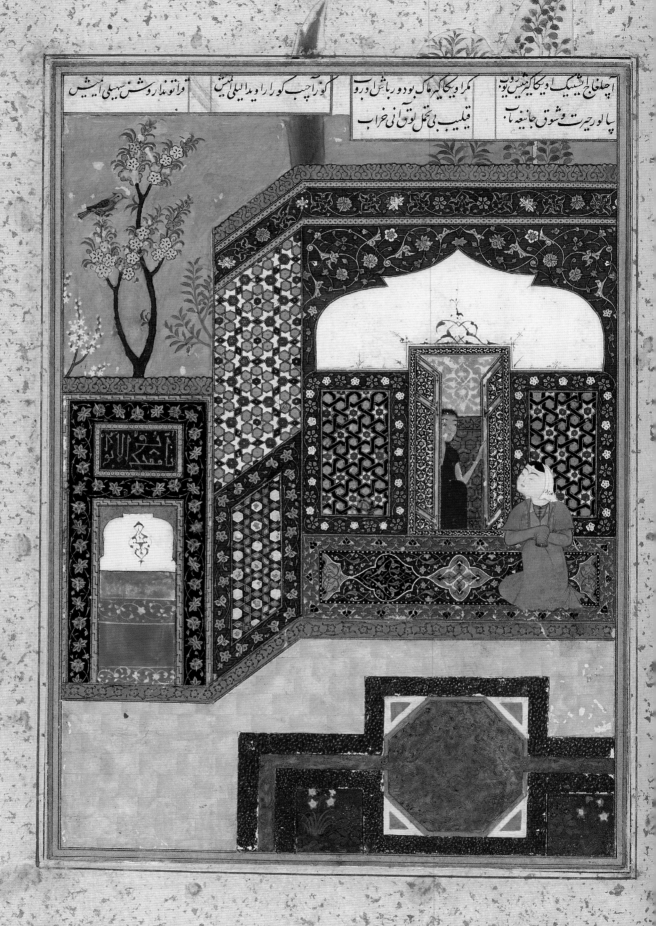

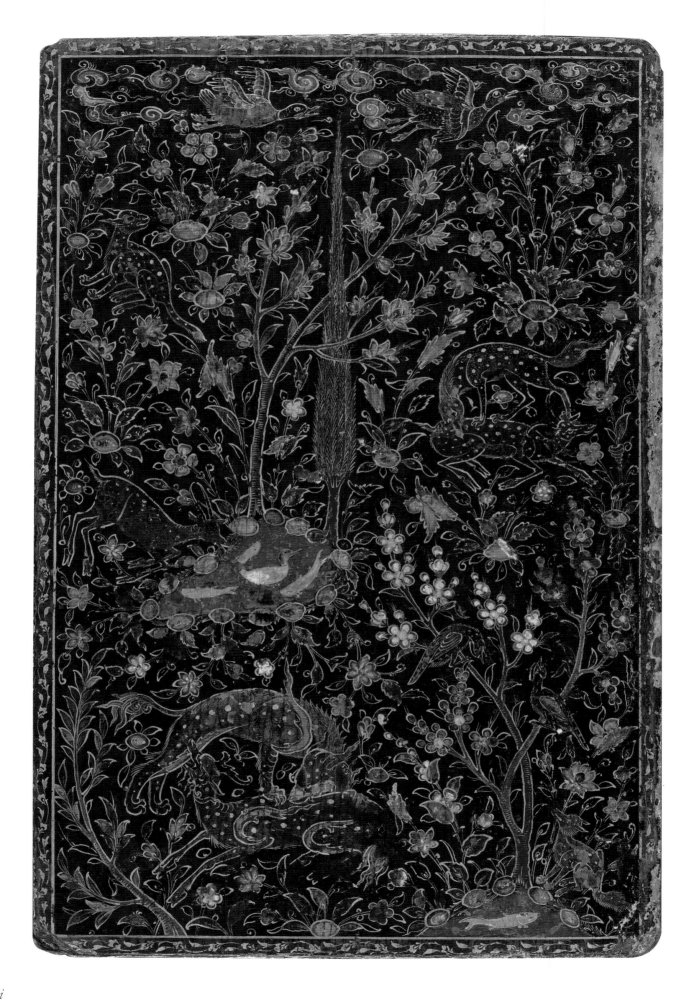

PREFACE

THE State Library of Victoria, Melbourne, and the Bodleian Libraries of the University of Oxford are delighted to be partners in *Love and Devotion: From Persia and Beyond*. This publication has been produced in conjunction with an international exhibition of the same name presented by both libraries.

At the heart of *Love and Devotion* is an array of Persian, Mughal and Ottoman manuscripts drawn from the world-renowned collections of the Bodleian Libraries. These illustrated volumes and folios were produced between the 13th and 18th centuries and provide a rare overview of miniature painting, illumination and calligraphy from one of the richest periods in the history of the book.

Love and Devotion focuses on classic Persian tales and poems of human and divine love that transcend time and place. It considers how these stories were retold and sometimes reinterpreted over time by Persian poets and those in the Persianate cultural sphere – especially in the Mughal Empire in India and also in the empire of the Ottoman Turks. *Love and Devotion* also points to parallels and echoes in European literature, dating back to writers such as Chaucer, Dante and Shakespeare through to Byron and Goethe. These writers are represented here by rare early manuscripts and printed editions from the Bodleian Libraries and the State Library of Victoria, together with accounts by European travellers to Persia.

The richness of these collections owes much to the foresight of scholar-collectors. The Bodleian Library's founding in 1602 coincided with a time of great interest in the East. When it opened, the Bodleian Library already possessed a copy of the Qur'an, and in that year acquired by gift a Persian and a Turkish language manuscript. Its Oriental collections grew steadily over subsequent centuries with the acquisition of manuscript collections amassed by Oxford academics and Orientalists such as Archbishop William Laud, Edward Pococke and Archbishop Narcissus Marsh. In the 19th century the Bodleian's holdings of Persian manuscripts increased dramatically with the acquisition of Sir William Ouseley's collection and, remarkably through the donation of J. B. Elliott, a Bengal civil servant, Sir William's collection was soon reunited with that of his brother, Sir Gore Ouseley, whose collection Elliott had previously acquired.

The wealth of the State Library of Victoria's collections is due in great part to the acuity of its founder, Sir Redmond Barry, and to librarians such as Augustus Tulk and A. B. Foxcroft, who have shaped the library's collections throughout its more than 150-year history. The State Library's holdings of Western literature, maps and travel accounts include rare early printed editions of Chaucer, Dante and Shakespeare, together with fine early atlases and travel accounts.

A project such as this would not be possible without many supporters. We especially wish to thank the Gordon Darling Foundation for its generous contribution towards this publication.

At a time when that which divides is often given greater prominence than that which unites, *Love and Devotion: From Persia and Beyond* is a timely endeavour. In addition to the partnering of institutions from the northern and southern hemispheres, it celebrates the rich heritage of cultural exchange between East and West, and the universal themes found in the poetry of love.

SUE HAMILTON
Acting Chief Executive Officer and State Librarian, State Library of Victoria

SARAH E. THOMAS
Bodley's Librarian and Director of Bodleian Libraries

صفت او دلیل معرفتش فعل او لوح آیه اصفش

که گزار و حقوق نعمت او که شناسد فنون حیرت او

نعمت او ز عدد حد افزون رحمت او ز عدد عدد برون

شکر نعمت یکی ز نعمت او ذکر رحمت یکی ز رحمت او

باد بر مصطفی درود بسی ابد الدهر از و بهر نفسی

مهر عزت نهاده بر در دین سرو رانبیا رسول امین

متجلی در و جمال و جلال ذات او مظهر صفات کمال

باد بر آل بیت و یارانش دایم از حق سلام و رضوانش

صدق و عدل و حیا و علم امین واشه دبره خلافت و دین

کرده بود از حدیقه منتخبی پیش ازین داعی از بی نسبی

حمد چد صفات یزدان را
مدح بی قدح ذات اسحان را

آنکه هم اولست و هم آخر
و آنکه هم باطنست و هم ظاهر

اول از محض آخریب خویش
باطن از عین ظاهر خویش

ذات او را کمال نور ظهور
بحجاب ظهور زخود پسور

واجد ذات خود بذات خود
ذاکر و شاکر صفات خود آ

غیر او در میانه واسطه نیست
ذات را ز صفات رابطه

ذات او مطلع وجود صفات
صفتش مظهر تجلی ذات

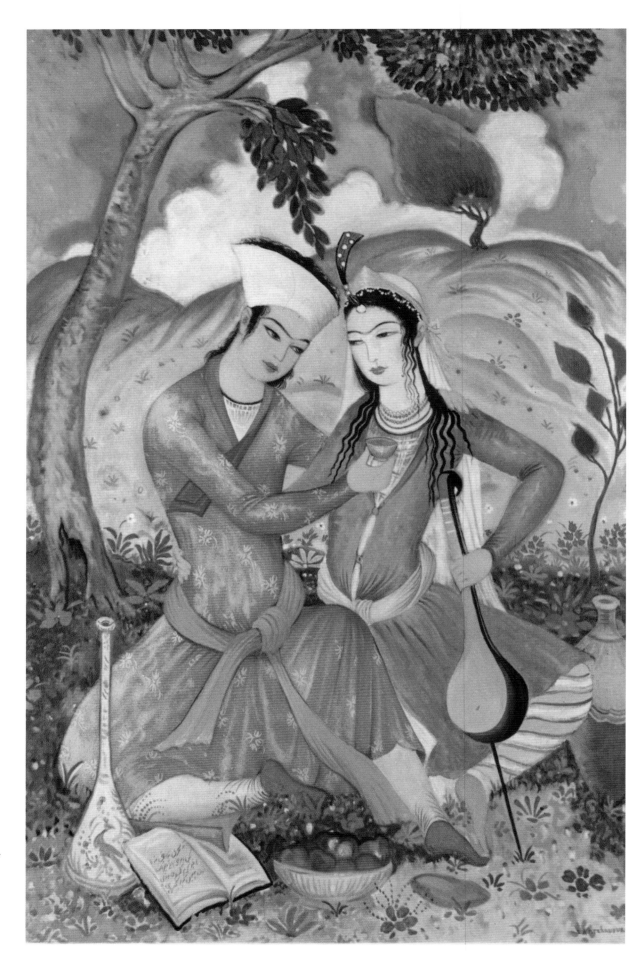

Figure 1.1

Edward FitzGerald, *Rubaiyat of Omar Khayyam.* Illustrated by Sarkis Katchadourian. New York: Grosset and Dunlap, 1946.
State Library of Victoria, Melbourne, RARES 891.5511 UM1FK, p. 31.

AN INTRODUCTION TO PERSIAN POETRY AND ITS MILIEU

Susan Scollay

A book of verses underneath the bough,
A jug of wine, a loaf of bread – and thou,
Beside me singing in the wilderness –
Oh, wilderness were Paradise enow! [1]

IN 1859, when the then-unknown English writer Edward FitzGerald translated verses attributed to an 11th-century mathematician and astronomer from Nishapur in north-east Iran, no one could have predicted they would become amongst the most widely published in the English language. The four lines above from the eleventh stanza of the compilation that FitzGerald called the *Rubaiyat of Omar Khayyam* are among its best known. [2] Originally published as a modest pamphlet, FitzGerald's highly interpreted translation of Khayyam's quatrains and its successive revisions significantly affected the Western literary canon, playing a major part in shaping the English-speaking world's idea of Persian life and literature. [3]

The world of Persian poetry, imbued with stories of love often in allegorical form, is the focus of this book and associated exhibitions in Melbourne and Oxford. Rare examples from the rich holdings of the Bodleian Libraries of the University of Oxford and the State Library of Victoria, Melbourne, provide a window onto an exquisite world of brave heroes, feisty princesses and beautiful beloveds. They also recount tales of pilgrims of the spirit, and are touched by melancholy and occasional tragedy. Illustrated books and manuscripts collected by European travellers, diplomats, merchants and scholars reveal the beauty, variety, emotion and multi-layered meaning of the tales they convey. Epic romances, adventure tales and poetry about love, both human and divine,

played a central role in Persian life and culture from antiquity, extending the Persianate world view well beyond ever-shifting imperial borders. With a geographic and philosophical reach comparable to that of ancient Greece or Rome, Persian stories and poetic themes also intersected with the creation of culture in Europe.

Until Edward FitzGerald made use of copies of a 15th-century Persian manuscript in the Bodleian Library to translate Khayyam's long-neglected verses,[4] the majority of Europeans associated love poetry with the idealised phenomenon of the courtly love of the Middle Ages. Love in this context was portrayed as a compelling but impossible quest for an unattainable woman. Songs of the troubadours from Provence were seen as the inspiration for this genre, with technical and thematic aspects of their lyrics playing an ongoing role in Western literary traditions.[5] Close contact with the Islamic world during the Crusades and mass pilgrimages to the Holy Land and beyond facilitated cultural exchange. Despite differences in religion and culture, the medieval world was more cosmopolitan and interconnected than many traditional histories would have us believe. The frontiers between the various Islamic empires and between the Islamic East and the Christian West have always been fluid. They shifted and changed over the centuries allowing for exchange between merchants, artists and craftsmen and for the movement of goods and ideas.

Two periods when this fluid exchange of culture was especially pronounced between Europe and the Islamic world were the era of the Crusades – from the 11th to the 13th centuries – and the period from the 14th to the 16th centuries that coincided with the Italian Renaissance. Trade between the Islamic world and Italy – especially through Venice – and the presence of Italian merchants in the great cities of Cairo, Istanbul and Damascus meant that trade in carpets and textiles, metalwork, glass, ceramics and books of all kinds brought Eastern imagery laden with poetic themes and stories into European church treasuries, private collections and ultimately into the libraries and storerooms of great institutions such as the Bodleian.

Some scholars maintain that, in addition to cultural contacts with pilgrims and traders, European troubadour songs already incorporated Andalusian and Sicilian poetic forms, which in turn had previously

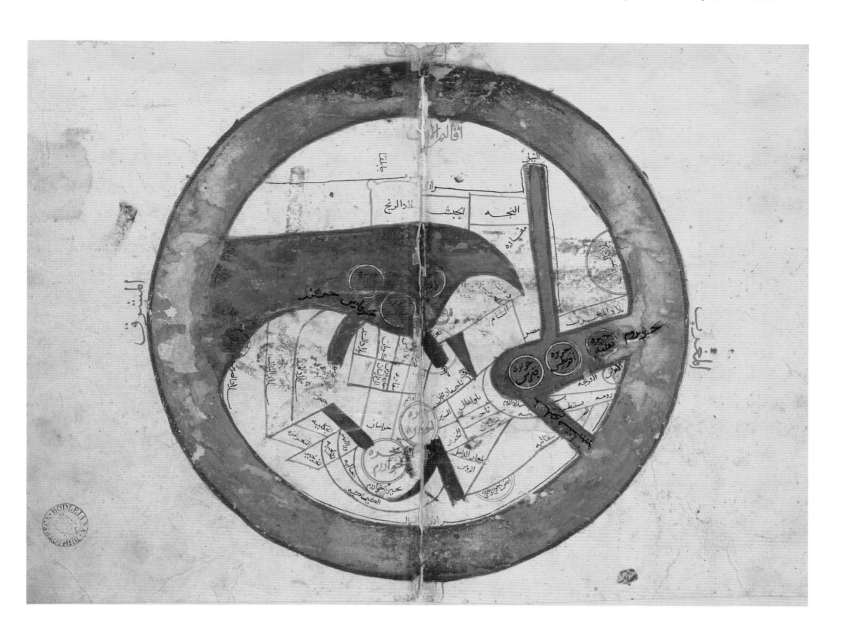

Figure 1.2 (opposite)

Illuminated title. From a
manuscript of Omar Khayyam,
Rubaiyat, dated 865 (1460),
Shiraz.
Bodleian Library, University of
Oxford, MS. Ouseley 140,
fol. 2v.

Figure 1.3 (above)

Circular map of the world.
From a Persian translation of
Kitab al-Masalik wa-l-Mamalik
('Book of Routes and
Provinces') by al-Istakhri,
copied c. 1295.
Bodleian Library, University of
Oxford, MS. Ouseley 373,
fols. 3v–4r.

This stylised world map is a
copy of one drawn in the 'Book
of Routes and Provinces'
compiled in the 10th century
by al-Istakhri, a member of the

so-called 'Balkhi school' of
geographers, based in
Baghdad.

The known world is repre-
sented in circular form
oriented with south at the top
of the map and the landmasses
surrounded by an outer ring of
ocean. Persia is labelled 'Fars'
and is shown in the centre of
the lower half of the map. The
Caspian Sea that forms part
of the border of Iran is shown
as the uppermost of the two
lower circles.

3

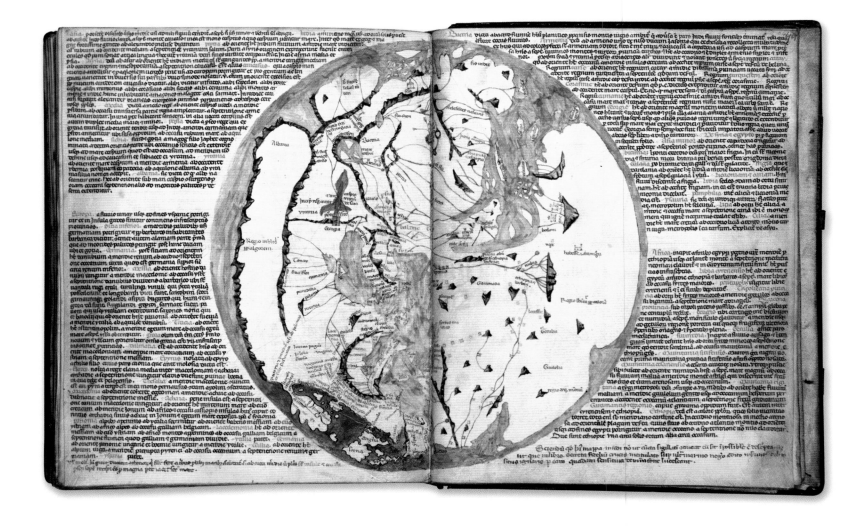

Figure 1.4 (detail opposite)

Pietro Vesconte, world map. From a manuscript of Marino Sanudo, *Secreta Fidelium Crucis*, produced by 1321, Venice. Bodleian Library, University of Oxford, MS. Tanner 190, fols. 203v–204r.

This map is an example of a *mappa mundi*, a circular map of the world produced in medieval Europe. It was drawn from a map made by the Genoese map-maker Pietro Vesconte for Marino Sanudo's *Secreta Fidelium Crucis* ('Secrets of the Faithful of the Cross'). Sanudo was a Venetian merchant and his book outlined his plans for the recovery of the Holy Lands through the revival of the Crusades. The Holy Lands are positioned at the centre of the map, which has east to the top, and Persia is identified in the area above.

absorbed a blend of Arabic and Persian literature. When the followers of the Prophet Muhammad left their Arabian homelands in the 7th century they unseated the Sasanian Persian dynasty ruling in the geographic area of present-day Iran. While invading Muslim Arabs gained political control in their new territories and added numerous converts to their growing faith, they also drew heavily on the rich literary and artistic heritage of the defeated Sasanians who followed the Zoroastrian faith, with strong cultural links to the great Persian empires of antiquity.

Shared concepts, structure and traditions in Persian and European poetry dating from classical times to the present have been noted by scholars.[6] Yet these medieval and early-modern intersections explored intermittently since the beginning of European literary criticism remain only partially argued or researched, leaving a 'maze of absences' in the extant literature.[7] What Maria Rosa Menocal described as the 'clichéd East–West dichotomy' may have until recently precluded any reorientation of medieval literary or cultural research or efforts to embark on comparative studies.[8]

Despite what may be seen as an entrenched demarcation of cultural spheres, there is an increasing acceptance of parallels spanning the breadth of Eurasia and transcending perceived boundaries of culture and religion.[9] Aspects of medieval and pre-modern European literature echoed the epic stories and romantic tales that proliferated and circulated in the cultural sphere of medieval Persia, composed in verse, recited as entertainment and erudition at all levels of society, and, from the 10th century, increasingly recorded in manuscripts. The aftermath of the Mongol invasions of the 13th and 14th centuries brought increased contact between China, Central Asia and the Islamic world. Amongst other things the resulting availability of paper favoured the burgeoning production of manuscripts, illustrated with miniature paintings. The growth of commercial and diplomatic networks facilitated their travel.[10]

Many poems and stories were composed and presented in manuscript form as gifts between elite rulers in Persia and Central Asia. They added an element of prestige and royal charisma to the romantic and didactic verses and prose that circulated in the same manner as the luxurious objects and costly garments produced exclusively for court use. Some, it has to be

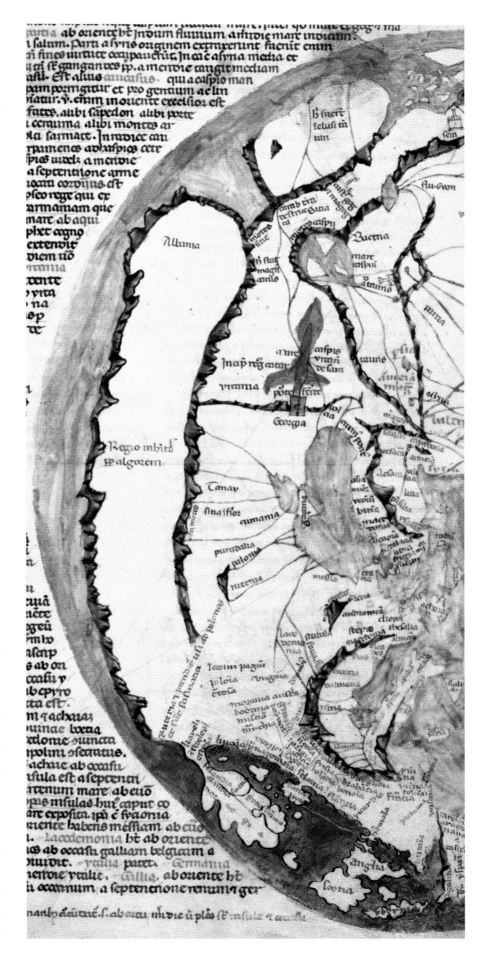

عشق تا زان جو جانستی نکنند

من که باشم که مرا نام بر

هر بجا ره بو آن سو نگرست

تا به بیند که در آن منظر کیست

ز بجوان دست و فکند از زبان بست

و ادجون سایه نخاک از رهش

کان که با ما ره سود اسر

ینست لایق که در جا یگر و

said, were seized as loot in ongoing skirmishes and campaigns between powerful rivals.[11] By various means the exploits of the powerful kings of Persian antiquity and the great love stories of various faiths and traditions were told and retold. Many were translated, reshaped and increasingly copied in beautifully illustrated manuscripts as an essential component of the articulation of power in the medieval Persian world.[12] This multifaceted process of the transfer of old stories and customs and their subsequent reframing to accommodate the needs of new rulers in new locations facilitated the creation of instant collective memory and legitimacy. Even the most upstart of foreign leaders could become embedded in the reworked mythic past of the royal lineage, so poetically eulogised in the *Shahnama*, the 'Book of Kings'. Through its stories they learnt the notions of social hierarchy and respect for militarily successful rulers developed in the ancient Persian empires of the Achaemenids (5th and 4th centuries BC) and later by the Sasanians (3rd–7th centuries AD). As well, they absorbed ancient Persian expectations that great kings were patrons of culture and all the arts, especially architecture and poetry.

To better understand this lively brand of cultural imperialism it is necessary to clarify some terms and consider the implications of the process that resulted in the 'translation' of Persian stories and ideas conveyed in poetry, in books and in cultural ideals. In the West the terms 'Iran' and 'Persia' are often used interchangeably. 'Persia' derives from the Greek word *Persis*, which once described the ancient territory of Fars in the multinational state of 'Iran'.[13] The terms 'Persia' or 'Persian' imply historical understanding that the land of Iran has served as a crossroads of commerce, religion and culture. Its pivotal position linking, developing and disseminating disparate cultures, stories and artistic forms is tacitly acknowledged when we use the words 'Persia' or 'Persian'.[14]

In recent years Western scholars have termed this broad understanding of cultural production 'Persianate'. This follows the distinguished historian Marshall Hodgson's coining and use of the term 'Islamicate' to differentiate the more receptive aspects of cultural practice from what he saw as the more restrictive realm of religious adherence suggested by the term 'Islamic'.[15] These distinctions are especially useful in the discussion of Persian poetry wherein recurring

Detail from Figure 1.5

Figure 1.5 (opposite)

An old man distracted by love throws himself from a lady's balcony. From a manuscript of Jami, *Subhat al-Abrar*, copied c. 1570–80.
Bodleian Library, University of Oxford, MS. Ouseley Add. 23, fol. 72r.

An illustration of the fourth part of Jami's *Haft Aurang* ('Seven Thrones'), titled *Subhat al-Abrar* ('Rosary of the Pious'). This section of the work consists of a series of short didactic tales, including this warning about the pitfalls of love.

Figure 1.6 (pages 8–9)

Ibrahim Sultan holding court (right); the queen and ladies on the balcony of the palace (left). Leaves from a disbound manuscript of Firdausi, *Shahnama*, copied for Ibrahim Sultan, c. 1430, Shiraz.
Bodleian Library, University of Oxford, MS. Ouseley Add. 176, fols. 239v–240r.

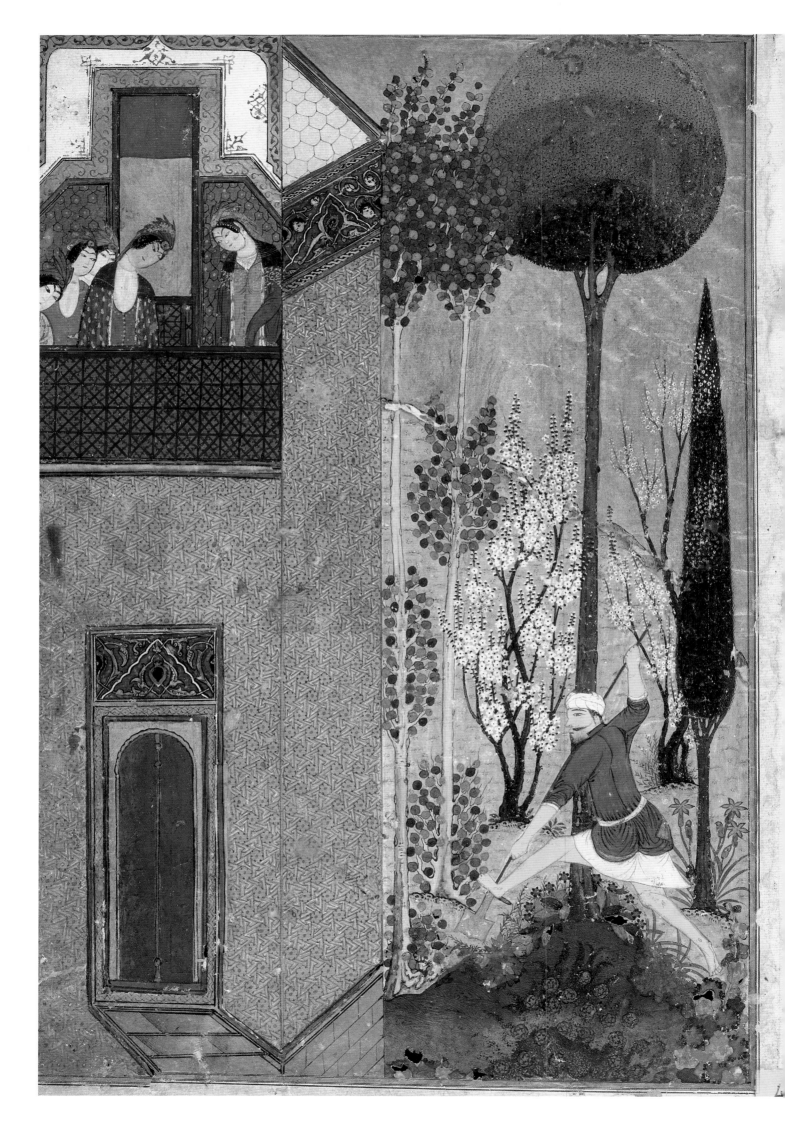

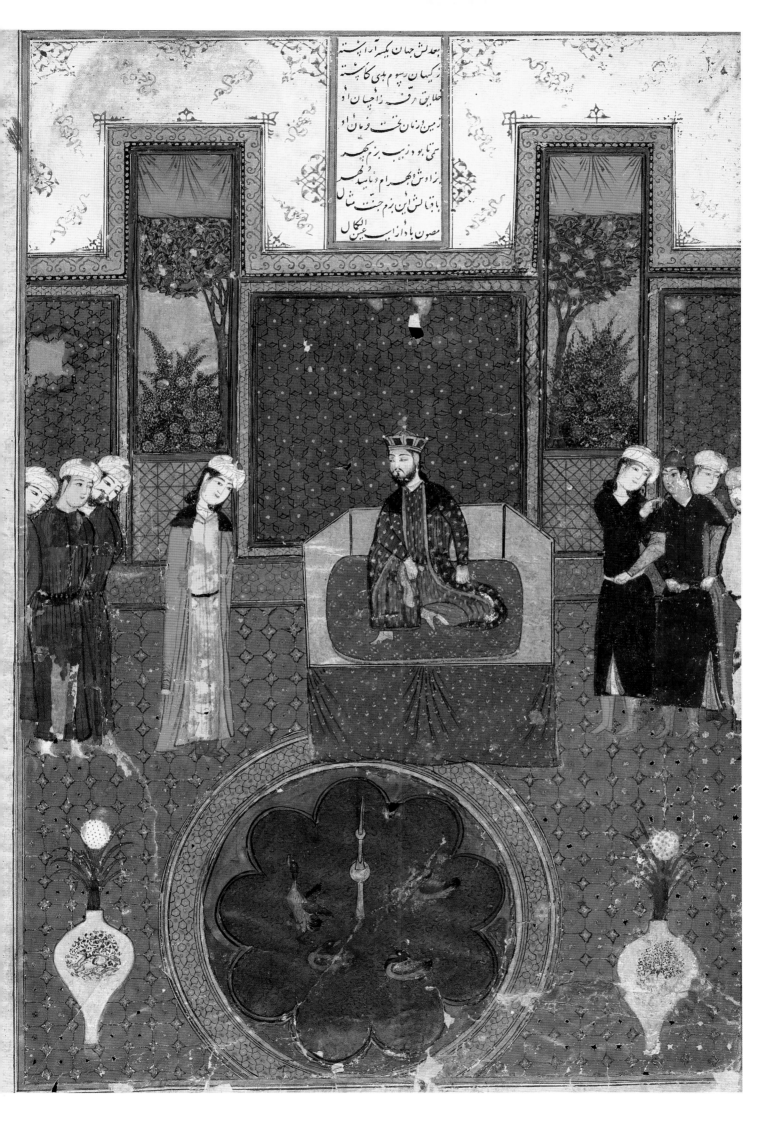

Detail from Figure 1.7

Figure 1.7 (opposite)

The poet Hafiz and a
companion. From a manuscript
of a work attributed to
Gazurgahi, *Majalis
al-'Ushshaq*, dated 959 (1552).
Bodleian Library, University
of Oxford, MS. Ouseley
Add. 24, fol. 96v.

Hafiz was noted for the politi-
cal criticism contained in his
writing as well as his intensely
lyrical love poetry. This depic-
tion of him comes from an
extensively illustrated copy of
'Meetings of Lovers', a work
that recounts the earthly loves
of famous mystics, lovers and
royalty.

themes such as drinking wine and admiration – even
infatuation – for handsome and accomplished young
men may be considered 'Islamicate' even though they
are not 'Islamic' because such behaviour contradicts
the tenets of the religion of Islam. Many of the poets
who operated outside the patronage of the ruling courts
were considered nonconformist if not heterodox by the
religious and political authorities they so often criticis-
ed in their works.

The manner in which strictly religious requirements
were observed varied from region to region across the
increasingly broad extent of the Islamic world. This
variety and reach was a result of the extreme mobility
of medieval Muslims, underpinned by their religious
obligation to make a pilgrimage to Mecca at least once
in their lifetime. Geographic dislocation and cultural
complexity were therefore as much a part of medieval
Persia and its neighbours in the Eastern world as they
are a global hallmark of the century in which we live
today. The transference and translation of culture was
therefore not only inevitable in this cultural milieu
but actively sought. Translating stories, ideas and
objects was part of the creation of distinct local
cultures, albeit in the Persian mode. A body of shared
cultural meanings, ideas and practices was the adhesive
that fixed and preserved the ongoing dialectic of trans-
culturation.[16] Subtle as a magician's sleight of hand,
this construction of culture was nevertheless an active
and conscious self-fashioning of identity. The sense
of cultural belonging that emerged drew on literary
models that had lasted for centuries, and that prevail
to this day.[17]

The process began in the 9th and 10th centuries
when powerful Turkic groups began encroaching on
eastern Iranian territory bordering Central Asia. In
1010 when the poet Firdausi presented his completed
Shahnama as guidance to Mahmud of Ghazna, the newly
ascendant Turkic ruler of eastern Iran, the Persians
were entering a long period of rule by outsiders. From
the time of the Seljuqs who ruled from Isfahan from
1059 onwards, one ruling dynasty of Persianised Turks
after another controlled Iranian territory, almost con-
tinually until the fall of the Qajars in 1925. Increasingly
cosmopolitan in the wake of the Arab invasion of the
7th century, the Persians still emulated pre-Islamic
Sasanian habits of court dress, art and ceremony, but
they had incorporated Hellenic philosophy as well as

شاه شجاع خود بر آن سر نهان اطلاع یافته چون جماعتی که بعرض شاه رسانیده بوده اند با من کمین کرده اند
شاه بر بام برآمده و از دریچه پنهان درایشان نظاره میکرده و چون حافظ کاسه بدست پسر مغنی نهاده

وآن جوان کاسه درکشیده شاه شجاع خوانده مصراع حافظ قرابه کش شد و مفتی پاله نوش
حافظ چون آواز شاه را شنا خته بی تأمل فی الحال گفته مصراع در دور پادشاه عطابخش جرم پوش
در شأی خود و بهای حافظ پسر مفتی عاشق حق بابی یی انگر شده مضمون این مطلع مصرع

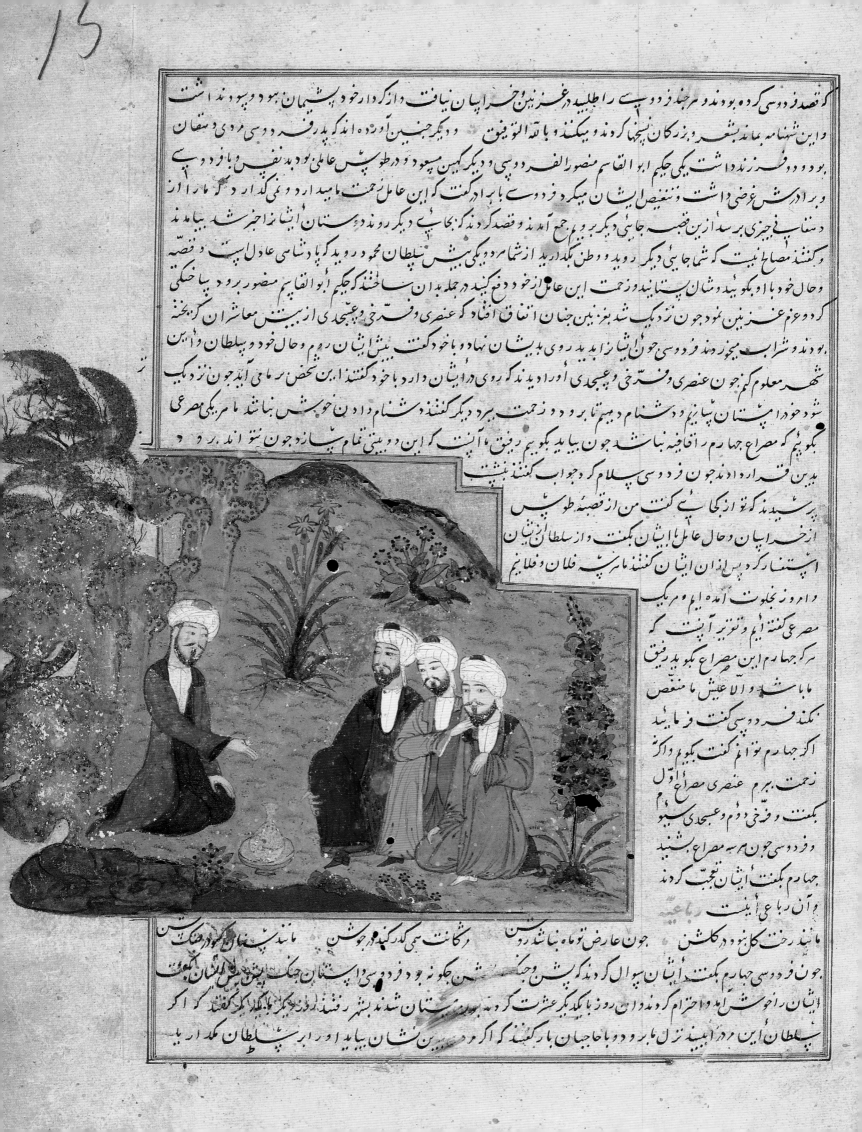

که قصد فردوسی کرده بود و مرجع او فردوسی را طلبید درغزنین خراسان نیافت واز کرده خود پشیمان بود و پسو دداشت
وان شهنامه ماندنشته و بزرگان نسخها کرده و بیکند و بالله التوفیق و دیگر حبین آورده اند که بدرفه فردوسی مردی دهقان
بود و قلعه زندگانی داشت یکی حکیم ابوالقاسم منصور الفردوسی و دیگر کهین مسعود و در طوس کهن بود و بنفس و بازو فردوسی
و براد رش غرضی داشت و تنغیص ایشان میکرد و فردوسی بابا گفت که ابن عامل رحمن می ماندارد و نمی گذارد دیگر ما را از
دسته پی چیزی برسد ازین خبیت بروم جمع آمد و قصد کرده دیگر روزبه جائی دیگر روند و دهستان ایشان نذا حر شه بیامند
و گفتند مصالح نیست و شما جائی دیگر روید و بلکد روید از شما مردم می دانیم عادل است و قصه
و حال خود با و بکوید و دشان بستایند و زحمت این عامل از خود دفع کنید در جمله بدان ساخته که حکیم ابوالقاسم منصور برود و پیا خنکی
کرد و عزم غزنین نمود چون نزدیک شد نزد غزنین جنان اتفاق افتاد که عنصری و فرخی و عسجدی از بیرون معاشره کریخته
بودند و شراب می جوز فردوسی چون ایشان را بدید روی بدیشان نهاد و باخود گفت ایشان روم و حال خود و سلطان وا این
شهر معلوم کنم چون عنصری و فرخی و عسجدی او را دیدند که روی در ایشان دارد با خود گفتند این شخص سر مای آبی چون نزد یک
شود در ابستان پسانیم و دشنام دهیم تا برود و زحمت ببرد و دیگر گفتند دشنام داد نا خوبش بناماند ما را یکی مصرعی
بکویم که مصرع جهار مرا اقافیه نباشد چون بیاید بکویم که رفیق ما این است ابن دوبینی نام پسار دو چون بنو انا برد و د
بدین قضه دارد او آمد چون فردوسی پسلام کرد و جواب بکفتند بنشست

پرسیدند که تو از کجائی گفت من از قصبه طوس
از خراسان و حال عامل با ایشان بکفت و از سلطان ابشان
است نا کرد و پس از ان ایشان بکفتند ما ایرن پیه فلان و فلانیم
و ما درزمن بخلوت آمده ایم و مریک یک
مصرعی کفته و تعزیر اویست که
سر که جهار مرا این مصراع بکو بد رفیق
ما باشد والا عیش ما منغص
بکنند فردوسی گفت وبفرمایند
اکر جهار نوازم کفت بکویم والکز
زحمت برم از عنصری مصراع اول
بکفت و فرخی دوم و عسجدی سیم
و فردوسی چون هر سه مصراع بشنید
جهارم بکفت ایشان تعجب کردند
و ان رباعی ابیات رباعیه

مانند رخت کلبه دردلکشن جون عارض نو ماه نباشد روشن مانند پسنبان کبود و رنگک بشن
جون فردوسی چهارم بکفت ازایشان این سوال کردند که این دو رشن و جنک جکو نه بود و فردوسی جنک ایشان بشان کرد بکفت
ایشان را خوش آمد و احترام کردند و ان روز با یکدیگر عشرت کردند و بو ابستان شدند بشهر رفتند زدیگر بارکفتند اکر
سلطان این مرد را بیند نزل ما برود و رباع بخان غیر حاجبان بارکفتند اکر مرد بین نشان بیاید اورا برسلطان و کلد این ارا یاد

Arabic commerce and tribal law alongside the religion of Islam.

A vibrant, ethnically and religiously diverse society evolved: under Ghaznavid control in the eastern territories and in India from the 11th century, and through the rule of the Seljuqs and their successors in parts of Iran and in Anatolia from the mid-11th to mid-12th centuries. It was a mix of Arabic, Persian and Turkish elements with Persian culture as its central element, writes Robert Canfield:

> It was 'Persianate' in that it was centred on a lettered tradition of Iranian origin; it was Turkish in so far as it was for many generations patronized by rulers of Turkic ancestry; and it was 'Islamicate' in that Islamic notions of virtue, permanence, and excellence infused discourse about public issues as well as the religious affairs of the Muslims, who were the presiding elite.[18]

New centres of artistic excellence emerged as a result of the Mongol invasions when many Persian-speaking poets, musicians and artists sought refuge in safer cities such as Delhi in northern India or Konya in central Anatolia. Orders of Sufi mystics expanded and became an integral part of these vibrant communities and their elite patrons. The oldest presently recorded illustrated manuscript in Persian is a copy of *Varqa u Gulshah*, a 10th-century love story, written by the poet 'Ayyuqi (Figure 1.9). It is attributed to a scribe and painter who worked in Konya in the middle of the 13th century and painted in an Anatolian variant of what has been called a 'Seljuq international figural style', the reach of which extended from Iran to Egypt.[19]

The accession to power of Timurid rulers in most of Iran and Central Asia during the 15th century saw an era of unprecedented patronage of Persian poets and book production. In all these centres of accelerated cultural contact, Turkish was the language of the military rulers, Arabic was the language of law and Persian was the language of state affairs and of literature.[20]

Figure 1.8 (opposite)

Firdausi and the poets of Ghazna. Leaf from a disbound manuscript of Firdausi, *Shahnama*, copied for Ibrahim Sultan, c. 1430, Shiraz. Bodleian Library, University of Oxford, MS. Ouseley Add. 176, fol. 15r.

Figure 1.9

Varqa and Gulshah's final embrace. From a manuscript of 'Ayyuqi, *Varqa u Gulshah*, copied c. 1250. Topkapi Palace Museum, Istanbul, H. 841, fol. 33v.

آن نقطه که بود تا ابد بال | حال چشیده ور | زان که که بود خجسته با او | مای دو و سه مهرا جفت با او

وصور فاضایت بازست | نوشت بود بتو | یکیک نوشت جوبین | ارقصه و قطعه و قضیب

آورد تحفه سوی بعد | و فان ماقت مجنون رشته کلی | آن جله که و گرفت براید

این قصه حسین برد بپاها | اگشتش سخن چپ ایان

جون خرد شکست با بر ش | بشکست فلک سرشک چکیده خرد ش | شد خر میناز سرشک دانه | کان سوته چشم من زانها

روزی بستم برباخه ش | جانی زغم رسیده ناب | بیزور تر و نزار تر کشت | زان هاک بود زار تر

کشتیش دریا بیره ات قاد | در حله آن حطیره ا فتاد | آمد سوی آن سرپس خاکی | بالید زر وی درون ای

اشک ی دوستیج تلج ساغر | یتی دو پر زار زاله بر جو | نند | بجمد جوار ز خرم خورد ه | غلطیده جو جو رشته کرد ه

اگشت شکافت دو دیع درا | برد از بسوی اسمان د | ثنت

او کند گسر جبر کست | سای خال اری جه آفریده ست

The advent of the so-called 'gunpowder empires' was the high point of this Turko-Persian tradition. The Ottoman Turks in Istanbul (1453–1923), the Mughals in the north of India (1526–1857) and the Safavids (1501–1736) in Tabriz and later, Isfahan, administered powerful empires, controlling weaker pastoral peoples through their superior weapons, including cannons. Persianised Turks ruled all three empires from sophisticated palace settings where poets competed with each other for patronage, composing and reciting stories of love and romance in richly ornamented Persian as well as local languages.

The essays that follow examine different aspects of these stories and the illustrated books in which they circulated and were reinvented. Whereas books and manuscripts from the medieval and early modern Christian, or even Buddhist, traditions were predominantly religious in their themes, illustrated Persian manuscripts were mostly inspired by secular prose and poetry sponsored by the royal courts and often equally well known outside elite circles. The early stories, characterised by those in Firdausi's *Shahnama*, were concerned with earthly love with strong attachments between devoted warrior knights and their rulers, and equally strong attachments between these monarchs and a series of beautiful and passionate women. The female protagonists became more liberated as, over time, well-loved stories were retold, emulated and 'improved' by generations of writers.

By the 12th century, mystic poets, especially those based in and around Herat in eastern Iran, began to attach spiritual meanings to some of the old stories of love and beauty, so that the life-changing process of chaste human love being transformed into divine love became an overarching theme.[21] In Europe, Dante's allegory, the *Divine Comedy*, closely paralleled Eastern models of the experience of love as a mystical and transformative journey from obsession with a beautiful beloved to an ecstatic experience of the Divine.[22] As well, Chaucer's *The Parliament of Fowls*, written in the second half of the 14th century, evoked an other-worldly vision and bore a title remarkably close to 'Attar's *Conference of the Birds*, written some two centuries earlier. Yet love in the European literary and artistic milieu developed different philosophical considerations even as it shared a 'language of love'. It also inspired a profusion of ambiguous symbolism with

numerous Persianate counterparts.[23] The skilled interweaving of language, literary devices and multi-layered meaning accelerated as stories and poems circulated in Persia's eastern neighbours and amongst Europeans, sometimes changing along the way.

Persian stories in poetic form have been likened to strings of precious pearls: refined, carefully crafted, polished and strung together in an ordered fashion, creating an interplay of form and ornament that is greater than the sum of their individual verses and jewel-like parts.[24] One of the words for poetry in Persian, is *nazm*, ordering – whereas the word for prose is *nathr*, scattered.[25] Some romantic tales in lyric form passed into Persian from Arabic sources, where the word *ansha'a*, meaning to create or compose, carries the additional suggestion of the beginning or commencement of something. In this sense, *ansha'a* is associated with the creation of a structure in an architectural sense and in literary terms means to 'compose a poem' and at the same time to 'begin reciting it'.[26] Persian poets themselves likened their work to the disciplined crafts of the weaver or the builder. Nasir-i Khusrau in the 11th century compared one of his poems to a palace complete with gardens and a view:

> A palace of my poem I'll make,
> in which from its verses I'll form
> flower beds and verandas. [27]

Like each stone of a well-made building or the blooms of a well-tended garden, the literary structure and the narrative framework of the stories depended on the strength of every jewel-like component that made up its pattern, its *badi'*, or ornament. In the words of Nasir-i Khusrau, 'I'll make for you the form of a man ... I'll make a lovely face, and then within the veil of wording I'll conceal it'.[28] The 'lovely face' of the verses revolved around stock settings such as enclosed gardens where courtly feasts and entertainments were enjoyed. Outdoor settings beyond the confines of the palace were suggested by flowing streams, rocky outcrops and trees. In these settings everything from literary conversation to music, archery, games of chess or polo, and the pleasures of the hunt could be pursued.

Originating in the distant past, yet resonant today, many of these tales remain at the forefront of the literature and languages of Iran, India, Turkey and Central Asia and in great works of the Western canon that echo and parallel their themes – Shakespeare's *Romeo and*

Figure 1.10 (opposite)

Death of Majnun at Layla's tomb. From a manuscript of Nizami, *Khamsa*, copied c. 1504.
Bodleian Library, University of Oxford, MS. Pers. d. 105, fol. 175r.

Nizami, a poet from Ganja in northern Iran, grouped five poetic stories together at the turn of the 13th century in a work named *Khamsa* ('Quintet'). One of these, the tragic story of Layla and Majnun, drawn from Arab sources, became especially well known, circulating beyond Iran into neighbouring territories that shared Persianate culture.

Figure 1.11 (overleaf)

A royal picnic. From a manuscript of 'Attar, *Intikhab-i Hadiqa* ('Extracts from the Hadiqa'), copied c. 1575.
Bodleian Library, University of Oxford, MS. Canonici Or. 122, fols. 4v–5r.

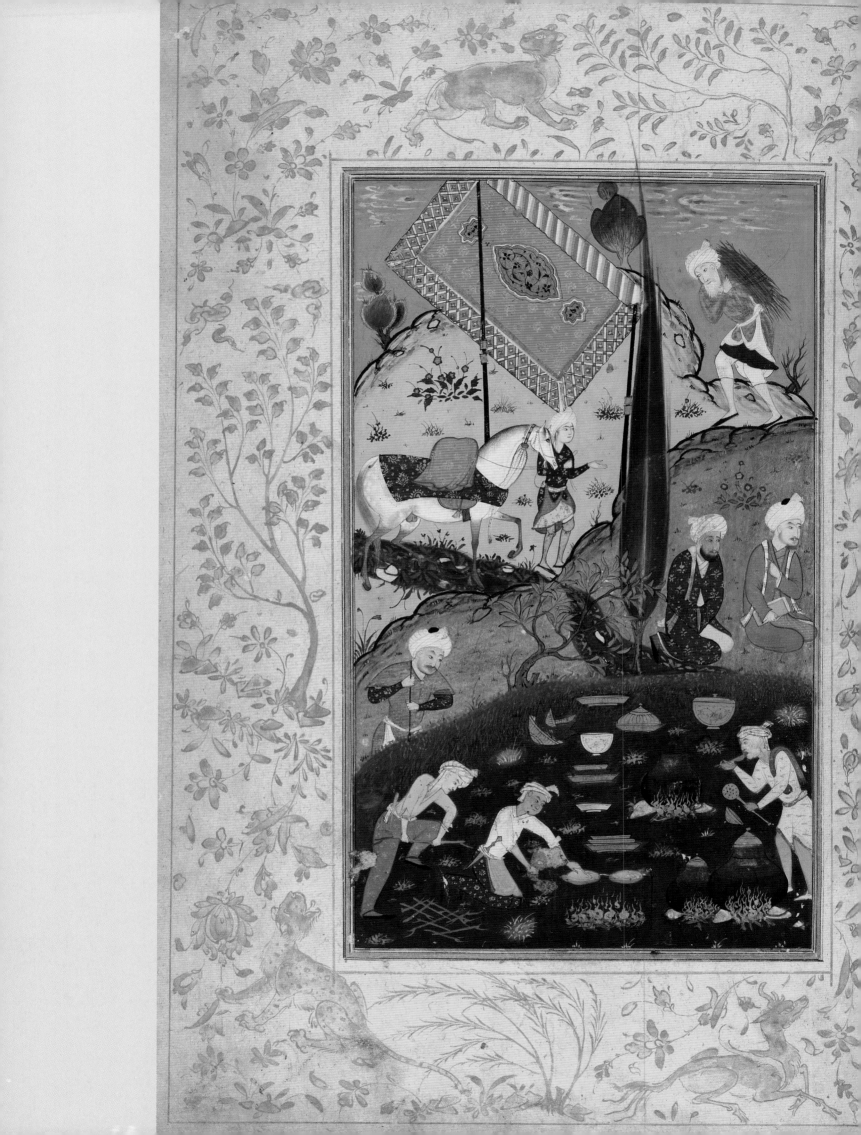

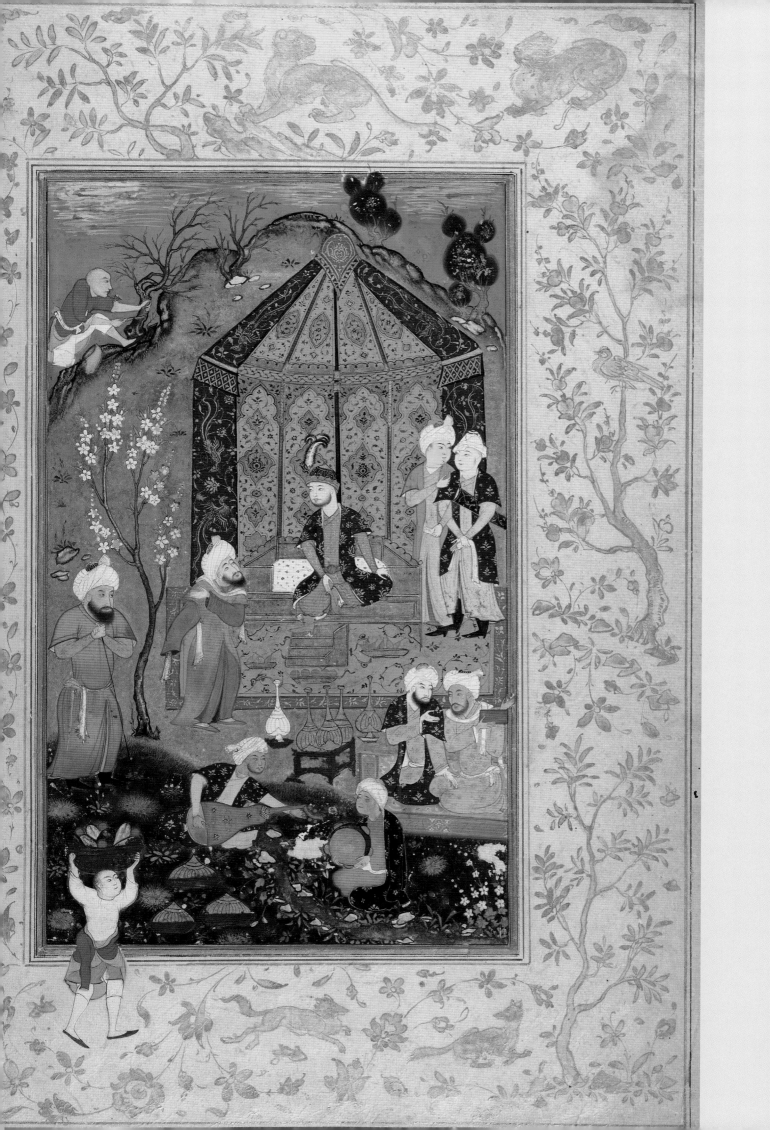

Juliet, Dante's *Divine Comedy*, Chaucer's *The Parliament of Fowls*, works of Goethe, Byron – and even the lyrics of Eric Clapton's hit song 'Layla', and those of other rock musicians of our more immediate past and present.[29]

Today Jalal al-Din Rumi is one of the best-selling poets of all time. He and other classic Persian poets are still – and increasingly so – studied by scholars across the globe; still crossing boundaries of geography, culture and class with words that transcend time and place, reminding us of the perennial beauty of the written word, the foibles of our shared humanity and our endless striving for the realm of the ineffable.

Susan Scollay is an independent scholar and curator specialising in the arts and culture of the Islamic world. Widely published, she is guest co-curator of the exhibition, *Love and Devotion: From Persia and Beyond*, a project that developed from her ongoing doctoral research at La Trobe University, Melbourne.

Notes:

1 Edward FitzGerald, *Rubáiyát of Omar Khayyám: A Critical Edition*, ed. Christopher Decker (Charlottesville, VA: University Press of Virginia, 1997), 130. The quoted lines are from FitzGerald's 1872 revision.

2 The word *ruba'iyat* means quatrains in Persian. FitzGerald, *Rubáiyát*, ed. Decker, intro., xiii.

3 Annemarie Schimmel, *A Two-colored Brocade: The Imagery of Persian Poetry* (Chapel Hill, NC: University of North Carolina Press, 1992), 6.

4 Edward FitzGerald studied Persian under the tutelage of an Oxford scholar, Edward Byles Cowell. It was Cowell who alerted FitzGerald to the presence of the Khayyam verses in the Ouseley manuscripts of the Bodleian Library and supplied him with copies. MS. Ouseley 140, Shiraz, dated 865 (1460). FitzGerald, *Rubáiyát*, ed. Decker, 1997, intro. xxvii, 93. The Bodleian Library also holds FitzGerald's workbook for the *Rubaiyat* with his original notes in Persian and English, MS. Whinfield 33.

5 The term 'courtly love' came into general use in the 19th century. Pamela Porter, *Courtly Love in Medieval Manuscripts* (London: The British Library, 2003), intro, 5–8.

6 By the early 14th century, the works of Ramon Lull, a Catalan scholar, and Joinville, chancellor at the court of Louis IX of France, demonstrated understanding of Sufic literature. Annemarie Schimmel, *Mystical Dimensions of Islam* (Chapel Hill, NC: University of North Carolina Press, 1975), 7; Maria Rosa Menocal, *The Arabic Role in Medieval Literary History: A Forgotten Heritage* (Philadelphia, PA: University of Pennsylvania Press, 1987), pref. ix–xv, 27–33, 71–90, 118–20; Maria Rosa Menocal, *Shards of Love: Exile and the Origins of the Lyric* (Durham, NC: Duke University Press, 1994), 143–88; Victoria Rowe Holbrook, *The Unreadable Shores of Love: Turkish Modernity and Mystic Romance* (Austin, TX: University of Texas Press, 1994), 1–31; Julie Scott Meisami, *Structure and Meaning in Medieval Arabic and Persian Poetry* (London: Routledge Curzon, 2003), 1–13. G. E.Von Grunebaum, 'Avicenna's Risala fi'l-'ishq and Courtly Love', *Journal of Near Eastern Studies* 4 (1952), 238. Michael Barry, *Figurative Art in Medieval Islam* (Paris: Flammarion, 2004), 335–6.

7 Holbrook, *Unreadable Shores*, 1994, 1.

8 Menocal, *Arabic Role*, 1987, 2.

9 Walter G. Andrews and Mehmet Kalpaklı, *The Age of Beloveds: Love and the Beloved in Early-Modern Ottoman and European Culture and Society* (Durham, NC: Duke University Press, 2005), 22 –31. Also see Mary D. Sheriff, ed., *Cultural Contact and the Making of European Art since the Age of Exploration* (Chapel Hill, NC: University of North Carolina Press, 2010), 1–16, for an outline of recent acceptance of the 'cultural appropriation and exchange' with other cultures that has been part of the making of European art.

10 Stephen Frederic Dale, *The Muslim Empires of the Ottomans, Safavids and Mughals* (Cambridge: Cambridge University Press, 2010), 163.

11 Finbarr B. Flood, *Objects of Translation: Material Culture and Medieval 'Hindu-Muslim' Encounter* (Princeton, NJ: Princeton University Press, 2009), 123–6.

12 Flood, *Objects of Translation*, 2009, 72–5, 81.

13 In 1935 'Iran' was adopted as the official name for the republic.

14 Giovanni Curatola and Gianroberto Scarcia, *The Art and Architecture of Persia*, trans. Marguerite Shore (New York: Abbeville Press, 2004), 6–8.

15 Marshall G. S. Hodgson, *The Venture of Islam: Conscience and History in a World Civilisation*, vol. 1 (Chicago and London: University of Chicago Press, 1977), 57–60.

16 The use of the word 'translation' in recent years in an academic sense has widened from that of the solely linguistic to other means of the creation of culture; as a metaphor and a process through which 'circulation, mediation, reception, and transformation of distinct cultural forms and practices is effected': Flood, *Objects of Translation*, 2009, 1, 8, 261–4.

17 In some regions of the Ottoman Empire a Persianate overlay of culture persisted until the early years of the 20th century. Also see Mammad Aidani, *Welcoming the Stranger: Narratives of Identity and Belonging in an Iranian Diaspora* (Breinigsville, PA.: Common Ground Publishing, 2010).

18 Robert L. Canfield, 'The Turco-Persian Tradition' in *The Turkic Speaking Peoples: 2,000 Years of Art and Culture from Inner Asia to the Balkans*, ed. Ergun Çaşatay and Doğan Kuban (Munich: Prestel, 2008), 149–58.

19 Personal correspondence with Eleanor Sims, 25 January 2011.

20 Canfield, 'The Turco-Persian Tradition', 2008, 158.

21 Schimmel, *Mystical Dimensions*, 1975, 290–300.

right: Detail from Figure 1.6

22 As early as the 1940s, Reynold A. Nicholson, a great scholar of Sufism, suggested that Dante's theme was based on that of 'Attar's *Mantiq al-Tayr*, which in turn was based on works by Sana'i, *Sayr al-Ibad Ila'l Ma'ad* ('The Journey of the Servants toward the Place of Return') and *Tasbih al-Tayr* ('The Birds' Rosary'). The philosopher Avicenna had expressed similar ideas a century before Sana'i. See Schimmel, *Mystical Dimensions,* 1975, 302–5.

23 C. S. Lewis, *The Allegory of Love: A Study in Medieval Tradition* (London: Oxford University Press, 1936). John Vyvyan, *The Rose of Love* (London: Chatto and Windus, 1960). Leonard Lewisohn, ed., *Hafiz and the Religion of Love in Classical Persian Poetry* (London: I.B. Tauris, 2010).

24 Meisami, *Structure and Meaning,* 2003, 1, 15–16.

25 Schimmel, *Two-colored Brocade,* 1992, 2.

26 Samer Akkach, *Cosmology and Architecture in Premodern Islam: An Architectural Reading of Mystical Ideas* (New York: State University of New York Press, 2005), 88–9.

27 Meisami, *Structure and Meaning,* 2003, 16.

28 Meisami, *Structure and Meaning,* 2003, 18.

29 Menocal, *Shards of Love,* 1994, 143–56.

Page 20 and introductory pages to Parts II–IV: Details from page xii

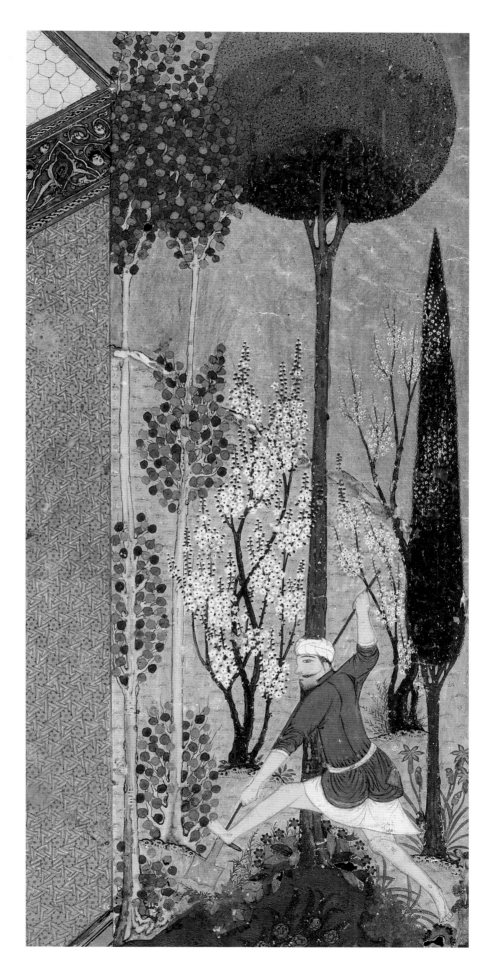

PART I

EPIC ROMANCE

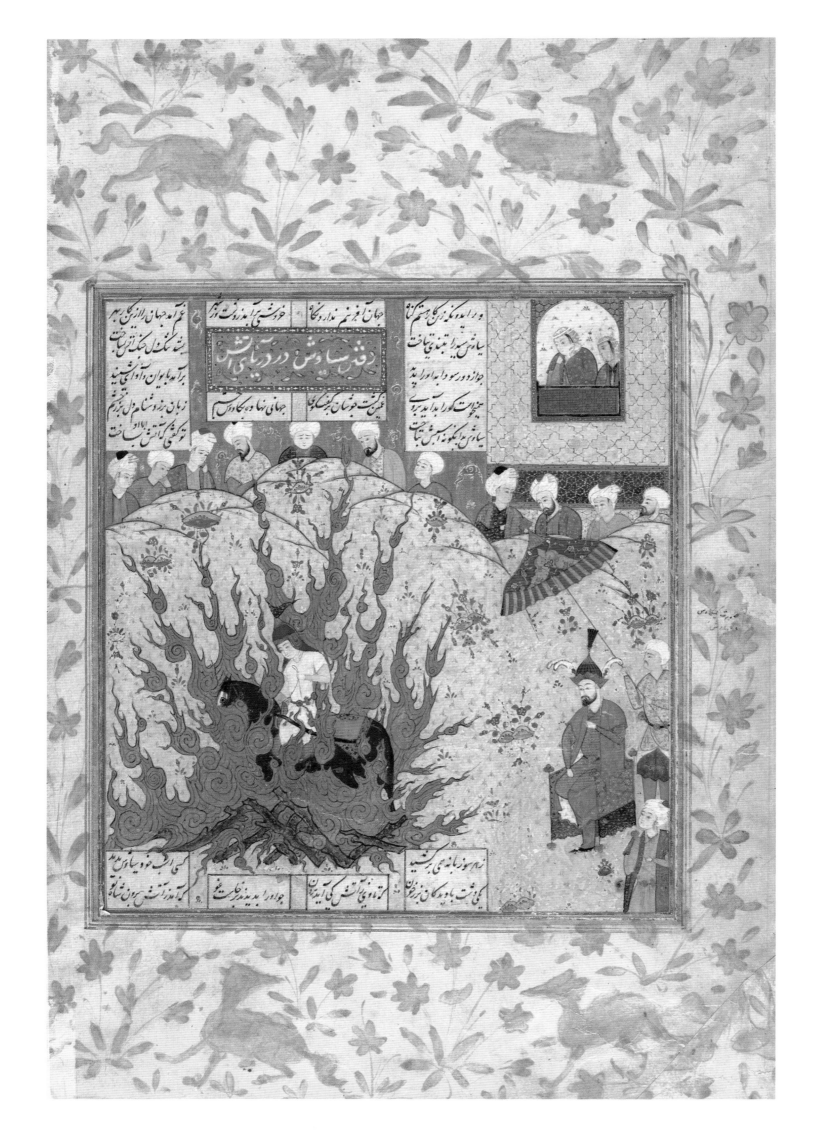

LOVE AND DEVOTION IN THE
SHAHNAMA OF FIRDAUSI

Barbara Brend

THE *Shahnama* ('Book of Kings') is the most celebrated work of Persian secular literature. It is an epic in verse completed about 1010 by the poet Abu'l Qasim Firdausi: it draws on previous myths, legends and chronicles but it has been shaped by an individual genius. Of central significance to the people of Iran as a vision of their history, and a tutor of moral values, it is not the exclusive preserve of scholarship but is known throughout the population, and it can still be discovered being recited for popular entertainment. The *Shahnama* traces the story of a notional fifty kings from the beginnings of civilisation to the coming of the Arab armies that defeated the last Persian king and brought Islam to Iran. Firdausi, who was born about 940 AD into a landowning family in north-eastern Iran, looks back first to a time of myth and legend; then to the time of Alexander the Great, in his Persian guise as Iskandar (see pp. 134–9);[1] and then to a rather more historical account of the Sasanian dynasty (224– 650 AD).

The *Shahnama* is an epic, and as such it can remind us of a host of other epics, the *Mahabharata* and the *Ramayana*, the *Iliad* and the *Aeneid*, *Beowulf* and the *Chanson de Roland*,[2] *Manas* and *Dede Korkut*. Warfare and disputation are frequently in the foreground of its narration but love and devotion are also to be found, sometimes in its deeper structures. In the epic context, these two abstractions are by no means easily teased apart but, if we consider love to be emotional, expressive and self-analytical, while devotion is more closely associated with respect and duty, it is devotion that receives the fuller treatment in the *Shahnama* as a function of its epic character.

The moral background to the *Shahnama* is formed by the Divinity and the opposing evil power, Ahriman. Devotion to the Divinity is the accepted norm for persons who have not been beguiled by Ahriman, and it is expressed by invocations, and prayers for success or rescue and of gratitude. A king of Iran, provided that his rule is legitimate, is the representative of this power on earth, the source of stability and justice. Zahhak, who is invited into the kingdom, is not of the royal line and so must be extirpated, but Iskandar, though he invades, is of the royal line and is accepted as his successor by the dying Dara (Figure 2.3).[3] The king is sometimes active in the narrative, but the main action is carried by the warrior paladins who surround him or – as is often the case with Rustam, the greatest of them – come to him at need. Princes who have not yet attained the throne also play a considerable part in the narrative. Active epic heroes are in principle devoted to the maintenance of the king's rule. This may entail a devotion to the office rather than to the occupant: thus Rustam faces seven perils on his way to rescue the foolish King Kay Kavus from captivity among the demons of Mazandaran, and to free him from the spell of blindness by the application of the liver of the White Div (Figure 2.4).[4] This is the normal or the formal way of things but the epic hero has another focus of devotion: his own glory. In the rescue of Kay Kavus, Rustam's devotion to the king

Detail from Figure 2.2

and to his own reputation are in alignment, but when a
later king, Gushtasp, orders that Rustam should be
brought to him in chains, this is at odds with the hero's
sense of his own dignity, and between these two claims
on his epic devotion Rustam chooses the latter.

Though Rustam is the most prominent hero of
the *Shahnama*, the workings of heroic devotion to the
throne are also very evident in a sequence concern-
ing the paladin Giv, the son of Gudarz and father of
Bizhan. Giv displays particular devotion to the royal
line when, during the reign of Kay Kavus, he finds,
defends and brings to Iran Kay Khusrau, the son of
Siyavush and grandson of Kay Kavus, who was born
during his father's exile in Turan. This event is marked
by divine intervention. Gudarz tells his son that he has
dreamed of an angel who has informed him that Giv
alone can find Kay Khusrau living in Turan. It is clear
that this task fulfils both imperatives of the warrior's
existence, since Giv can restore the true line of kings
of Iran and win enduring fame. Without a moment's
hesitation he accepts this task and sets out alone. As he
wanders, Giv's devoted purpose does not admit any
minor considerations, and so to maintain secrecy he
kills those whom he has questioned along the way.

Giv's devotion is evident in the fact that he wan-
ders for seven years in enemy territory. When he is
near despair, he comes to a flower-filled, well-watered
place – a background suggestive of regeneration –
where he sees a beautiful youth, none other than Kay
Khusrau, who has recognised Giv from a prophecy
made by his father. This moment is beautifully con-
veyed in an illustration to the *Shahnama* for Shah
Tahmasp by an artist who is well grounded in the mean-
ing of the text (Figure 2.5).[5] The prince is at the apex
of a sector of water and verdure, while the unearthly
effect of the cool palette in the picture as a whole
suggests an epiphany. In confirmation that he is of the
true line of kings, Kay Khusrau bares his arm to show
his birthmark, and Giv makes obeisance and expresses
his joy. This moment is shown in a particularly touching
illustration to the 'First Small' *Shahnama*, datable to
about the 1290s (Figure 2.6). Kay Khusrau mounts
Giv's horse and the latter defends him as they make
their way to Farangis, the mother of Kay Khusrau in
Siyavushgird, the city of Siyavush.

In the next phase of the episode we may perhaps
see a blend of love and devotion at a non-human level,

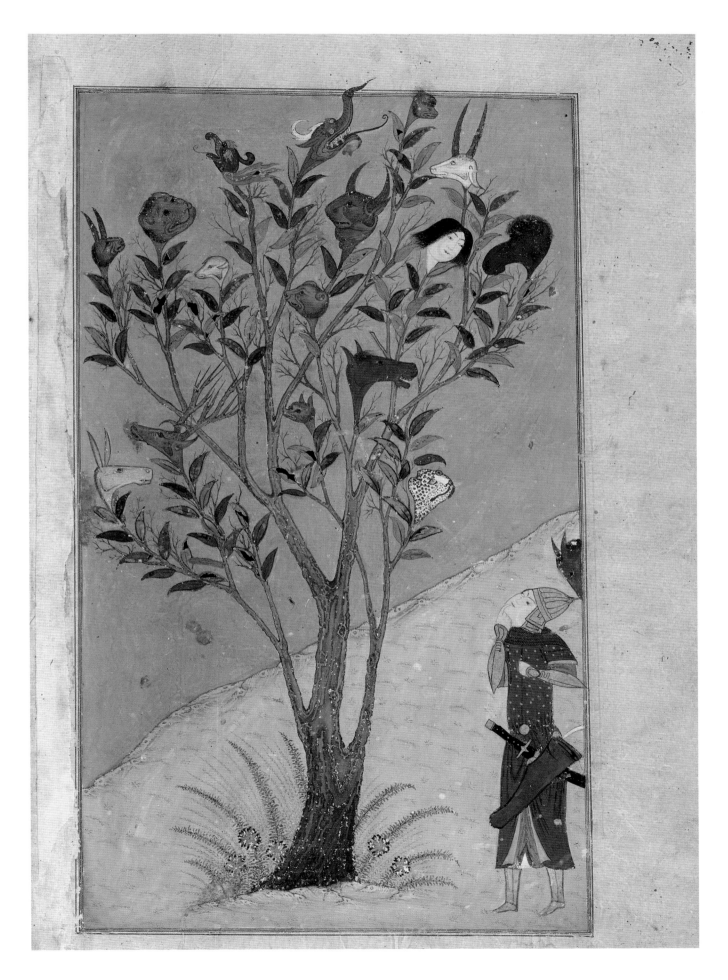

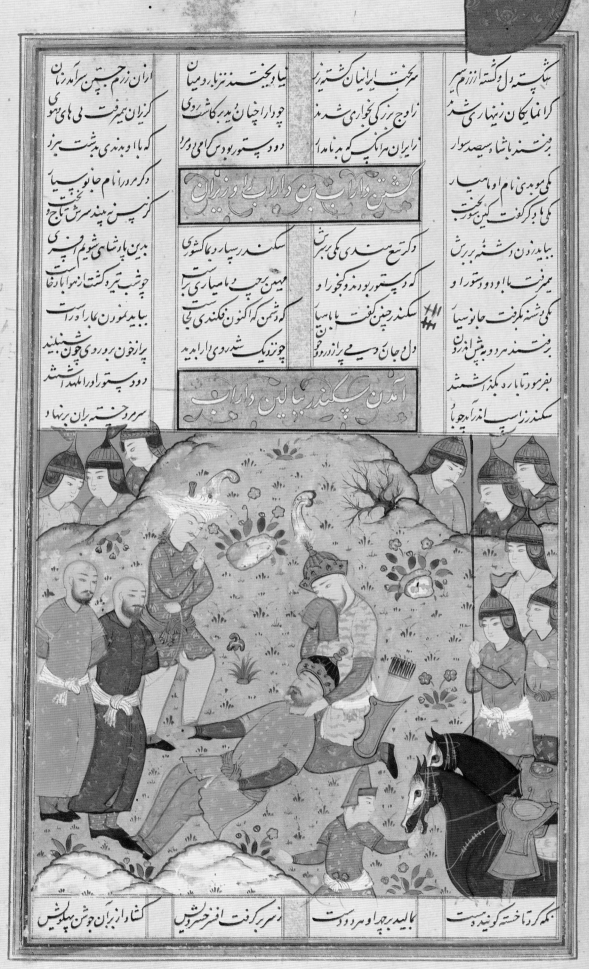

شکسته‌دل و کشته از رزم سیر
کرمانیکان زینهاری شدند
برفتند با شاه سیصد سوار

سرتخت ایرانیان کشته زیر
زواج بزرگی نگونسازی شدند
نرایان هر انک که به نامدار

نیا وبخنت تترنا رومیان
جو دارا جهان پیدر کاشروی
ودو پستور بود بس کامی ورا

ازان رزم چیشین سراآمد زمان
کریزان همی‌رفت بی‌های و هوی
که بابا و بندی بپشت برز

کشتن دارا بن دارا وزیران

وکرتع سندی کمی بربش
سکندر سپارد دما کشوری
سکندر جنین کفت بابا سیا
جو نزدیک شبه سروی دارابید

ودو پستور بودند و خوزار او
میهن به جب ما میارنی‌برا
کنون که نکنندی تاجا
دل جان و سیم سروی پراز رو چو

بدین باز شای شویم افندی
جو شب تیره کشت زانرو اباد رخا
بباید سمودن ماباراست
پرازخون بر وردی چون شنبلید
ودو پستور واراملهند شر

کرپس پندی مر سرش بخیت‌تاج
دکرمرد را نام جانو سپار
ازان رزم جیشین سراآمد زمان
کریزان همی‌رفت بی‌های و هوی
سرمر وخسته بران برنها

آمدن سکندر بربالین دارا

یکی دشته بکرفت جانو سپار
بزد پیرو سپه شنایار
نکون شتو سرنام داورشاه
وزروباز کشنه یکسر سپاه
بنزدیک اسکندر لنده وزیر
لیما با شاه پیروز لمتی بزیر
بکشتم ایں دشمنت ناکهان
کرا بود تاج و تخت مهان
جوبشنید کتار جانو سپار

کمک کرتا خسته کرنده‌بست
باید بر جدا و مرد وست
زیر بر کرفت افسر خسروی
کشا واز بران جوش پهلوی

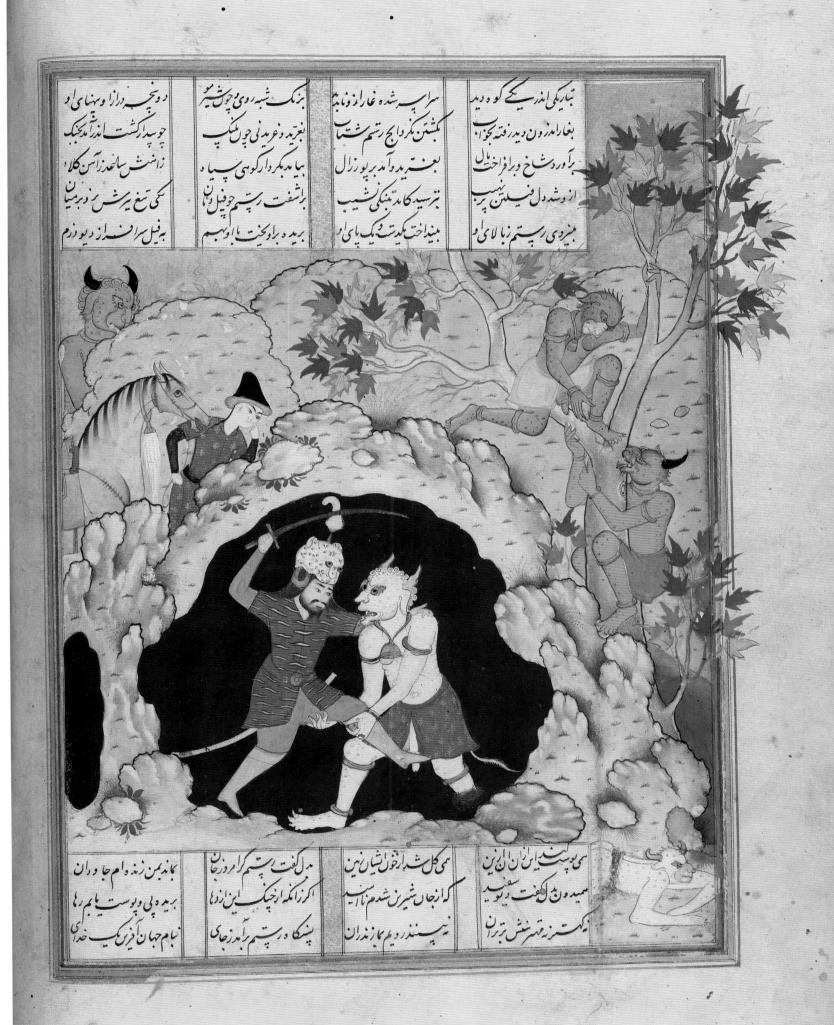

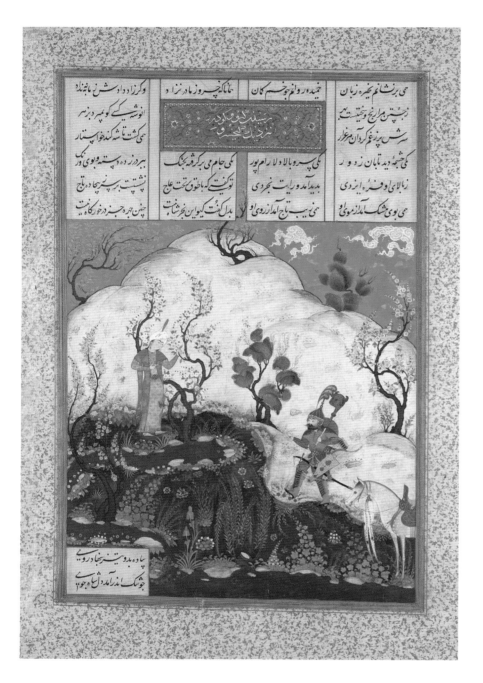

when Kay Khusrau's identity is further demonstrated by the behaviour of his father's horse. Shown Siyavush's saddle and bridle, the horse recognises a new master and allows itself to be caressed, then, mounted by Kay Khusrau, it gallops away in delight.[6] The devotion of the steed is a topos of the epic world and is seen earlier in the *Shahnama* in the willingness of Rustam's steed, Rakhsh, to defend his master in the First and Third Perils that he faces. The close relationship between man and mount also gives rise to an interesting expression of human love, since Farangis shows her feeling for murdered Siyavush by further caresses to his horse. The party then set out for Iran, but this becomes known to Afrasiyab of Turan.

In the fourth phase of the episode Giv twice, single-handedly, defends Kay Khusrau and Farangis against the forces of Turan that have been sent to capture the one and kill the other. In this section Firdausi touches on the two aspects of the warrior's endeavour: his devotion to the throne and to his personal glory. When the second attack is known to be approaching, Kay Khusrau himself offers to fight but Giv refuses this with a clear statement of their respective roles in life:

> Giv answered: "Noble prince! the world
> hath need
> Of thee to wear its crown. My sire and I
> Are paladins whose loins are ever girt
> To serve the shahs'.[7]

After the second engagement, Giv captures Piran and brings him before Kay Khusrau, evidently expecting him to pronounce a death sentence, but has to bow to Kay Khusrau's inclination to mercy. Thus Giv's devotion to his prince triumphs over his own more primal urge to destroy his opponent – but we may feel this outcome was not a foregone conclusion.

The last phase of the episode begins as, still pursued, Kay Khusrau, Farangis and Giv reach the River Jihun (Oxus), the boundary between Turan and Iran. The venal ferryman adds tension to the action of the narrative by causing a delay, but he also throws the devotion of Giv into relief by exhibiting its opposite. His action is, of course, an echo of that of the ferryman who refused passage to Faridun when he was coming to dethrone the tyrant Zahhak, and thus further confirms that Kay Khusrau is of the royal line. As a true successor to Faridun, Kay Khusrau decides to dispense with

Figure 2.5 (above)

The discovery of Kay Khusrau by Giv. From a manuscript of Firdausi, *Shahnama*, copied for Shah Tahmasp, c. 1525–30, Tabriz.
The Metropolitan Museum of Art, New York, 1970.301, fol. 210v.

Figure 2.6 (opposite)

The discovery of Kay Khusrau by Giv. From a manuscript of Firdausi, *Shahnama*, copied c. 1290.
Chester Beatty Library, Dublin, Per. 104, fol. 15.

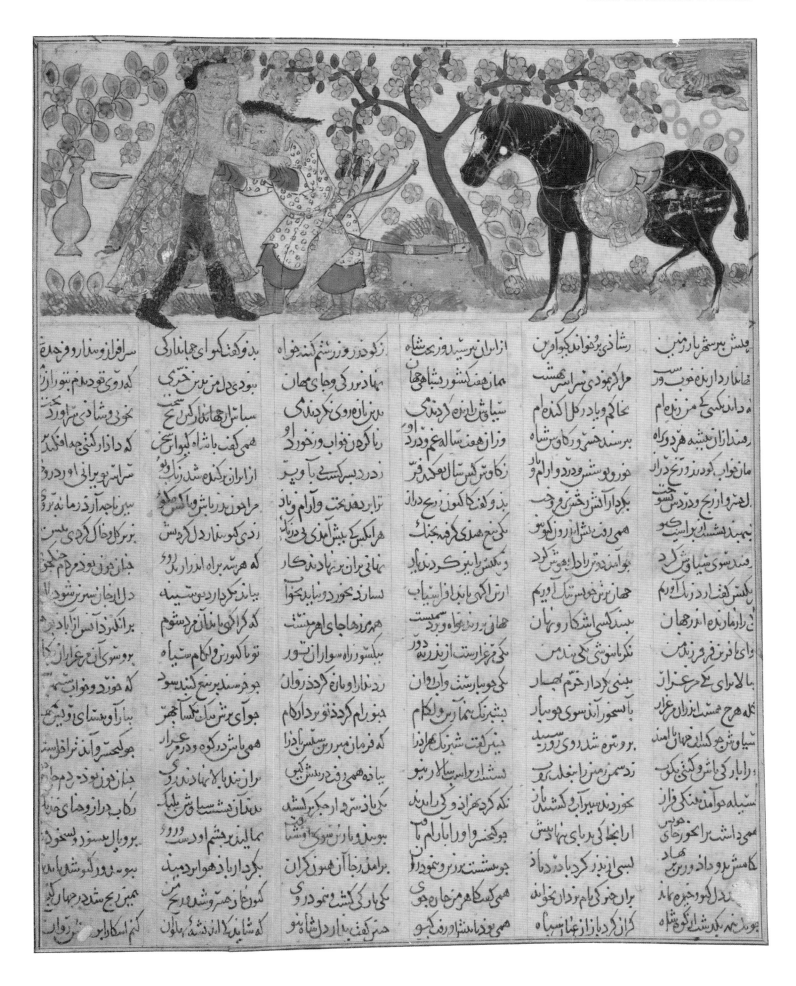

the services of the ferryman; he offers a prayer, and leads Farangis and Giv across the river on horseback (Figure 2.7). Thus Kay Khusrau is seen as a true descendant of royalty, and, as a result, Giv's devotion is seen to be rightly ordered. The pursuers turn back and the party are received with rejoicing in Isfahan.

In contrast to the clear exploration of devotion, episodes of love between men and women are included in the *Shahnama* but not closely examined.[8] Though love is not shown as entirely without anguish, this is not dwelt on; nor is love seen as potentially transcendental, in the sense of being a pathway to God. These things would come later in the development of Persian literature. Love in the *Shahnama* occurs at first sight or at first hearing of a description, and it endures without changing. On the whole, it will have a satisfactory outcome, though its satisfaction may temporarily be delayed by external factors. In consequence, love is not presented as the subject of prolonged analysis. Instead it seems to be used to introduce variety into the narrative: a different set of characters, a different set of problems and perils, a different atmosphere.

This difference is often established by the description of a beautiful woman who is, on that basis alone, a worthy object of love and capable of loving. The description, which deploys the traditional metaphors of flowers and precious materials, does not aim at an individual portrait but rather at an evocative atmosphere. In the context of episodes of love, floral and decorative metaphors may also be used of young men, though less insistently, and with the addition of the animal comparisons – lion, elephant – that betoken a warrior. In addition, the impression of human beauty may be supported by that of a beautiful landscape setting, which as it were reflects the person – as was the case at the finding of Kay Khusrau – and, on the narrative side, drama may be heightened by taking place at night. Thus during these scenes the mind's eye of the reader or listener is turned away from the blood and dust of battles – mainly set in daytime – that prevail in much of the text. The plot is then often moved by the action of the woman, while the male lover follows and accepts. The love episode may be quite brief in comparison with the surrounding matter, but its difference causes it to loom larger in a listener's or reader's recollection. This literary effect is strongly reinforced by the fact that the love stories are much favoured for illustration. Thus

love is static but iconic. Three principal love stories in the *Shahnama* are those of Zal and Rudaba, Rustam and Tahmina, and Bizhan and Manizha.[9]

The story of Zal and Rudaba is needed to establish the parentage of the great hero Rustam. In the time of Shah Manuchihr, Sam, ruler of the vassal kingdom of Zabul in Sistan in the marches of the south-east, hands his realm over to the lordship of his son Zal. The latter sets out to survey his domain and reaches Kabul, ruled by Mihrab, who pays tribute to Zabul and who, in spite of being a descendant of the wicked Zahhak, is of distinguished appearance and upright character. Zal is told that Mihrab has a daughter. Her description has already been prepared in the agreeable impression made on Zal by her father. It is now continued with metaphors of sun, ivory, teak, musk, silver, cherry, pomegranate and narcissus. Thus we anticipate that Zal and she will fall in love, and the interest of the story will be in the skill with which this is worked out.

In a similar way Rudaba falls in love with the description of Zal, which depends on his physique and martial prowess. The fact of her love is established by the visual clue that she flushes red.[10] Rudaba enlists the help of her five Turkish maids. They go to pick roses in a flowery meadow by a river near Zal's camp. Zal sees his opportunity: he shoots a waterfowl that falls on their side of a river (Figure 2.8). He sends a servant to pick it up, and so establishes contact with the maids. This passage appears to be employing allegory, which contrasts with the general tenor of the epic.[11] This is most evident in the topos of the lover's shot that strikes home but is perhaps also to be seen in the maids who, being five in number, may well represent Rubaba's five senses. If that is so, the roses that they are picking may be a further floral metaphor of her beauty, or perhaps a representation of her thoughts of love. Significantly it is the maids who invite Zal to come at night with his lasso to scale the wall of her pavilion.

The romantic climax of this episode comes in two parts, both of which are expressed by action within a given space that is defined by architecture, rather than by detailed description. In a phase replete with symbolism Zal comes to the wall of Rudaba's pavilion, she unlooses her tresses to form a rope that he can climb, but he throws his lasso to the battlements and so gains access to her pavilion.[12] In the second phase they pass the night closeted within her secluded abode. This, one

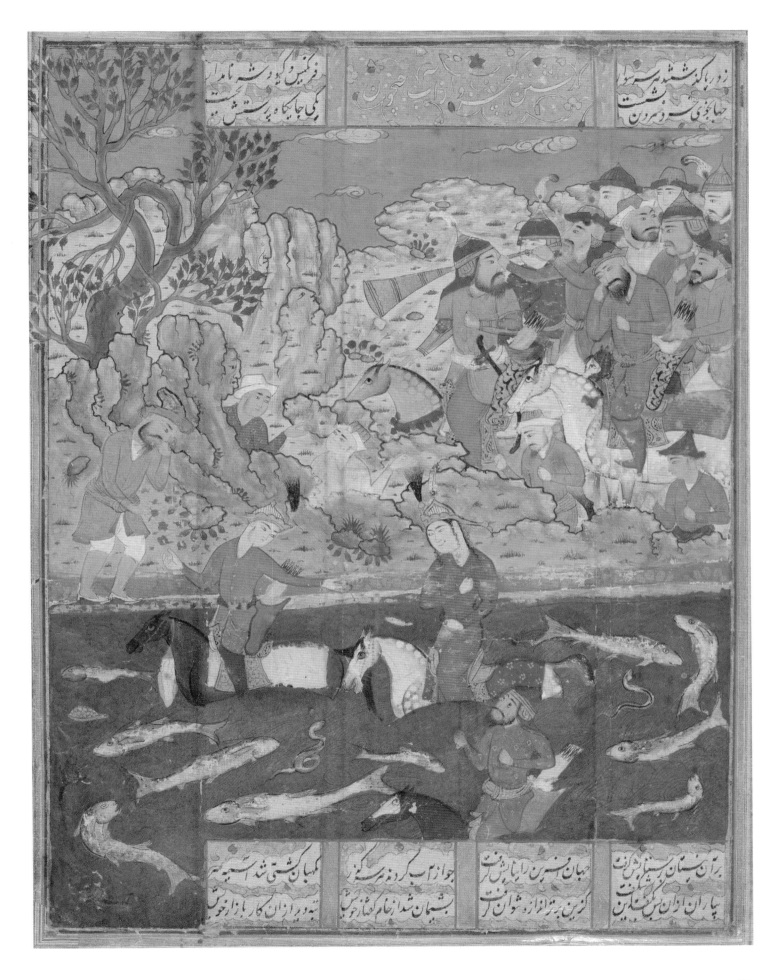

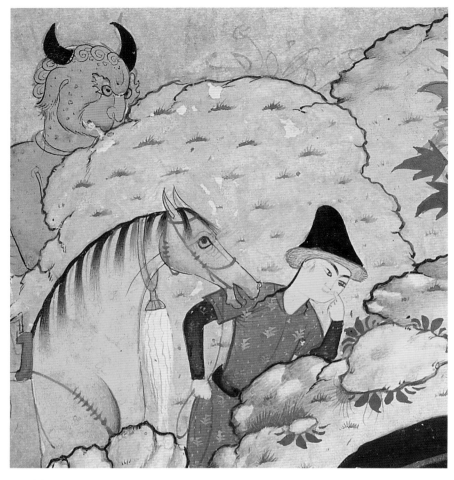

Detail from Figure 2.4

could almost say, concludes the love story of Zal and Rudaba. We know enough. It remains only for the obstacles to be worked through and we learn nothing more of the couple's love, save that it has a successful outcome.

The encounter between Rustam and Tahmina can barely be called mutual love but it has great narrative interest. Rustam, sleeping in an unfamiliar room, experiences an unexpected happening:[13] at midnight the door opens and a slave enters followed by the beautiful Tahmina. She is described with suitable metaphors, but quite briefly. Tahmina explains that she has been fascinated by accounts of his deeds and is looking to him to sire a child. Her interest can be read as the infatuation of a lonely girl, but this is combined with the conscious – and in her circumstances a very sensible – intention to use Rustam, if one may say so, as a sperm donor. Tahmina is not primarily looking for a soul mate: she is trying to fulfil her proper function in life, which is to give birth to a hero. Rustam's emotions are not engaged in this incident and do not emerge until later when he kills Suhrab, the son that he has unknowingly fathered. Tahmina weeps when Rustam leaves her, but it is her daring action rather than her sad fate that remains with us (Figures 2.9, 2.10).

The story of the love of Bizhan and Manizha is more complex, being derived from a complete tale. We learn this from the mysterious prelude in the poet's own voice, which tells us of a black night – whether this is a poetic figure or a manifestation of depression we cannot tell – in which Firdausi asks a loved one – whether wife, or a concubine – to bring a light and entertain him. The beloved brings wine and a book containing this story. The prelude raises many questions but its tone suggests that if Firdausi had been writing at a different period and in a different mode he might have been much more expansive on the topic of love.

Bizhan has gone with Gurgin to a borderland to deal with some troublesome wild boar. Gurgin wishes to lure Bizhan into danger and so he describes to him a beautiful landscape in which Manizha, the daughter of Afrasiyab, and her fairy-faced maids disport themselves. Bizhan wishes to visit the place and dresses himself in finery – thus showing that he is prepared for love. Manizha's active role begins when she sends her nurse to meet Bizhan, and soon he is being entertained in her tent with food and drink and music, while

Figure 2.8 (opposite)

Zal shoots waterfowl. From a manuscript of Firdausi, *Shahnama*, copied c. 1335. Topkapi Palace Museum, Istanbul, H. 2153, fol. 65v.

Figure 2.9 (page 34)

Tahmina comes to Rustam's bed chamber. Leaf from a disbound manuscript of Firdausi, *Shahnama*, copied for Ibrahim Sultan , c. 1430, Shiraz. Bodleian Library, University of Oxford, MS. Ouseley Add. 176, fol. 82r.

Figure 2.10 (page 35)

Rustam mortally wounds Suhrab. Leaf from a disbound manuscript of Firdausi, *Shahnama*, copied for Ibrahim Sultan, c. 1430, Shiraz. Bodleian Library, University of Oxford, MS. Ouseley Add. 176, fol. 92r.

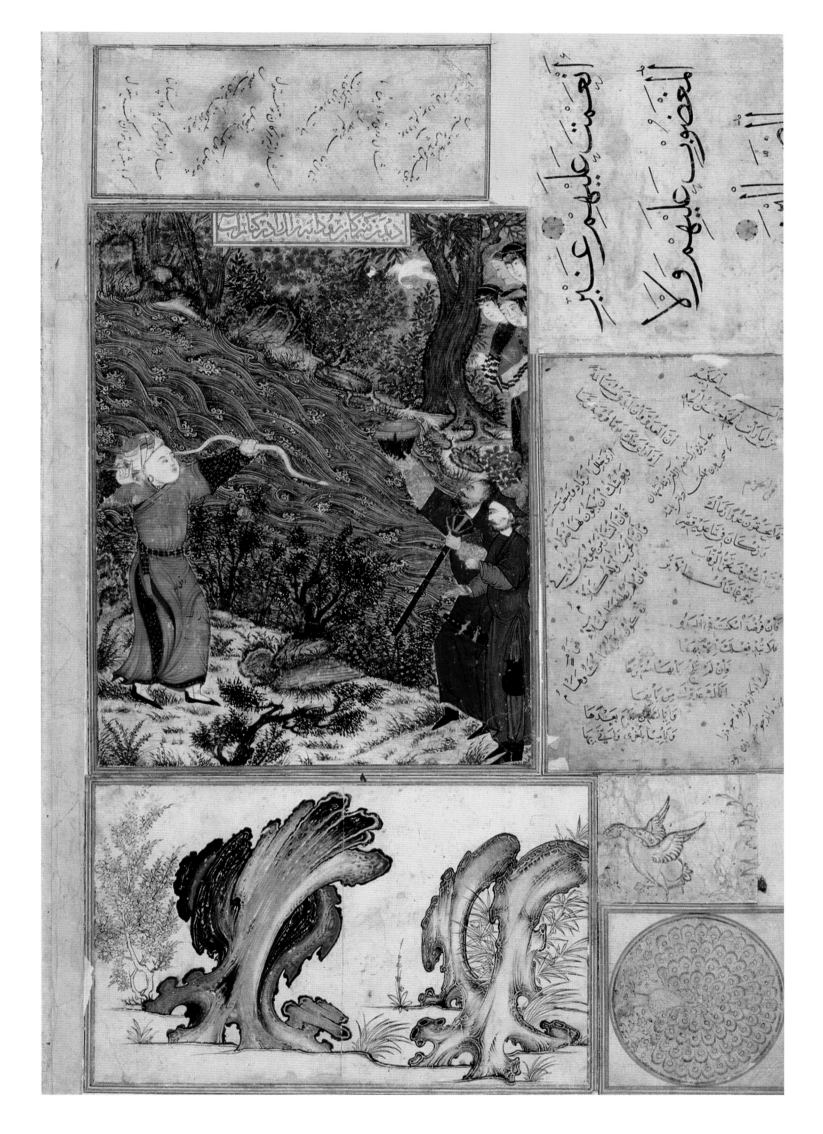

درین نگه داری چه میخواهی بجوئیم
جوستم کفتار او ونکرد
کنون تاسمنگان نشان پی است

نشسته بفرخ کلاه نوایم
زبدها کاینش کوته دید
ازآنسوی کی جوی باروی نی است

تن خوابسته زیر فرمان است
بدوکفت رختم بدین مرغزار
نباشد ارباز جوی بی سپاس
بدوکفت شاه ای پسر افروز
یکی امشب ای شاه دارم دل
تهمن زکف باد او شاد است
مگر باز یابد ازرخش خویش
بشهر روز لشکر سرازنه
نشستند بار دسامان بهم
جوشیده بت هنگام خواب آمد

سرار جنبش ان وجان آن تست
زمن دورشد نه کام وبار
نیارد کسی با نوان کار کرد
درزاندیشه آزاده داریم دل
روانش ازاندیشه آزاد شد
سعادت بود زان رامجن خویش
همه بدچگالان بیش رامند
بدان تا تهمتن بیاشد درم
سمی ازنشستن شتاب آمد

بفرمود خواب یکر ازاک خوان
سزاوار او جای آرام وخواب
جوبک بهده ازنیره شب در
سخن کفتن بهفت برازاز
یکی بنده شمع معبر بدست
دواب وکان ودد کیسو کمد

سراز ابسی پسر دخوام برید
بکام نوکرد ده سرا پسر سخن
جهان باره نامه ار جهان
شدن شاه دامانه بهمان او وی
سمی بو وجون بنده بهش سپاهی
سیه جشم کل رخ بنان طراز
بیارند وبهند بیت کوان

ازآنسوی کی جوی باروی
نوشمان من باشش وتندی مکن
بی رخش بستم نماند نهان
سزا بید رفتن پسوی خان اک
سپیدند باره ورواد درکاخ جای
کساره ورود وبیاز

پس بده ابریکی ماه روی
خرامان بیامد بالین مت
بالابکر دارنده وبلند

جان ازطرزد زبان لی سکر
زبانش بکلال بدزده که
ستاره بنان کرد زنیرعفتین
وکوب وب ورزمره آمد رفین

چو سهراب بازآمد او را بدید
جنین گفت کای رسته از چنگ شیر
دگر باره آسمان بستند سخت
سرانکه خشم آورد بخت بدم شوم
بر شیر بگیر تا سایه بکشد درو سور
سرانجام سهراب و آن آرزو بود
غمی گشت آن بر و بازوی دیلیر دست
روش بر زمین بر بگردید شیر
بیک تیغ تیز از میان برکشید
بر شیر بیدار دل بر درید

زبان جوانی دلنش بردمید
جدا آمدی باز زنده دلیر
بسر برمی کشت بدخواه بخت
کرفت آن بر و بازوی میل دست
بداشت بر زمین نماند بزیر
خم آورد پشت دلیر جوان

جوان را بدان سرکشان بر دمید
جدا آمدی باز بیستم کموی
بگشتی کرفتن نهاد پسر

یکی تیز رست بد و نیک دید
بهمی آستی جون سایی بروی
کرفتند مردو دوال اکمر
شود سنگ خارا کرد مردم
سپه اینان در آن گرد زور
توکفتی که جرخ بلندش ببست
زمانه بیامد بجو دستر توان

مراکه کشته شدی تو نو بخون
زنیک و بداندیش کوتاه کرد
مراکر کشید و بزاری بکشت
رمیدند اندر ره و دم بسر
و باجون شب اندر سیاهی کنوی
جو بیند که خشتت با بین من
سهی خواست کردن تو راخرا پتار
سی سلخ تن نیاب وزی تو کشت

بالود تو آنجه را تو بخون
بدیک و بد آندیش کوتاه کرد
مراکر کشید و بزاری بکشت
رهیده اندر ره آمد بسر
جو بیند که خشتت با بین من
سهی خواست کردن تو راخرا پتار
سی سلخ تن نیاب وزی تو کشت

زمانه بخون تو تشنه شود
بدوکفت کین برملی از مزی بد
بازی که بند سم پسا سن
سی جستش تا ببیتش روی
وکر جون ستاره شوی برسپهر
ازین نامداران و کردکشان
جوشید رستم سریش خبرکشت
بهر سیده اندان پس اهوشت

مراندام تو موی کشته شود
زمانه بدست تو داد کلید
بابر اندر آمد جنین یال منغ
جنین جان بدادم بدید اروی
بتری ارو زمین پاک مهر
کسی نیز زمین رستم درکشان
جهان بیش خشم اندرش تیزه کشت
بدوکفت ناما لو با خروشی

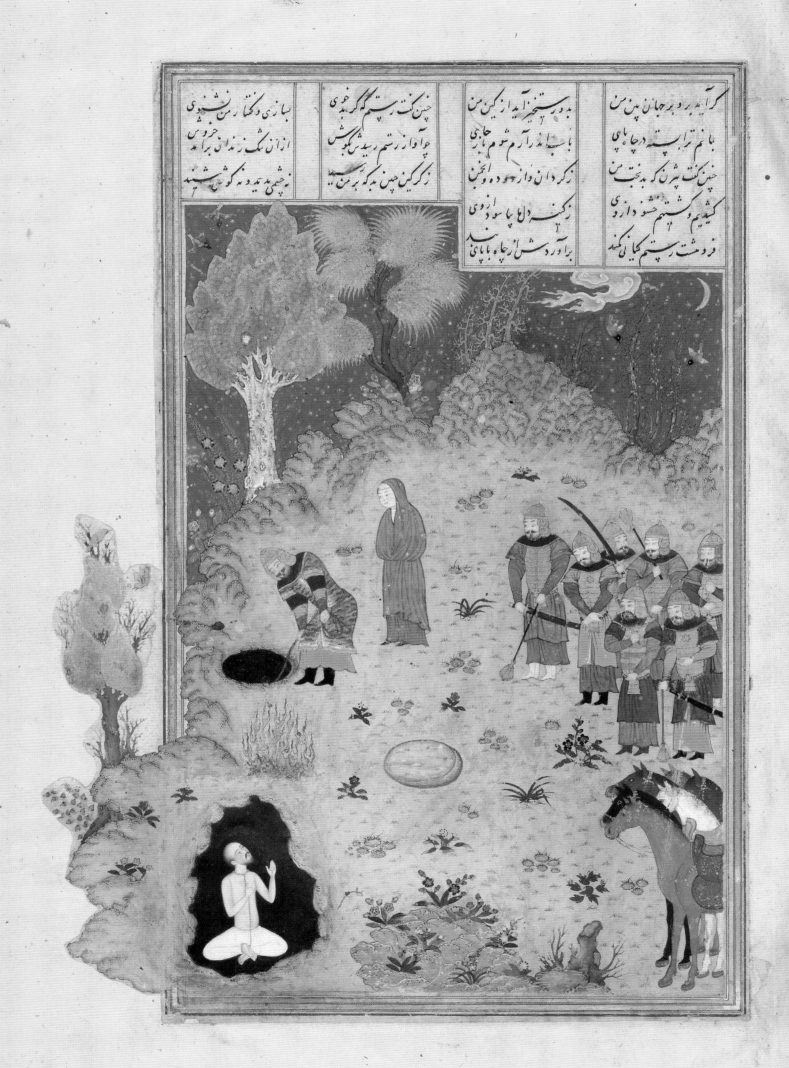

surrounded with brocade and jewels and gold, and perfumed with musk and ambergris. The eagerness of Manizha's love is to be judged by the boldness of her next action as she takes possession of Bizhan, drugging him and having him transported to her palace. Bizhan's reaction is rage at Gurgin's treachery, but Manizha tells him to live in the moment and they return to enjoyment. This situation is discovered and Bizhan is brought before Afrasiyab. Bizhan's developing love for Manizha is now shown indirectly by the fact that he invents a story with the aim of exonerating her. Bizhan's life is spared, but he is fettered and thrown into a pit under a heavy stone. Manizha is disgraced but shows her very devoted love by begging for food that she passes in to Bizhan.

The love element of the tale is now established. Rather as in the case of Zal and Rudaba, the containing physical setting marks it off from life in general. Again similarly, the narrative now moves to the events that will bring about a resolution. This takes us to Iran and Rustam and the projected rescue of Bizhan.

Manizha's first encounter with Rustam has dramatic tension with a touch of comedy. The hero has arrived in the guise of a merchant from Iran. Not knowing his true identity, Manizha comes to ask him for news of Giv, Bizhan's father, and if there might be a rescue attempt. Rustam is afraid that she will give his game away and is extremely short with her. The question of possible accidental betrayal is then examined a second time, since, when Rustam has made his presence known to Bizhan – by means of his signet ring in a roast chicken carried by Manizha – she has to endure a flash of misogyny from her lover as he hesitates before explaining to her why he is suddenly so relieved. Manizha then collects wood for a fire to guide Rustam to the pit. Though it could be said that the fire is emblematic of her love, this is the last point in the story at which we see her active. As he develops the account of the actual rescue, Firdausi focuses on themes other than love. At a simple narrative level there is the strength of Rustam as he heaves up the capstone, and at a more reflective level there is the moral question of whether Bizhan will pardon Gurgin for leading him into trouble. It seems, however, that illustrators saw the rescue as the climax of a romance, and Manizha is usually well in the picture. A romantic atmosphere is especially effective in the illustration of this scene in the

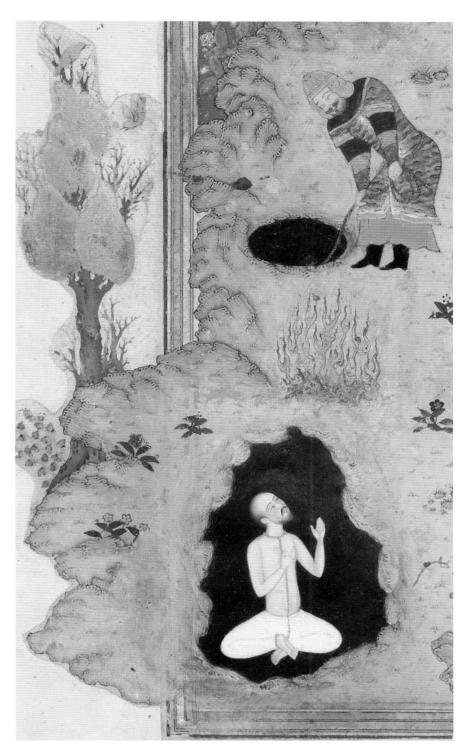

Detail from Figure 2.11

Figure 2.11 (opposite)

Rustam rescues Bizhan from the pit. Leaf from a disbound manuscript of Firdausi, *Shahnama*, copied for Muhammad Juki, c. 1440. Royal Asiatic Society of Great Britain and Ireland, London, MS. 239, fol. 180r.

Shahnama for Muhammad Juki, painted in the early 1440s (Figure 2.11).

Though love between the sexes sometimes appears as a deviation from the main themes of the *Shahnama*, parental love, and particularly paternal love is woven into the main fabric. (Grieving maternal love is seen in Tahmina for Suhrab, and Jarira for Farud.) Famously, Rustam mourns when he has killed Suhrab. In the story of the finding of Kay Khusrau, Gudarz is anxious for Giv, and later Giv is anxious for Bizhan, when he is missing in Turan. Another passionate episode is that in which Faridun mourns for his youngest son, Iraj, murdered by his brothers.[14] Paternal love is not seen exclusively in tragic circumstances and it is not experienced exclusively by worthy fathers. So it is that even the feckless Kay Kavus embraces his son, Siyavush, when he has passed through the fire ordeal (Figure 2.12). Tragic or joyful, paternal love is the personal face of the epic questions: who under God is the legitimate ruler; and who is a true warrior. Thus the epic pull is away from the world of love and towards the world of devotion.

Barbara Brend is an independent scholar whose principal research interest is form and meaning in Persian and Mughal manuscript illustration. Her many publications include *Islamic Art* (1991); *The Emperor Akbar's Khamsa of Nizāmī* (1995); *Perspectives on Persian Painting: Illustrations to Amir Khusrau's Khamsah* (2003); *Muhammad Juki's Shahnamah of Firdausi* (2010). She was curator of the exhibition *Epic of the Persian Kings* at the Fitzwilliam Museum, University of Cambridge, in 2010 and co-author of the accompanying catalogue.

Figure 2.12 (opposite)

Kay Kavus embraces Siyavush after the fire ordeal. Leaf from a disbound manuscript of Firdausi, *Shahnama*, copied for Ibrahim Sultan, c. 1430, Shiraz.
Bodleian Library, University of Oxford, MS. Ouseley Add. 176, fol. 99v.

Notes:

1 In the *Shahnama* Alexander/Iskandar's father is the son of Darab of Iran and his mother is the daughter of Faylaqus of Rum ('Rome', the classical world, eventually Byzantium).

2 King Arthur and his knights also come to mind, but they come to us from the romance genre, rather than the epic.

3 There are also traces of the idea that the king contributes to the fertility of the land. See below the story of the finding of Kay Khusrau.

4 The remedy suggests some distant connection with the Biblical story of Tobias in the Apocrypha.

5 Martin Bernard Dickson and Stuart Cary Welch, *The Houghton* Shahnameh (Cambridge, MA, and London: Harvard University Press, 1981), No. 130, fol. 210v.

6 Dickson and Welch, *Houghton* Shahnama, No. 130, fol. 212r.

7 Djalal Khaleghi-Motlagh, ed., *Abu'l-Qasem Ferdowsi: The Shahnameh (Book of Kings)*, II (Costa Mesa, CA and New York: Mazda with Bibliotheca Persica, 1990), 436; Arthur George Warner and Edmond Warner, trans. *The Sháhnáma of Firdausí* (London, 1905–25, repr. London: Routledge, 2000), II, 382.

8 We learn less than we do of Dido, in Christopher Marlowe's play *The Queen of Carthage,* more than of La bel Aude in the medieval *Chanson de Roland*.

9 Other heroines of love stories are Katayun, who marries Gushtasp, and Shirin. For the latter, see Christine van Ruymbeke, 'Firdausi's *Dastan-i Khusrau va Shirin*: Not much of a Love Story!' in *Shahnama Studies*, I, ed. Charles Melville (Cambridge: Centre of Middle Eastern and Islamic Studies, 2006), 125–47.

10 Khaleghi-Motlagh, *Shahnameh*, I, 346; Warner and Warner, trans. *The Sháhnáma*, I, 260. The simple colour signal suggests a continuing influence from aural experience of poetry.

11 This is not yet the *Roman de la Rose* but it has started in that direction.

12 We think of Rapunzel, and of Romeo and Juliet in the European context.

13 This unit of construction is used for comic effect in Jane Austen's *Northanger Abbey*.

14 This subject was illustrated, c. 1335, in the Great Mongol *Shahnama* in what is perhaps the most explosively powerful picture in all of Persian painting. Glenn D. Lowry with Susan Nemazee, *A Jeweller's Eye: Islamic Arts of the Book from the Vever Collection* (Washington, DC: Arthur M. Sackler Gallery with University of Washington Press, 1988), No. 7, s86.0101.

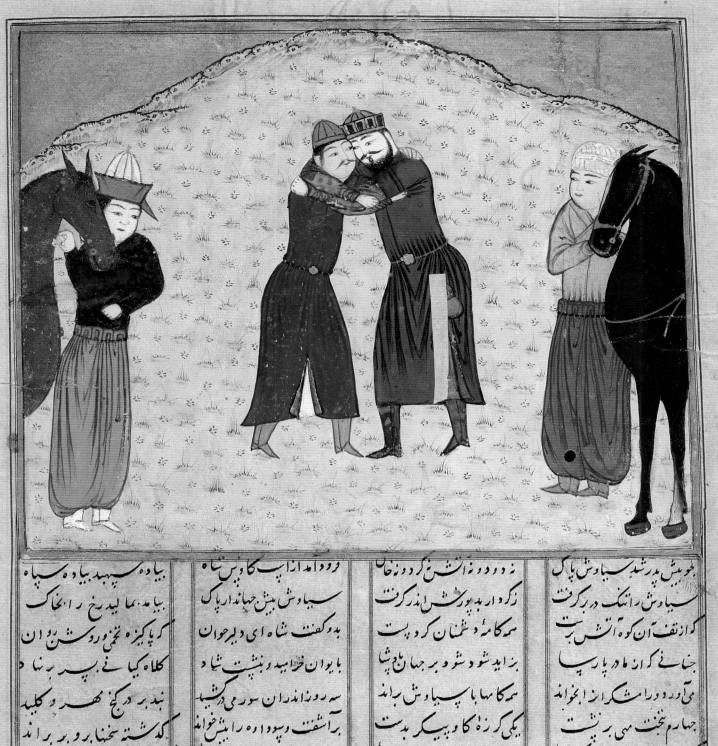

بیاده سپهبد بیاده سپاه	فرود آمد از اسپ کاوس شاه	نزد و د و خواند تش روز جهان	خویش پدرش ته سیاوش پاک
بیامد نما بیدم خ بر خاک	سیاوش پیش جهاندار پاک	زگرد او به پور ش اندر گرفت	سیاوش رنگ در برگرفت
که پاکیزه تخت و درد شن روان	بدوگفت شاه ای دلیر جوان	همه کامه و ثمنان کرد پست	که ازسف آن کوه تش برت
کلاه کی نی به سر برند	بایوان خرامید و بنشست شاد	بیاید شود و بر جهان یاج شا	جنای که از ان ماد پارسا
بند بر در کنج مهرو کلید	سه روز اندران سوری کشید	همه کامها با سیاوش براند	می آید و د و امشکر از ابخوانذ
کشته سخنها بر و بر براند	براشفت و سپوه و اده رابش خواند	یکی کر رهٔ کاو بیکر بدست	جهارم بنخت می بر بنت
که بر جان فرزند من زنهار	جه بازی نمود ی بفه جام کا	فراوان ول من بها بزد ه	کسی شدمی و بدنے کرد ه
بپردازد جای و بر آرای کار	نیاید نزد اپورش اکنون بکار	برین گونه بر جاد و پیی ساخت	نخوردی و در تش اندر اخنی
نگافت این بد بر من رسید	بدوگفت اگر به پسر بیا بید	جز او بجتن نیست پادشن این	ناید که بباش نو اندر زمین
دل شاه از تش ببشو پے	سیاوش سخن است که بدوی	خواتر که باشد دل پر زکین	بقد مای من دل نهاد م برین
نگردد سے پنت شوب گور	بدوگفت نیرنگ دا نی هنوز	به نو آتش نیز باوی بکین	ی جاد و بپپال کرد اندرین
همه شاه را بخو اندند آزبن	جه سازم جه باشد مکافات این	که این بد کجا ساخت اندر نهان	با براینان کفت شاه جهان
زدار اندر آو بز و بر تاب دی	بد ربخ فد سود کین ابکوی	زبد کردن خوبش بجان شود	که پاد شاغ انک بجان شود
که دل رابدین کار غمکین ار	سیاوش حین کفت باشد یار	شبستان همه بانک برد اشتند	جو سود او ه رارو بر کشتند

كدام آمد افكنده خواهى بتير
تو آن زاده را زركردان بتير
كان مهه اندار ناكوش خويش
بيكان سربانى كوشش پيش
دوبيكان بتركش يكى تير دوز
بتير دوبيكان زسربركرفت
همان برسه كوش شاه ده دوتير
سپوزا اسپى جنت وبكر جنت
نخاريد كوش آسوا اندر زمان

كه ماده جوانيش ونغم جنت يبر
شود ماده اده از تير تو تيز ور
هند مجنان خوار در دوش خويش
جوحواسى كه خوامت كيتى فروز
بدست اندار زبهر نخر داشت
كينز ك بدومانه اندر سكنت
زنده يمنان مرد نجخيد كير
نخم كان مهه بركوش ساخت
بتير اندرون راند جادو دكان

جنين كفت ازاده كاى شيرى
وزان پس سيوزا براكيز
همانكه زمه كشيد دوكوش
كا نبازبه كرد هرام كور
همانكه جوكار آمدش ناكزيه
هم اندرزمان نرجون ماده
دوبيكان بجاى سرو در سرش
بكوش يكى آهوا اندر فكن
بران سوازاده بدل بسوخت

با سوبخوى بيش مردان برد
جوآسو زجنك توكيرد كرد
بى ازارپايش سروا بلدش
براكيخت ازا دنت اربه شو
سپهبد پروهاى آن نويبر
سرش زان سرو سربرساده
نخون اندرون لعل كشته برش
پسندا مدش بوجاى بسند
بران آسوازاده بادل بسوخت

WOMEN IN THE ROMANCES OF THE *SHAHNAMA*

Firuza Abdullaeva

WOMEN in the *Shahnama* ('Book of Kings') enjoy extraordinary freedom compared with their counterparts in medieval European literature. Firdausi's female aristocrats from feminine *belles dames* in rose gardens to Amazon-like warriors almost never let men decide their fate, readily going against the will of their fathers or even their reluctant beloveds, and often initiating a relationship out of wedlock.

The story of Tahmina and Rustam is the most dramatic example (Figures 2.9, 2.10). The tragedy of a father unknowingly killing his son is not unique to the Iranian epic tradition.[1] One may think the Turanian princess Tahmina selfish in her desire to have a child fathered by the greatest hero in the world. The heartbreaking finale to Firdausi's story could be seen as his disapproval of her behaviour after she comes to Rustam's bedroom in the middle of the night offering herself as his child's mother. But this does not seem to be the case. It is remarkable that when this story in the shape of the legend of Eruslan Lazarevich – Rustam, son of Zal-e Zar – entered the Russian *bylina* epic tradition, Tahmina's role was radically changed to a classical passive character who waits for a hero to come and impregnate her.

The story of the Kabul princess Rudaba and the Iranian chevalier Zal, the parents of Rustam, ends more happily (see pp. 30, 32). Again the girl welcomes her beloved into her bedroom before being married to him. The story presents a whole gallery of weak male figures, especially Rudaba's father who is paralysed by fear of Zal's

family and is ready to kill his own daughter to save his life and reputation. The king's pitiful personality contrasts with that of his strong-willed and wise wife who leads the delegation to her future in-laws to negotiate her daughter's happy future.

A less optimistic finale is in the story of Sudaba and her stepson Siyavush,[2] the son of Rustam's suzerain king Kay Kavus. Sudaba was eventually decapitated by Rustam in revenge for Siyavush's death. This is the *Shahnama* version of the Biblical story of Joseph and Potiphar's wife, who was known as Zulaykha in the Islamic tradition. The story is comparable to Euripides' adaptation of the ancient Greek myth of Hippolytus and Phaedra, yet Firdausi's femme fatale, Sudaba, is closer in her powerful passion to the Greek Phaedra than to Zulaykha's unnamed Semitic counterpart. In later Persian literary tradition, Sudaba's prominence was replaced by that of Zulaykha, mainly as a result of Jami's mystical erotic interpretation of her story. Jami's 15th-century version differed from the poem *Yusuf u Zulaykha* ascribed to Firdausi centuries earlier.[3]

All these stories have their versions in other cultural traditions, creating the phenomenon of the wandering iconography of wandering stories,[4] whereby the literary images and their visual representation are borrowed, exchanged, influenced and emulated in different cultural traditions over the centuries. The idea of textual emulation (*tazmin*) as a literary genre (as opposed to plagiarism) was extolled by Shams-i Qays, a Marv theoretician of

Persian and Arabic literatures, as early as the 13th century.[5]

The *Shahnama* story of Prince Bahram Gur and his slave musician, Azada, presents a brilliant example of classical *tazmin*, inspiring several authors to create a whole chain of emulating imagery.[6] Firdausi's original version is brief (35 *bayts* or double verses) and episodic. His great 'improver', Nizami from Ganja[7] (1141–1209), develops it into a deeply symbolic tale in one of the most important poems of his *Khamsa* ('Quintet'), *Haft Paykar* ('Seven Portraits'). Amir Khusrau from Delhi[8] (1253–1325) expands Nizami's *Haft Paykar* to *Hasht Bihisht* ('Eight Gardens of Paradise'), where the original marginal story of a slave girl receives its full shape as the main (frame) story of special significance among the eight sections of the work.

It is remarkable how the poets gradually 'improve' the tale in a more feminist direction. Firdausi depicts Prince Bahram[9] as a clever and just monarch although he is a bon vivant and womaniser, interested only in feasts and hunts. Once, having gone hunting accompanied only by his favourite Byzantine slave Azada ('free, noble'), he expects her to sit behind him and play her harp (Figure 3.1). Instead, she challenges him to perform a daring feat and then accuses him of cruelty when he succeeds. Infuriated, Bahram throws the girl on the ground to be trampled by his camel.

Nizami named his slave girl Fitna ('trouble, rebel' – rebelling against her fate as a slave) and moved her place of origin from the West to the East, to China. When Bahram fulfils her tasks, she is also not impressed, attributing them to his constant practice rather than skill. Bahram is enraged but lacks the courage to kill the girl himself. On their arrival home, he orders his general to execute her. Secretly, she is taken instead to the officer's estate where she carries a pet calf up and down the castle steps every day, gaining strength as the animal grows (Figure 3.2). Later the general invites Bahram to his estate where he sees Fitna carrying a bull, which proves that she had been right about his skills being gained by constant practice. Bahram recognises her and proposes marriage.

Amir Khusrau's version is obviously a *javab* ('answer') to Nizami's but it has more allusions to Firdausi's text than it at first seems. Firdausi, a consistent royalist and nationalist, meant to preach that a

foreigner and a slave should know their place. Slaves who had illusions they were free, noble and equal to kings deserved punishment. Nizami turned this didactic sermon into a Cinderella-type fairy tale, perhaps in honour of his Qipchaq wife Afaq, a former slave, whom he married after he received her as a gift. He rebelled against Firdausi's elitist attitude, proclaiming what today would be called the American dream of a talented, hard-working professional, even of lowly origin, having the right to reach the highest rank in society. This was in fact a characteristic feature of Muslim societies compared with the pre-Islamic era, in which, for example, the Sasanians were strictly hierarchically organised with impermeable borders between the classes.

Then it was Amir Khusrau who turned Nizami's story upside down. He obviously did this with respect for his predecessor but the element of satire is strong. He calls his heroine Dilaram ('calming down one's heart'), after he explicitly says that she was 'like a thunderstorm, full of passion and desire'. Amir's Dilaram is also a foreigner, from the East, but Amir does not mention her social origin. The hunting scene mainly repeats the two previous stories but Amir's Bahram, instead of killing the animals, brands them and then lets them go. He breaks his taboo to impress Dilaram but receives no appreciation. She says that she was expecting a miracle but got a well-rehearsed performance. Compared with Nizami's version in which Bahram was too weak to kill the girl himself but calculating in his revenge, Amir's Bahram immediately throws her on the ground but does not trample her, leaving her to her fate.

From here it is Amir's interpretation of what happened next, completing circles of facts from his predecessors' tales around Dilaram: when the girl regains consciousness, she walks days and nights through the desert until she sees a village. She enters the first house, which belongs to an old *dihqan* (a hereditary aristocrat and landowner), who, struck by her beauty and the priceless pearls she has given him, offers to teach her music that he has learned in Rum (the Byzantine West). This is Amir's first completed circle: Firdausi's Azada, when she met Bahram, was already an experienced musician, a skill she had learned in her Byzantine homeland. So Amir's Dilaram, being from the East (like Nizami's Fitna) added knowledge from the West to her accomplishments.

Figure 3.1 (page 40)

Bahram Gur hunts with Azada. Leaf from a disbound manuscript of Firdausi, *Shahnama*, copied for Ibrahim Sultan, c. 1430.
Bodleian Library, University of Oxford, MS. Ouseley Add. 176, fol. 337v.

Figure 3.2 (opposite)

Practice makes perfect. From a manuscript of Nizami, *Khamsa*, copied c. 1570. Bodleian Library, University of Oxford, MS. Ouseley 316, fol. 199v.

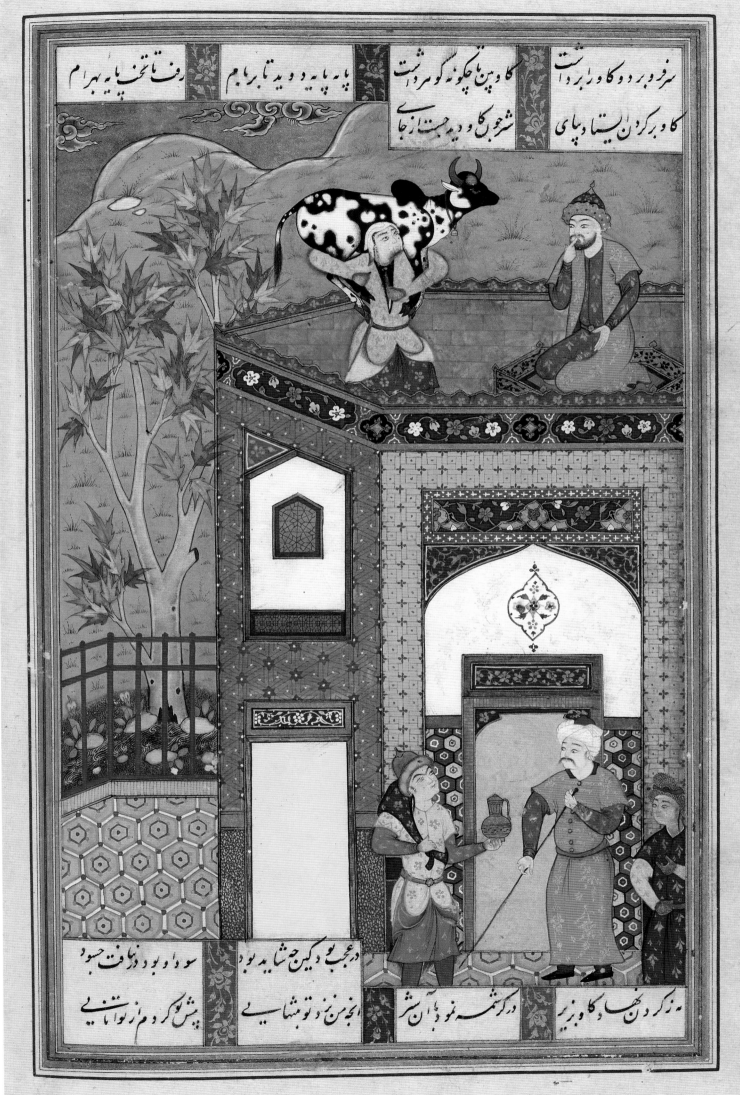

Here is the second circle: regardless of Dilaram's status, she is now to be taught by a real Iranian aristocrat, who calls her his daughter! As a result Dilaram produces miracles, like the prophet Solomon: when she plays her harp, animals from the desert move towards her. Her music sends them into a lethargic state as if they had suddenly died, and then revives them again. Bahram hears of her musical prowess, and summons her (Figure 3.3). Seeing her performance he repeats Dilaram's words from many years ago. She agrees that resurrecting the dead is not a miracle compared with cutting an onager's horns with an arrow as he had done. Bahram recognises her, apologises and takes her back to his palace, which has already been decorated with their portraits in the throne hall.

Amir's last circle is that he juxtaposes Nizami's onager, which brings Bahram to the cave where he finds treasure, with the black onager (in Persian *gur*, which also means 'grave') that brings Bahram to the abyss in which he meets his death. The moral of Amir's story is that a monarch is useless if he wastes his life on love affairs and hunting. Dilaram, compared with Azada and Fitna, not obviously a slave, finds her salvation in music after she has been abandoned in the desert; while for her predecessors an initial musical career proves fatal.

The attitude of Firdausi towards women reflects one of the main inconsistencies in his idea of social hierarchy,[10] in that he makes special allowances for the royal persons in his poem, even if they are foreign women. This seems to be influenced by his sources, based on the ancient pre-Islamic Iranian literary cultures of mixed origin. It is remarkable that the images of almost all *Shahnama* women with strong personalities were borrowed from stories of Parthian or Soghdian origin: that is, from the Sistan cycle (related to the hero Rustam).

Compared with the main urban centres of the Sasanians and then the Caliphate, where a young female aristocrat was an object of the harem culture but not mistress of her own will, in the far-flung territories of Sistan and Zabulistan (Arachosia), a noble-woman seemed to experience more rights in her household.[11] This is what caused the inconsistency that later encouraged 'improvements' by Firdausi's successors.

Firuza Abdullaeva is a graduate of St Petersburg University, where she taught as Associate Professor until 2005, when she moved to Oxford as University Lecturer in Persian Literature and Fellow and Keeper of the Firdausi Library of Wadham College. From 2010 she has been in charge of the Shahnama Centre at Pembroke College, University of Cambridge. With Charles Melville, she is co-author of *The Persian Book of Kings: Ibrahim Sultan's* Shahnama (2008).

Notes:

1 Cf. The legend of Hildebrand and Alebrand in Germanic folklore, or of Clessamore and Carthon in Celtic. V. Minorsky, '*L'épopée Persane et la littérature populaire Russe*', in *Iranica: Twenty Articles*, (Tehran: 1964), 114, 115 n4.

2 A personage associated with both Soghdian and Parthian mythological and literary tradition (see, for example, E. Morano, '"If they had lived . . .": A Soghdian–Parthian Fragment of Mani's Book of Giants', in *Exegisti Monumenta: Festschrift in Honour of Nicholas Sims-Williams*, ed. W. Sundermann, A. Hitze and F. De Blois, *Iranica* 17 (2009): 325–30).

3 Even in the surviving *Divan* of Rudaki (d. 940 AD), the first prominent poet of Mawarannahr, Zulaykha is a common trope, while Sudaba and Siyavush are not mentioned at all. Firuza Abdullaeva, 'From Zulaykha to Zuleika Dobson: Femmes Fatales in Persian Literature and Beyond', in *Ferdowsi, the Mongols and the History of Iran: Art, Literature and Culture from Early Islam to Qajar Persia*, eds. R. Hillenbrand, A. C. S. Peacock and F. Abdullaeva (London: I. B. Tauris, 2012, forthcoming).

4 Firuza Abdullaeva, 'Divine, Human and Demonic: Iconographic Flexibility in the Depiction of Rustam and Ashkabus', in *Shahnama Studies I*, ed. Charles Melville, Pembroke Papers 5 (Cambridge: Centre of Middle Eastern and Islamic Studies, University of Cambridge,

2006), 203–19; Firuza Abdullaeva, 'Kingly Flight: Nimrūd, Kay Kāvūs, Alexander, or Why the Angel has the Fish', in *Persica* 23 (2009–10): 1–29.

5 Shams ad-Din Muhammad b. Qays ar-Razi, *Al-Muʿjam fi Maʿayyir Ashʿar al-ʿAjam*, II, trans. and comment, N. Chalisova (Moscow: 1997), 166–73. See also Julie Scott Meisami, *Structure and Meaning in Medieval Arabic and Persian Poetry: Orient Pearls* (London: Routledge Curzon, 2003), 271–80.

6 Julie Scott Meisami, 'Fitna or Azada? Nizami's Ethical Poetic', in *Edebiyat, A Journal of Middle Eastern Literatures* 2/1 (1989): 41–75.

7 One of Nizami's poems in his *Quintet*, the *Iskandarnama*, the 'Book of Alexander', is one of the best emulations of Firdausi's version of the Alexander legend.

8 S. Sharma, *Amir Khusrau. The Poet of Sultans and Sufis*, Makers of the Muslim World series (Oxford: Oneworld, 2005), 71.

9 Sasanian king Varahran (Bahram) V (r. 420–38 AD). Obviously the story about Bahram's hunting expedition accompanied by his slave musician was famous much before Firdausi, as witnessed in several *objets d'art* such as the 6th-century Sasanian silver plate (S-252) in the Hermitage Museum, St Petersburg.

10 F. Abdullaeva, 'Ferdowsi: A Male Chauvinist or a Feminist?' in Manfred Milz et al., *Painting the Persian*

Book of Kings Today: Ancient Text and Modern Images (Cambridge: Talking Trees Books, 2010), 102–20; Dick Davis, 'The Aesthetics of the Historical Sections of the Shahnama', *Shahnama Studies I*, ed. Melville, 117.

11 These distant territories were populated by a blend of ancient civilisations, including the Medes, Greco-Bactrians, Indo-Scythians, Parthians and Kushans. Cf. the Bactrian marriage contract of a woman, Ralik, married to two men, Bab and Piduk, in 343 AD. See N. Sims-Williams, *Bactrian Documents from Northern Afghanistan: Legal and Economic Documents*, Corpus Inscriptionum Iranicarum, pt. II, vol. VI (Oxford: Oxford University Press, 2001), 32–6; see also I. Yakubovich, 'Marriage contract in the pre-Islamic period. i. Bactrian marriage contract', in *Encyclopaedia Iranica* online edition, 20 July 2005, available at http://www.iranica.com/articles/marriage- contract-in-the-pre-islamic-period. In a Soghdian marriage contract concluded 27 April 711 AD in Samarqand between a nobleman, Ottegin, and a princess, Chat, the future wife is entitled to initiate divorce if she is unhappy with her husband's behaviour and take all her dowry with her. Published several times, first by J. M. Jamasp-Asana, *Pahlavi Texts* II (Bombay, 1913), 141–3; more recently, V. I. Livshits, *Sogdiyskaya epigrafika Sredney Azii i Semirechya* (St Petersburg: St Petersburg University Press, 2008), 18–48.

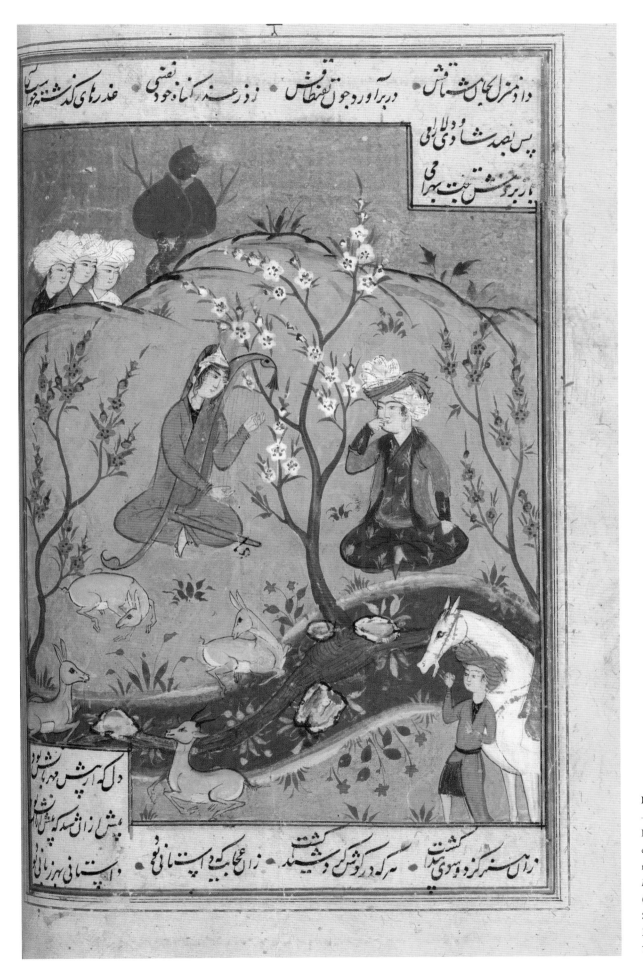

Figure 3.3

Bahram Gur listens as Dilaram
enchants the animals. From a
manuscript of Amir Khusrau,
Khamsa, dated 1007–08
(1599–1600).
State Library of Victoria,
Melbourne, RARESF
745.670955 AM5K, fol. 172v.

PART II

LANGUAGE OF
THE HEART

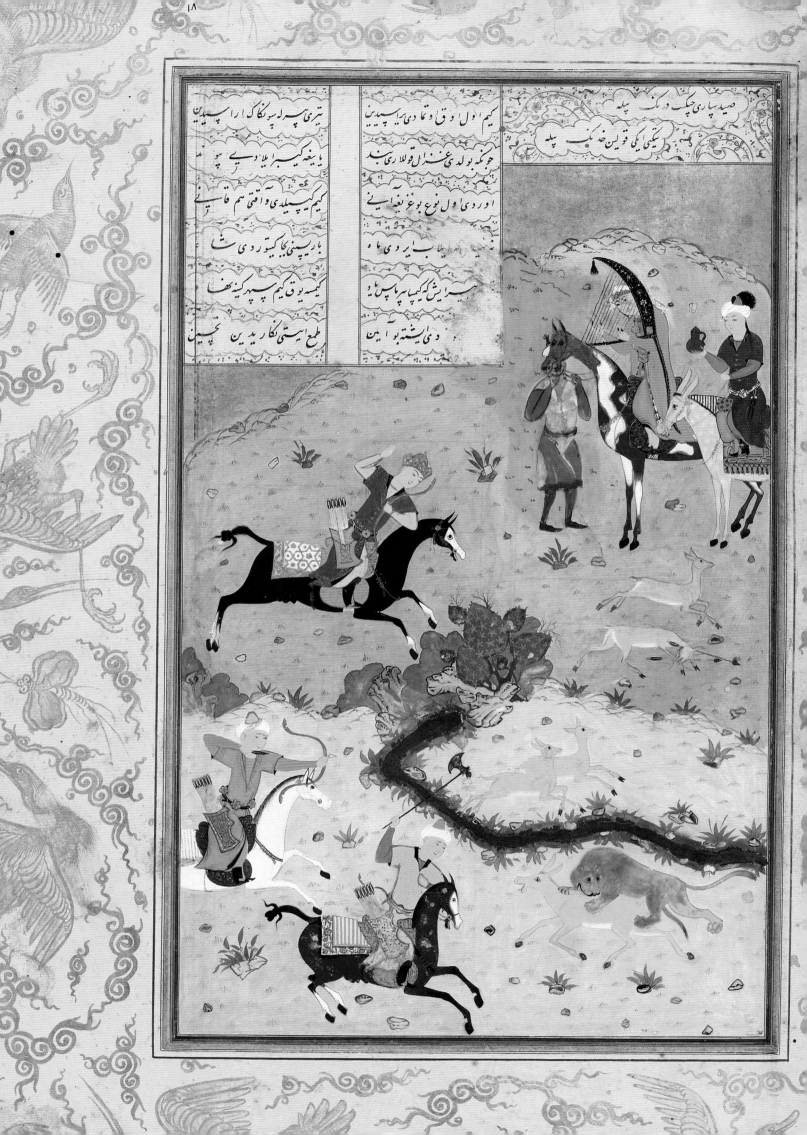

'BAHRAM GUR VISITS THE LADY FROM KHWARAZM IN THE BLUE PAVILION ON WEDNESDAY'

and similar representations from illustrated manuscripts by Nizami, Hatifi and Mir 'Ali Shir in the Bodleian Library

Eleanor Sims

THE SASANIAN monarch Bahram V (r. 420–38 AD) was celebrated by Firdausi in the *Shahnama* ('Book of Kings') for his military deeds and his passionate zeal for the hunt. This later earned him the poetic epithet Bahram Gur: 'that great hunter'. He is also the hero of the medieval allegorical romance in which, on the seven successive days of the week, he entertains seven lovely princesses from the seven climes of the world, in seven domed pavilions of seven different colours – black, yellow, green, red, turquoise (often illustrated as lapis-blue), sandalwood and white – constructed in the grounds of his hunting-castle of Khawarnaq where he is, in turn, entertained by a story told by each of the seven. So complex a literary structure is epitomised in its name, *Haft Paykar*, meaning 'Seven Portraits'– or sometimes, *Haft Gunbad*, 'Seven Domes'.

This richly allegorical romance was composed around the turn of the 13th century by the poet usually known by his pen name, Nizami. He came from Ganja, in Transcaucasia, where he was born around 1141. His gathering of five poems in *masnavi* form is usually called *Khamsa* ('Quintet'), of which the *Haft Paykar* is its fourth. The first is short and didactic but the other four are long narrative romances, indelibly fixing in Persian hearts the names of the lovers, the other characters, events and places: Khusrau and Shirin, and the hapless Farhad; Layla and Majnun; Bahram Gur and Fitna, and

the seven princesses; Iskandar. Their images have illustrated countless manuscript copies of the texts over the past centuries, and were painted on the walls of many princely pavilions. Most of the architectural paintings no longer survive but quantities of volumes do, many of the finest being manuscripts in the collection of the Bodleian Library.

Yet not all *Khamsa* manuscripts are by Nizami: he was much imitated in the eastern Muslim world.[1] The best known and most influential is by Amir Khusrau, surely the finest, and most prolific, of the Persian poets of the Indian subcontinent. He was a self-described 'Turk of Hindustan', born in 1253 – about half a century after Nizami died – and living to 1325, primarily in Delhi whence his *nisba*, Dihlavi. Amir Khusrau's entire *Khamsa* was composed within the space of three years, between 1298–99 and 1301–02, when his version of the *Haft Paykar*, *Hasht Bihisht* or 'Eight Gardens of Paradise', was completed. He follows Nizami's model in poetic form and structure, although he places *Hasht Bihisht* as his last poem.

Amir Khusrau begins the tale-telling with Bahram's arrival in the paradise of a flowery meadow where have gathered the seven princesses of his initial vision. The stories they tell differ from Nizami's, a second divergence from his model,[2] while a third is that his Wednesday colour – fifth in the series – is violet.

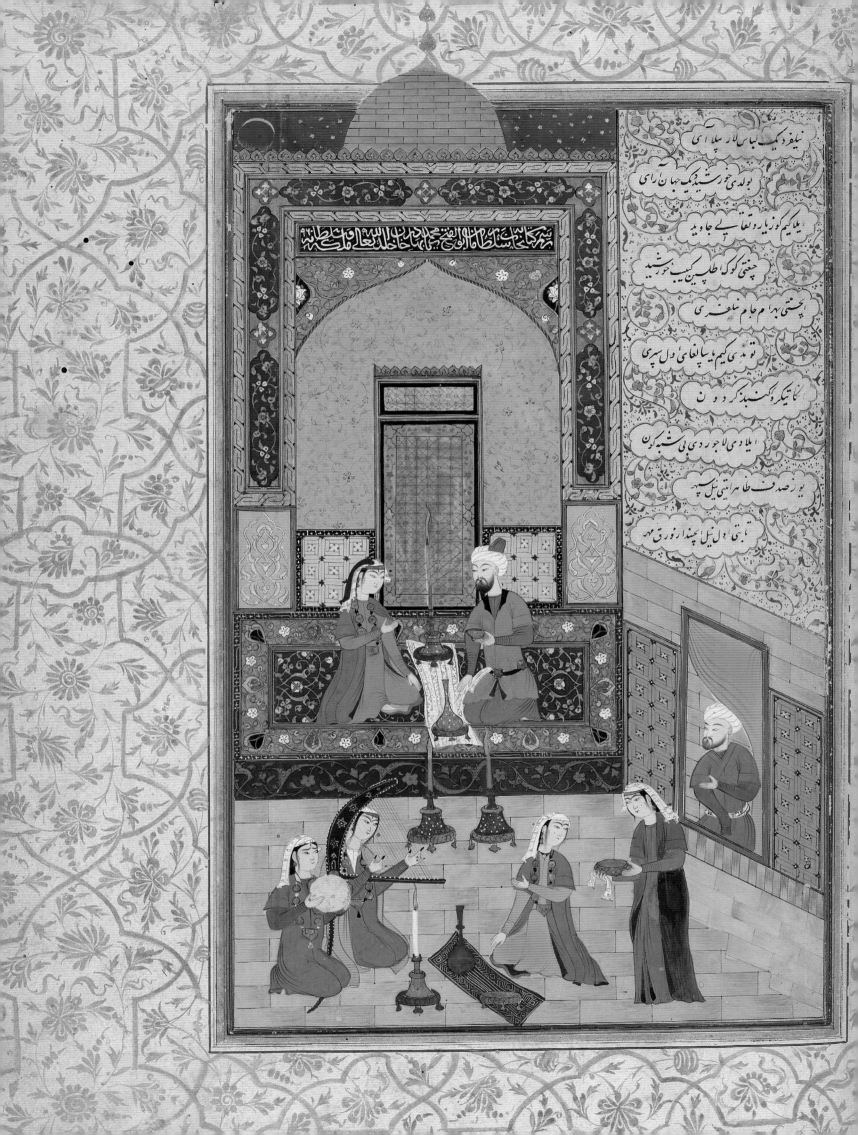

Of other eastern poets who took Nizami's allegorical masterpiece as a model, two were denizens of that most glittering of Timurid periods, approximately the last third of the 15th century in Herat, when Sultan Husayn Bayqara had re-established Timurid dominance in Iran, and literary culture flourished. 'Abdullah Hatifi (d. 1521) was the nephew of the greatest of Persian poets of the period, Nur al-Din 'Abd al-Rahman Jami (1414–1492). Hatifi planned to write a *Khamsa* modelled on Nizami's, but completed only three of the five poems: one is his *Haft Manzar* ('Seven Visages').[3]

The second Herati poet is probably the most significant of those who used Nizami's *Haft Paykar* as a literary and philosophical model, Sultan Husayn Bayqara's foster-brother, courtier and friend Mir 'Ali Shir (1441–1501), a cultured man of countless accomplishments. Among the greatest is his championing of Chaghatay Turkish – or Eastern Turkish – as a literary language suitable for poetry at least equal to if not greater than Persian. Taking Nava'i as his pen name, and Nizami, Hafiz, Jami, and especially Amir Khusrau Dihlavi as his models but writing in Chaghatay, he composed more than 30 works in most of the literary genres of the day. His *Khamsa* consists of five *masnavi*, composed between 1483 and 1485.

One of the finest of recorded copies, and probably the earliest, was made for a son of Sultan Husayn and is dated 1485. It survives as five separate volumes, four in the Bodleian Library,[4] including Nava'i's version of Nizami's *Haft Paykar*, called *Sab'a Sayyara* ('Seven Planets').[5] The Bodleian's treasures also include parts of another princely copy of Nava'i's *Khamsa*, of which one volume is also a *Sab'a Sayyara*.

This second princely set was made for the Uzbek Khan (and later Sultan) Abu'l-Fath Yar Muhammad Bahadur Khan and completed in Bukhara in 1553. Its illustrated pages include a coolly splendid painting, in which Bahram visits the lady from Khwarazm on Wednesday in the blue pavilion under the influence of the planet Mercury – the emblematic colour originally bestowed on the planet by the Prophet Muhammad (Figure 4.2). Nava'i makes great use of Nizami's repeated sevens: planets, colours, climes, days of the week – but imposes upon the structure a somewhat different conception. He retains the planetary influences, evident in his very title, and Nizami's seven

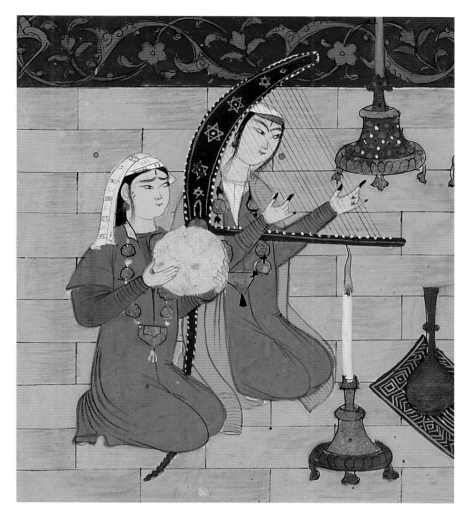

Detail from Figure 4.2

Figure 4.1 (page 48)

Bahram Gur hunting with Dilaram. From a manuscript of Nava'i, *Sab'a Sayyara*, one volume of a *Khamsa*, dated 960 (1553), Bukhara.
Bodleian Library, University of Oxford, MS. Elliott 318, fol. 18r.

Figure 4.2 (opposite)

Bahram Gur visits the lady from Khwarazm in the Blue Pavilion on Wednesday. From a manuscript of Nava'i, *Sab'a Sayyara*, one volume of a *Khamsa*, dated 960 (1553), Bukhara.
Bodleian Library, University of Oxford, MS. Elliott 318, fol. 47r.

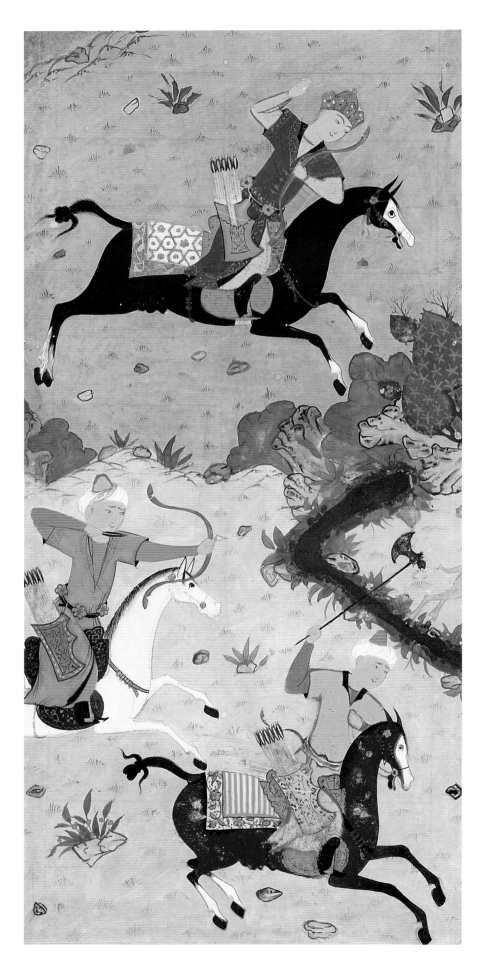

emblematic colours, and he largely retains the division of the seven climes of the known world. The principal lady of the poetic narrative is a Chinese beauty called Dilaram with whom – from her portrait – he has fallen deeply in love (see pp. 42, 45).

Once met, she accompanies him while he hunts but a falling-out leads to her abandonment in the desert and, to assuage the ensuing agony of his loneliness, he turns to the company of other women and to the diversion of tales. On seven nights, in each of the seven different-coloured pavilions, his guest is a lady – not a king's daughter – from one of the seven climes of the world; unlike Nizami and Amir Khusrau, in Nava'i's version Bahram calls for a professional storyteller to recite a tale. Most of the *haft gunbad* illustrations in Yar Muhammad's *Sab'a Sayyara* explicitly tell us this: its large pictures offer us large and resplendent interiors, and in five of the seven we may see a white-turbaned male who approaches the *ayvan* (arched chamber) at the side, or kneels in front of it. He is surely the storyteller, for, in the classical composition for Bahram's evening entertainments in Nizami's *haft gunbad*, the ruler is the only male figure.

In this Bukhara *haft gunbad* series, 'Bahram Gur visits the lady from Khwarazm in the Blue Pavilion' is the picture to which the anonymous painter devoted especially careful attention. Its setting is pronouncedly blue, more so than others are pronouncedly red or yellow, sandalwood or even white; its interior is crowned by a blue dome, whereas the only other dome of the series is a peculiarly unharmonised brick-colour pink – the 'red' of this image, textually the Russian lady, is altogether peculiarly un-red. And in the upper frame of the *ayvan* in which Bahram sits with the Khwarazmian lady is the fine inscription that both names Yar Muhammad, for whom the manuscript was made, and states its date of completion, 960 (1553).

Nava'i also departs more fundamentally from Nizami's model: he creates a greater textual unity for his composition by framing the seven evening entertainments and their seven tales with the story of the shah and his Chinese lady: at the end of the *Sab'a Sayyara*, Bahram and Dilaram are reunited. His diversions over, his anger assuaged, Bahram returns to the desert whence he had abandoned her and finds her, bringing to an end the agonies of his love for her. Indeed, a narrative of love and devotion!

Eleanor Sims is a London-based, independent historian of Islamic art with a special interest in the arts of the Eastern book. With her late husband, Ernst J. Grube, she has been the co-editor of the journal *Islamic Art* since 1982. She is the author of more than 80 articles, reviews and dictionary entries, and two books, including the prize-winning *Peerless Images: Persian Painting and its Sources* (2002), and *The Windsor Shahnama of 1648*, written together with the late B. W. Robinson and Manijeh Bayani (2007).

Notes:

1 Works are recorded by more than 100 poets in many different languages. Julie Scott Meisami, *Nizami: The Haft Paykar: A Medieval Persian Romance* (Oxford: Oxford University Press, 1995), xxii.

2 Barbara Brend, *Perspectives on Persian Painting: Illustrations to Amir Khusrau's* Khamsah (London: Routledge Curzon, 2003), 24–34.

3 A copy in the Bodleian Library is illustrated with the entire series of seven pavilions and dated 946 (1540). MS. Elliott 161: Ethé 1016, Robinson 1089–96.

4 The fifth volume is held by the John Rylands Library, University of Manchester, Turk MS 3, *Layla wa Majnun.*

5 Despite the excellent overview of scholarship relating to Mir 'Ali Shir's life and works and much relevant bibliography, in Maria Subtelny, 'Mir Ali Shir Nawa'i', *Encyclopaedia of Islam*, 2nd ed., vol. VII, Leiden and London, 90–3, his *Sab 'a Sayyara* – indeed, his entire *Khamsa* – remains untranslated into any European language. I am therefore deeply indebted to Selen Etingü who translated for me the Turkish digest by A. S. Levend, *Ali Shir Nevai* (Ankara: 1965–68), vol. I, 138–50; the entire Chaghatay text, transcribed in Latin characters, is in vol. III, 289–407. I am also grateful to Professor Christiane Gruber and her student, Nicholas Walmsley; Professor J. M. Rogers; Dr Barbara Brend; Professor Christine van Ruymbeke; Sergei Tourkin; and my old friend Wheeler Thackston, all of whom answered my many questions on the subject with good-humoured alacrity.

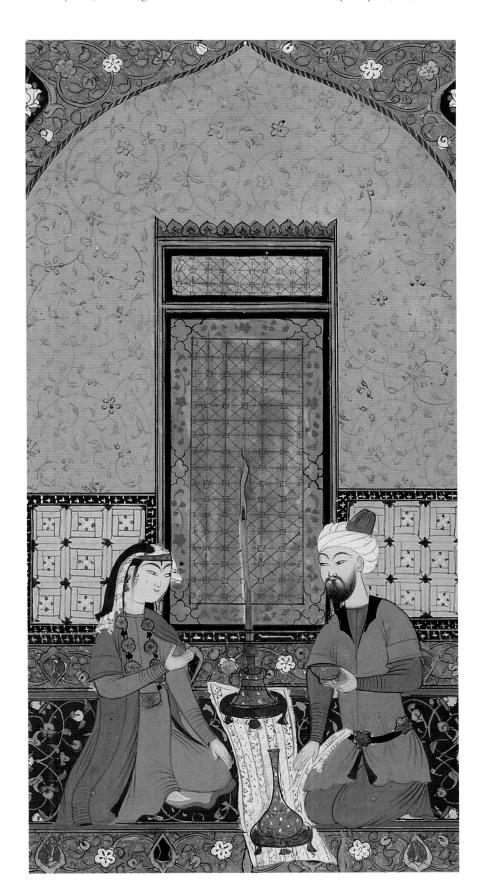

page 52: Detail from Figure 4.1; right: Detail from Figure 4.2

چون رو داد و که بس که او در آتش بسوز ند حضرت رسالت صلی الله علیه و آله و سلم

رقت فرمودند و در آن اثنا شخصی خبر آورد که در آن دم که و رشده که شفیع دحیة الکلبی بود

فوت شد این چایش را در آن محل فرمودند و بر آن درویش رفت و حالت او را اظهار فرمود

دحیة الکلبی امر کرد که آب بر و ریخت و دفن کردند و در آن آخر خدمت مولانا محمد مشار الله

شفیع درویش محمد نایی بود ند و در مجلس سماع مطاقی بسیار میکردند و بدین بایع

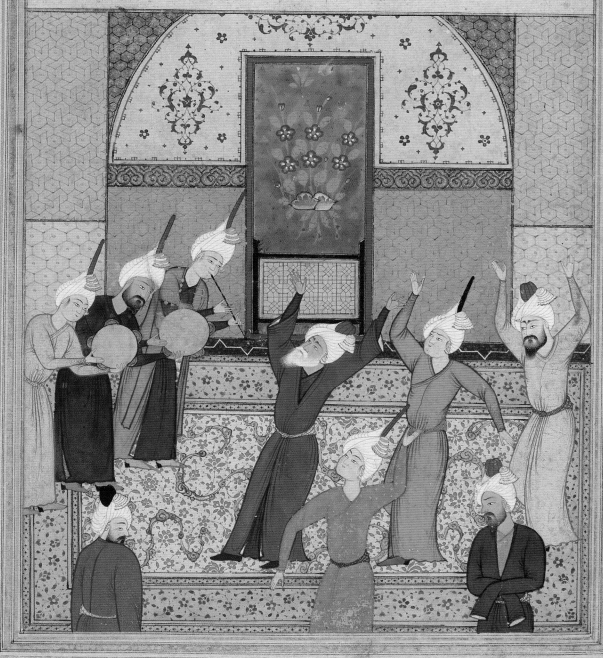

CHAPTER FIVE

EARTHLY AND SPIRITUAL LOVE IN SUFISM

Ibn 'Arabi and the Poetry of Rumi

Süleyman Derin

MAHABBA, the Arabic word for love, is used to convey both earthly and spiritual love. Linguists and classical Sufi authors have produced various etymologies for the word. Ibn Qayyim suggests that *mahabba* derives from the word *hubab* meaning purity. Ibn al-Manzur, author of the largest encyclopedic Arabic dictionary, writes that *mahabba* comes from *hubab*, which are the bubbles that form on the surface of water during a strong rainstorm, so love is the bubbling up of the heart when it thirsts and is desperate to meet the Beloved. Al-Hujwiri says that *mahabba* is said to be derived from *hibbat*, which are seeds that fall to the earth in the desert. The name *hubb* (love) was given to such desert seeds, because love is the source of life just as seeds are the origin of plants.[1] When love becomes excessive and ardent it is called *'ishq*. These two terms are used both for divine as well as spiritual love, although the latter has produced controversy since it is not mentioned in the Qur'an. It is also interesting to note that the terminology of profane love is also used in conveying the feelings of divine love. As Schimmel rightly states, Sufis express their love for God by symbols taken from human love.[2]

As a term, love has been described in many ways by different disciplines. Literature considers love as the driving force behind the finest poetry; medieval medical science perceives it as a kind of disease; theology sees it as a way of approaching and nearness to God; and in philosophy it is the desire of the imperfect to attain perfection.[3] Among influential Sufi writers, al-Ghazali (1058–1111) comes very close to a psychological analysis of love's origins and its gradual development. He describes love as 'an inclination towards a thing, which gives pleasure'.[4] According to al-Ghazali, in the early stage, a child's love is directed exclusively towards the mother. As children develop, their love starts to explore different avenues, games and toys. It further expands to include friends in its ambit. When the children reach adolescence, they start experiencing a natural inclination towards the opposite sex. The love of the opposite sex in the early stages of adulthood turns into the love of health and status in later ages. This process eventually culminates in the love of God.[5] According to al-Ghazali, there is a progression along a continuum: from the concrete, such as mother, toys and friends, to the abstract, completely non-material being, Allah.

بسوختی دل خسرو هنوز خواهی خت کسی بگفت ترا این جفا چرا کردیی فی الحال درجواب

شیخ گفته من العلم الی العین لتحصیل الطرفین یعنی از علم سیے آیم تا عین از برای حاصل طرفین از علم

بی زنکی سیے ایم بعالم زنک تا زنم شیشهٔ دل برسنک بجهت این جواب تمام شیفته

شده بوده اند واز رفته اشعار عربیے درآن آشفنگی دارند بعد ازان ملازمت حضرت شیخ

سرافراز گردید ورسید از خدمت با علی درجه معرفت و دید آنچه دید حضرت شیخ کاسیے

Al-Ghazali thought that love should be experienced through all these stages, and that the gradual transition in material loves prepares the heart for the reception of non-material love: the love of God.[6] This line of thinking did not conflict with Qur'anic teachings, since Sufi authors found examples of divine love that began initially as human love. Among these is the story of Zulaykha's love for Yusuf, the Prophet Joseph; how she passionately loved him in the beginning but later her love transformed into a love of God.[7]

Although Sufis have produced many different paradigms of love, two Sufis in particular – Ibn 'Arabi and Rumi – have gone a step beyond: the former in prose, the latter in poetry. Muhammad Ibn 'Ali Ibn 'Arabi (1165–1240) was born in Murcia in southern Spain. Ibn 'Arabi lived in the far western end of the Muslim world of his time. He grew up in an atmosphere steeped in the most important ideas – scientific, religious and philosophical – of his day. Distinguished from other Sufis by his huge output of writings, Ibn 'Arabi is described by Brockelmann as a writer of 'colossal fecundity'.[8]

Most Sufi authors had either disdained profane love or they saw it as a stepping stone to divine love. Resulting from his ontology, however, Ibn 'Arabi, the renowned Shaykh al-Akbar or the greatest Sufi master, introduced a completely new dimension to the relationship between divine and earthly love. Ibn 'Arabi suggested that there is only One Being and all existence is nothing but the manifestation or outward radiance of that One Being. Hence, everything other than the One Being, that is, the whole cosmos in all its spatial and temporal extension, is non-existent in itself. Only through the self-existent Being can it be considered to exist.[9]

The natural consequence of this teaching is that, essentially, it is not possible to love something exclusive of God. Since God is hidden in all objects manifest in the universe, loving any created object automatically entails loving God. Concisely put, as there is only One Being in reality, there can really be only one Beloved, and that is God. Proceeding from this, Ibn 'Arabi's view of *wahdat al-wujud* ('the oneness of being') can be more accurately described as *wahdat al-hubb*, that is, 'the oneness of love'. Therefore, whatever it may be that we love, we love God 'in it'. Objects of love are but veils between humanity and God; in the words of

Ibn 'Arabi: 'In reality, everybody only loves the Creator but God is veiled by Zainab, Suad, Hind, money or position.'[10]

That Ibn 'Arabi was unique in his use of metaphors of profane love to explain divine love speaks for itself. In his book *Tarjuman al-Ashwaq*, ('Interpreter of Desire') in particular, the Shaykh depicts Lady Nizam as the manifestation of divine beauty.[11] Unable to understand his delicate philosophy, many felt scandalised by the apparently erotic and sensuous imagery of his writings, compelling him to write a commentary on his own works in self-defence.[12] Alluding to the difficulty of making out the style in which the work was penned, Nicholson raises the question, 'Is this a love poem disguised as a mystical ode, or a mystical ode expressed in the language of human love?'[13] It may well be said that it is both, since Ibn 'Arabi's paradigm of love holds all kinds of love to be divine. But this love needs to be brought to consciousness, because if one is ignorant of God's existence in the earthly beloved, one's love is not directed towards God.

To arrive at a better understanding, we can perhaps compare Ibn 'Arabi with al-Ghazali. Al-Ghazali strove to persuade people that God is the only being that deserves our love by arguing that it is God alone who fulfils all the causes of love in perfection. Ibn 'Arabi, on the other hand, believed that all lovers already love God in different manifestations, without the least power to exclude Him from their love. They only need to be awakened to the fact that God is present everywhere and in everything.

Ibn 'Arabi made much use of the famous prophetic saying, 'God created Adam in His own form'[14] to explain how earthly love delivers one to the love of God. It is from this perspective that Ibn 'Arabi defined profane love; the love between man and woman is a direct consequence of their divine forms. This idea is in stark contrast to the general view that explains the love of the opposite sex as an outcome of contemplating beauty in the other. In Ibn 'Arabi's view, the essential basis of this love is the divine form in which men and women were created, a fact that relegates beauty to a secondary role. Moreover, Ibn 'Arabi believed that human love is fully satisfied only when the object of love is God. Thus, a love whose object is another human being may never experience complete fulfilment, the reason being that there is a much stronger

Figure 5.1 (page 54)

Maulana Muhammad Tabadkhani and other dervishes dancing. From a manuscript of a work attributed to Gazurgahi, *Majalis al-'Ushshaq*, dated 959 (1552). Bodleian Library, University of Oxford, MS. Ouseley Add. 24, fol. 119r.

Figure 5.2 (opposite)

Ibn 'Arabi riding towards two young men. From a manuscript of a work attributed to Gazurgahi, *Majalis al-'Ushshaq*, dated 959 (1552). Bodleian Library, University of Oxford, MS. Ouseley Add. 24, fol. 69r.

similitude between God and humans than there is between opposite sexes.[15] In a sense, Ibn 'Arabi implied that if we think in human terms, God is the original form whereas humankind is a copy of this form. Hence, loving another from the opposite sex without realising the divine form in him or her will diminish the full satisfaction of love.

Unlike most Sufis such as the early female poet and thinker Rabi'a, Ibn 'Arabi did not reprimand elemental love as a necessary evil. He even suggested that for the true gnostic (*arif*) it is necessary for men to love women. Compared to early Sufis who despised the world and saw marriage as an obstacle on the spiritual path, this is quite revolutionary to say the least. For Ibn 'Arabi, the real gnostic loved women because the Prophet himself declared that he did so in a *hadith*. Ibn 'Arabi's argument was that the Prophet would not love someone or something that would distance him from God. Therefore the idea that 'Marriage or love of women in general are the cause of separation from God' is an error entirely inconsistent with the Prophetic paradigm of love.[16]

In the commentary of the *Tarjuman*, Ibn 'Arabi further stated that the nature of earthly love is the same as divine love, that is, the love with which we love God. The difference is only that in earthly or elemental love the lover is infatuated with a phenomenon (*kawn*), whereas in divine love the lover is enamoured by the essential, the real (*asl*). Elemental love itself has always provided the most excellent cases of an ecstatic, rapturous lover losing consciousness and reasoning over the love of the beloved.[17] Therefore, claimants to God's love, Ibn 'Arabi suggested, should love God no less than those whose object of love is another human being.

In so far as lovers of the elemental level may easily be directed to the real object nonetheless, Ibn 'Arabi favours a lover to someone who does not love anything, be it divine or earthly. Loving another almost complements attaining divine love, since it serves as a kind of training for the lover, with God manifested in the highest form in the beloved. One cannot love *Maula* (God) without first loving *Layla* (woman). Still, emphasised Ibn 'Arabi, a man who loves a woman only for sexual desires is heedless and gravely ignorant about the nature of women, unable to discern the divine manifestation in them.[18]

But the candle of Love is not like that
>
> (external) candle:
>
> it is radiance, in radiance, in radiance.[19]

It was not only Ibn 'Arabi from the west who exerted a great influence on the development of Sufism and shaping of the conception of love theories; Rumi, from the east, was another writer who had a similar impact. Rumi (d. 1273), the mystic of divine love and rapture who lived in the 13th century, was born in the far east of the Persian lands in Balkh. Compared to other Sufis like al-Ghazali, the works of Rumi do not present a philosophical system as such, and the poetic and discursive nature of his idiosyncratic style makes it difficult to abstract a systematic conception of love.[20] However, his two main works, the *Masnavi* and the *Divan al-Kabir* famously referred to as the *Divan of the Lovers*[21] offer plenty of verses on love, divulging for us the main characteristics of his conception of love.

In Rumi, love is the reason behind the creation of the Universe, compliant with a *hadith* often quoted by Sufis, in which God says, 'I loved to be known, so I created the world'. Love is hence God's initial act in His approach to creation, a creative affection through which love is manifested in the entire creation. In the poetic and fiery language of Rumi, love flows through the world's arteries and is the origin of all movement and activity.

> The creatures are set in motion by Love,
>
> Love by Eternity without beginning;
>
> the wind dances because of the spheres, the
>
> trees because of the wind.[22]

The postulate that God created humanity 'in love' necessitates humanity to return to Him 'in love'. Early Sufis like Hasan of Basra (d. 728 AD) and Ibrahim bin Adham (d. 777 AD) had emphasised the concept of fear in their relationship to God. As opposed to these early Sufis who had championed the fear of God, Rumi instead placed his accent on love as the unique way of approaching God.[23] Not by loveless austerities and sheer asceticism centred on the fear of God may the base faculties of humans, the *nafs*, be fully conquered, but by love. Running a comparison between the ascetic and the lover of God, Rumi said (*Masnavi* V, 2092–3):

> The timorous ascetic runs on foot; the lovers
>
> of God fly more quickly than the
>
> lightning and the wind. (cont. p. 62)

Figure 5.3 (opposite)

Rumi at the blacksmith's shop. From a manuscript of a work attributed to Gazurgahi, *Majalis al-'Ushshaq*, dated 959 (1552).
Bodleian Library, University of Oxford, MS. Ouseley Add. 24, fol.78v.

Figure 5.4 (pages 60–61)

Illuminated pages with opening lines of Book I. From a manuscript of Rumi, *Masnavi*, copied before 1465.
Bodleian Library, University of Oxford, MS. Elliott 251, fols. 3v–4r.

| یکی مدام و دوم بیچد و سیّوم هرجا | بلا و فتنه و غوغای من ز فرقت اوست |

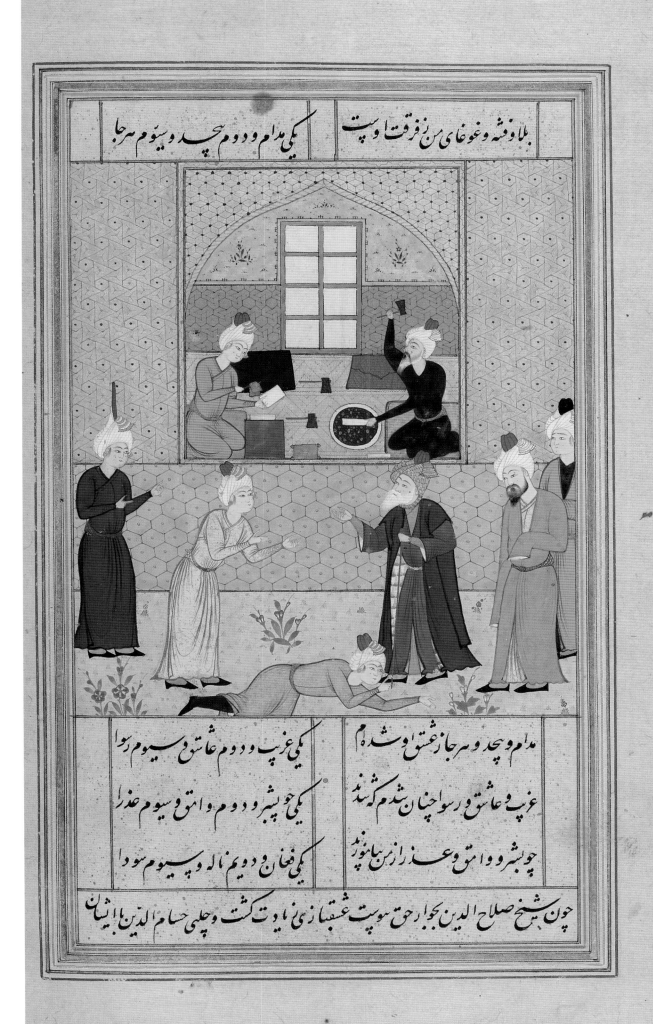

مدام و بیچد و هر جا ز عشق تو شد ام	یکی عزیب و دوم عاشق و سیّوم رسوا
عزیب و عاشق و رسوا چنان شدم که مپند	یکی چو پسر و دوم واثق و سیّوم عذرا
چو پسر و واثق و عذرا ز من بیاموزد	یکی فغان و دویم ناله و سیّوم سودا

چون شیخ صلاح الدین نجار از حق سوی حق عشق بازی زیادت کشت و چلبی حسام الدین ایشان

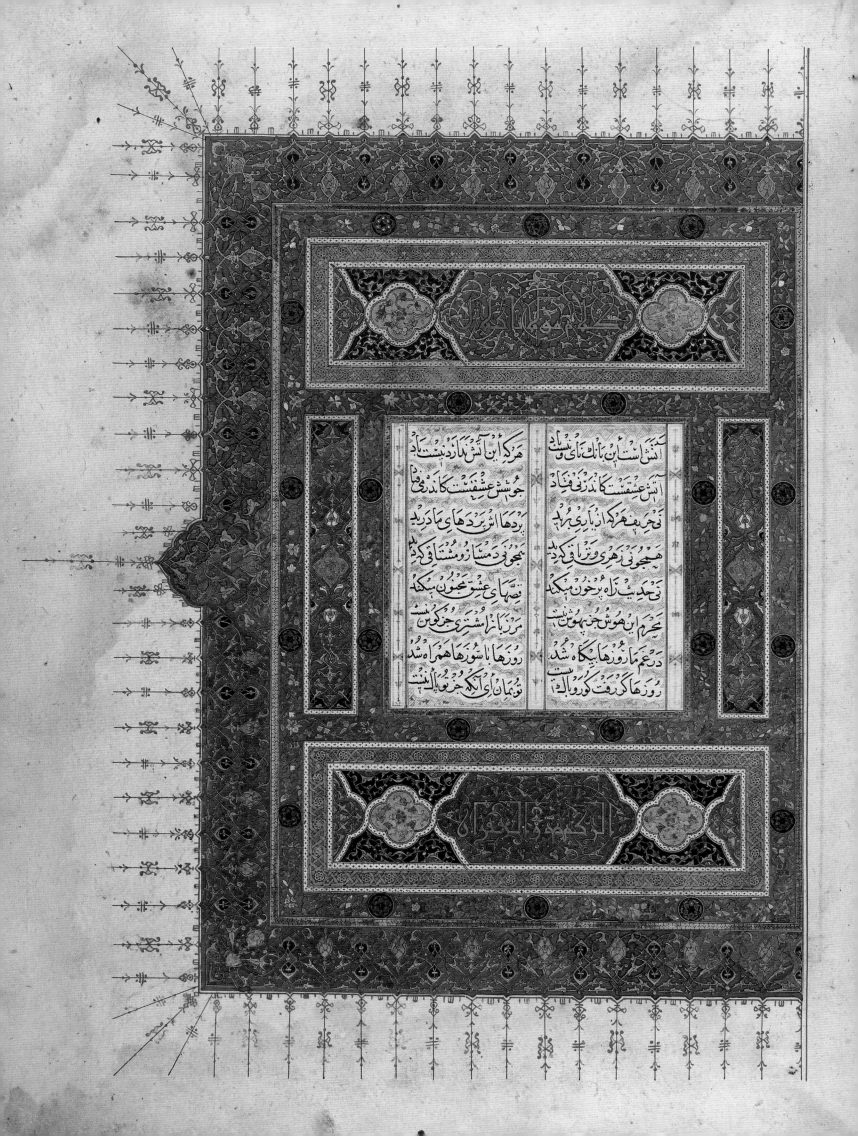

آتش است این بانگ نای و نیست باد هر که این آتش ندارد نیست باد
آتش عشق است کاندر نی فتاد جوشش عشق است کاندر می فتاد
نی حریف هر که از یاری برید پرده هاش پرده های ما درید
همچو نی زهری و تریاقی که دید همچو نی دمساز و مشتاقی که دید
نی حدیث راه پر خون می کند قصه های عشق مجنون می کند
محرم این هوش جز بی هوش نیست مر زبان را مشتری جز گوش نیست
در غم ما روزها بیگاه شد روزها با سوزها همراه شد
روزها گر رفت گو رو باک نیست تو بمان ای آنکه جز تو پاک نیست

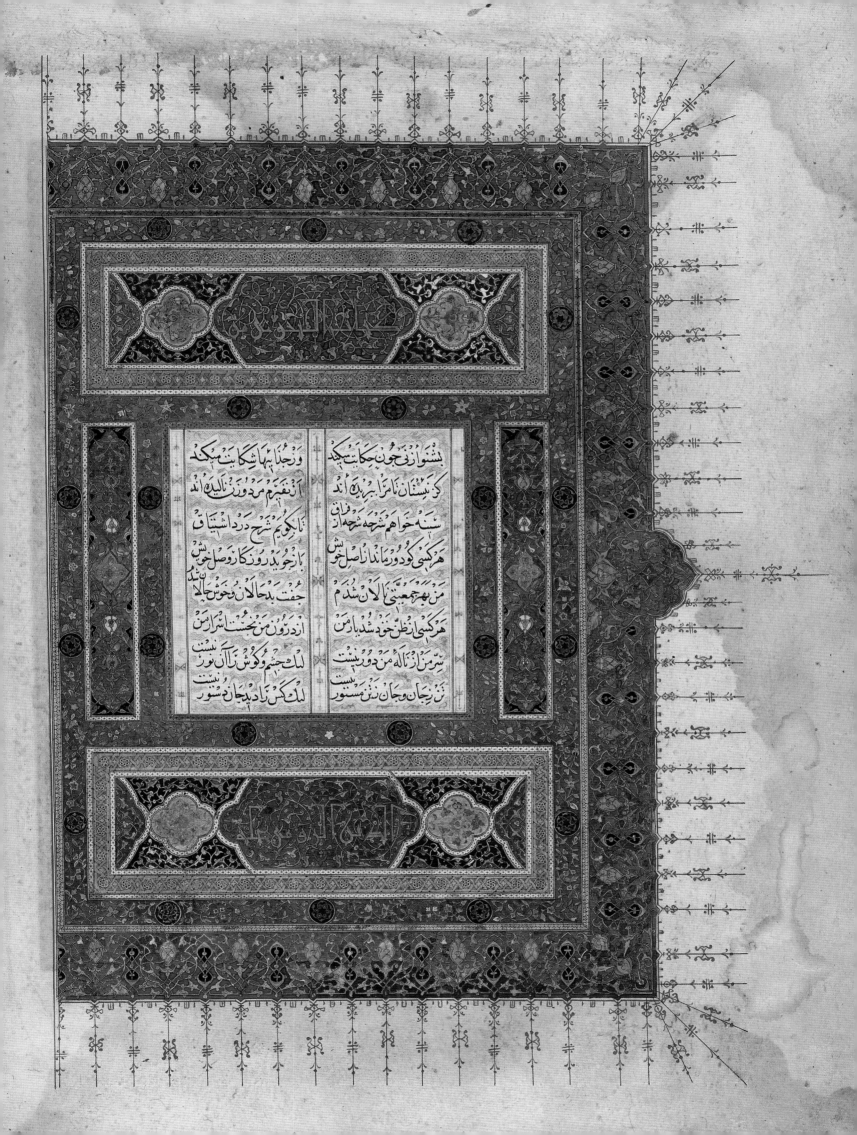

بشنو این نی چون حکایت می‌کند
وز جدایی‌ها شکایت می‌کند

کز نیستان تا مرا ببریده‌اند
از نفیرم مرد و زن نالیده‌اند

سینه خواهم شرحه شرحه از فراق
تا بگویم شرح درد اشتیاق

هر کسی کو دور ماند از اصل خویش
باز جوید روزگار وصل خویش

من به هر جمعیتی نالان شدم
جفت بدحالان و خوش حالان شدم

هر کسی از ظن خود شد یار من
از درون من نجست اسرار من

سر من از ناله من دور نیست
لیک چشم و گوش را آن نور نیست

تن ز جان و جان ز تن مستور نیست
لیک کس را دید جان دستور نیست

Figure 5.5 (below)

A scene from the story of Joseph and Potiphar's wife. From a German-language Bible, Genesis 39. Nuremberg, Anton Koberger, 1483. State Library of Victoria, RARESEF 093 C833K, vol. 1, fol. 23v.

The Persian tale of Yusuf and Zulaykha has its roots in the *Qur'an,* which in turn drew on Biblical accounts of Joseph and Potiphar's wife.

Figure 5.6 (opposite)

The interpretation of Zulaykha's dream. From a manuscript of Jami, *Yusuf u Zulaykha,* dated 940 (1533). Bodleian Library, University of Oxford, MS. Hyde 10, fol. 39v.

> How should those fearful ones overtake Love?
> For love's passion makes the (lofty)
> heaven its carpet.

For Rumi, love is the fastest way to reach God. The following verses (*Divan*, 6922–3) are so clear that they barely need an explanation:

> Mount upon Love and think not about
> the way.
> For the horse of Love is very sure-footed.
> Though the path be uneven,
> in a single bound it will take you to the
> way station.

Rumi divided human love into two: true love (*'ishq-i haqiqi*), or love of God; and metaphorical love (*'ishq-i majazi*), or love of anything else other than God. Yet since whatever exists is God's reflection or shadow,[24] all love is in fact love of God. The difference between these two types of love transpires in the approach of both types of lovers: some know that only God truly exists and thus direct their love only towards Him,

while others believe in the independent existence of various objects of desire and so direct their love to them. He explains this notion in the following verses: (*Masnavi* VI, 3181)

> Beautiful faces are in fact mirrors of
> His beauty
> Loving them is in fact the reflection of
> searching for Him.

Hence all material beauties, be they one's lover, a rose or whatever else, borrow their beauty from God. Rumi uses a similar language to that of al-Ghazali in this respect. Like him, Rumi also insists that we need spiritual insight to see divine beauty in creation.

Rumi's philosophy affords a positive relationship between profane love and divine love, in so far as all love has a divine origin and love eventually takes the lover to the real beloved – the Divine – whether the beloved is earthly or not. This conception approximates Rumi to Ibn 'Arabi, who also thought that one first needed to love another before loving God. However,

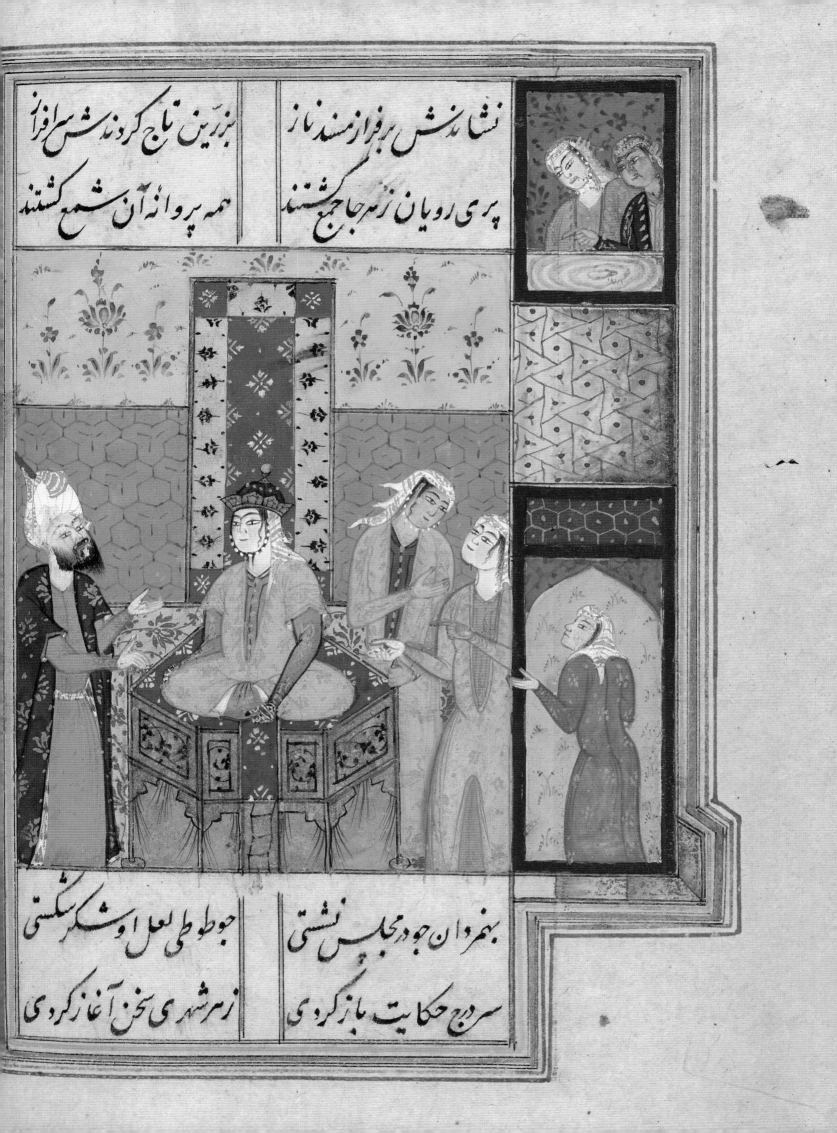

نشاند خویش برفراز مسند ناز | بزرّین تاج کرد زندۀ سر افراز
پری رویان زبهر حاجب گشتند | همه پروانۀ آن شمع گشتند

بهمردان چو در مجلس نشستی | چو طوطی لعل او شکّر شکستی
سر درج حکایت باز کردی | زهر شهری سخن آغاز کردی

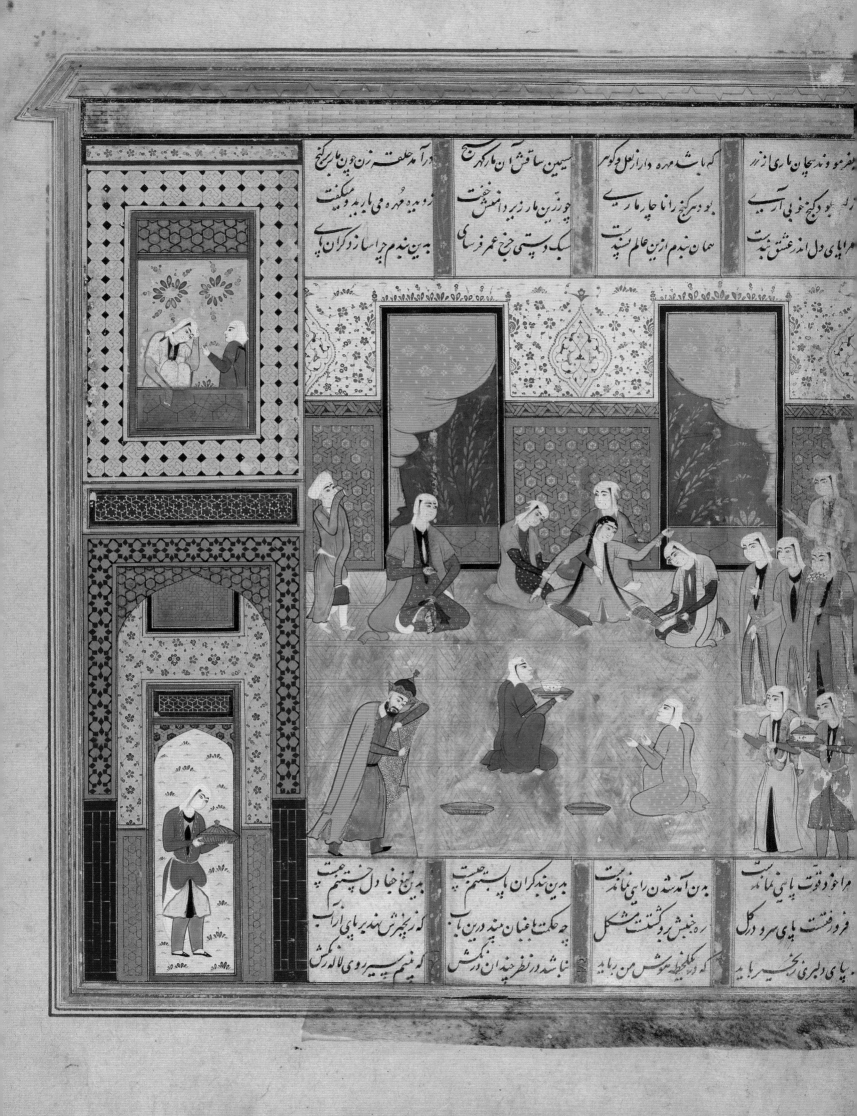

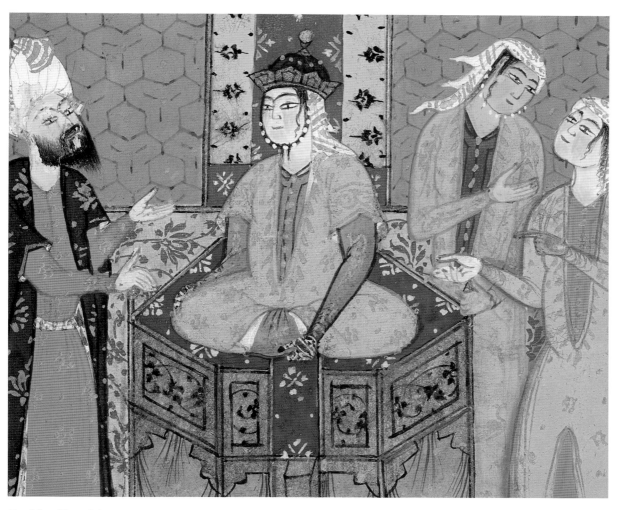

Detail from Figure 5.6

Rumi believed that the love of physical beauty quickly faded away, requiring one to ascend from earthly love to a love divine. A Sufi therefore had to turn his face to divine beauty and seek to go further than the earthly beloved. In Rumi, it is thus imperative for one to elevate one's love from human beings to the Creator, to God (*Masnavi* I, 219):

> Choose the love of the Living One who is
> everlasting, who gives thee to drink
> of the wine that increases life.

Not only did Rumi promulgate an elevation of earthly love to divine love, he also brought forth examples of those who had achieved this feat, the most prominent of which is perhaps the story of the prophet Yusuf (Joseph) and Zulaykha. Despite Zulaykha's immense love for Yusuf, when the latter does not reciprocate, she has him put in prison.[25] Zulaykha's love, however, is finally transformed to divine love; after all, 'the metaphor is the bridge to reality'.

Among instances of profane love that lead humans to divine love, Rumi also referred to the legendary story of Layla and Majnun. He depicted Majnun as a gnostic who, in the final reckoning, finds *Maula* (God) through *Layla* (woman). When those ignorant of the transforming power of love criticised Majnun for loving an unattractive woman like Layla, whose sheer appearance, they held, did not merit a love of such calibre, he answers (*Masnavi* V, 3288):

> The outward form is a pot, and beauty is the
> wine: God is giving me wine from
> her form,
> He gave you vinegar from her pot. Lest love
> should pull you by the ears.

In another place in the *Masnavi*, Rumi wrote that a burning candle can light the fire of a thousand other candles. To become a lover of God, one therefore needs to accompany other lovers of God. Rumi himself became a lover only by initially accompanying another

Figure 5.7 (opposite)

Zulaykha, having seen Yusuf in a dream, is mad with love for him. Leaf from a disbound manuscript of Jami, *Haft Aurang*, copied c. 1570. Bodleian Library, University of Oxford, MS. Elliott 149, fol. 179r.

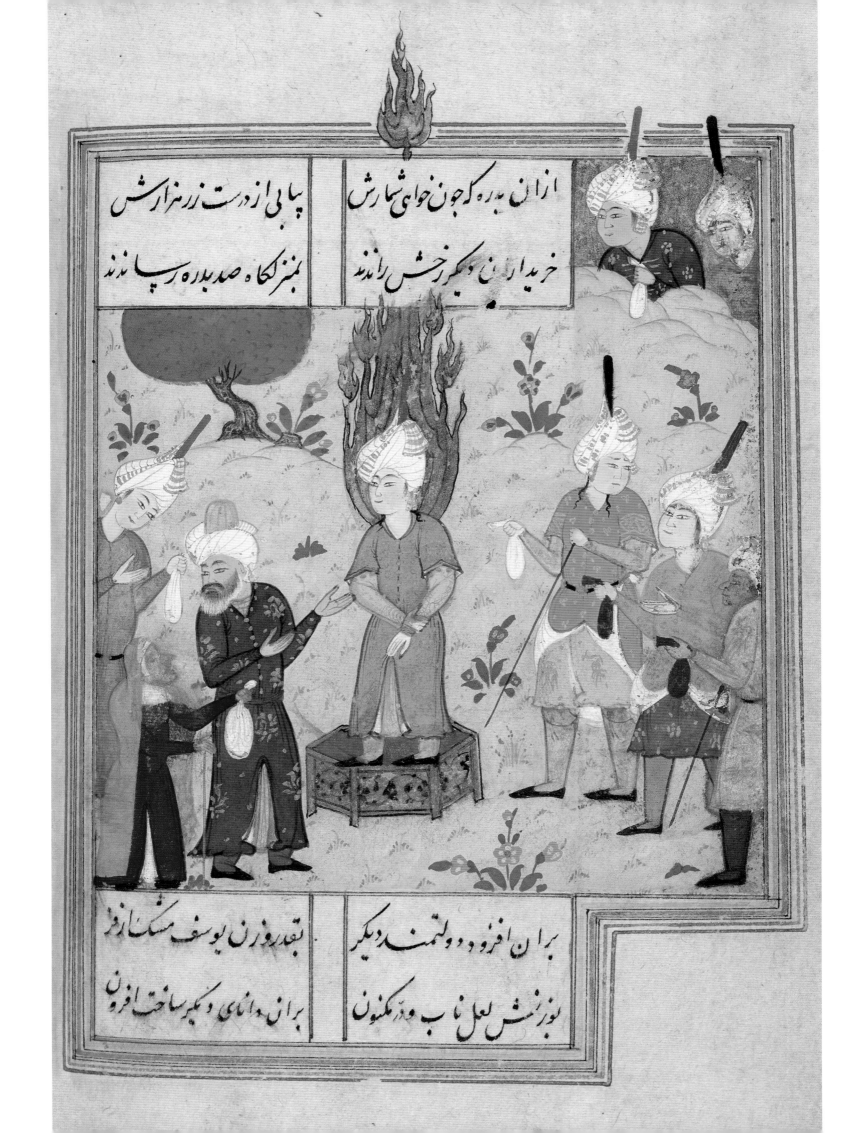

ازان بدره که جون خوای شمارش
پایی از دست زر منارش

خریداران دیکر رخش راندند
بمنزلکاه صد بدره رساندند

بران افزود و دولتمند دیکر
بقدر وزن یوسف مشک نازد

یوزرخش لعل ناب و در مکنون
بران دانای دیکر ساخت افزون

of God; with this mindset, he invited others to join him on this path (*Divan*, 29050–1):

> Someone asked 'What is love?' I replied
> 'Ask not about these meanings.
> When you become like me, then you will
> know. When he calls you, you will
> recite its tale.

Profane love therefore has an evident capacity to take humans to divine love. Could we perhaps further invert this proposition and ask if divine love leads one to the love of humanity? The basis of a human relationship with God is not merely an issue of theological interest. Its consequences have an enormous bearing on the life of humankind. When the relationship between humans and God depends on love, the resultant relationships

between human beings become infused with love, characterised by mercy and benevolence. In this regard, one cannot help but completely agree with Nicholson's conclusion, where comparing the famous Christian poet Dante with Rumi, he decides that Dante 'falls far below the level of charity and tolerance' advocated and practised by Rumi.[26] In the words of Rumi, 'lovely birds fall into Love's trap, except some bird like the owl that refuses to look at the sun and is content to remain among the ruins.'[27]

> The path of our Prophet is love
> We are the children of love,
> Our mother is love.
>
> (*Ruba'i*, 18)

Süleyman Derin teaches in the Faculty of Theology at Marmara University, Istanbul, Turkey. His research focus is Sufism, and in particular Sufi commentaries on the Qur'an and Sufi psychology. His doctoral thesis, completed at the University of Leeds, UK, was published as *Love in Sufism* by Insan Publications, Istanbul, in 2006.

Figure 5.8 (opposite)

Yusuf sold as a slave. From a manuscript of Jami, *Yusuf u Zulaykha*, dated 940 (1533). Bodleian Library, University of Oxford, MS. Hyde 10, fol. 72v.

Figure 5.9 (above and detail p. 68)

Zulaykha's maids overcome by the beauty of Yusuf. From a manuscript of Jami, *Yusuf u Zulaykha*, dated 977 (1569). Bodleian Library, University of Oxford, MS. Greaves 1, fols. 103v–104r.

Figure 5.10 (page 69)

Yusuf tempted by Zulaykha. Leaf from a disbound manuscript of Jami, *Haft Aurang*, copied c. 1570. Bodleian Library, University of Oxford, MS. Elliott 149, fol. 199v.

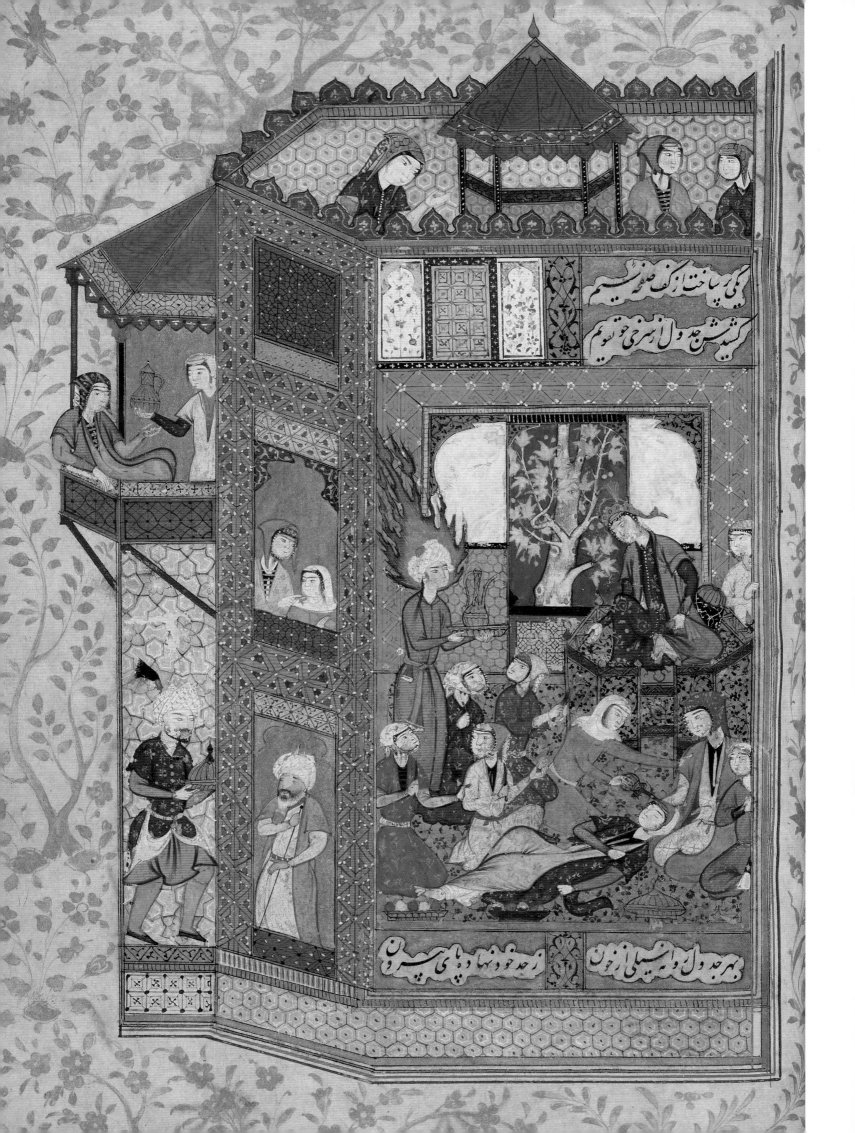

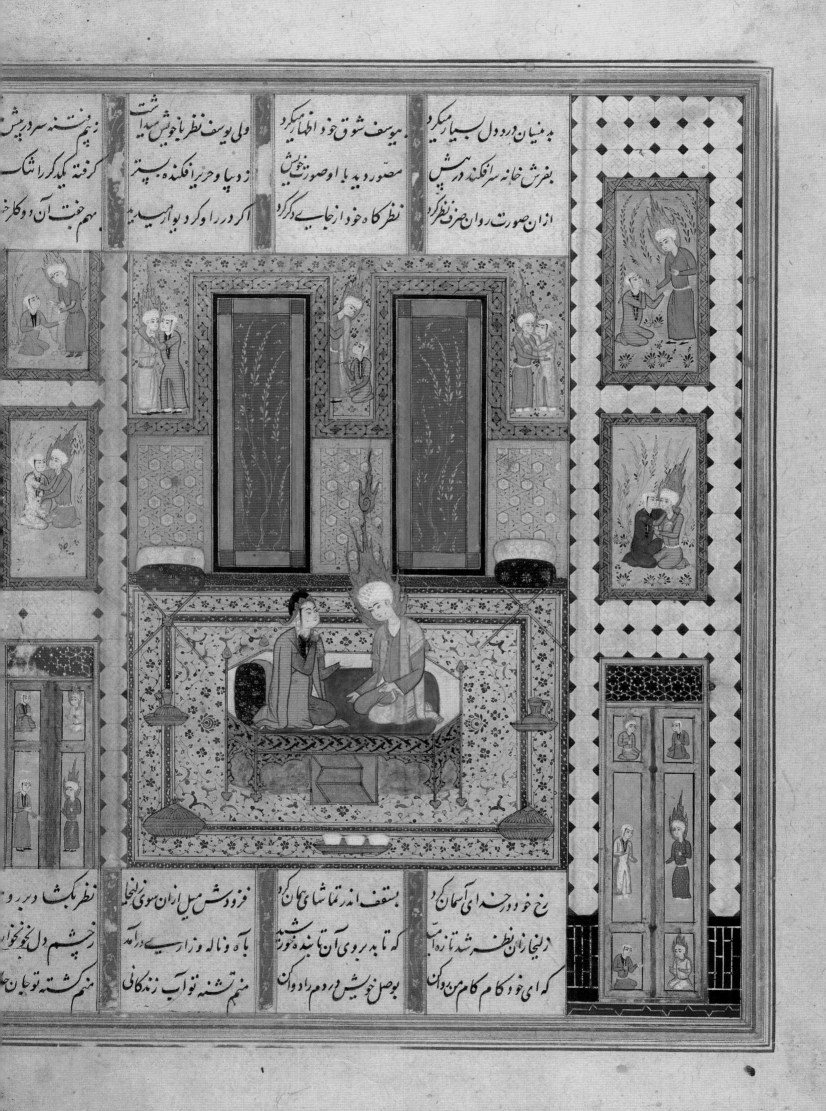

Notes:

1 Ibn Qayyim, *Madarij al-Salikin*, vol. 3, 6; al-Qushayri, *al-Risalah*, 328; Ibn al-Manzur, *Lisan al-ʿArab*, ha-ba-ba entry; al-Hujwiri, *Kashf*, 305–6.

2 Annemarie Schimmel, *Mystical Dimensions of Islam* (Chapel Hill, NC: University of North Carolina Press, 1975), 5.

3 The scientific view is in Masʿudi, *Muruj al-Dhahab* (Beirut: Dar al-Andalus, vol. 3, 1965–66), 370–5; Ibn al-Khatib, *Rawdat al-Taʾrif bi Hubb al-Sharif* (Beirut: Dar al-Saqafah, 1970), 341, provides a theological view.

4 Al-Ghazali, *Ihyaʾ ʿUlum al-Din* (Beirut: Dar al-Kutub al-ʿIlmiyyah, 1992), vol. 4, 312; for more details see Süleyman Derin, *Love in Sufism: From Rabia to Ibn al-Farid* (Istanbul: Insan Publications, 2008), 131–63.

5 Ibn al-Khatib, *Rawdat* vol. 4, 326

6 M. Ozak, *The Unveiling of Love*, trans. Muhtar Holland (London and the Hague: East West Publications, 1981), 27; for the definition of the different stages of love see Mir Valiuddin, *Love of God, the Sufi Approach* (Lahore, 1979), 2–3.

7 Makki, Abu Talib, *Qut al-Qulub*, vol. 2, 52

8 Abu al-ʿAla Afifi, *The Mystical Philosophy of Ibn ʿArabi* (Cambridge: Cambridge University Press, 1939), 21.

9 W. Chittick, *The Sufi Path of Knowledge* (Albany, NY: State University of New York Press, 1989), 79.

10 ʿA. Hifni, *al-Mawsuʿah al-Sufiyyah* (Cairo: Dar al-Irshad, 1992), 290.

11 R. W. J. Austin, 'The Lady Nizam – an image of love and knowledge', *Journal of the Muhyiddin Ibn Arabi Society* 7 (1988): 35–48.

12 Ibn ʿArabi, *Zakhair al-ʿAlaq Sharh Tarjuman al-ʿAshwaq*, ed. M. A. Karwi, 4–5.

13 Ibn ʿArabi, *Tarjuman al-ʿAshwaq,* ed. and trans. by R. A. Nicholson (London: Theosophical Publishing House, 1978), 7.

14 Bukhari, *al-Sahih Istiʾzan*, n5759; Ibn ʿArabi, *al-Futuhat* (Yahya ed.), vol. 2, 490.

15 Ibn ʿArabi, *al-Futuhat* (Yahya ed.), vol. 14, 64.

16 Ibn ʿArabi, *al-Futuhat*, vol. 14, 67–8.

17 Ibn ʿArabi, *Zakhair al-ʿAlaq Sharh*, 51; *Tarjuman al-ʿAshwaq*, trans. Nicholson, 69–70.

18 Austin, 'The Lady Nizam', 35–48.

19 *Masnavi*, III, 3921. The translation of the verses of *Masnavi* are taken from Reynold Nicholson's works unless otherwise stated.

20 Ibn ʿArabi and al-Ghazali have separate chapters on love, where they give a detailed and organised view of their take on the nature of the concept. For a comparison, see al-Ghazali, *Ihyâ* (Beirut: Dâr al-Kutub al-ʿIlmiyyah, 1992), vol. 4, 311–81; Ibn ʿArabi, *al-Futuhât al-Makkiyyah* (Beirut: 1998), vol. II.

21 Abdülkerim Suruş, 'Tebliğ no:1', *Mevlânâ Güldestesi* (Konya: 1996), 13.

22 *Divan*, 5001. All translations of the verses quoted from Rumi's *Divan* belong to W. Chittick, unless otherwise stated.

23 Abdülbâki Gölpınarlı, *Mevlânâ Celâleddîn* (Istanbul: 1985), 209; Derin, *Love in Sufism.*

24 W. Chittick, *The Sufi Path of Love: The Spiritual Teachings of Rumi* (Albany, NY: State University of New York Press, 1983).

25 (*Divan*, 21305) The story can be read in varying detail in the Bible, Genesis 39:1–23; in Jewish commentaries on the Hebrew Scriptures; and in the Qurʾan, 12: 23–35. It was also retold by various Persian poets in addition to Rumi. The most prominent of these was Jami. See also pp. 41, 74, 91, 201 and Figure 8.2.

26 R. A. Nicholson, *Mystics of Islam* (London: G. Bell & Sons, 1914; reprinted London: Routledge & Kegan Paul, 1979), 100.

27 Annemarie Schimmel, *I Am Wind You Are Fire: The Life and Work of Rumi* (Boston: Shambala, 1996), 182.

left: Detail from Figure 5.7

opposite: Detail from page iv

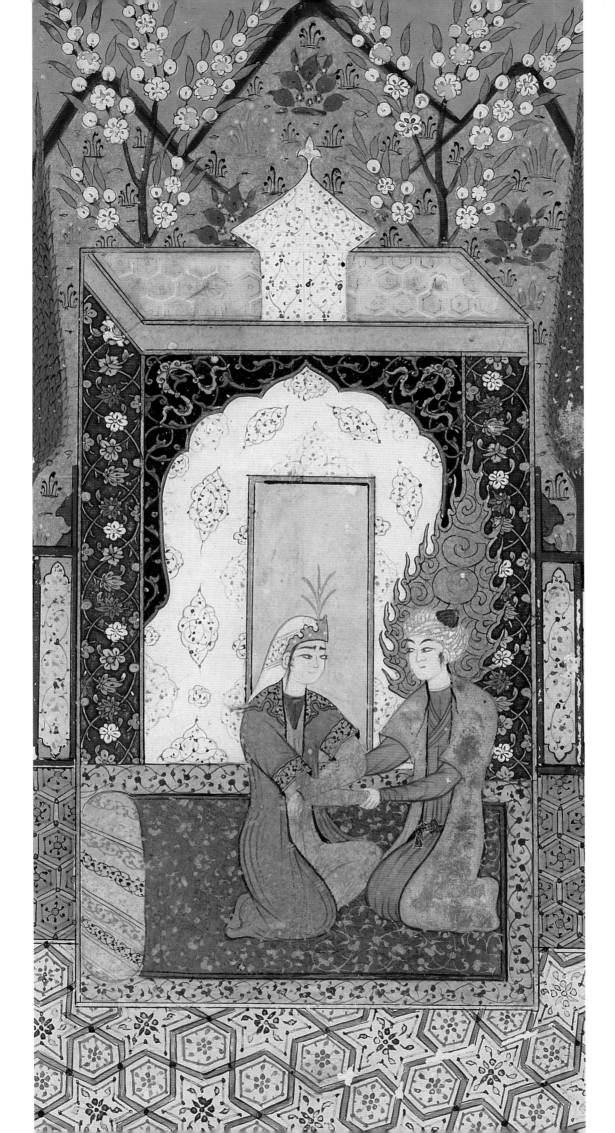

یعنی که رخ بپوش و جهانی خراب کن

کلبرک ر آز سنبل مشکین نقاب کن

چون شیشهای دیده ما پر گلاب کن

نفشا عشق از چهره و اطراف باغ را

ایام گل چو عمر برفت و شتاب کرد

سایه بر او باده گلگون شتاب کن

بوی بنفشه بشنو و زلف نگار گیر

سبزه برنگ لاله و عزم شراب کن

SELECTION OF POETRY

FIRDAUSI (d. circa 1020)

I shall not die, these seeds I've sown will save
My name and reputation from the grave,
And men of sense and wisdom will proclaim,
When I have gone, my praises and my fame.

> Closing lines of the *Shahnama*,
> trans. Dick Davis, New York:
> Penguin Books, 2007, p. 854.

NIZAMI (d. 1209)

One night desperate Majnun prayed tearfully,
'O Lord of mine who has abandoned me,
Why hast Thou 'Majnun' called me?
Why hast Thou made a lover of Leila of me?
Thou hast made me a pillow of wild thorns,
Made me roam day and night without a home.
What dost Thou want from my imprisonment?
O Lord of mine, listen to my plea!'

The Lord replied, 'O lost man,
With Leila's love I have your heart filled;
Your Love of Leila is my will.
The Beauty of Leila that you see
Is just another reflection of me.'

> From *Khamsa,* trans. Mahmood
> Jamal, *Islamic Mystical Poetry*,
> Harmondsworth, UK: Penguin
> Books, 2009, p. 65.

'ATTAR (d. circa 1221)

My love is for the rose; I bow to her;
From her dear presence I could never stir.
If she should disappear the nightingale
Would lose his reason and his song would fail,
And though my grief is one that no bird knows,
One being understands my heart – the rose.

Another bird spoke up: 'I live for love,
For Him and for the glorious world above –
For Him I've cut myself from everything;
My life's one song of love to our great king.
I've seen the world's inhabitants, and know
I could not worship any here below;
My ardent love's for Him alone; how few
Can manage to adore Him as I do!'

> *The Conference of the Birds*, trans.
> Afkham Darbandi and Dick Davis,
> Harmondsworth, UK: Penguin
> Books, 1984, pp. 36, 144.

IBN 'ARABI (d. 1240)

I follow the religion of Love: whatever way Love's
camels take, that is my religion and my faith.

> Trans. R. A. Nicholson, in
> Mahmood Jamal, *Islamic Mystical
> Poetry*, Harmondsworth, UK:
> Penguin Books, 2009, p. 110.

pages 73–75: Extracts from *The Conference of the Birds* (© Afkham Darbandi and Dick Davis, 1984) and *Islamic Mystical Poetry* (trans. © Mahmood Jamal, 2009) used with permission from Penguin Books Ltd. Extracts from *Shahnameh: The Persian Book of Kings* (trans. Dick Davis) © 1997, 2004 by Mage Publishers, Inc., used with permission from Viking Penguin, Penguin Group (USA) Inc.

JALAL AL-DIN RUMI (d. 1273)

Listen to the reed how it tells a tale, complaining of separations –

Saying, 'Ever since I was parted from the reed-bed, my lament hath caused man and woman to moan.

I want a bosom torn by severance, that I may unfold (to such a one) the pain of love-desire.

Every one who is left far from his source wishes back the time when he was united with it.

In every company I uttered my wailful notes, I consorted with the unhappy and with them that rejoice.

Every one became my friend from his own opinion; none sought out my secrets from within me.

My secret is not far from my plaint, but ear and eye lack the light (whereby it should be apprehended).

Body is not veiled from reed, nor soul from body, yet none is permitted to see the soul.

This noise of the reed is fire, it is not wind: whoso hath not this fire, may he be naught!

'Tis the fire of Love that is in the reed, 'tis the fervour of Love that is in the wine.'

Masnavi 1: lines 1–10. *The Mathnawi of Jalaluʾddin Rumi*,
trans. Reynold A. Nicholson, London: Luzac and Co., 1926, vol. 2, p. 5.

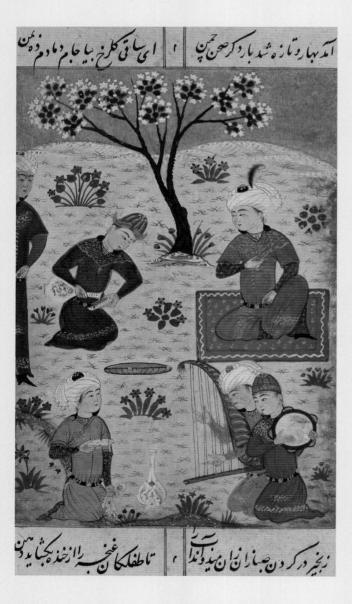

JAMI (d. 1492)

In days of yore
Thy robe from off thy body once I tore.
Thou hast my garment now from off me torn,
And I my crime's just punishment have borne.
Of right and wrong I now no longer fear;
In tearing robes we both stand equal here.

Epilogue, *Yusuf and Zulaykha*,
trans. Ralph T. G. Griffith and
Alexander Rogers, in John D.
Yohannan, *Joseph and Potiphar's
Wife in World Literature*, New
York: New Directions Books,
1968, p. 220.

page 72: Young man and a girl seated in a landscape holding hands.
From a manuscript of Hafiz, *Divan*, dated 945 (1538).
Bodleian Library, University of Oxford, MS. Ouseley Add. 26, fol. 117r.

left: A young prince with attendants. From a collection of verse in
ghazal form, copied c. late 15th century (detail).
Bodleian Library, University of Oxford, MS. Elliott 329, fol. 120r.

HAFIZ (d. 1390)

Beauty radiated in eternity
With its light;
Love was born
And set the worlds alight.

It revealed itself to angels
Who knew not how to love;
It turned shyly towards man
And set fire to his heart.

Trans. Mahmood Jamal, *Islamic Mystical Poetry*,
Harmondsworth, UK: Penguin Books, 2009, p. 233.

DANTE ALIGHIERI (d. 1321)

I saw rain over her such ecstasy
　Brought in the sacred minds that with it glowed –
　Created through the heavenly height to fly –
That all I had seen on all the way I had trod
　Held me not in such breathless marvelling
　Nor so great likeness vouched to me of God.

La Divina Commedia, 'Paradiso', Canto XXXII,
lines 88–93. *Dante's Paradiso*, trans. Laurence
Binyon, London: Macmillan and Co., 1943, p. 379.

WILLIAM SHAKESPEARE (d. 1616)

Wilt thou be gone? It is not yet near day.
It was the nightingale, and not the lark,
That pierced the fearful hollow of thine ear.
Nightly she sings on yond pomegranate tree,
Believe me, love, it was the nightingale.

Romeo and Juliet, Act III, Scene 5, lines 1–5, ed.
T. J. B. Spencer, Harmondsworth, UK: Penguin
Books, 1967.

LORD BYRON (d. 1824)

Know ye the land of the cedar and vine?
Where the flowers ever blossom, the beams ever shine,
Where the light wings of Zephyr, oppressed with perfume,
Wax faint o'er the gardens of Gúl in her bloom;
Where the citron and olive are fairest of fruit,
And the voice of the nightingale never is mute;

There lingered we, beguiled too long
With Mejnoun's tale, or Sadi's song;
Till I, who heard the deep tambour
Beat thy Divan's approaching hour –
To thee and to my duty true,
Warn'd by the sound, to greet thee flew:

The Bride of Abydos: A Turkish Tale, Canto I,
part 1, lines 5–10 and part III, lines 71–6,
London: John Murray, 1813.

JOHANN WOLFGANG VON GOETHE
(d. 1832)

The man who loves will never go astray,
Though shadows close around him and above,
Leila and Medschnun, if they rose to-day,
From me might understand the path of love.

Is it possible, sweet love, I hold thee close!
Hear the divine voice pealing, musical!
Always impossible doth seem the rose,
And inconceivable the nightingale.

West-Eastern Divan (*West-östlicher Divan*), Book
of Zuleika, VI & VII, trans. Edward Dowden,
London: J. M. Dent, 1914, pp. 100–1.

نمودند جوان بنیز و اماندند خود را بدیشان رسانند نجدمت حضرت خواجه عبد الله انصاری

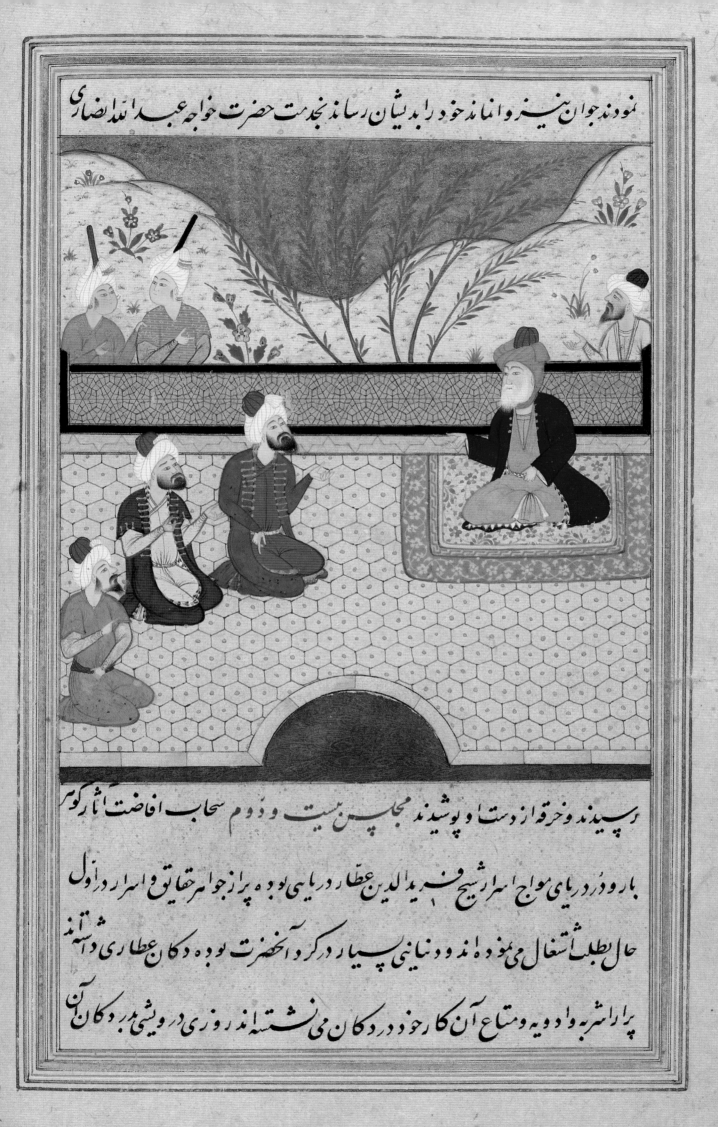

رپسیدند و خرقه از دست او پوشیدند مجالس بیست و دوم سحاب افاضت آثار کوثر

بار و در دریای مواج اسرار شیخ فرید الدین عطار در یایی بوده پر از جواهر حقایق و اسرار در اول

حال بطلب اشتغال می نموده اند و دنیایی بسیار در کرد و آنحضرت بوده دکان عطاری دیده اند شیئاند

پر از اشربه و ادویه و متاع آن کار خود در دکان می نشسته اند روزی درویشی بر دکان آن

THE MYSTIC POETRY OF 'ATTAR AND THE *CONFERENCE OF THE BIRDS*

Rafal Stepien

SHAYKH Farid al-Din 'Attar Nishapuri is generally acknowledged to be the greatest Persian Sufi poet of the 12th century. A native of Nishapur, the then bustling, cosmopolitan administrative capital of Khurasan in what is now north-eastern Iran, 'Attar was born c. 1145. Though scholars still debate the precise date and circumstances of his death, he most probably died in either 1221 or 1229 at the hands of the invading Mongol armies.[1]

Though a pharmacist by trade, 'Attar appears to have shown throughout his life a marked interest in the mystical strand of Islam known as Sufism. According to one popular account, he devoted himself to the writing of Sufi poetry on the basis of one particular encounter with a wandering dervish. The story goes that this latter's appeal for alms was rejected by the busy pharmacist, whereupon the dervish rebuked 'Attar for his excessive attachment to worldly preoccupations: 'How will you face your Maker?', the dervish demanded, to which 'Attar replied: 'Just as you will!'. At this the mendicant lay down, invoked Allah and died. 'Attar, it is said, thereupon left off his business pursuits and devoted himself to the composition of the Sufi poetry upon which his fame rests.[2]

Although some 190 works have been ascribed to 'Attar at various times, his certainly authentic works are seven in number. 'Attar's only prose work, entitled the *Tazkirat al-Auliya* or 'Biographies of the Companions', is a collection of partly hagiographical biographies of famous Sufis. The *Divan* of shorter poems includes close to 900 lyrics largely ecstatic in tone. The *Mukhtarnama* or 'Book of the Chosen' is a collection of *ruba'i* (quatrains) arranged into fifty chapters dealing with such typical Sufi themes as the mystical path, divine love and self-annihilation. The most important among 'Attar's works are the four *masnavi* poems or religious epics. The *Asrarnama* or 'Book of Secrets', *Ilahinama* or 'Book of Divinity' and *Musibatnama* or 'Book of Affliction' all chart the progress of the spiritual wayfarer towards final union with the Divine through spiritual counsel, philosophical speculation and hundreds of illustrative tales and legends. Indeed, it is first and foremost on the basis of his skill as a storyteller that 'Attar's works have been used for centuries as Sufi manuals throughout Iran, Central Asia, India and Turkey.

'Attar's most famous work is the *Mantiq al-Tayr* or 'Conference of the Birds'. This *masnavi*, composed of 4724 rhyming couplets in the most authoritative modern edition,[3] is framed around the story of the birds' journey to the Simurgh, who is understood to be an allegorical representation of the Divinity. An illustration from a Bodleian Library manuscript of the 'Conference of the Birds' (Figure 6.2) depicts a scene early in the story, in which the Hudhud (hoopoe) tells the assembled birds about the Simurgh and urges them to set out on the long journey to find it. Many of the birds present their excuses, in what is obviously a figurative criticism of those of 'Attar's contemporaries who – like many today – refuse the arduous task of spiritual fulfilment in favour of worldly pursuits. Thus, for example, 'Attar presents the partridge, bedazzled by bright objects, as preferring jewels and ornaments to the attainment of inner beauty, and the melodious nightingale as contenting himself with the transient beauty of the rose to whom he sings.

Finally a multitude of birds set out, traversing in the process the seven valleys of the spiritual path as here conceived of by 'Attar. In the first of these, that of Seeking, the birds are required to abandon all other pursuits in their all-encompassing endeavour to attain their one true goal. In the Valley of Love, the birds renounce all worldly distinctions just as lovers give up all that separates them from their beloved. In the Valley of Wisdom, each bird uncovers its own place in the cosmic hierarchy in accordance with its own virtues and nature. Next, the Valley of Self-sufficiency unveils to the birds the lowly worth of the created world, dependent as it is on the self-sufficient Creator. In the fifth valley, that of Unity, the birds uncover the oneness underlying the many manifestations of the visible world, which leads them to a state of Bewilderment, the sixth valley, in which they are no longer able to discern this from that, self from other, and enter into ecstatic rapture. Finally, the birds arrive at the Valley of Poverty and Self-extinction, in which they lose themselves in the imperative omnipresence of the divine Self.

Only thirty birds arrive at their destination, the home of the Simurgh, and are granted access to its inner chamber. There, in what is doubtless the single most celebrated pun in all of Persian literature, the thirty birds (*si murgh*) realise that they are nothing other than the Simurgh Itself:

> As soon as the thirty birds looked
> Doubtless they saw thirty birds to be but Simurgh
>
> Their heads all spun in bewilderment
> They knew not this until they became that
>
> They saw themselves to be all Simurgh
> Simurgh Itself had always been the thirty birds.[4]

The 'Conference of the Birds' has enjoyed great fame and a wide readership throughout its 800-year history. Indeed, given its popularity throughout much of the Islamic world, some scholars have proposed that it may have influenced, or at least parallels in important ways, even works so far removed from it in both place of composition and tenor as *The Parliament of Fowls* of Geoffrey Chaucer (c. 1343–1400).[5] Though no manuscript evidence has been brought to light indicating any possible direct link, the two poems are alike in their allegorical depiction or vision of a journey to a realm other than and in some sense transcendent to the everyday world (see pp. 151–56). Both poets, moreover, use the topos of the journey or pilgrimage to structure their text, thoroughly in keeping with the literary conventions prevalent in both Persia and Europe at the time and into the later medieval period. Indeed, we may cite the *Itinerarium Mentis in Deum* ('The Path of the Mind to God') of Bonaventure (1221–1274), the *Vision of Piers Plowman* ascribed to William Langland (c. 1332– c. 1386) or the *Sayr al-Ibad ila al-Ma'ad* ('The Journey of the Servants to the Place of Return') of Sana'i Ghaznavi (c. 1080–1131) as but a representative selection of many such works.

These extended allegorical journeys find perhaps their most ambitious exemplar in the *Divina Commedia* of Dante Alighieri (1265–1321). Dante's heavenly cosmology, with its hierarchy of spheres and 'Intelligences' (or angels), shares its basic structure and Neoplatonic underpinnings with that of his Muslim contemporaries (see Figure 6.3). These latter, however – and not least 'Attar among them – could draw upon a specifically Islamic source for their literary depictions of mystical flight: the Night Journey (*Isra'*) or Ascent (*Mi'raj*) of the Prophet Muhammad. Though only briefly alluded to in the Qur'an,[6] the Prophet's journey from Mecca to Jerusalem and thence upward through the heavenly spheres and on ultimately to a direct vision of the

Figure 6.1 (page 76)

'Attar conversing in a courtyard. From a manuscript of a work attributed to Gazurgahi, *Majalis al-'Ushshaq*, dated 959 (1552).
Bodleian Library, University of Oxford, MS. Ouseley Add. 24, fol. 65v.

Figure 6.2 (opposite)

The Hoopoe tells the birds about the Simurgh. From a manuscript of 'Attar, *Mantiq al-Tayr*, dated 898 (1493).
Bodleian Library, University of Oxford, MS. Elliott 246, fol. 25v.

چون بسوزی هرچه پیش آید ترا | نزل حق هر لحظه بیش آید ترا

چون دلت شد واقف اسرار حق | خویشتن را واقف کن در کار حق

چون شوی در کار حق مرغ تمام | تو نمای سوی حق بماند و السلام

مجمع طیور

مجمعی کرد مرغان جهان | آنچه بودند آشکار و نهان

Divinity – all in the blink of an eye – spawned an entire genre of exegetical literature, and evidently fascinated 'Attar, who described it in every one of his *masnavis*. Indeed, so prevalent among the Sufis was the use of the Prophet's *Mi'raj* as an allegory of the soul's ascent to spiritual union with God that Dante himself may have had occasion to profit from it in constructing the immense artifice of his own vision.[7]

Though it is difficult, if not impossible, to establish any direct influence upon Dante of the *Mi'raj* literature, let alone of 'Attar's 'Conference of the Birds',

there can be no doubt whatsoever as to 'Attar's immense impact upon Persian Sufi poetry. So inspiring was his poetry and so lofty his spiritual station that his great disciple, the poet Rumi (1207–1273), is purported to have humbly acknowledged:

> 'Attar traversed the seven cities of love
> We're still stuck in an alley corner.[8]

Still widely studied and enjoyed in Iran today, 'Attar's masterpiece remains one of the great poetic allegories of humankind's spiritual aspirations.[9]

Rafal Stepien studied Persian language and literature at the University of Isfahan, Iran. Following a stint in Afghanistan as a Persian interpreter, he received a Master's degree from the University of Cambridge, where he worked on Persian Sufi poetry. He also holds degrees from the University of Western Australia and the University of Oxford, and is currently pursuing a PhD at Columbia University, New York, where he is exploring the intersections between Buddhist poetry in Chinese and Sanskrit, and Sufi poetry in Arabic and Persian.

Figure 6.3 (opposite)

The Virgin in the centre of the rose, surrounded by saints and children in the petals, *Paradiso*, Canto XXXII. From a manuscript of Dante Alighieri, *La Divina Commedia*, copied c. 1350–75, Italy. Bodleian Library, University of Oxford, MS. Holkham misc. 48, p. 145.

Notes:

1 For a recent summary of the scholarly debate surrounding 'Attar's death, see Hermann Landolt, ''Attar, Sufism and Ismailism', in *'Attar and the Persian Sufi Tradition*, ed. Leonard Lewisohn and Christopher Shackle (London: I. B. Tauris, 2006), 8.

2 This story is told by 'Abd al-Rahman Jami (1414–1492) some two centuries after 'Attar's death. For a discussion of it, see Muhammad Este'lami, 'Narratology and Realities in the Study of 'Attar,' in *'Attar and the Persian Sufi Tradition*, ed. Lewisohn & Shackle, 58.

3 Muhammad Riza Shafi'i Kadkani, ed. *Mantiq al-Tayr*, (Tehran: Milli, 1387 [2008]).

4 Kadkani, ed. *Mantiq al-Tayr*, verses 4263–5. Translation by current author.

5 See for example the introduction to Dick Davis and Afkham Darbandi, trans. *The Conference of the Birds* (Harmondsworth, UK: Penguin, 1984), 20–1.

6 See primarily the opening of Sura 17: *Al-Isra*.

7 Miguel Asín Palacios was the first scholar to propose Islamic influences upon

Dante. See in particular his *La Escatologia Musulmana en la Divina Comedia* (Madrid: Real Academia Española, 1919). His work was elaborated by Enrico Cerulli in *Il 'Libro della scala' e la questione delle fonti arabo-spagnole della Divina commedia*, (Rome: Biblioteca aspostolica vaticana, 1949).

8 Cited in Badi' al-Zaman Foruzanfar, *Sharh-i Ahval va Naqd va Tahlil-i Asar-i Shaykh Farid al-Din Muhammad 'Attar Nayshaburi*, (Tehran: Anjuman-i Asar va Mafakhir-i Farhangi, 1374 [1996]), 72, where, however, the author casts doubt as to the authenticity of this verse. Still, authentic or not, the wide circulation of this verse and others like it sheds much light upon at least the perceived relationship between the two poets.

9 Apart from the works already cited, readers interested in deepening their knowledge of 'Attar should refer to Hellmut Ritter's monumental work, *The Ocean of the Soul*, trans. Bernd Radtke (Leiden: Brill, 2003). The 'Conference of the Birds' has recently been translated in full by Peter Avery (London: Islamic Texts Society, 1998).

145

Pero secondo ilcolor decapelli
dicotal gratia laltissimi lume
degnamente conue che sincapelli.

Dunque sança merçe dilor costume
locati son p gradi differenti
sol differendo nel primero acume.

Bastaua li ne secoli recenti
col in nocença per auer salute
solamente lafede deparenti.

Poi chelle prime etadi fur compiute
conuenne amaschi alle innocente pene
per circuncider aquistar uirtute.

Ma poi chel tempo della gratia uenne
sança battesmo perfecto di xpo
tale innocentia lagiu siritenne.

Riguarda omai nella faccia che axpo
piu similia chella sua chiareçça
sola tipuo disporre aueder xpo.

Jo uidi sopra lei tanta alegreçça
piouer portata nel mente sante
create atrinsuolar p quel alteçça.

Che quantunq io auea uisto dauante
dicanta amiration no musospese
ne mumostro didio tanto sembiante.

Et quello amor che primo lidiscese
cantando aue maria gratia plena
dinançi allei le suo ale distese.

Rispuose alla diuina cantilena
datuicte parti labeata corte
sicogni uista sense piu serena.

O santo padre che perme cóporte
lesser qua giu lasciando ildolce loco.
nel qual tu siedi p eterna sorte.

Quale quel angel che contanto giocho
guarda neliocchi alla regina
innamorato siche par difoco.

Cosi ricorsi ancora ladoctrina
dicolui che abelliua dimaria
come delsole stella matutina.

Et elli ame baldeçça elegiadria
quant esser puote in angelo i alma
tucta e inlui i suolem che sia.

Per chelli e quelli che porto lapalma
gui amaria quandol figliuol didio
caricar suolse della nostra salma.

Mauiene omai cogliocchi sicomio
andro parlando i nota iugran princi
diquesto imperio giustissimo i pio.

Que due che seggon lasu piu felici
pesser propinquissimi ad augusta
son desta rosa quasi du radici.

Colui che dasinistra le saguista
elpadre perlocui ardito gusto
lumana specie amaro gusta. tanto

Dal dextro uedi quel padre uetusto
disancta chiesa acui xpo lechiaui
ricomando diquesto fior uenusto.

Et quei che uide tucti itempi graui
pria che morisse della bella spoxa
che saquisto colla lancia coli claui.

Siede lung esso i lungto laltro posa
quel duca socto cui uisse dimanna
lagiente ingrata mobile i ritrosa.

Dicontro apietro uedi seder anna
tanto contenta dimirar sua figlia
che non muoue occhio percantar oçana.

Et contro almaggior patre difamiglia
siede lucia che mosse latua donna
quando chinaui i a rouinar leciglia.

Ma per chel tempo che tasonna fugge
qui faren punto come buon sartore.
che comelli a delpanno fa lagonna.

جلوه در کسوت بدیع عجیب | عشق مطلق در و بیان کرده | وان پان از سر عیان کرده

راختلاف تغاقب بسیار | عشق او وصف کرده دراطوار | ورباعیات عریب بشتمل بر

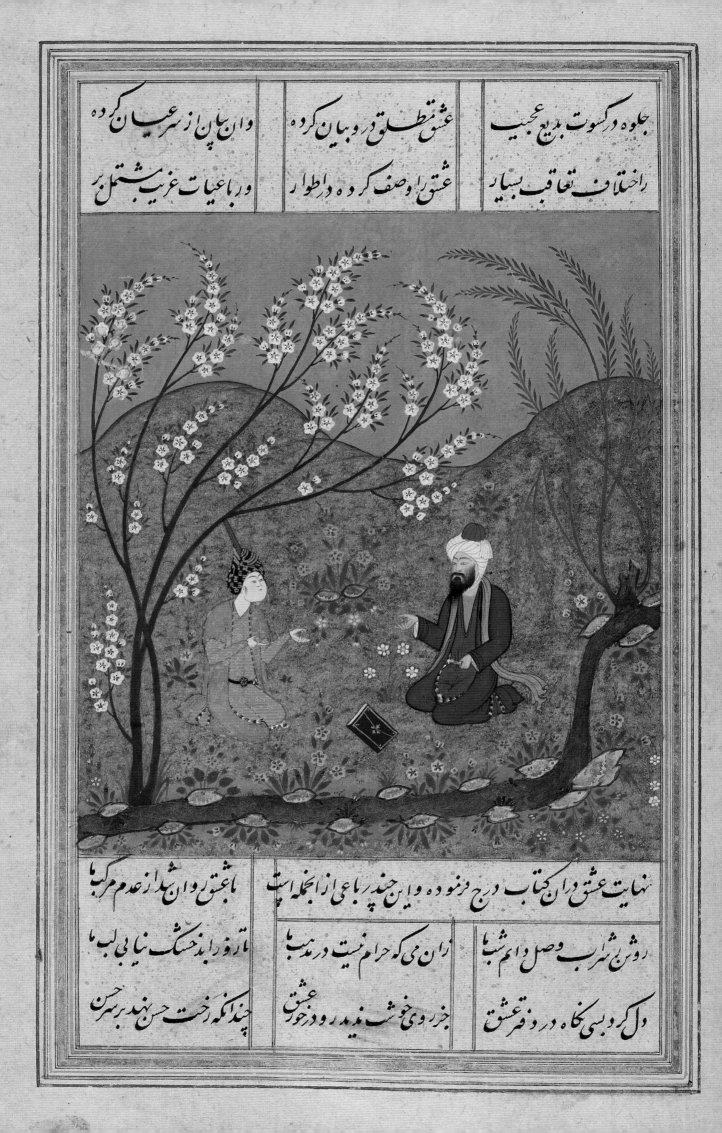

نهایت عشق در ان کتاب درج فرموده و این چند رباعی از انجمله است | باعشق و انشدار از عدم مرکبا

روشن شراب وصل دام شبا | زان می که حرام نیست در مذهبا | تا روز ابد خشک نیابی لبها

دل کرد بسی نگاه در دفتر عشق | جز روی خوش ندید رو در خور عشق | چندانکه رخت حسن نهد بر سر حسن

CHAPTER SEVEN

MEETINGS OF LOVERS

The Bodleian Majalis al-ʿUshshaq, *MS. Ouseley, Add. 24*

Lâle Uluç

AROUND the middle of the 16th century, illustrated copies of the *Majalis al-ʿUshshaq* ('Meetings of Lovers'), a work compiled at the Timurid court of Sultan Husayn at Herat (r. 1470–1506), began to be produced in the Safavid city of Shiraz.[1] Its introduction treated mystic love as typified by the story of Yusuf and Zulaykha, followed by episodes from the lives of seventy-six famous religious or royal personages, such as Ahmad al-Ghazali (1058–1111), the widely revered Islamic theologian and mystic.

Its theme is the need to cross the bridge of material love in ecstasy before attaining ideal love. The *Majalis* is mainly romantic accounts of the worldly love of famous mystics, legendary lovers and royalty, which led Babur, the founder of the Mughal empire, to condemn it as 'a miserable production, mostly lies, and insipid and impertinent lies to boot, some of which raise a suspicion of heresy'. He also said that the author 'attributes carnal loves to many prophets and saints, inventing for each of them a paramour'.[2]

Although the preface of the Bodleian Library's *Majalis al-ʿUshshaq* manuscript identifies Sultan Husayn himself as the author, contemporary writers Babur Mirza and Khwandamir ascribed it to Kamal al-Din Husayn Gazurgahi, a religious official

who was Sultan Husayn's intimate companion, and for the most part modern scholarship agrees.[3] The attribution of its authorship to the Timurid sultan Husayn Bayqara must have contributed to its popularity among members of the Ottoman elite, who were keen to collect works stemming from his court. Ottoman sources contain frequent references indicating the Ottoman idealisation of Sultan Husayn, his court and especially his companion, Mir ʿAli Shir, known as Navaʾi, who wrote primarily in Chaghatay Turkish. Chaghatay dictionaries were prepared in Istanbul to help his readers understand both his works and the *Divan* of Sultan Husayn, which was also written in Chaghatay. The *Majalis al-ʿUshshaq,* which was thought to have been another work by the Timurid sultan, is one of the most common titles found in the Ottoman archival book lists.[4]

Copies of the *Majalis al-ʿUshshaq* were systematically illustrated at Shiraz from the second half of the 16th century onwards. The Oxford volume is the earliest known dated and illustrated Shiraz copy, carrying the date 959 (1552). Many of its seventy-five illustrations are the earliest examples of the compositions newly formulated for this text, which became popular in the 1570s and 1580s.

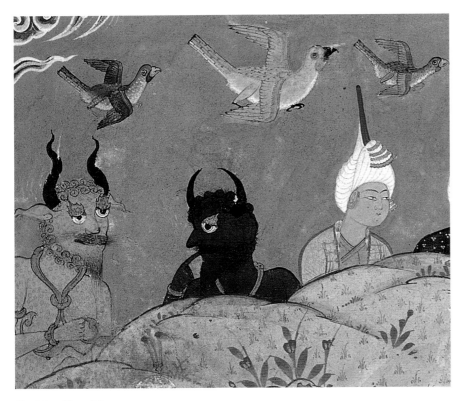

Detail from Figure 7.2

The illustrations of the Oxford copy of 1552 often provided models for later compositions depicting the same subjects, though some in a considerably modified form. The illustration from the section on King Solomon is a case in point.[5] The incident depicted is found in many sources including the Qur'an. In the story, one of Solomon's demon servants tells him that since Bilqis, the Queen of Sheba, was mothered by a female *jinn* (spirit), she had hairy legs. To prove it the demon constructed a pavilion with a double-tiered glass floor and put fish between the layers of glass to give the impression of a stream. When Bilqis entered this room, she lifted her skirts in order to wade in the water and thus Solomon saw her hairy legs (Figure 7.2). A depilatory was later invented by another demon from the lime that accumulated in the pipes of a bathhouse so that Solomon could have his heart's desire and wed Bilqis with her stripped legs.[6]

The importance of the *Majalis al-ʿUshshaq* manuscripts lies in the urban settings used to depict episodes from the lives of famous mystics. When the illustrative cycle in the *Majalis* manuscripts was being developed, in the illustrations for which there were precedents, such as court scenes, scholarly meetings or incidents from well-known mythical stories like that of 'Yusuf and Zulaykha', 'Layla and Majnun' or 'Farhad and Shirin', the compositions simply continued earlier traditions. When the incident described could not be depicted by adaptations of earlier compositions, new ones closely following the text had to be formulated. Many of the incidents chosen for representation were meetings, which often occurred in the street or the bazaar, between the protagonist of the tale in each section and his 'beloved.' Since there were no precedents or models for such scenes, they were original images providing a rare glimpse of street life in Shiraz in this period.

One example depicts an incident from the life of Hakim Sana'i, the renowned 12th-century court poet, who was enamoured of a fine-looking butcher boy. When the boy asked Hakim Sana'i to show his love by giving him 500 goats, he had to settle for the mystic's much-mended shoes, but soon afterwards the governor of Khurasan presented Sana'i with a gift of 500 goats, which he immediately brought to the butcher boy.[7] The Oxford copy of 1552 shows Hakim Sana'i and the boy in front of the butcher's shop (Figure 7.3).[8] The

Figure 7.1 (page 82)

The mystic Ahmad al-Ghazali conversing with a young man in a landscape. From a manuscript of a work attributed to Gazurgahi, *Majalis al-ʿUshshaq*, dated 959 (1552). Bodleian Library, University of Oxford, MS. Ouseley Add. 24, fol. 42r.

Figure 7.2 (opposite)

Solomon tricks Bilqis into wading into a simulated stream made of glass. From a manuscript of a work attributed to Gazurgahi, *Majalis al-ʿUshshaq*, dated 959 (1552). Bodleian Library, University of Oxford, MS. Ouseley Add. 24, fol. 127v.

در آن آب رخ دید چنان که مردم که در آن میدان در آمدندی خیال کردندی که آبست جامه خود را

بالا کشیدندی و این کار برای آن کرد که چندانچه دیوان بلقیس بود چنان بگفته تو بدند چنان هست یاپنی

چون بلقیس بکرسی سلیمان رسید

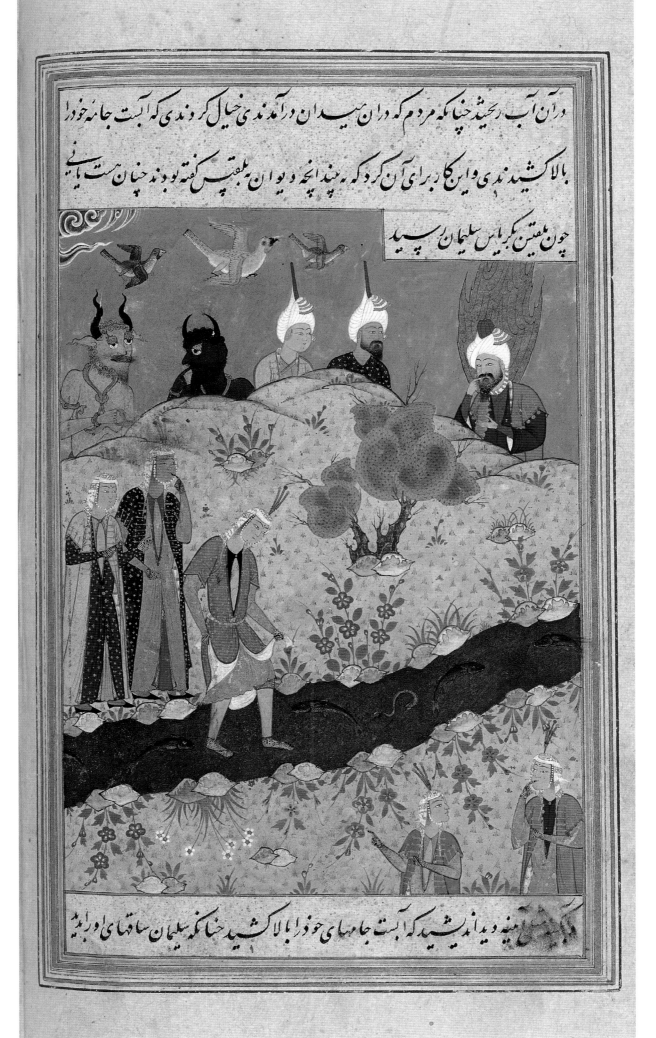

چگونه آیینه دید اندیشید که آبست جامهای خود را بالا کشید خانه خانه که خانه سلیمان ساقهای او ابید

Figure 7.3

Hakim Sanaʾi leaves his shoes
with the butcher boy. From a
manuscript of a work attrib-
uted to Gazurgahi, *Majalis
al-ʿUshshaq*, dated 959 (1552).
Bodleian Library, University of
Oxford, MS. Ouseley Add. 24,
fol. 44v.

Figure 7.4 (opposite)

Hakim Sanaʾi brings goats to
the butcher boy. From a
manuscript of a work
attributed to Gazurgahi,
Majalis al-ʿUshshaq, copied
c. 1580.
Topkapi Palace Museum,
Istanbul, H.829, fol. 50v.

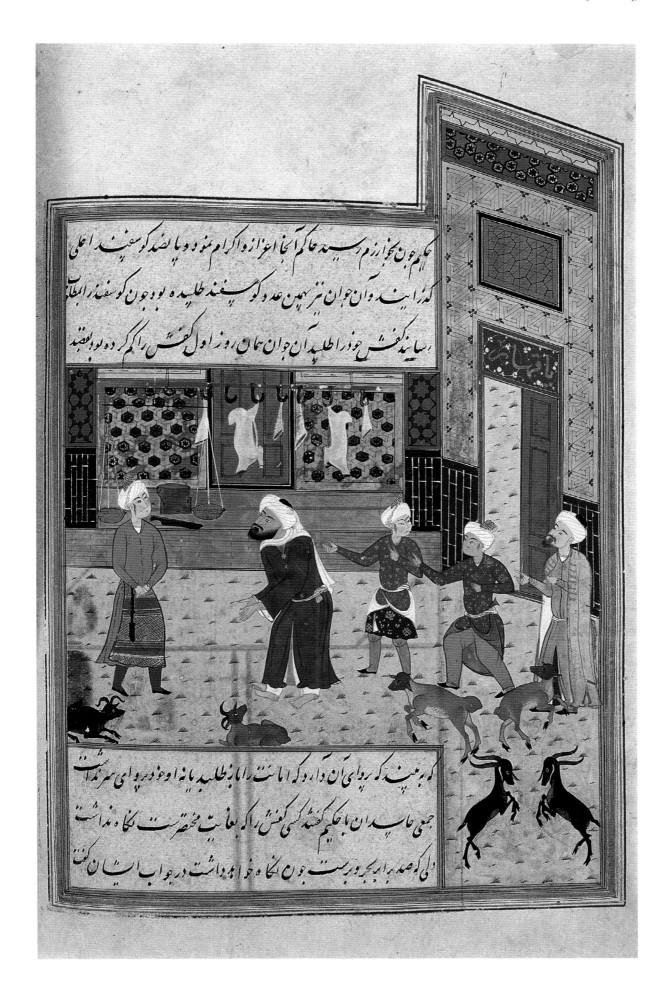

boy holds a large butcher's knife; a pair of shoes sits on the ground in front of the shop. The c. 1580 copy from the Topkapi Palace Museum in Istanbul illustrates the second stage of the story and shows the barefooted Sana'i with the 500 goats that would have allowed him to reclaim his shoes (Figure 7.4).

Even though Edward Browne was critical of the literary merit of the *Majalis al-'Ushshaq*, saying that it 'hardly deserves to be mentioned as a serious biographical work',[9] it was evidently very popular. The abundance of illustrations in most *Majalis* manuscripts from the 1580s must have contributed to its popularity. Most had a picture every two or three pages, as well as the interesting or entertaining details found in the images, including urban scenes never before seen in Persian classical texts.

Lâle Uluç completed her PhD in 2000 at the Institute of Fine Arts, New York University, and is currently teaching at Boğaziçi University in Istanbul. Her publications include 'Selling to the Court: Late Sixteenth Century Shiraz Manuscripts', *Muqarnas 17* (2000) and *Turkman Governors, Shiraz Artisans and Ottoman Collectors: Arts of the Book in 16th Century Shiraz* (2006).

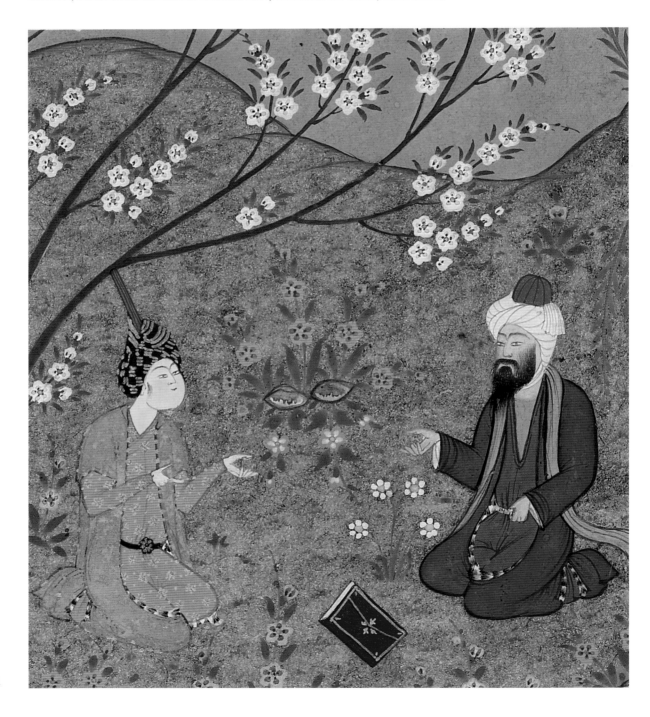

Detail from Figure 7.1

Notes:

1 Charles Rieu, *Catalogue of the Persian Manuscripts in the British Museum,* 3 vols & supplement (London: British Museum, 1879–95), 1: 351–53; Edward G. Browne, *A Literary History of Persia,* 4 vols (Cambridge: Cambridge University Press, 1928), 4: 439–40; Charles A. Storey, *Persian Literature: A Bio-Bibliographical Survey,* 2 vols and supps (London: Luzac, 1927–58), 2: 959–62; Kamal al-Din Husain Gazurgahi, *Majalis al-ʿUshshaq,* ed. G. R. Tabatabaʾi (Tabriz: Intisharat-i Zerrin, 1375 [1997]).

2 Babur Mirza, *Baburnama,* ed. and trans. Wheeler M. Thackston (Cambridge, MA: Harvard University, Department of Near Eastern Languages and Civilizations, 1993), 366–7, cited by Browne, *A Literary History of Persia,* vol. 4, 439–40.

3 Babur Mirza, *Baburnama,* 366–7; Khwandamir, *Habibuʾs-siyar,* vol. 3, ed. and trans. Wheeler M. Thackston (Cambridge, MA: Harvard University, Department of Near Eastern Languages and Civilizations, 1994), 513. Storey, *Persian Literature,* 2: 960 and n1; Jan Rypka, 'Persian Literature to the Beginning of the Twentieth Century', in *History of Iranian Literature,* ed. Jan Rypka (Dordrecht: D. Reidel Publishing Co., 1968), 289; Felix Tauer, 'Persian Learned Literature from Its Beginnings up to the End of the 18th Century' in *History of Iranian Literature,* ed. Rypka, 452–3. The 16th-century chronicler Sam Mirza, *Tuhfaʾ-i Sami* (957 [1549]), ed. V. Dastgirdi (Tehran, Armaghan, 1314 [1935–36]), 15, on the other hand, attributes it to Husayn Mirza. Rieu, *Catalogue of the Persian Manuscripts,* 351–2, accepts this attribution, as does Browne, *A Literary History of Persia,* vol. 4, 439–40.

4 Lâle Uluç, *Turkman Governors, Shiraz Artisans, and Ottoman Collectors: Arts of the Book in 16th Century Shiraz* (Istanbul: Iş Bankası Kültür Yayınları, 2006), 500–3; also see Lâle Uluç, '*Majalis al-ʿUshshaq*: Written in Herat, Copied in Shiraz and Read in Istanbul', in *M. Uğur Derman 65 Yaş Armağanı/65th Birthday Festschrift,* ed. Irvin C. Schick (Istanbul: Sabancı University, 2000), 569–603; also published in *Proceedings of the 11th International Congress of Turkish Art, Utrecht, The Netherlands, August 23–28, 1999,* ed. M. Kiel, N. Landman & H. Theunissen, *Electronic Journal of Oriental Studies* 4, no. 54 (2001), 1–34, http://www.let.uu.nl/EJOS.

5 Thomas Arnold, *Painting in Islam* (Oxford: Clarendon Press, 1928), pl. XXXIII, facing 110; Uluç, *Turkman Governors,* 190, figs 134 and 135.

6 Priscilla Soucek, 'Solomon's Throne/Solomon's Bath: Model or Metaphor?' *Ars Orientalis* 23 (1993): 115; Arnold, *Painting in Islam,* 108, cites the Qurʾanic verse (27.44): 'It was said to her "Enter the palace"; and when she saw it, she thought it was a lake of water and bared her legs. He said, "Lo! it is a palace smoothly paved with glass".' This was later elaborated by commentators.

7 The word used in the text is *gusfand* (Kamal al-Din Husayn Gazurgahi, *Majalis al-ʿUshshaq,* fol. 93), which can mean either a sheep or a goat. I prefer goat, because the illustrations of this incident in some of the *Majalis al-ʿUshshaq* manuscripts depict goats.

8 Basil W. Robinson, *A Descriptive Catalogue of the Persian Paintings in the Bodleian Library* (Oxford: Oxford University Press, 1958), pl. XIV, cat. no. 763; Uluç, *Turkman Governors,* 202, fig. 144.

9 Browne, *A Literary History of Persia,* vol. 4, 439–40.

Detail from Figure 7.3

القول على اصل الكابوس واتباعه

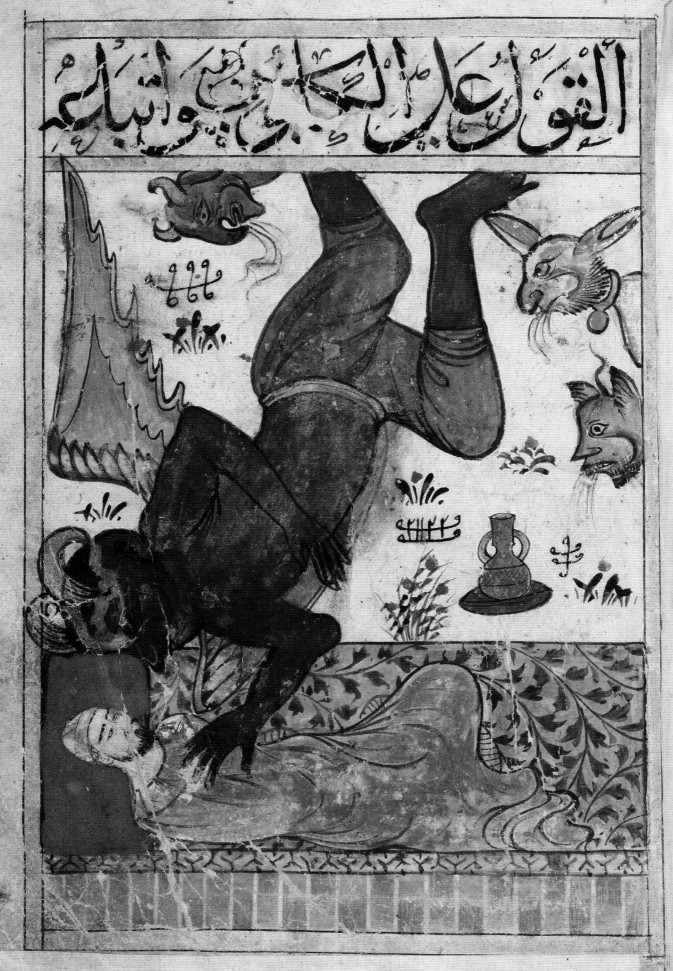

DREAMS, PREMONITIONS AND COSMOLOGIES IN PERSIANATE LITERATURE

Stefano Carboni

ONE of the crucial moments in the Qur'anic narration of the story of Yusuf (Sura 12) is when he tells his father Ya'qub that he saw in a dream the sun, the moon and eleven stars prostrating themselves to him. At the end of the story Yusuf becomes the spiritual centre of the constellation of his family (his father, mother, and eleven brothers symbolised by the heavenly bodies of his dream) who prostrate and are guided by his spiritual authority. The Persian poet Jami's mystical interpretation of the related love story between Yusuf and Zulaykha also uses the power of dreams in order to make Potiphar's wife fall in love with the handsome and righteous youth: she sees him in three different dreams 'dreamt with the eyes of the heart open' and her life is changed forever (Figure 8.2).

Persian and Persianate literature are rich with premonitions, magical events, portents, and dreams that warn either the hero or the villain of things to come. It is a fate that cannot be changed, a destiny that cannot be avoided. Yusuf's Qur'anic ability to interpret dreams finds a counterpart in Jami's text in Zulaykha's vision of a Yusuf-like apparition who claims to be the vizier of Egypt. Thinking that he is literally 'the man of her dreams' she becomes betrothed to the official, Potiphar, but grows obsessed by desire for Yusuf

when she finally casts her glance on him. Appropriately, Jami turns this messy triangle into mystical love but this is only a prologue to the eventual inevitable union between the two.

One of the many ill-fated examples of premonition can be found in Firdausi's *Shahnama* ('Book of Kings') in the epic narration of the evil Zahhak's ultimate demise at the hands of Faridun. He has a terrible dream – he sees three warriors attacking him, the youngest of them knocking him down with his mace, tying him up and dragging him to Mount Damavand – and sets out in vain to eliminate the young future hero.[1] Zahhak's fate was sealed the very moment he dreamed about it.

Premonitions often come through *jinn* – smoke-like creatures that inhabit the underworld and are able to bring illnesses and deception – and *div*s (demons, but also ogres or giants) who have the faculty of interacting with humans while they are asleep, communicating with them through dreams and nightmares. A rare direct visual example is provided by the illustration of the demon Kabus (the Nightmare) in the Bodleian Library's *Kitab al-Bulhan*, a mostly 14th-century miscellaneous compilation in Arabic of astrology, astronomy, and divination that includes a section on the *jinn* and their talismans (Figure 8.1).[2] Here, the menacing

dark-skinned, horned, winged demon, exercising his
power over the oblivious human, hovers above a hap-
less sleeping man.

Dreams and premonitions are often associated
with divination and, by extension, with astrology, that
is, the prediction of the best moment to perform
specific actions according to the position of the planets
at the time of birth. Whereas we have no issues in
acknowledging astronomy (*ʿilm al-falak*, 'the science of
the celestial sphere') as a scientific discipline, today's
perception of astrology, magic and divination is largely
that these are unreasonable beliefs belonging to the
realm of folklore, myths, popular literature and gullible
people. Yet this distinction was far from the minds of
medieval Arabic and Persian writers and scholars, who
saw astrology (*ʿilm ahkam al-nujum*, 'the science of the
judgement of the stars') as a natural and demonstrable
consequence of the movement of the planets across the
sky and divination (*fal*) as an incontestable proof of
God's will.

The universe was the consequence of a prescient
scheme in which the human race played but an insignif-
icant part. It was organised in concentric circles that
started from the Outer Sphere where God sat on His
throne, progressively down to Earth with its denizens,
among which humankind was situated between the
plant world and the *jinn*.

Zakariyya ibn Muhammad ibn Mahmud al-Qazvini
(d. 1283) is the best known among the cosmographers
who contributed to this type of literature. Last in a line
of writers on astronomy, astrology, geography, zoology
and botany, he was ultimately perhaps not much more
than a compiler of previous texts[3] but he succeeded in
condensing within a single and well-organised book the
entire cosmographical knowledge and understanding of
the physical world of his time. Originally from Qazvin
in central Iran, he spent most of his life in Syria and
Iraq, becoming fluent in both Arabic and Persian and
electing the former language for his writings. Little is
known of his biography, but we know that he was a
judge (*qadi*) in al-Wasit and Hilla in Iraq, serving first
under the patronage of the last Abbasid caliph, al-
Muʿtasim, and later under the Mongol governor of
Baghdad, Ata Malik Juvaini, to whom he dedicated his
major work.

The 'Wonders of Creation and Oddities of Exist-
ing Things' (*Kitab ʿAjaʾib al-Makhluqat wa-Gharaʾib

al-Mawjudat*), originally written in Arabic but soon
translated into Persian and later into Ottoman Turkish,
quickly became a best seller, partly because the 'existing
things' were habitually illustrated. Thus, it became a
sort of encyclopedia and a standard reference text for
any library.

Al-Qazvini's work is broadly divided into two
parts, the first dealing with the celestial world, the
second with the terrestrial. His astronomical knowledge
is evident from the lucid way in which the planets, the
constellations of the two hemispheres and the zodiac
are discussed (Figure 8.3). In this section are also
located the angels, beings of simple substance, uncon-
cerned with anger and sexual desire and executing
God's will.

The second part of al-Qazvini's text deals with the
sphere of fire (meteors and thunderbolts); the sphere of
air (clouds, rain, wind, halo and rainbow); and the
sphere of earth (mountains, rivers, and springs; miner-
als; plants; humans; *jinn*; animals, including mounts,
grazing livestock and wild beasts; birds; insects, reptiles
and creeping animals; and, finally, hybrids of humans
and animals). One of the most entertaining sections of
the work deals with the sphere of water: the seas and
islands and the fish, animals and strange peoples found
there. Derived originally from Greek texts and bearing
comparison with contemporary medieval European
literature on the geography of the farthest reaches of
the world, it mentions islands inhabited by sciapods
(people with one giant foot), people without bones in
their legs, with dog-heads, and with ears so large that
they use them as a blanket while they sleep.

Remarkably, the groups and subgroups of flora and
fauna are organised in alphabetical order, a feature that
is taken for granted today in an encyclopedic work but
which can be considered to be of pioneering nature in
the 13th century. Al-Qazvini considered animals as part
of the third stage of creation because they possess the
qualities of growth, feeling, and movement. Humans
have both a soul and a body and therefore are the high-
est of animals: they grow like a plant, move and feel
like all animals, but also understand, have knowledge
and wonder about the reality of creation like an angel.

The 'Wonders of Creation' is filled with fantastic
stories, many of which include dreams and omens, and
an entire chapter of the animal kingdom is devoted to
the *jinn* and their interaction with, and mischievous

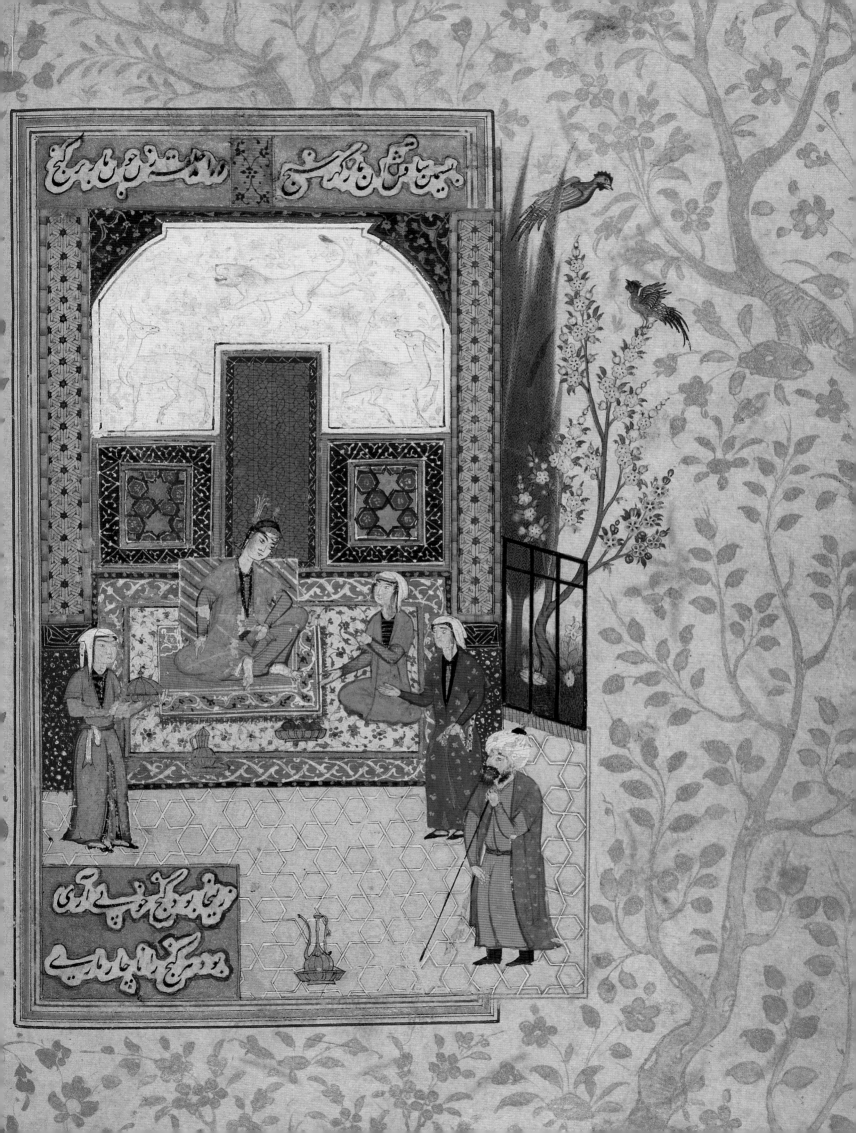

چناق كبى وبوكواكب جوزالاسد وعرش السماكدين
غواب بونك كواكبى يديدر وبوبر قرنغه دن

شجاع ارقطه اونزه وكواكب شبا عدن بركوكبى منقار يليه دو ٠٠٠ شمس ٠٠٠ واولكوكب منقار العواب ديرلر٠٠٠

بونك كواكبى اون قوز بدى ديدرر بونك صورتى باشندن بليه دك آدم صورتى
وبلندن آشخه آت صورتى دربونزى دى مشرق جانبنه آدى دى مغرب طرفنه دروب الذنب
صلقم واروب الذنب سبع ابا قلن دوتمش واولآت قرنى اونزه بركوكب نيروانركه الكابطن
الحوت ديرلر وصاغ طرناغى اونزه بركوكب وارىكه الكاحضار ديرلر وب الذنب دخى بركوكب
وارىكه اكا اونزد بوظهر بونلر اولرا يكى كوكب دركه مخالفين ديرلر ديو ذكر اتمشندر

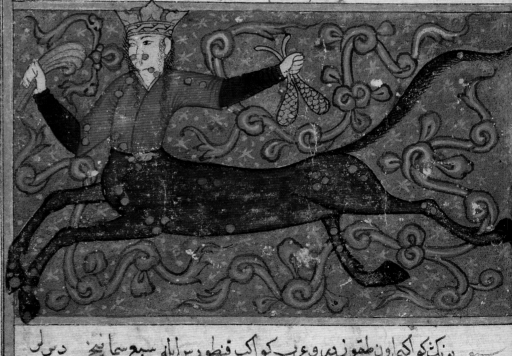

بونك كواكبى اون طقوز دمر وعرب كواكب قنطورس اله سبع سمايى ديرلر

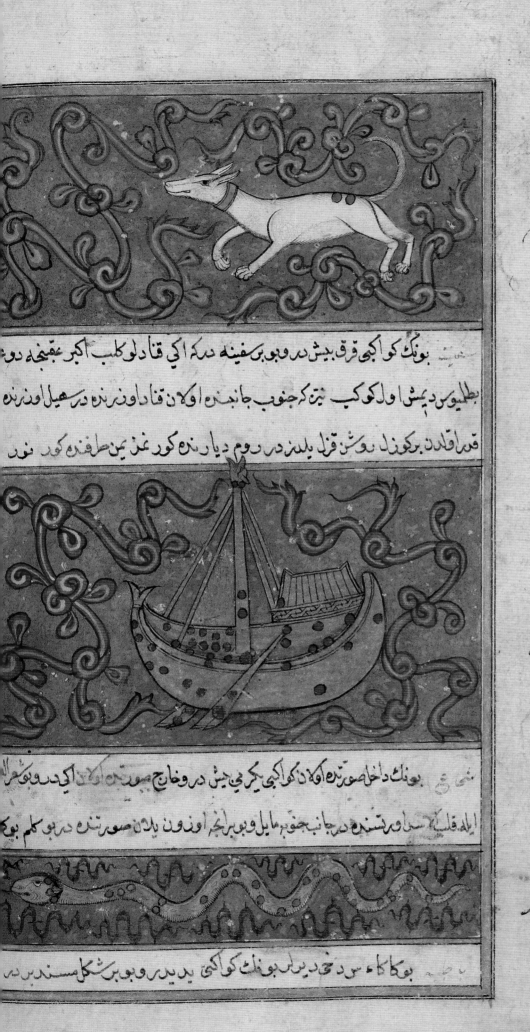

بونك كواكبي قرق بيش در وبوبي سفينه دكه اكي قادلو كلاب اكبر عقبنجه دوـ

بطلیوس دیش اولكوكب نتر که جنوب جابندن اولان قادون زنده درسهیل اوذزنـ

قادقادد برکوزد بوش قزل یلدز در روم دیارنه کور غز یمن طرفنه کود نفد

بونك داخلصورتنه اوكلادكواكبي يكرمي بيش در وخارج صورتنه اولان اكي در وبوـ

الله قلبـ سـ ى اور تستنده در جانب جنوب مايل وبوبرنجم اوزون يلدان صورتنه در بوكلم بوـ

بوكاكا سود خودیرلي بونك كواكبي يدید وبوبر شكل مسند در دـ

attitude toward, the human race. One in particular comes to mind, 'The man and the *jinn*'s woman'. The narrator is a man belonging to the tribe of the Banu al-Harith:

> I intended to go to Syria [but] I fell behind my companions and found myself alone when darkness came ... While I was in my tent [I saw] a beautiful woman standing in front of me, so I asked her: 'What are you doing in this place?' She replied: 'A *'ifrit* [a spirit, *jinn* or demon] kidnapped me; he disappears overnight and comes back with the daylight'. I said: 'Do you want to stay with me?'... I urged her and made her sit on my camel and we rode away until the moon set, after which [we spent the night together] and became intimate.[4]

The story continues explaining that the *jinn* pursued the couple but the man made his camel kneel, drew a line in the sand around the animal, and recited verses from the Qur'an so that the *jinn* was forced to give up his inappropriate union with the beautiful woman.

Love and lust, magic and daily actions, religious and talismanic beliefs, dreams and premonitions, and interaction between humans and the underworld form a continuous thread in al-Qazvini's work as well as in so many works of Arabic, Persian and Persianate literature. They are woven into intricate and wonderful stories and images through exquisite texts and illustrations which contributed to create one of the best manuscript traditions in the world.

Stefano Carboni is Director of the Art Gallery of Western Australia in Perth, and Adjunct Professor, University of Western Australia. Until 2008, he was Curator and Administrator of the Department of Islamic Art, The Metropolitan Museum of Art, and Visiting Professor at the Bard Graduate Centre, New York. His publications include *Venice and the Islamic World* (2006), *The Legacy of Genghis Khan* (2002) and *Glass from Islamic Lands* (2001).

Notes:

1 Illustrations of Zahhak's story can be found in Firuza Abdullaeva and Charles Melville, *The Persian Book of Kings: Ibrahim Sultan's* Shahnama (Oxford: Bodleian Library, University of Oxford, 2008), 67; and Barbara Brend and Charles Melville, *Epic of the Persian Kings: The Art of Ferdowsi's* Shahnameh, exh. cat. (London: I. B. Tauris, 2010), cat. 4, 33, 62–3, 108–9.

2 The manuscript, Bodleian MS. Bodl. Or. 133, a rare and early example of this genre noted for its large number of illustrations, is written in Arabic rather than Persian. The various treatises were collated some time in the late 14th or early 15th century in Baghdad. The title can be loosely translated as 'The Book of Portents'. See *Islamic Art, An Annual Dedicated to the Art and Culture of the Muslim World* (New York: The Islamic Art Foundation, 1981), vol. 1, fig. 235; Stefano Carboni, *Il* Kitab al-bulhan *di Oxford*, *Eurasiatica*, vol. 6 (Turin: Quaderni del Dipartimento di Studi Eurasiatici, Università degli Studi di Venezia, 1988), 56–7, pl. 16.

3 He duly mentions more than 100 different oral and written sources throughout his text.

4 The translation is based on my own translation from the Arabic text of the so-called London Qazvini (British Library, Or. 14140), one of the earliest known copies datable to the beginning of the 14th century. Stefano Carboni, 'The *Wonders of Creation* and the Singularities of Ilkhanid Painting: A Study of the London Qazwini, British Library Ms. Or. 14140' (PhD thesis, School of Oriental and African Studies, University of London, 1992), vol. I, 220–1. The image illustrating the story is published in Stefano Carboni, 'The London Qazwini: An early 14th century copy of the *Aja'ib al-makhluqat*', *Islamic Art*, III, 1988–89, 15–1, fig. 1.

Figure 8.4 (opposite)

The East and West winds. From an Ottoman Turkish translation of Zakariyya ibn Muhammad ibn Mahmud al-Qazvini, *Kitab 'Aaja'ib al-Makhluqat wa-Ghara'ib al-Mawjudat*, copied late 16th or early 17th century. Bodleian Library, University of Oxford, MS. Turk. d. 2, fol. 101v.

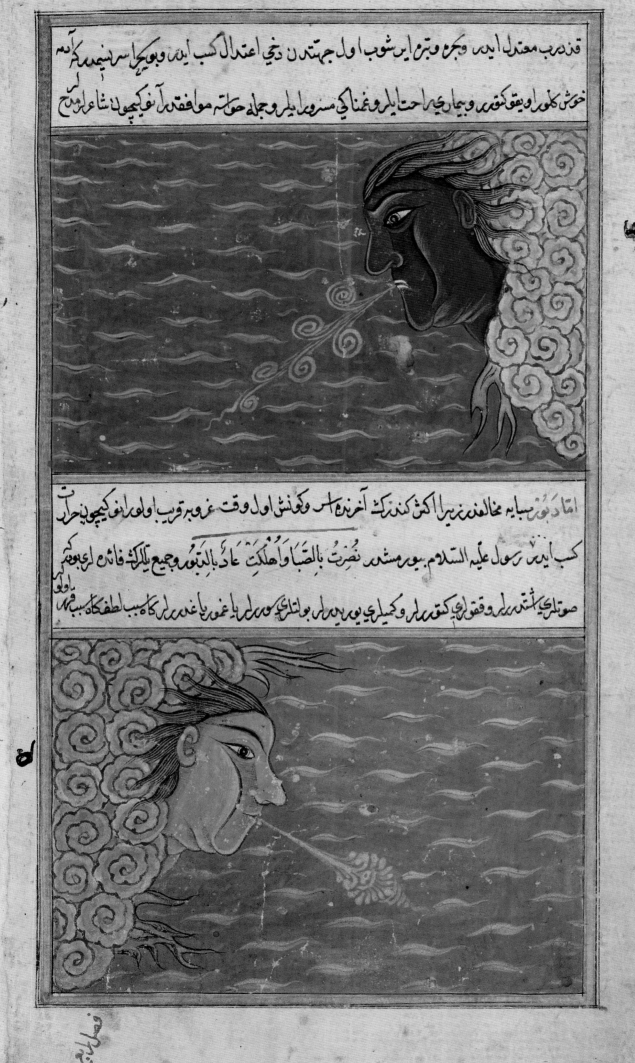

قدرت مب معتدل ايد وجمع وتم ايدر شوب اول جهتدن دخي اعتدال كسب ايدر وبو يحار سنيمدك آدم
خوش كلور اويقو قوقور وبيماريحه راحت ايلر ودغناكي مسرور ايلر وجله حولته موافقت آ نفيحود نشا عراور دح

اتقاد بونز سبايه مخالفندنير اكبر كندبرك آخرندك اول وقت غروبه قريب اولدرافو كيجو بنجر آت
كسب ايدر رسول عليه السلام بوم مشهد نصرت بالصبا واهلكت عاد بالدبور وجميع بلرك فائش ارى بوتكم
صوتلري بشتيرريلر وقفولري كتغرريلر وكميلري بوم ييم ايلر بولتلري كوبريلر يا غمور يا غدريلر كاسب لطغك كاسب وه

PART III

INTERSECTIONS:
FROM
PERSIA AND BEYOND

اطناب ملال

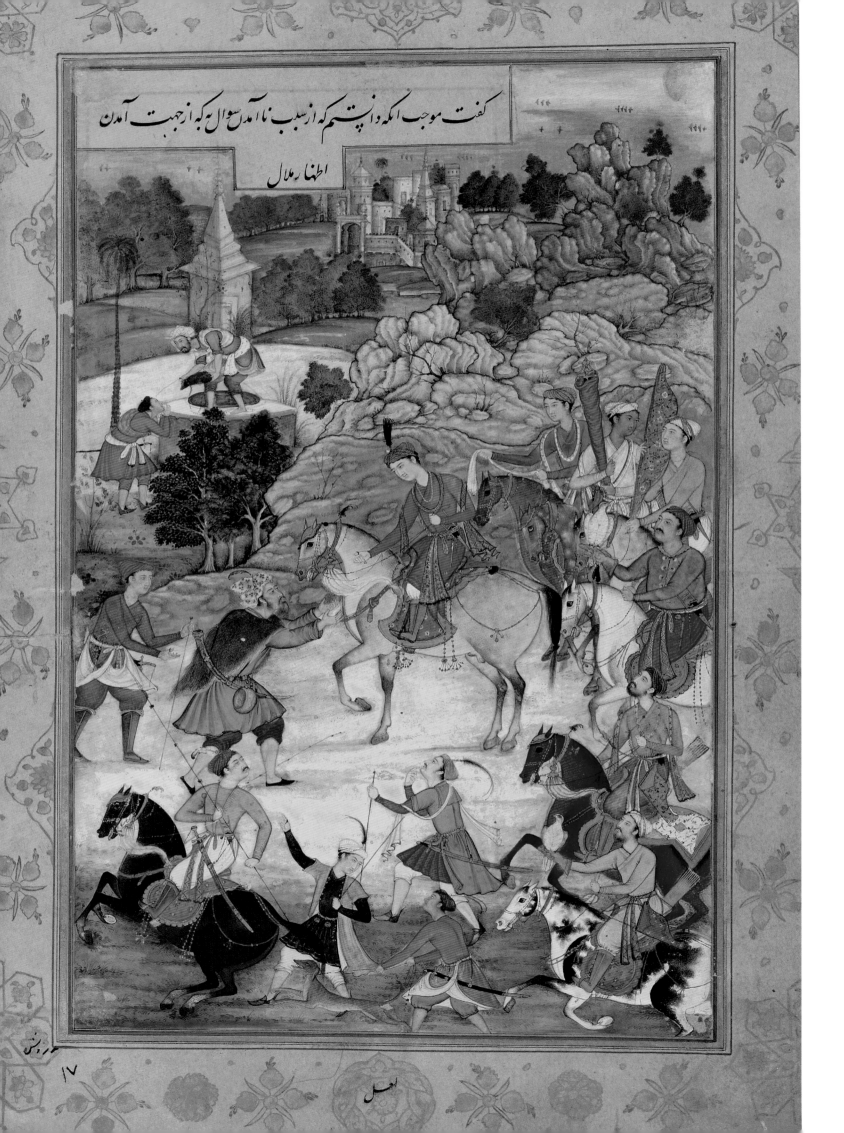

اصل

IMAGES OF LOVE AND DEVOTION

Illustrated Mughal Manuscripts and Albums in the Bodleian Library

Andrew Topsfield

LIKE their Timurid ancestors, the early Mughal emperors from Babur onwards were keen bibliophiles and devotees of Persian literature. While in temporary Iranian exile, the notably bookish Humayun (r. 1530–56) had also begun the process of attracting Persian poets and painters to India, where richer rewards would await them than at home. Under the dynamic emperor Akbar (r. 1556–1605), a great expansion of the Mughal library and painting studio took place. Manuscripts of the Persian classics and other works were copied and often abundantly illustrated in the new and energetic Mughal style, a rapidly developing synthesis of the Persian and Indian painting traditions with the novel conventions of European art.

Akbar himself had difficulty in reading and would have books read aloud to him. His wide-ranging tastes included popular romances and animal fables in his younger days, as well as works of dynastic history, moral philosophy, Sufi mystical treatises and the classics of Persian literature,[1] many of these also being strongly imbued with Sufi themes and inner meanings. Besides being a restless man of action, Akbar took a strong interest in religion and

spirituality, as did many of his descendants. While Mughal art would always remain secular in tendency, glorifying outward displays of imperial pomp or dwelling on life's fleeting pleasures, the emperors and princes also had an eye turned towards the unseen world of spiritual wisdom, as is shown in paintings depicting their respectful attendance on venerable Sufi masters or even Hindu ascetics. Portraits of individual holy men were also often included in the sumptuously bound imperial albums (*muraqqaʿ*) of choice paintings and calligraphy specimens that were increasingly favoured by the emperors Jahangir (r. 1605–27) and Shah Jahan (r. 1627–58).

The Bodleian Library's historic collection of Mughal manuscripts and painting albums dates back as early as 1640 – a time when Shah Jahan still ruled as the 'Great Mogul' – with Archbishop Laud's gift of an album of *ragamala* paintings (illustrations of musical modes) and other subjects. The collection then grew sporadically over the next three centuries up to the last major acquisition of the Atkinson *Layla u Majnun* manuscript in 1952 (see Figure 9.5).[2] Many of the library's most important holdings,

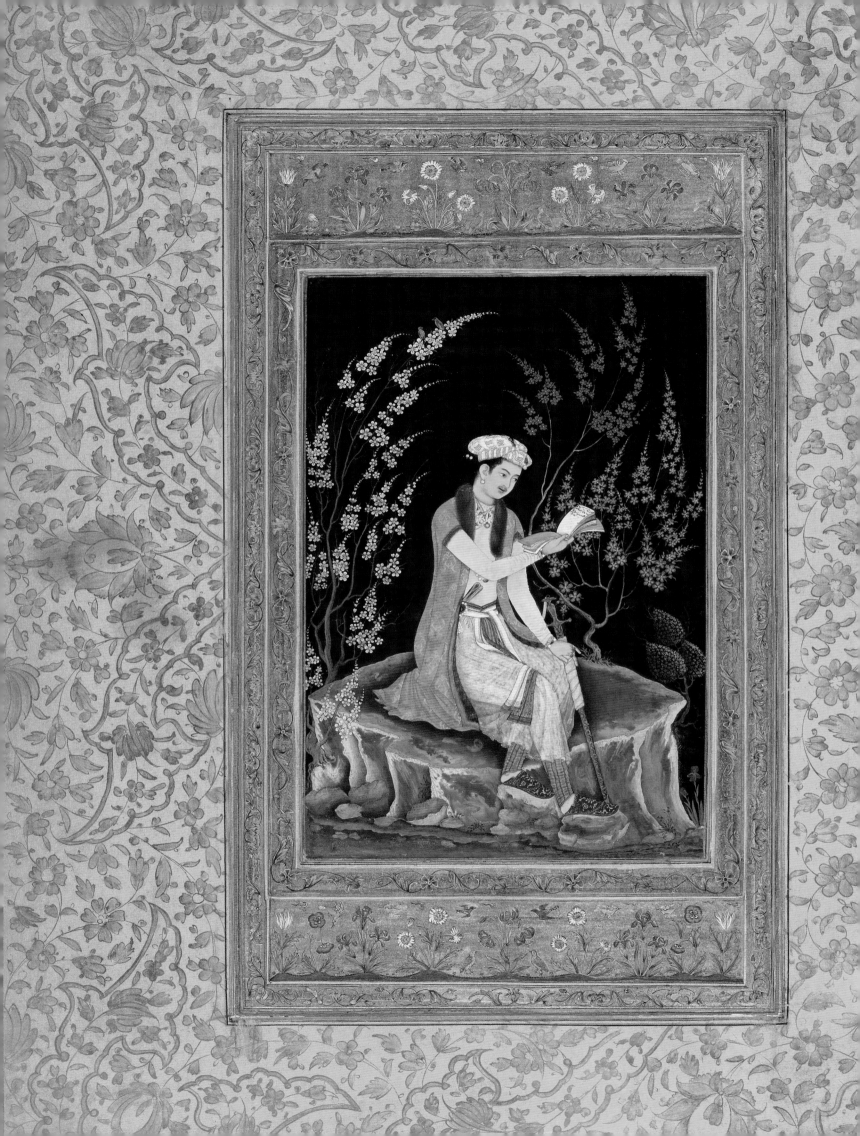

originally acquired in India by British nabobs and officials, came to it during the 19th century, especially from the collections of the bibliophile and antiquary Francis Douce, the scholar-diplomat Sir Gore Ouseley and the Bengal civil servant J. B. Elliott. Among the latter's gifts in 1859 was the magnificent imperial copy of the *Baharistan* of Jami, prepared for Akbar at Lahore in 1595 (see Figure 9.1),[3] which represents the high point of Mughal luxury manuscript production achieved towards the end of his reign.

During the 17th century, Mughal manuscript painting increasingly took second place to the production of *muraqqa'* albums, which indeed predominate over illustrated manuscripts in the Bodleian's collection. The earliest and finest example is the album MS. Douce Or. a. 1 (see Figure 9.2), dating from the 1650s or late Shah Jahan period. This album was evidently assembled for a prince of the imperial family, most likely Shah Shuja' (1616–60),[4] the second son of Shah Jahan, towards the end of his service as governor of Bengal (1639–59), which culminated in his doomed attempt to succeed his father. Later albums in the library's collection are mainly diverse compilations formed at provincial centres in Avadh, eastern India or the Deccan down to the late 18th century. Their pictorial content varies widely in subject, quality, date and style. Viewed as a totality however, this diverse, fortuitous corpus conveys a vivid picture of social life and human experience and aspirations in the later Mughal age. Inevitably, in view of its patronage, it shows a bias towards portraits of the nobility and scenes of court life. But setting this aspect aside, it is apparent that the perennial subject of love played a large part in the favoured imagery of the time, whether erotic or spiritual love or an ambivalent poetic fusion of the two.

The most common expressive vehicles for these themes were illustrations to popular romances such as that of Layla and Majnun, which was interpreted metaphorically by Sufis and poets as a mystical story of divine love (*'ishq-i haqiqi*). A more overt case of a romance composed specifically as a Sufi allegory is *Husn u Dil* ('Beauty and Heart'), a 15th-century Persian text by Fattahi of Nishapur.[5] An illustrated copy of this work, probably made for Akbar at his newly built capital of Fatehpur Sikri in the early 1570s, is now known only from a single stray page that was later incorporated in an 18th-century Avadh album in the

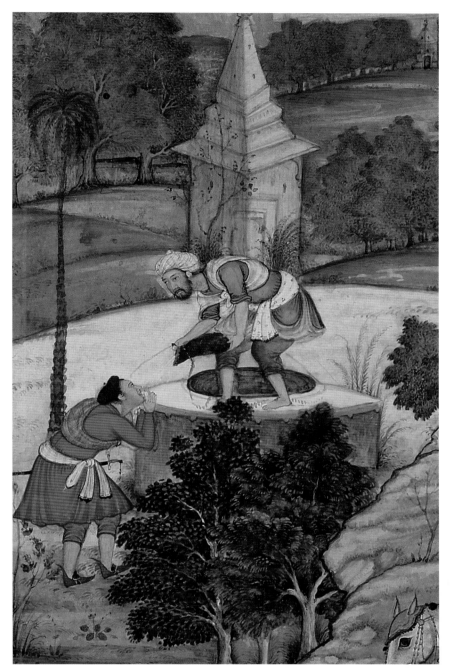

Detail from Figure 9.1

Figure 9.1 (page 100)

The dervish and the king. Leaf from a disbound manuscript of Jami, *Baharistan*, copied for Mughal Emperor Akbar, dated year 39, Ilahi era, reign of Akbar (1595), Lahore, painted by La'l. Bodleian Library, University of Oxford, MS. Elliott 254, fol. 17v.

Figure 9.2 (opposite)

A prince reading in a garden. From a Mughal album, image painted c. 1640–50. Bodleian Library, University of Oxford, MS. Douce Or. a. 1, fol. 46r.

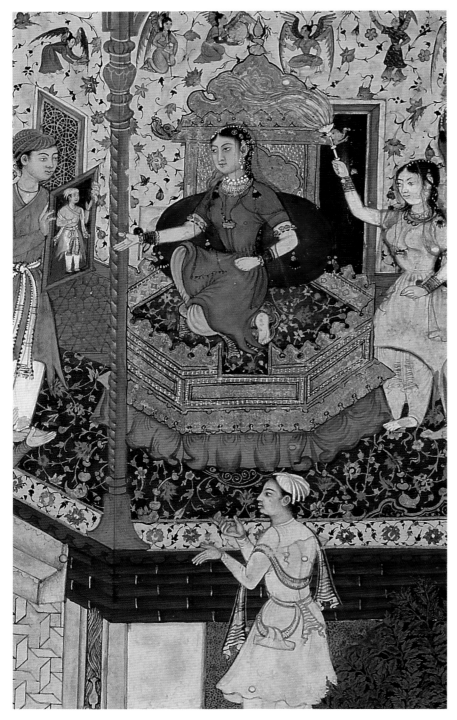

Detail from Figure 9.3

Figure 9.3 (opposite)

Beauty is shown the portrait of
Heart. Leaf from a dispersed
manuscript of Fattahi, *Husn u
Dil*, copied c. 1570–75. Bound
in an 18th-century Mughal
album.
Bodleian Library, University of
Oxford, MS. Pers. b.1, fol. 28v.

Bodleian Library (Figure 9.3).[6] In this work the mysti-
cal quest is symbolised through the personification of
the human faculties in a tale of princely lovers, Heart
and Beauty. Heart, prince of the West and governor of
the city of Body, sends forth his emissary Vision to
seek the miraculous Water of Life. Vision sets out and
eventually encounters Attention, king of the city of
Direction, who tells him the Water of Life is difficult to
find 'because there is no road to it, nor person who
knows in which direction it lies'.[7] But in the East is a
king called Love, with a matchless daughter named
Beauty, who dwells in a garden where the Water flows.
Arriving at this garden after many perils, Vision is able
to reveal to Beauty that a mysterious image in her
possession is in fact the portrait of his own master
Heart. Beauty thereupon falls in love with the prince,
recognising him as her soul mate although still sepa-
rated from him. After many further adventures the
lovers are ultimately united. In this illustration by an
unknown Mughal painter, Beauty sits enthroned in an
elegant pavilion adorned with wall-paintings of Persian
peris (fairies) among arabesques; the image of Heart
which is held up for her to contemplate is shown as a
contemporary Mughal portrait painting.

The *Baharistan* ('Garden of Spring'), composed by
the poet Jami in 1487, is divided into eight chapters or
'Gardens', comprising edifying stories interspersed with
verses on the model of Sa'di's classic, the *Gulistan*.
The fifth Garden is devoted to the subject of love, and
two of the six illustrations to Akbar's superb copy of
the work depict stories taken from this chapter. One
tells of a sudden attraction between a youth and a
beautiful singing-girl (Figure 9.4). In the artist Madhu's
illustration,[8] the young man stands captivated by the
love song that the girl is practising, high on a terrace
of her master's house: 'What happiness for the lover,
deprived of the sight of his beloved, to hear her words
behind the wall of separation!'[9] In the background a
walled garden is shown bursting out with blossoms,
floral sprays and a spreading palm tree. Meanwhile,
looking out and seeing the youth below, the master
courteously invites him in and converses with him.
But the youth and the girl have eyes only for each
other. When the master leaves the room, they both
express their ardent longing. Ultimately the young man
declares that this ephemeral love must be renounced,
since it could only turn to bitter enmity on the day of

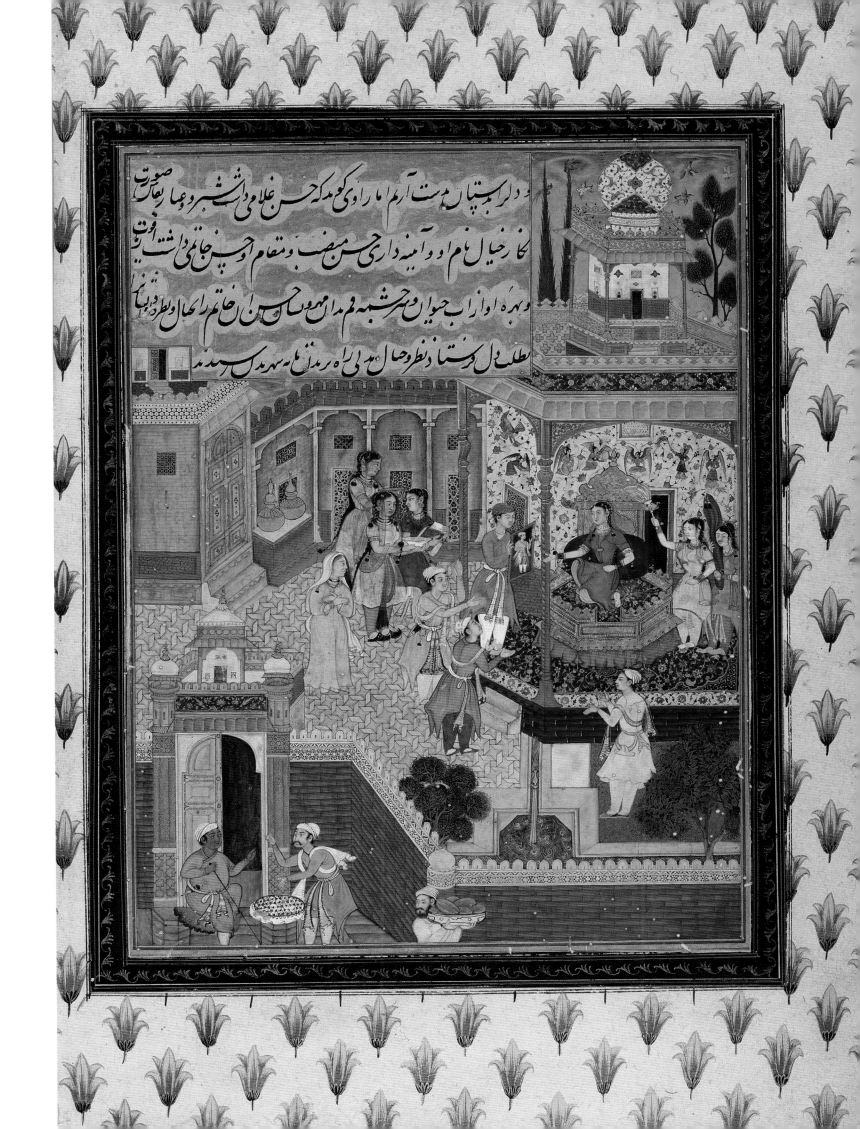

Detail from Figure 9.3

Figure 9.4 (opposite)

The youth and the singing-girl.
Leaf from a disbound manu-
script of Jami, *Baharistan*,
copied for Mughal Emperor
Akbar, dated year 39, Ilahi era,
reign of Akbar (1595), Lahore,
painted by Madhu.
Bodleian Library, University
of Oxford, MS. Elliott 254,
fol. 35v.

Figure 9.5 (pages 108–9)

Majnun among the animals
(right); the youth thrown to the
king's dogs is unharmed (left).
From a Mughal manuscript
of Nizami, *Layla u Majnun*,
copied c. 1590, painted by
Dhanwan and Asi, respectively.
Bodleian Library, University
of Oxford, MS. Pers. d. 102,
pp. 65–66.

judgement. This tale may appear a conventional homily
in favour of chastity, but as so often Jami may intend
a further level of meaning intelligible to the Sufi ini-
tiate, relating to the mystical path rather than carnal
passion.[10]

By the 18th century, several popular Islamic or
Indian romances that were sometimes used for similar
esoteric interpretation had become firmly established
in a general North Indian artistic repertoire. Recurring
subjects within the Bodleian corpus include, for exam-
ple, Yusuf and Zulaykha or the tragic Punjabi village
lovers Sohni and Mahinval. However the most influen-
tial theme of all was that of Layla and Majnun. In this
old Arab story, the young Qays is driven mad (*majnun*:
'possessed by *jinn*') by his all-consuming love for the
unattainable Layla. Separated from her, he leaves the
city of reason to wander among the wild beasts of the
desert, which soon fall under his spell: in Nizami's
words, 'If Majnun rested the place soon looked like an
animal camp. He became a king among his court like
Solomon'.[11] For Sufis from the 9th century onwards,
Majnun's single-minded love became an image of the
devotee seeking the ultimate goal of *fana fi Allah* or
'annihilation in God'. The story was later treated in
various literary versions,[12] in Persian above all by
Nizami as part of his *Khamsa* ('Quintet') in 1188, and
later by Amir Khusrau of Delhi in his own *Khamsa* of
1298–99, deriving from that of Nizami. Another source
for the story's influence in Mughal India was the great
Sufi *Masnavi* of Jalal al-din Rumi, who refers to Majnun
as an exemplar of the divine madman in his all-embrac-
ing love for Layla. The *Masnavi* was a favourite text
among the Chishti saints of Delhi and it became so also
for Akbar and his descendants,[13] including Prince Dara
Shikoh, his fratricidal brother the emperor Aurangzeb
(r. 1658–1707), and the latter's daughter, the poetess
Zeb-un Nisa'.[14]

Narrative elements deriving from both Nizami and
Amir Khusrau's versions are evident in the numerous
paintings of the Layla–Majnun theme produced by
Mughal and provincial artists from the 17th to mid-
19th century. Among the canon of illustrative subjects
within the manuscript tradition, that of Majnun among
the animals later became by far the most dominant
image, reworked or reinterpreted in countless single-
page paintings. Among the versions in the Bodleian
Library, the earliest is that of Dhanwan in the Atkinson

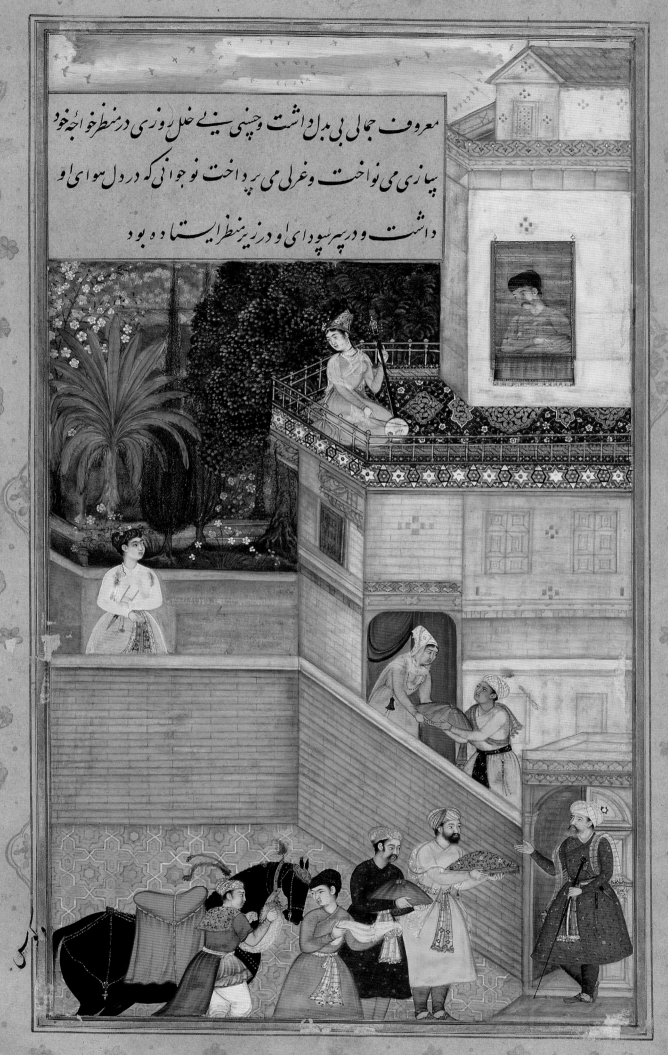

معروف جمالی بی بدل داشت و حسنی سینه خلل روزی در منظر خواجه خود
بازی می نواخت و غزلی می پرداخت نوجوانی که در دل هوای او
داشت و در پی سودای او در زیر منظر ایستاده بود

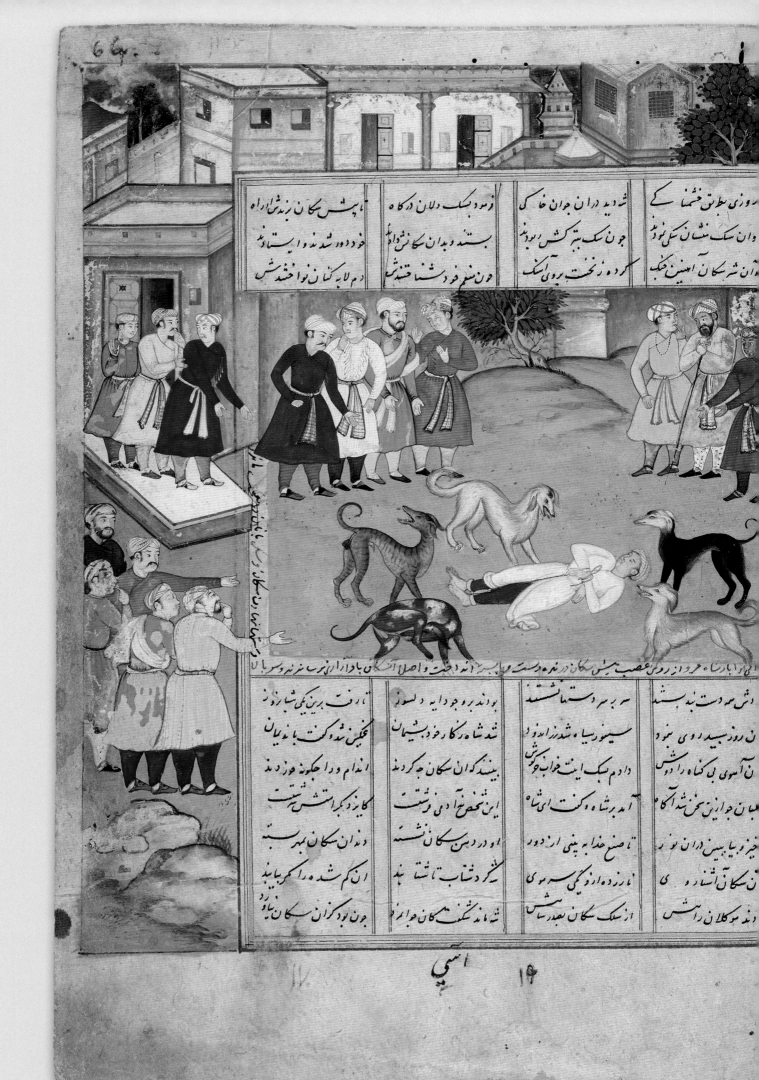

"66" "١٦" "اسپ".







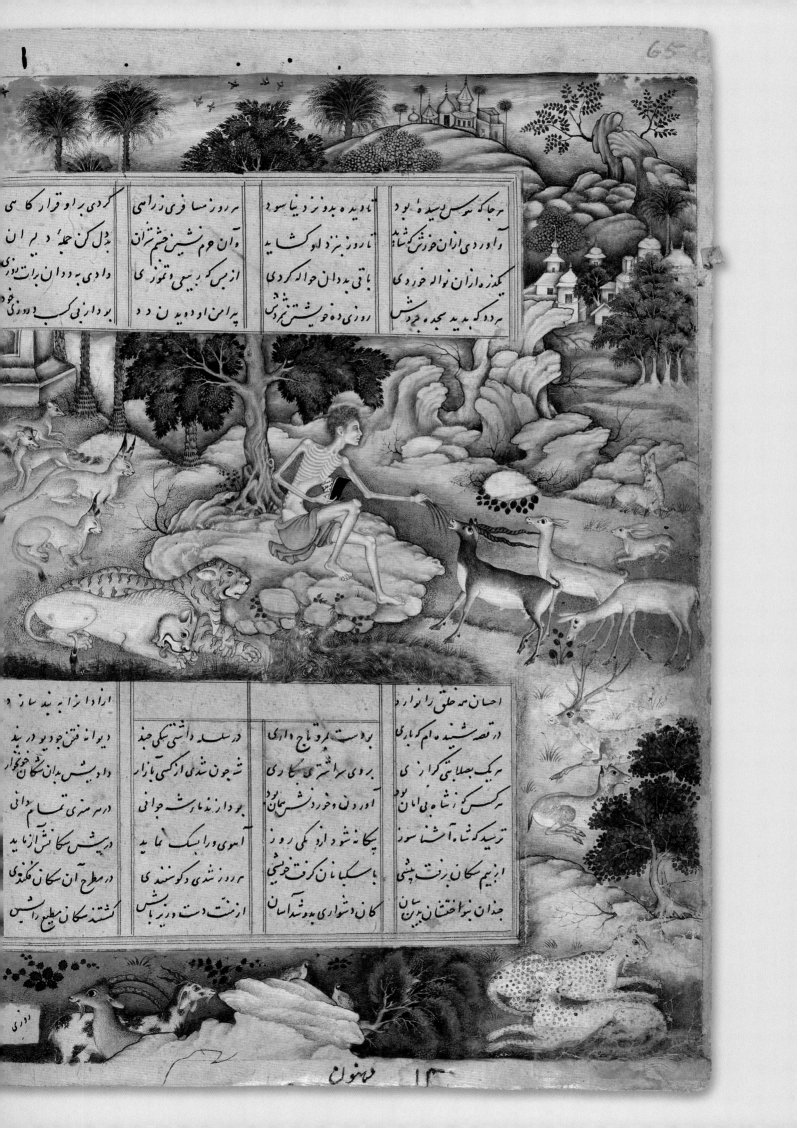

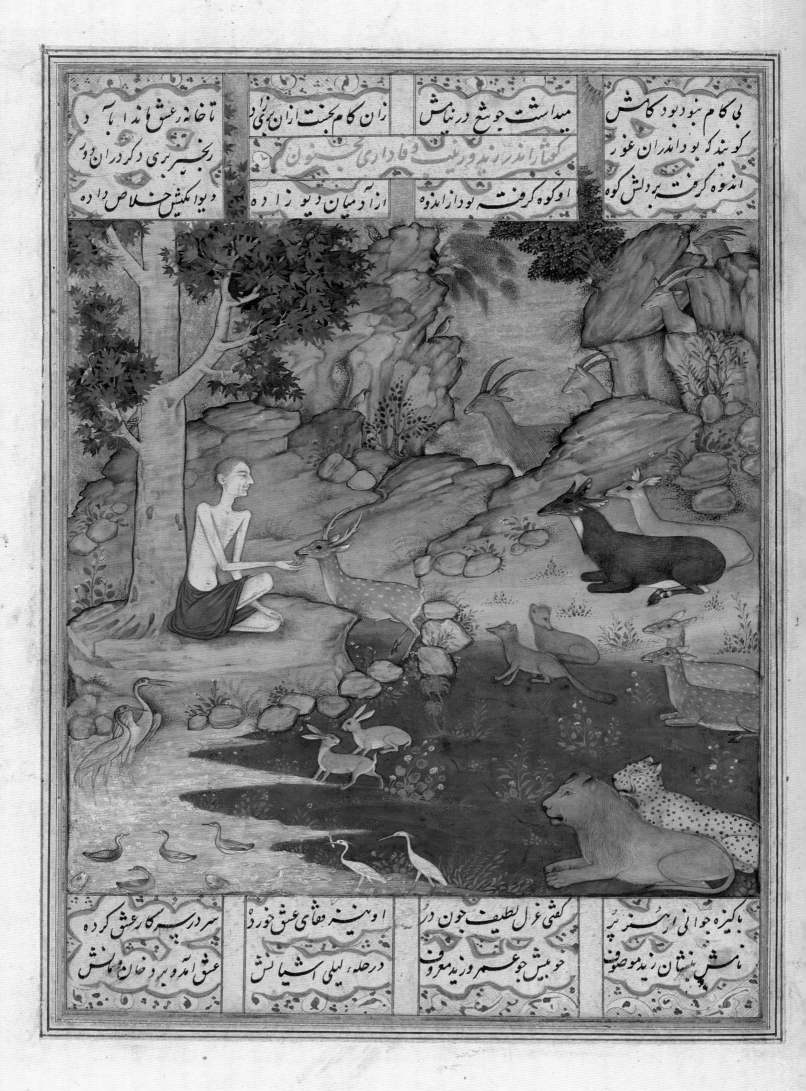

بی کام بنو دبود کامش میداشت جوشع در نیایش زان کام بخبت ازان نبی آد تا خانه عشق اندا آد
کویند که بو دا ندران غنوز کنار اندر زید ورنیک فا داری الحسنون رنجبر بری دکمر در ان او
اندوه کرفت بر دلش کوه او کوه کرفت بو دا ز اندوه از آدمیان ویو زا ده دیوا کنیش خلاص زا ده

باکیزه جوانی از حسنه پر کسی غزل لطیف جون در او ہینه فقای عشق خورد سر در پس کار عشق کرده
ہاش پی نیشان زید موصوف خوہ بش جو عمر ورید معروف در حله، لیلی اشیا یس عشق آ د وبر د خان رہانش

Layla u Majnun manuscript of around 1590 (Figure 9.5, right).[15] The central presiding figure of the emaciated Majnun is seated or enthroned on a rocky outcrop, from which a tree grows above and a flowing stream issues below. Docile herbivores and carnivores are serenely assembled around him in pairs: in this state of ascetic renunciation, 'he lived among all these creatures like an exiled ruler in a foreign country'.[16] The image of the sage or yogi who pacifies wild animals generally symbolises the ascetic's successful conquest of the inner passions, in Sufi terms the *nafs* or lower self, which is sometimes described as a dog or other unruly animal whose appetites or impulses must be disciplined and not indulged.[17] This theme is aptly complemented in the facing page of the manuscript, illustrating Nizami's subsequent tale of dangerous hounds that are cleverly tamed (Figure 9.5, left).[18] One day a blameless young courtier was cruelly punished by an irascible king, who ordered him to be thrown to the royal dogs. But the youth remained wondrously unharmed, as these ferocious beasts merely stood round him wagging their tails. As he would later explain, he had for some time taken the precaution of feeding them regular titbits and thus befriending them.

An illustration of Majnun among the animals that appears to have been painted slightly later[19] shares such familiar conventions as his throne-rock with its verdant tree (here a Persian-style chenar or Oriental plane) and a flowing stream in which the fish and waterfowl are as enthralled by his presence as are the land birds and quadrupeds (Figure 9.6). In contrast to the Mughal receding landscape seen in Figure 9.5 (right), with its distant buildings on hill ridges, the composition is shallower in treatment and closer to the earlier Persian tradition with its gold-ground sky and craggy rock formations.

In a frequent variant of the theme deriving from Amir Khusrau's version, Layla is shown visiting Majnun in the wilderness for their only reunion, having arrived there on a riding-camel (Figure 9.7).[20] She sits near him holding open a book (perhaps of his impassioned verses), while the gaunt Majnun strokes his canine companion. Painted in a semi-grisaille style, this tall landscape composition and its artfully grouped terrestrial and aquatic beasts derive from an influential prototype conceived by the artist Miskin in the late 1590s, showing his skill and sensitivity as an animal painter and his compositional dexterity.[21] This version of Miskin's model is probably of the 1640s, though enlarged above and below when mounted in its present album in the following decade. The facing page in the album is a related composition of c. 1595–1600, which depicts King Solomon as the archetypal just ruler of all creation,[22] holding court among the animals, *peris* (fairies) and *divs* (demons) in much the same way as Majnun (whom Nizami indeed described as 'a king among his court, like Solomon').

An unusual variation of this pictorial theme, somewhat less clear in its symbolic meaning, is found in the same album (Figure 9.8).[23] It was painted around 1600 by Muhammad Sharif, son of the great Persian master 'Abd us-Samad and a childhood friend of Prince Salim (the future emperor Jahangir). Salim himself felt a strong personal identification with the figure of Majnun, especially in his grief following the execution in 1600 of his beloved, the legendary Anarkali, an event that also occurred around the time of his revolt against his father Akbar.[24] In this composition, which Salim and his artist friend and ally may have conceived jointly, the prince kneels in supplication before a bearded Sufi shaykh wearing a plain, pale turquoise-blue robe in a rocky landscape setting. Carnivores from a leopard to a lynx attend the shaykh, indicating the power of his presence to subdue wild beasts (or the *nafs*, the lower self). Although wearing blue, not green, the shaykh figure may relate at a narrative level to the old man resembling Khizr ('the Green One': the Sufis' divine messenger figure) who appears briefly in Nizami's romance; or it could perhaps also allude to a particular shaykh venerated by Salim at this time from whom he had sought counsel or received solace.

By the 18th century, Majnun among the animals (with or without the figure of Layla) had become a stock subject in numerous regional painting schools, at the Rajput courts of Rajasthan and the Punjab Hills as well as in provincial Mughal and Deccani centres. Versions by the later provincial Mughal painters had become largely conventional and uninspired, though sometimes showing a naive charm in their reworking of the familiar subject matter. But within the cultural milieu of the Muslim courts, the story's Indo-Persian literary sources and its poetic nuances and attributed inner meanings continued to be most fully appreciated. Elsewhere in northern India the story would attain a

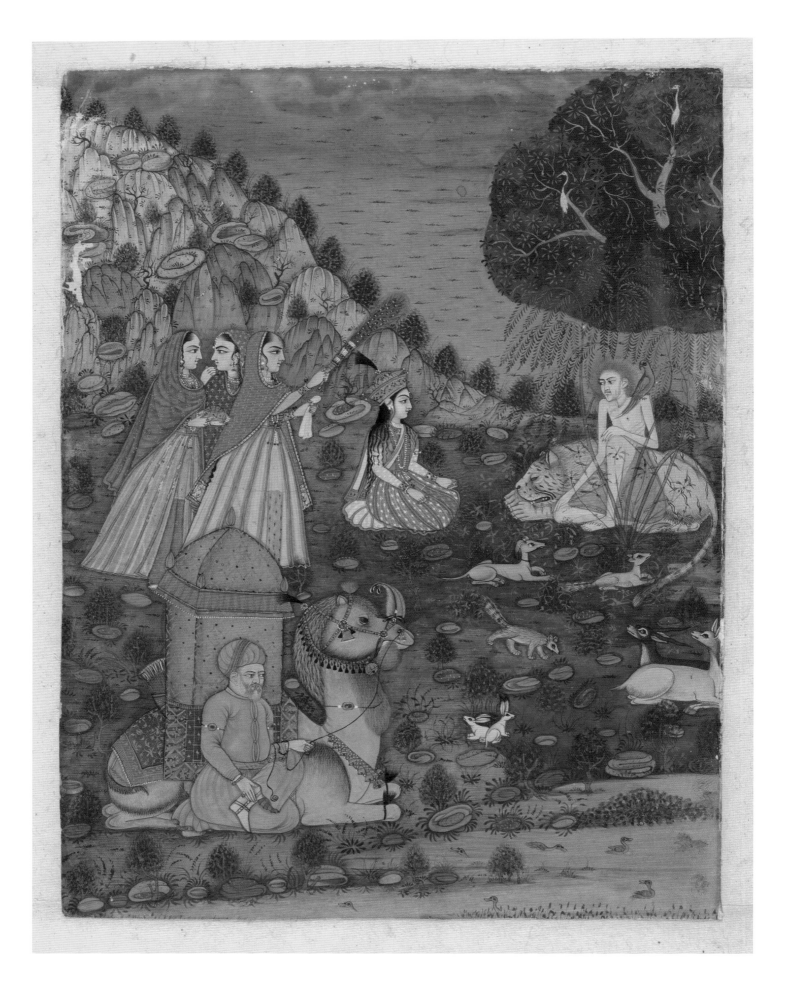

wide but in some degree banal popularity as a tale of tragic love comparable to *Romeo and Juliet*. With rare exceptions[25] its pictorial renderings also became more formulaic and remote from their original source.

A Rajasthani version of Layla's visit to Majnun, in the National Gallery of Victoria,[26] derives from earlier Mughal examples[27] in placing Majnun under a tree to the right of the composition, seated against a lion as his throne cushion, though here it has the markings of a tiger (Figure 9.9). There are unusual Persianate features in the pinkish-mauve rocky hills and scattering of similar rocks in the foreground. Layla, in the dress of a noblewoman, sits facing Majnun attended by her maids, one waving a *morchal* (peacock-feather fan). Her riding camel and its driver assume a prominent position in the foreground, more so than the little group of smaller animals in front of Majnun. The artist moreover embroiders his theme with one or two extraneous references. As sleeping tigers are often conventionally depicted half-concealed among tall grass, here thin willow fronds provide similar cover for both the animal and Majnun. Gazing pensively at Layla as usual,

Majnun also has on his shoulder a green parrot, a bird which occasionally appears as an attribute of emaciated *bhang*-drinkers in genre paintings of drug addicts.[28] It is, however, a painting still recognisably within the mainstream Layla–Majnun pictorial tradition.

This holds less true of a 19th-century Rajasthani version in the same collection,[29] in which a similar compositional model is pared down to its elements within a largely empty, bluish-green landscape typical of Udaipur painting in the late 1830s (Figure 9.10). Here Majnun's companion animal (or throne-cushion surrogate) is a small blue hound, while a lion and *nilgai* (Asian antelope) appear as token attendant animals in the foreground. While Majnun gazes at Layla, she turns away in three-quarter face with an air of distraction. One of the maids also gazes off behind her, and two others are oddly half-hidden in a depression in the foreground. The image still retains a certain quaint charm, but one wonders quite what the artist was aiming at. By this time, and at this staunchly traditionalist Hindu court, there is a palpable disconnection between the Layla–Majnun theme and its living Indo-Persian sources.

Andrew Topsfield has been Curator of Indian Art at the Ashmolean Museum, Oxford, since 1984 and Keeper of Eastern Art since 2009. He has written many catalogues and articles on Indian painting in the Mughal period and related subjects. His books include *Court Painting at Udaipur* (2002) and *Paintings from Mughal India* (2008).

left: Detail from Figure 9.8

Figure 9.9 (opposite)

Layla visits Majnun. Rajasthan, painted 18th century. National Gallery of Victoria, Melbourne, AS 62-1980.

Figure 9.10 (page 117)

Layla visits Majnun. Udaipur, Rajasthan, painted c. 1835–40. National Gallery of Victoria, Melbourne, AS 272-1980.

Notes:

1 Annemarie Schimmel, *The Empire of the Great Mughals: Art, History and Culture* (London: Reaktion, 2004), 263–70, for a summary account of Akbar's literary tastes.

2 Bodleian MS. Pers. d. 102; it formerly belonged to James Atkinson, author of the first English verse translation of Nizami's text, *The Loves of Laili and Majnun* (1836). The MS has nine illustrations: e.g., A. Topsfield, *Paintings from Mughal India* (Oxford: Bodleian Library, 2008), nos 8–10; A. F. L. Beeston, 'The Atkinson *Laila Majnun*', *Bodleian Library Record* IV, 2 (1952): 63–6; Bodleian Library, *Mughal Miniatures of the Earlier Periods,* Bodleian Picture Bk No.9 (Oxford, 1953), figs. 1–7.

3 Bodleian MS. Elliott 254, e.g., Topsfield, *Paintings from Mughal India*, nos 12–17; J. P. Losty, *The Art of the Book in India* (London: British Library, 1982), no. 64.

4 As suggested in recent years by Saqib Baburi, e.g., in his paper 'In Search of Heroism: Rustam and Sultan Muhammad Shahshuja Bahadur, Prince of Bengal' given at the Cambridge *Shahnama* conference, December 2010. I am grateful to Robert Skelton for discussing this interpretation of the album's patronage with me in 2008 (in the light of which several identifications of portrait subjects from this album given in my *Paintings from Mughal India* are in need of correction).

5 The text is itself a short summary of the long epic *Dastur-i 'Ushshaq* ('Handbook for Lovers') of 840 (1436–67): J. Rypka, *History of Iranian Literature* (Dordrecht: Reidel, 1968), 284–5. It was translated by William Price, Assistant Secretary to Sir Gore Ouseley, under the title *Husn oo Dil or Beauty and Heart, A Pleasing Allegory in Eleven Chapters, Composed by Alfettah of Nishapoor* (London: Parbury, Allen & Co., 1828).

6 Topsfield, *Paintings from Mughal India*, no. 5; I. Stchoukine*, La peinture indiennne à l'époque des Grands Moghols* (Paris: Leroux, 1929), pl. VII. This album passed into the family collection of a British official in India and was purchased by the Bodleian in 1888 from an Inverness bookseller for four guineas.

7 Price trans., *Husn oo Dil*, 5.

8 Topsfield, *Paintings fom Mughal India*, no. 16.

9 After H. Massé trans., *Le Béharistan* (Paris: Geuthner, 1925), 111.

10 The other story from this chapter illustrated in Akbar's copy (by the painter Miskin) is an Arab tale of the adulterous love between Ashtar and Jayida, who consort by night in the wilderness: Topsfield, *Paintings from Mughal India*, no. 17. It may be noted also of a preceding illustration by Mukund (fol. 29r) that, while belonging to Jami's fourth chapter, on the subject of generosity, it too explores a theme (comparable to 'The youth and the singing-girl') of the sudden ardent love for a slave girl that affects a learned theologian, who, while walking in the street, overhears her singing: Topsfield, no. 15.

11 R. Gelpke trans., *The Story of Layla and Majnun* (Oxford: Cassirer, 1966), 135.

12 *Encyclopaedia of Islam*, 2nd edn, vol. 5 (Leiden: Brill, 1986), s.v. 'Madjnun Layla'.

13 Annemarie Schimmel, *Mystical Dimensions of Islam* (Chapel Hill, NC: University of North Carolina Press, 1975), 327.

14 A connection may be noted in passing between this learned princess and the Bodleian, which possesses a charming illustrated *Gulistan* of Sa'di (MS. Pers. d. 43), with some lively border illustrations, which formerly belonged to her library: Topsfield, *Paintings from Mughal India*, no. 47.

15 Topsfield, *Paintings from Mughal India*, no. 9.

16 Gelpke trans., *Layla and Majnun*, 136.

17 Schimmel, *Mystical Dimensions*, 112–13.

18 Topsfield, *Paintings from Mughal India*, no. 10.

19 Topsfield, no. 22.

20 MS. Douce Or. a. 1, fol. 52r: Topsfield, *Paintings from Mughal India*, no. 30; E. Koch, 'The Mughal Emperor as Solomon, Majnun and Orpheus', *Muqarnas* 27 (2010): 291, fig. 20, with further thematic analysis; M. Aitken, *The Intelligence of Tradition in Rajput Court Painting* (New Haven, CT: Yale University Press, 2010), fig. 4.18 (there attributed to Miskin, in my view incorrectly), 170–4 et seq. with further discussion of Layla–Majnun paintings of the Mughal and Rajasthani schools.

21 P. Vaughan, 'Miskin', in P. Pal, ed., *Master Artists of the Mughal Court*, (Mumbai: Marg Publications, 1991), 17–38.

22 MS. Douce. Or. a. 1, fol. 51v: Koch, 'The Mughal Emperor,' fig. 21.

23 MS. Douce Or. a. 1, fol. 36v: Topsfield, *Paintings from Mughal India*, no. 24; Koch, 'The Mughal Emperor', fig. 22, 295, 303–4, with further discussion and a differing interpretation of the shaykh figure as Salim's father Akbar.

24 Topsfield, *Paintings of Mughal India*, 171, n. 18; Koch, 'The Mughal Emperor'. I am again grateful to Robert Skelton for his helpful communications on this topic at various times. Some of his most original speculations, such as the identification of Anarkali with the female artist Nadira Banu, remain unpublished outside the lecture room.

25 For example, the spirited reinterpretation by the eccentric Mewar painter Chokha, c. 1810–15, in the Jagdish and Kamla Mittal Museum, Hyderabad: Stuart Cary Welch, *Indian Drawings and Painted Sketches* (New York: Asia Society, 1976), no. 9; J. Mittal, *Sublime Delight through Works of Art* (Hyderabad: Jagdish and Kamla Mittal Museum, 2007), pl. 15; Aitken, *The Intelligence of Tradition*, fig. 4.1.

26 A. Topsfield, *Paintings from Rajasthan in the National Gallery of Victoria* (Melbourne: National Gallery of Victoria, 1980), no. 46; Aitken, *The Intelligence of Tradition*, 198, fig. 4.24.

27 Aitken, *The Intelligence of Tradition*, figs 4.33–36.

28 E.g. D. Ehnbom and A. Topsfield, *Indian Miniature Paintings* (London: Spink and Son, 1987), no. 3 (now in the Ashmolean Museum, Oxford). The 'green parrot' and 'parrot of mysteries' are Persian nicknames or euphemisms for hashish: E. G. Browne, *A Year amongst the Persians* (London: Black, repr. 1970), 569, n.1; E. G. Browne, *A Literary History of Persia* (Cambridge: Cambridge University Press, 1964), II, 205. The Hindu god Shiva as a Tantric ascetic is also popularly associated with cannabis in the form of *bhang*; in an unusual Pahari painting iconography he is even depicted riding the green parrot as his *vahana* or divine vehicle: T. R. Blurton, *Hindu Art* (London: British Museum, 1992), fig. 121.

29 Topsfield, *Paintings from Rajasthan*, no. 257; Aitken, *The Intelligence of Tradition*, fig. 4.25.

بنام آنک دلرا وصل جان داد
تعشق ترا بر و حکم روان داد

گل رخسار و سرو قامت دوست
نمود آثار قدرت اوست

چراغ گل ز گلشن برفروزد
دل بلبل ز عشق گل بسوزد

چو کرد ش بندگی شد سرو آزاد
ز لطفش مستوی قد کشت شمشاد

مدام از جام شوقش مست نرگس
شراب عاشقی بر دست نرگس

چو ریحان خط سنبل مشک بو کرد
گل از خار و ز گل نسرین برآورد

نسیم باد از لطفش روان بخش
ز فیض فضلش آب خضر جانبخش

گلستان شد ز صنع او دل افروز
چو گلزار بهشت عدن نوروز

رخ معشوق را رنگین کنی ساخت
بدیع خوش نفس را بلبلی ساخت

AN OTTOMAN 'GARDEN OF LOVE'

The Oxford Dilsuznama, *the 'Book of Compassion'*

Susan Scollay

*The garden of Love is green without limit
and yields many fruits other than sorrow or joy.*

RUMI, *Masnavi* I, verses 1805–6

OF the many significant eastern manuscripts in the collection of the Bodleian Library at the University of Oxford, the *Dilsuznama*, MS. Ouseley 133, dated 860 (1455–56), is one of the earliest known literary works of Ottoman production. It is one of very few dated examples from the formative Ottoman period, yet until recently the manuscript has been little studied or published.[1] The small, bound volume carries an inscription on its third leaf, folio 3r, that identifies it as a copy of the love story of the Rose and the Nightingale composed by 'the prince of modern poets, the paragon of versifiers and prose writers, our master' Badi' al-Din Manuchihr al-Tajiri al-Tabrizi. Badi' al-Din was a little-known poet from Tabriz in north-west Iran who had travelled with his merchant father in Anatolia in 1391–92.[2] The story recounted in the *Dilsuznama* has been copied in Persian, the language in which it was originally composed. Its last folio, 105r, is inscribed in Arabic language in gold script set within a lozenge-shaped compartment, stating the work was copied 'in the year 860 [1455–56] in the city of Edirne', in Ottoman-controlled Thrace. The scribe and the illustrator are not identified (see Figure 10.8).

The work is a mystical treatise, a Sufic mystical text, whose title, *Dilsuznama*, means the 'Book of Compassion' or 'Book of Heart Burnings' (in Persian, *dil* means heart, *suz* means burning). An additional note on the third leaf says the manuscript was once owned by Mustafa bin Ibrahim in 1130 (1718). In 1840 the book entered the collection of the Bodleian Library, University of Oxford, after its purchase from Sir William Ouseley (1767–1842).

The *Dilsuznama* manuscript measures only 165 mm x 114 mm, a format that would allow it to be carried by its owner from place to place or be read in an outdoor setting, rather than being confined to library use. Its 105 folios include an illuminated frontispiece embellished with gold leaf and five leaves illustrated with miniature paintings, also embellished with gold leaf. It is written in clear *nasta'liq* script in two columns with no marginalia (Figure 10.1).

Its small size and relatively modestly illustrated pages belie the significance of what may be deduced from the *Dilsuznama*'s textual and visual contents and the context in which it was produced. Few Ottoman manuscripts remain from the period up to the pivotal era of Mehmet II's 1453 siege of Constantinople, and its transforma-

tion into Istanbul, the third and last Ottoman capital. Not only was the Oxford *Dilsuznama* produced at a critical time in Ottoman history, but it serves as an example of the way Persian stories, and the poets who wrote them, travelled from place to place. In the process, the tales and poetic language in which they were framed contributed to a way of life and culture that was appreciated and understood beyond the borders of Iran, traversing a wide swathe of territory that eventually stretched from south-eastern Europe to the western fringes of modern-day China. This cultural sphere included the ever-expanding territories of the Ottoman empire.

From modest beginnings in the early 14th century, the Osmanli Turks, later known to Europeans as the Ottomans, expanded their territory in western Anatolia, the part of modern-day Turkey that lies in Asia. As Byzantine and Seljuq power bases yielded, the Ottomans crossed into south-eastern Europe in 1360, establishing their second capital at Adrianople, a Byzantine city they referred to as Edirne, the name used to this day.

Little is known of the literary tastes of the early sultans, but like their fellow Turkic rulers in later empires – the Mughals in India and the Safavids in Iran by the early 16th century – the Ottomans developed their imperial style incorporating elements of Persian culture and its ancient Iranian prototypes.[3] The cosmopolitan Seljuq capital, Konya, had already fostered an artistic and literary community where Maulana Jalal al-Din Rumi wrote his famed verses in his native Persian, but also in the languages of his adopted home, Turkish and Greek.[4] By the reign of Sultan Murad II in the middle of the 15th century, Edirne was a cultural centre of note in the Timurid style, attracting scholars, poets and artists from across the Ottoman territories and also from regions beyond its borders that shared the interrelated way of life and civilisation of Turko-Persian culture.

Like other Muslim rulers keen to extend the appearance of legitimacy and power, Murad II and his son and successor, Mehmet II, collected luxury editions of classic Persian poetic works, some of which were translated into Ottoman Turkish.[5] As well as being active patrons, both sultans also wrote poetry in the Persian-language literary tradition, sometimes alluding to the gatherings they frequented beside the riverbanks and pleasure gardens of Edirne, at which local wine was served and musicians, singers and poets entertained the royal entourage:[6]

> *Saki*! Bring back my wine of yesterday!
> Make your tongue sing! Bring back my harp and
> *rebec*!
>
> While I am alive, I need this pleasure and
> enjoyment:
> A day will come when no-one will see my
> mortal form.[7]

For a period during his thirty-year reign Murad II abdicated, leaving Prince Mehmet, later Mehmet II, the Conqueror, to rule in Edirne from 1444 to 1446. Chronicles refer to at least one calligrapher or illuminator from Shiraz in southern Iran being hired during this period to work on manuscripts directly linked to court production.[8] Murad's death in 1451 came at a key time in the transformation of Ottoman identity to a grander, more imperial vision. In accordance with his father's plans, Mehmet II completed the construction of a new imperial palace already begun north-east of Edirne, where the confluence of the Tunca and Maritza rivers forms an island among verdant meadows. It was a place where previous sultans had enjoyed hunting parties, literary gatherings and other celebrations including the circumcision festival and wedding party of Mehmet while still a prince.[9] The energetic new sultan ordered extensive planting of trees, tulips and rose gardens. He enlarged his father's libraries, adding volumes not just in Persian and Turkish but also in Greek and other European languages in accordance with his own interests and talents. There was a library near the treasury in the main building of the newly built palace.[10]

Here, deep in south-eastern Europe, the Ottomans were further west than any Turkic Muslim group had ever settled. Despite their close proximity and necessarily harmonious interaction with the Christians who formed the majority of the population of their newly conquered European territories, the Ottomans still looked primarily to Persianate models for their royal palaces, their courtly behaviour, their manner of dress, their books and literary culture.

At that time Mehmet II had still not made a permanent move to the new capital in Istanbul. He was fond of Edirne, and lived mostly in the new palace complex beside the river while royal residences in Istanbul were

لنه واجب ايتمشلردكم هرمسلمان كه اننه كله بونلر آنی ضیافت ایدهلر وقفنق

برکلسه قرغه پنجردن باشنی ایچروبه صوقوب برکة اوانایدی ایکی

قوبق کلسه ایکی کرة اوان ایدی والحاصل قوبنق عددنجه اوترکشنیلر

بونندن قوبنق نفدر کلدوکن بیلورلر الحاکمه طعام ایدرلر واولـــ

کلیسا اهلیدیرلر اول قرغه دایما بونده اولورنه اکی ایتدرکن وقانندکلدوکن کشمه بلن

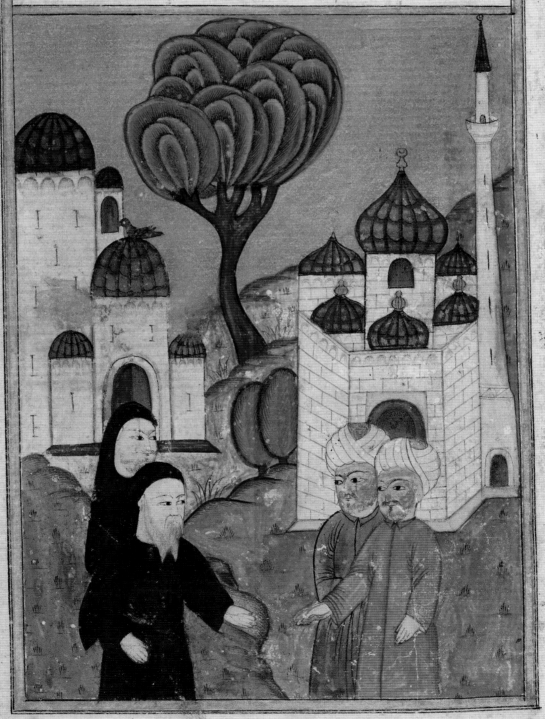

under construction. The Edirne palace in its garden setting also served as a setting-off point and supply centre for his many military campaigns into the Balkans. The royal libraries, ateliers and palace school for training military leaders and high-level administrators remained in Edirne until at least 1458[11] but it is not known whether the Oxford *Dilsuznama* manuscript was linked to any of these institutions.[12]

While the exact circumstances of its production remain uncertain, the manuscript's exordium or opening, while praising God in the conventional way, leaves the reader in no doubt as to its theme:

> In the name of Him who fused heart to soul,
> Summarily commanding it to be alive with love.
>
> … He lights the lamp of the rose in the lower
> garden,
> He makes the nightingale's heart burn with love
> for the rose.
>
> … He made the Beloved's face like a bright red
> rose
> He made the poet Badi' a sweet-singing
> nightingale.
>
> … I had a lovely friend more delicate than a rose,
> I was in love with her face like a nightingale.

The romance of the Rose and the Nightingale inspired Persian and Turkish poets at all levels of society, and acquired allegorical and mystical dimensions through the works of renowned Persian Sufi poets such as Sa'di (d. 1292), Khwaju Kirmani (d. 1351), Hafiz (d. 1390) and Kamal Khujandi (d. 1400), who was the teacher of Badi' al-Din, the author of the *Dilsuznama* story.[13] The longing of the nightingale for the rose and the pain of its separation from its earthly beloved is compared to the eternal longing of the human soul for the Divine.[14]

In Badi' al-Din's interpretation of the standard Rose and Nightingale story, the narrative has been 'improved' by some variations;[15] a charming example of the admired literary technique of emulation (*tazmin*), embellished by a degree of creativity and recognisable references to the Qur'an and to classic love stories in the Persian literary tradition. The tale is set in a garden, a favoured location for love stories and the illustrations that gave their literary images visual form. The nightingale falls in love with the rose who disguises the mutuality of their passion, by telling him in an exchange of letters that her rival, the thorn, is an obstacle to their union. Meanwhile the rose has been obliged to marry the wind, who intercepts the exchange of letters and in his rage wounds the already suffering nightingale with a well-aimed arrow and imprisons the rose along with her friend and go-between, the narcissus. The nightingale, maddened with grief like Majnun, the legendary thwarted lover, departs in self-imposed exile to the desert (Figure 10.3).[16]

> Thence Nightingale, friendless and driven out
> Sometimes whipped by the wind, sometimes
> lashed by thorns.
>
> His Heart broken a hundred fold because of
> separation from his Beloved,
> Drowned in blood, constricted as a rosebud in
> its sepals.
>
> In a turmoil, heading for the wilderness,
> Like tears streaming between dust and blood.

Some time later the nightingale is forced to leave the wilderness and is reunited with his friend the cypress tree and with the rose and narcissus who have managed to escape their jailer, the wind. The second of the manuscript's miniature paintings depicts the reunion of the lovers, with the rose giving the nightingale a handkerchief as a token of their love (Figure 10.4). To the right of the image, a pair of human lovers, she named Rose and he, Nightingale, repeat the exchange seated in their pavilion, tiled in the manner of the garden pavilions of the newly built palace at Edirne, and overlooking the rose bushes that dominate the painting in terms of scale. The flower heads and the blossoms are very carefully drawn and coloured in exact rendition of the variety of damask roses planted by Mehmet II in the palace grounds.[17]

> Gul had a handkerchief with gold brocade
> She gave it to Nightingale in the hour when she
> was leaving.
>
> She said: keep this in memory of me,
> Oh my beloved, my perfume is in this
> handkerchief so never lose it.

Figure 10.3 (opposite)

Love-mad Nightingale takes to the mountains, despairing at being separated from his beloved. From a manuscript of Badi' al-Din Manuchihr al-Tajiri al-Tabrizi, *Dilsuznama*, dated 860 (1455–56), Edirne. Bodleian Library, University of Oxford, MS. Ouseley 133, fol. 49r.

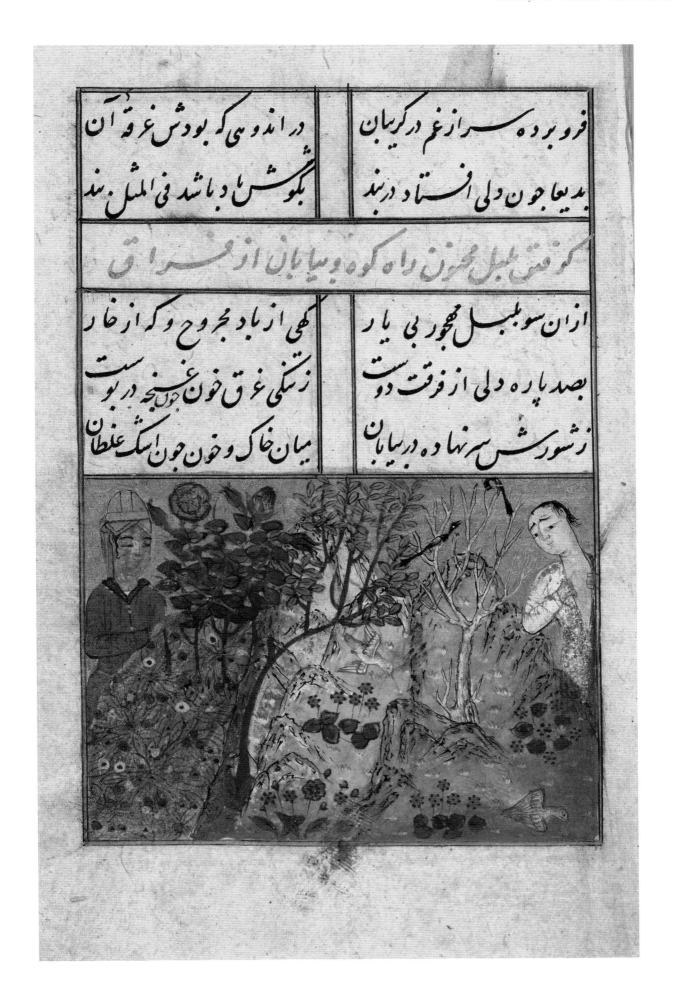

Detail from Figure 10.3

Figure 10.4 (opposite)

Rose gives Nightingale a hand-kerchief as a keepsake. From a manuscript of Badiʿ al-Din Manuchihr al-Tajiri al-Tabrizi, *Dilsuznama*, dated 860 (1455–56), Edirne. Bodleian Library, University of Oxford, MS. Ouseley 133, fol. 62r.

Figure 10.5 (page 126)

Nightingale gives Rose a ring as a keepsake. From a manuscript of Badiʿ al-Din Manuchihr al-Tajiri al-Tabrizi, *Dilsuznama*, dated 860 (1455–56), Edirne. Bodleian Library, University of Oxford, MS. Ouseley 133, fol. 62v.

Figure 10.6 (page 127)

Rose sends her maid to take Nightingale's ring hidden inside a cooked chicken. From a manuscript of Badiʿ al-Din Manuchihr al-Tajiri al-Tabrizi, *Dilsuznama*, dated 860 (1455–56), Edirne. Bodleian Library, University of Oxford, MS. Ouseley 133, fol. 74v.

So that instead of me, your slave, it may
 constantly kiss
Sometimes your ruby lips, sometimes your face,
 sometimes your hands.

When it kisses your hands, then remember me,
And at every moment let your tears drop
 and drench the handkerchief.

For in each weft thread there is an intimate
 connection with me,
And each warp thread is like a sinew that has
 lost its strength.

In exchange for the handkerchief, both text and image tell us the nightingale gave the rose a ring, seen clearly in its beak and echoed in the action of the male lover placing a ring on his beloved's right hand, while she tenderly, but chastely, embraces him with her left arm as their heads incline towards each other (Figure 10.5).

A martyr in the way of love, heart-sore Nightingale
When he received that kerchief from Rose.

He too with many a sigh and moan to Rose,
Gave her from his own hand a ring.

Her silvery hand he kissed as if himself had
 been the ring

Saying 'Oh sweeter than my own life to me.

This only I now have to hand
What choice do I have but to offer that which
 I have?'

Disaster strikes as the rose and narcissus are abducted and sold to Shah Nowruz of Shirvan. Nightingale cries in anguish:

'... Today my eyes have seen the turbulence
 of the Last Days
For they are cutting me off from you, who set
 my heart alight.

You are cut off from me, as the ruby from the mine
With you gone, my soul is left vermiculated,
 full of holes.'

The ruler, 'the exalted Shirvanshah [Shah of Shirvan] of Nowruz [the Spring equinox]', includes rose and narcissus in his courtly festivities. One evening the shah hears the plaintive song of the nightingale, lamenting his ongoing separation from his beloved, and invites the songbird to join the party. The next miniature (Figure 10.6) is placed in the part of the story that describes the rose, who has recognised the nightingale's song, sending narcissus, her maid, to present him with

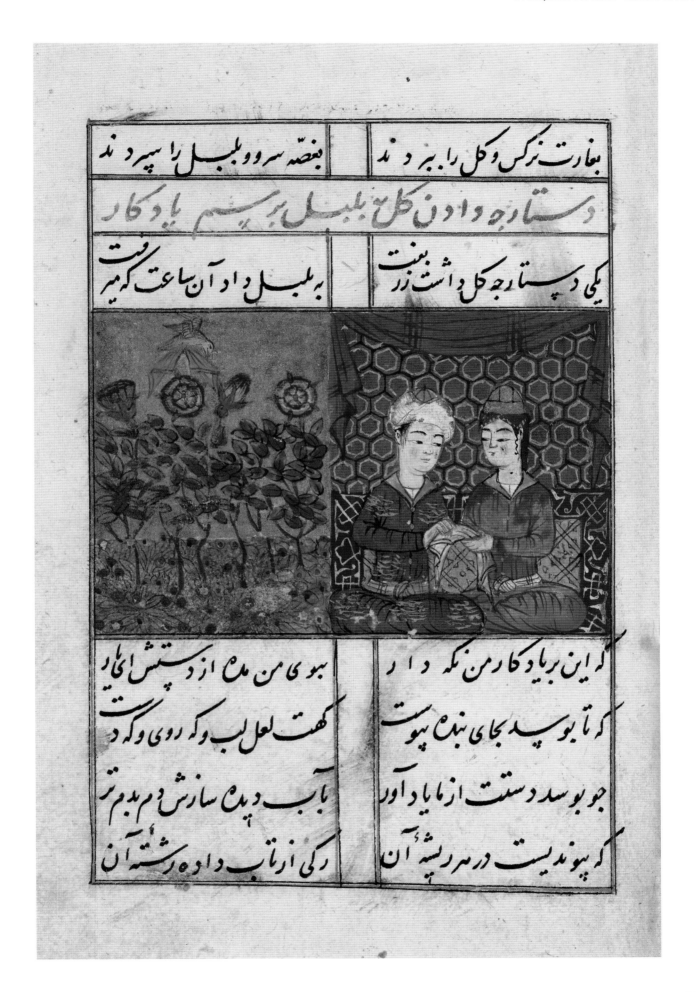

بغارت نرکس و کل را بردند بقصه سرو و بلبل را سپردند

دستار جه دادن کل بلبل بر پسم یادگار دستاره داد آن کل بلبل بر پسم یادکار

یکی دستار جه کل داشت زرنفت به بلبل داد آن ساعت کوبر

که این بر یاد کار من نگهدار بوی من ماه از دستش ای یار

که تا بوسیده بجای نبده بوست بگفت لعل لب و کر روی و که د

جو بوسد دستت از ما یاد آور تاب ده پده سازش دم بدم تر

که پیوندیست در سر رشته آن کی از تاب داده رشته آن

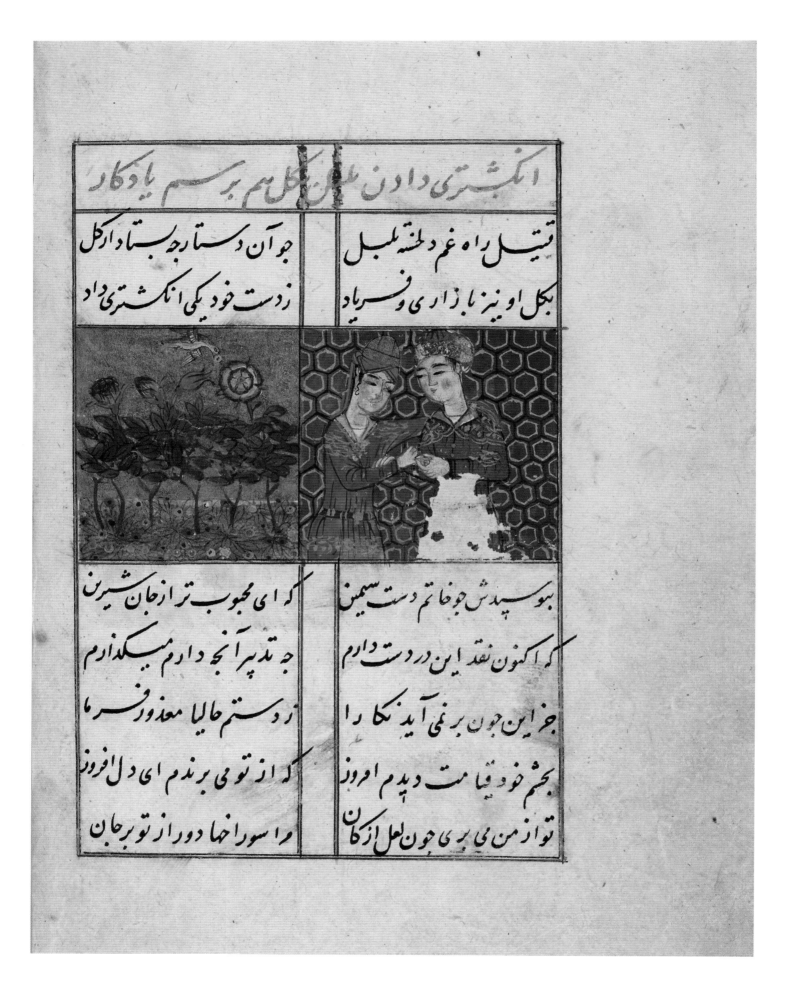

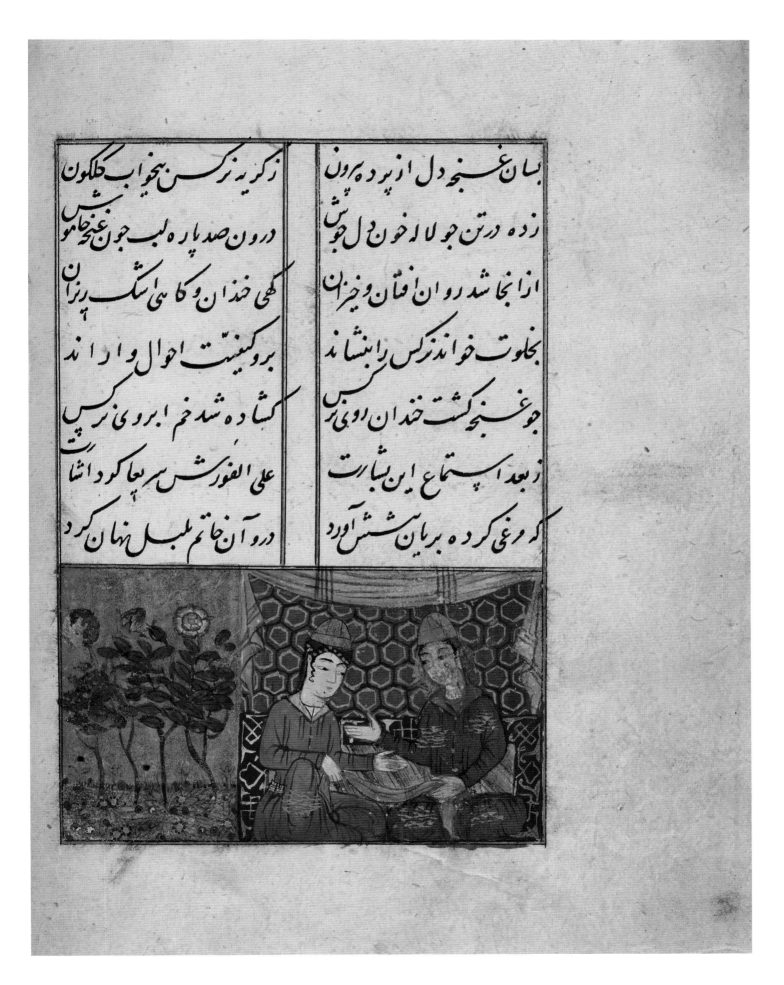

the ring he had previously given her, now hidden in a cooked chicken.[18] But the painter has drawn only Rose and her maid, who wears a blue robe like Nightingale but is identified by her girl's cap. They hold a softly draped cloth, and there is no depiction of the ring-concealing bird alluded to in the text:

> She called Narcissus into a private place and
> sat her down
> Explaining the state of affairs
>
> … With tears she washed that kerchief
> And wrapped the chicken in it
>
> She handed it over to her maid wrapped and
> sealed
> And told her to take it to her master.

Shah Nowruz then facilitates the reunion of the two lovers, and the narcissus with the cypress, and they all happily join the royal party depicted in the final illustration in which the shah is enthroned, attended by courtiers and entertained by a group of three musicians. The artist has shown Nightingale on the far left, recognisable in his blue robe and distinctive trimmed cap (Figure 10.7). He is playing a reed flute, the *ney*, an instrument whose sound was understood by Sufis to embody the pain of the separated lover, or the spiritual suffering of those who follow the path of union with God.[19]

Nightingale's musical cry foreshadows the tragedy that follows. Once again the prickly thorn intervenes, preventing the ultimate union of the rose and the nightingale. The distraught nightingale – at once both bird and lover – dies of grief. The loyal narcissus kills the thorn in retaliation, bringing the tale of doomed love to its expected conclusion.

> Stand aside from the children of these times
> Like a mystic anchorite sit quiet in a corner …
>
> See in miniature the way of the world,
> Take heed from the example of Rose and
> Nightingale.

It only now remains for the story that frames the tale from the beginning to be repeated, so that the whole cycle can begin again:

> When the exalted Shirvanshah of the Spring
> Equinox,
> Came to feast in the flowery meadow one day

He ordered that Nightingale be brought into
 his presence,
Summoning him from the flower garden to the
 flowery meadow.

And so ends the story, but not without an exhortation written diagonally in gold on either side of the lozenge-shaped dated inscription that concludes the book (Figure 10.8):

> May you live long, for under your protection,
> I can hope to realise my dreams
>
> May you live long, for of all God the Truth's …
> many gifts,
> The sweetest is the gift of life!

While at one level the storyline is simple in its appeal, enjoyed for its known predictability and 'quotations' from the Persian classics, its metaphors of thwarted love and the reach of sovereign power are complex. The tale combines two examples of symbolic language widely used in the Islamic world: the idea of a soul-bird that can fly beyond the limits of the earth – embodied in the nightingale, singing most intensely when roses are in bloom. The rose in poetry symbolises the earthly beloved's cheek – and as the ultimate manifestation of divine beauty, doubly attracts the nightingale's yearning.[20]

One of the first Persian poets known to have alluded to the tradition that the Prophet Muhammad saw the rose as the embodiment of God's glory was Ruzbihan Baqli, a native of Shiraz in southern Iran, who died in 1209.[21] Thereafter roses played an important part in the symbolism of the mystic brotherhoods that had a powerful influence in the region, including on the early Ottoman sultans. In the belief system of the Sufi orders, the fragrance of the rose came from the sweat of the face of the Prophet himself, and the so-called rose of Muhammad was often drawn in religious texts. Ottoman poetry and literature alluded to the Prophet in language incorporating references to the rose – hence expressions such as *gül-i gulzar-i resul,* the 'rose-cheeked messenger', and *gül-i gulzar-i nübüvvet,* the 'rosy mission of prophecy'. In Sufi thought, a rosebud symbolised the state of being alone and a rose in bloom represented plurality and communality.[22]

Gardens and their roses were in a wider sense an Islamic rendition of the Biblical and Qur'anic gardens of Paradise. Since Muhammad was regarded as the last

Figure 10.7 (opposite)

Shah Nowruz invites Nightingale to join his party. From a manuscript of Badiʿ al-Din Manuchihr al-Tajiri al-Tabrizi, *Dilsuznama*, dated 860 (1455–56), Edirne. Bodleian Library, University of Oxford, MS. Ouseley 133, fol. 80v.

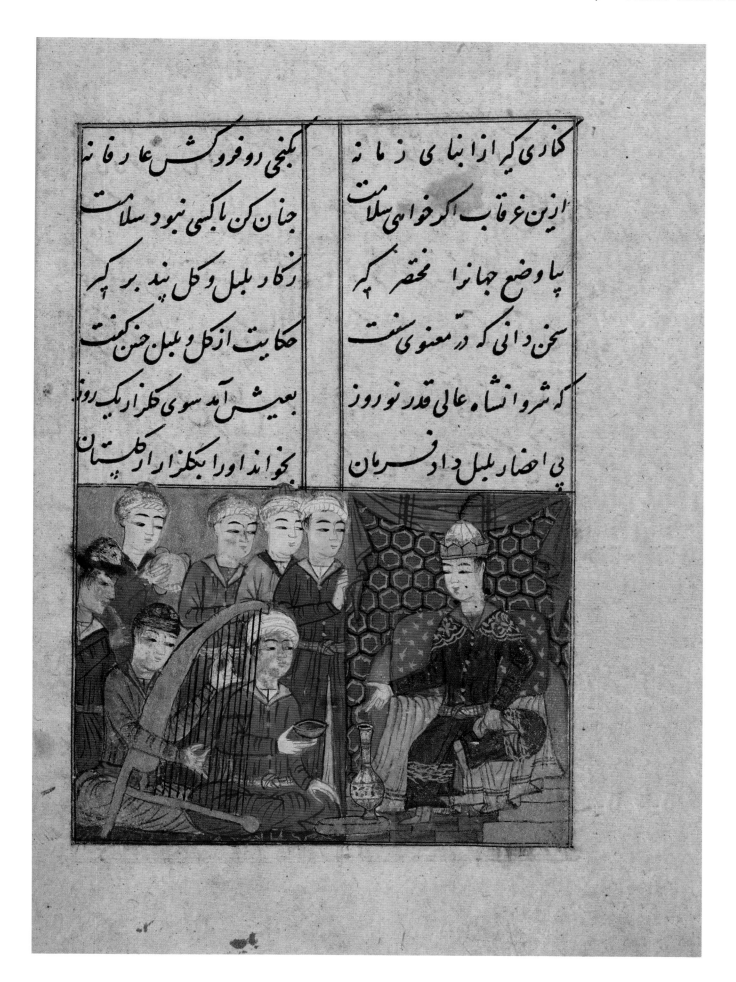

کناری گیر از ابنای زمانه

ازین غرقاب اگر خواهی سلامت

پی اوضاع جهان را مختصر گیر

سخن دانی که در معنی نشست

که شروان شاه عالی قدر نوروز

پی احضار بلبل داد فرمان

گنجی رو فروکش عافیت نه

جهان کن یا کسی نبود سلامت

رنگار بلبل و گل پند بر گیر

حکایت از گل و بلبل حسن گفت

بعیش آمد سوی گلزار یک روز

بخواند اورا ببلزار از گلستان

 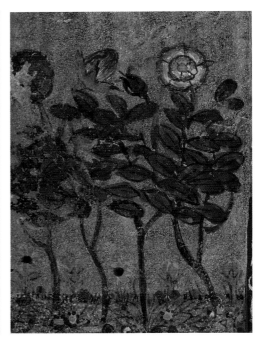

Details from Figures 10.4, 10.5 and 10.6

Figure 10.8 (opposite)

Inscriptions. From a manuscript
of Badi' al-Din Manuchihr
al-Tajiri al-Tabrizi, *Dilsuznama*,
dated 860 (1455–56), Edirne.
Bodleian Library, University
of Oxford, MS. Ouseley 133,
fols. 104v–105r.

prophet, it was only natural that Islam's other-worldly garden, promised for the after-life, would continue Judaeo-Christian tradition. Persian and Ottoman poets often took up these sacred themes and combined them with traditions of the royal pleasure garden that pre-dated Islam, thus combining religious and profane ideas, often with a political overlay. In describing the role of their government the Ottomans asserted 'the world is a garden, its walls are the state'. The sultan himself was consistently referred to in Ottoman poetry as the 'beloved'. Court poetry placed the central powerful figure of the sultan or regional ruler in the 'emotional sanctuary' of the gardens where many of the activities of the court and its subjects were carried out.[23]

Floral and springtime themes, modelled on those of the classical world, had been popular with Byzantine writers. The work of the 4th-century pagan orator Libanius incorporated motifs that were carried over into Christian writing and art, and easily absorbed into the literary and artistic production of border areas of the Persianate world. 'Delight in the songs of the birds and scents of the flowers', he wrote, 'the swallow sings in the spring, as does the nightingale ... The meadows are sweet ... with roses, with violets, with lilies ...'[24] Just as the sultan was referred to or addressed in poetry as a flower or a slender cypress tree, and the Prophet alluded to as a rose, Byzantine precedents described the Virgin Mary as 'a sweet smelling meadow ... a

flower ... the fount of a perennial stream'.[25] The sermons of Saint Bernard of Clairvaux, who belonged to the monastic Cistercian order in north-eastern France in the mid-12th century, were instrumental in formalising the rose as a symbol of Mary. The Marian cult he inspired proliferated throughout Europe, extending the reach of devotion to Mary and her association with imagery of the rose that had already been established in Byzantine Constantinople.[26]

Dante Alighieri used the figure of Bernard of Clairvaux to explain the vision of the celestial 'rose of light' with the Virgin Mary as 'Queen of Heaven' at its centre in the penultimate canto XXXII of his poetic masterpiece, the *Divine Comedy*, completed in 1321. A rare manuscript, c. 1350–75, from the collection of the Bodleian Library depicts this radiant image of transcendence (see p. 81).[27] A century earlier, the two French authors of the *Roman de la Rose* had used the symbol in a more allegorical and earthly sense. Translated into English by the end of the 14th century, partly due to the efforts of Chaucer, the story is set in a private, enclosed garden in much the same way as the Rose and Nightingale story of the *Dilsuznama*. A miniature of the 'Lover with Reason' from a mid-15th century *Roman de la Rose* from the Bodleian Library collection depicts the same variety of many-petalled, flat pink damask roses seen in the Oxford *Dilsuznama* (see p. 140).

Copied and painted about the same time as this *Roman de la Rose* in a frontier region where Christian Europe and the far reaches of the Persianate world met, the Oxford *Dilsuznama* demonstrates a comparable preoccupation with a poetic 'religion of love' and use of an ambiguous language of poetic and visual symbols. These cultural attributes, underpinned by mysticism, were shared across an area that stretched from Central Asia to Europe. They prevailed despite the obvious cultural and religious differences in play. It was an age of 'love and beloveds', albeit with differences in the conceptions of love in the Christian and Islamic worlds.

The *Dilsuznama*, with its references to classic Persian tales such as those of the *Shahnama* and Layla and Majnun, with its intertwined themes of exile or separation and unrequited love and with its mystic overtones, exemplifies the genre of Persian love poetry adopted in the Ottoman context. Its themes and symbols of an enclosed pavilion in a garden setting, a rose and nightingale, and its denouement in courtly entertainment are both sensuous and mystical. They are also as much part of European literary culture of the time as they are of the realm of the Ottomans.[28]

Translations from the *Dilsuznama* by Bruce Wannell.

Notes:

1 I am grateful for the generosity of Ayşin Yoltar-Yıldırım in providing access to the advance text of her paper, 'The 1455 Oxford *Dilsūznāma* and Its Literary Significance in the Ottoman Realm', in *Tradition, Identity, Synthesis, Cultural Crossings and Art, Studies in Honor of Günsel Renda*, ed. S. Bağcı and Z. Yasa Yaman (Ankara: Hacettepe University, in press), 243–8. Thanks are also due to Doris Nicholson of the Bodleian Library who put me in touch with Ayşin Yoltar-Yıldırım after I began to research the *Dilsuznama* in 2006. Previous references to the manuscript include I. Stchoukine, 'Miniatures Turques du Temps de Mohammed II', *Arts Asiatiques* 15 (1967): 47–51; Ernst Grube, 'The Date of the Venice Iskandar-nama', *Islamic Art II* (1987): 192; Barbara Brend, *Islamic Art* (London: The British Museum Press, 1991), 188–9; Ayşin Yoltar, 'The Role of Illustrated Manuscripts in Ottoman Luxury Book Production, 1413–1520' (PhD thesis, Institute of Fine Arts, New York University, 2002); Serpil Bağcı et al., *Osmanlı Resim Sanatı* (Istanbul:

T.C. Kültür ve Turizm Bakanlığı Yayınları, 2006), 24–5.

2 Yoltar, 'The Role of Illustrated Manuscripts', 208.

3 Stephen Frederic Dale, *The Muslim Empires of the Ottomans, Safavids and Mughals* (Cambridge: Cambridge University Press, 2010), 135–76.

4 Annemarie Schimmel, *Mystical Dimensions of Islam* (Chapel Hill, NC: University of North Carolina Press, 1975), 312.

5 Julian Raby and Zeren Tanındı, *Turkish Bookbinding in the 15th Century: The Foundation of an Ottoman Court Style*, ed. Tim Stanley (London: Azimuth Editions, 1993), 29; Gönül Tekin, 'Turkish Literature: Thirteenth to Fifteenth Centuries,' Halil Inalcık and Günsel Renda, eds., *Ottoman Civilisation,* vol. 2 (Ankara: Republic of Turkey Ministry of Culture and Tourism, 2004), 497–520.

6 These social gatherings with music, poetry, wine and entertaining conversation were known in the Ottoman context as *sohbet*. See Walter G. Andrews and Mehmet Kalpaklı, *The Age of Beloveds: Love and the*

Beloved in Early-Modern Ottoman and European Culture and Society (Durham, NC and London: Duke University Press, 2005), 106–12.

7 Quoted in Raby and Tanındı, *Turkish Bookbinding*, 29. Murad II was the first Ottoman sultan known to write poetry, Tekin, 'Turkish Literature,' 511.

8 Raby and Tanındı, *Turkish Bookbinding*, 29.

9 Rifat Osman, *Edirne Sarayı* (Ankara: Türk Tarih Kurumu Basımevi, 1957).

10 Aziz Nazmi Şakir-Taş, *Adrianopol'den Edirne'ye: Edirne ve Civarında Osmanlı Kültür ve Bilim Muhitinin Oluşumu XIV–XVI Yüzyıl* (Istanbul: Boğaziçi Üniversitesi Yayınevi, 2009), 134–5.

11 Franz Babinger, *Mehmed the Conqueror and His Time*, ed. William C. Hickman, trans. Ralph Manheim (Princeton, NJ: Princeton University Press, 1978), 150.

12 Ayşin Yoltar-Yıldırım suggests the manuscript is likely to have been produced in a Mevlevi Sufi context, citing Hilal

Detail from Figure 10.4

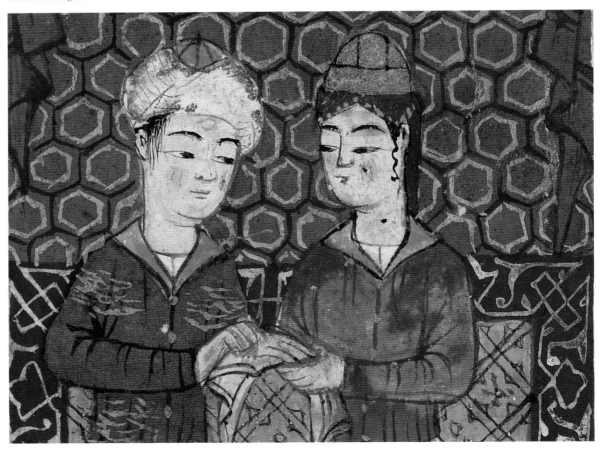

Inalcık in asserting that dervish lodges acted as centres for the study of Persian and Persian literature since orthodox religious schools taught only in Arabic. 'The Role of Illustrated Manuscripts', 221; 'The 1455 Oxford *Dilsūznāma* and Its Literary Significance', 245.

13 Yoltar-Yıldırım, 'The 1455 Oxford *Dilsūznāma* and Its Literary Significance', 208.

14 Annemarie Schimmel, *As through a Veil: Mystical Poetry in Islam* (New York: Columbia University Press, 1982), ch. 7; *Mystical Dimensions*, 287–343.

15 Badi' al-Din also wrote a treatise on riddles, *Mu'amma*. See Yoltar-Yıldırım, 'The 1455 Oxford *Dilsūznāma* and Its Literary Significance', 244, and S. Zabih Allah, *Tarikh-i Adabiyat Dar Iran* (Tehran: 1367 [1989]), 117–18.

16 This is a reference to the 12th-century Persian poet, Nizami's classic tale of the unhappy love of *Layla u Majnun*. See story summary, p. 200.

17 The variety of rose is Trigintipetala or Kazinlik, after the town in Bulgaria that became a production centre for attar of roses after the 17th century, and remains so to this day. See Peter Harkness, *The Rose: An Illustrated History* (London: Royal Horticultural Society, 2003), 120.

18 A direct reference to a similar ploy in the love story of Bizhan and Manizha in the *Shahnama*. See pp. 32, 37.

19 Schimmel, *Mystical Dimensions*, 317–8.

20 Schimmel, *Deciphering the Signs of God*, 26.

21 Annemarie Schimmel, 'The Celestial Garden,' in *The Islamic Garden*, ed. Elisabeth B. Macdougall and Richard Ettinghausen (Washington, D.C.: Dumbarton Oaks, 1976), 32–3; Schimmel, *Mystical Dimensions*, 296–9.

22 Beşir Ayvazoğlu, 'The Rose,' in *The Turkish Rose,* ed. Süheyl Ünver and Gülbün Mesara (Istanbul: Kule İletişim Hizmetleri, 1999), ix.

23 Walter G. Andrews, *Poetry's Voice: Society's Song: Ottoman Lyric Poetry* (Seattle: University of Washington Press, 1985), 36, 62.

24 Quoted in Henry Maguire, *Art and Eloquence in Byzantium* (Princeton, NJ: Princeton University Press, 1981), 43.

25 Maguire, *Art and Eloquence*, 46.

26 Caroline H. Ebertshauser et al., *Mary: Art, Culture, and Religion* (New York: Crossroad Publishing Company, trans. Peter Heinegg, 1988), 175–6; James Snyder, *Medieval Art: Painting, Sculpture, Architecture, 4th–14th Century* (New York: Harry N. Abrams, 1989), 288–90.

27 Bodleian Library, MS. Holkham Misc. 48. For comparisons between Dante's *Divine Comedy* and medieval Islamic philosophy, literature and symbolism, see Michael Barry, *Figurative Art in Medieval Islam* (Paris: Flammarion, 2004), 249, 255–6, 335–6.

28 Research into the context of the Oxford *Dilsuznama* was carried out during the course of an Australian Postgraduate Award in the history and art history program of the School of Historical and European Studies, La Trobe University, Melbourne.

Detail from Figure 10.2

Figure 1 (opposite)

ISKANDAR COMFORTS THE DYING DARA

From a manuscript of Nava'i, *Sadd-i Iskandar*, dated 960 (1553), Bukhara. Bodleian Library, University of Oxford, MS. Elliott 340, fol. 32r.

In Firdausi's account of the life of Iskandar in the *Shahnama,* the Macedonian hero defeats the Persian king Dara (Darius) and comforts him as he dies on the battlefield. In the process Iskandar learns they are half-brothers and legitimately assumes the Persian imperial throne, after marrying Dara's daughter. Subsequent poetic versions of the conqueror's life such as *Sadd-i Iskandar* ('The Wall of Alexander'), written by Nava'i in the 15th century, were increasingly romanticised, and this tender episode of fraternal love remained a favourite subject for Persian manuscript illustrators.

Figure 2 (page 136)

ISKANDAR ENTERTAINING THE KHAN OF CHINA

From a manuscript of Nizami, *Khamsa*, dated 907 (1501). Bodleian Library, University of Oxford, MS. Elliott 192, fol. 279r.

In Nizami's romance, *Iskandarnama* ('The Book of Alexander'), one of the five stories of his *Khamsa* ('Quintet'), Iskandar travels in an easterly direction after his adventures in the west. He builds a wall to keep out Gog and Magog, who symbolise the nomadic tribes on Iran's north-east border, and meets the Khan of China, ruler of the region of western China we know today as Xinjiang, or Chinese Turkestan.

Figure 3 (page 137 and detail right)

ISKANDAR LEADING HIS ARMY TO ANDALUS

From a manuscript of Firdausi, *Shahnama*, dated 1010 (1601–02). Bodleian Library, University of Oxford, MS. Ouseley 344, fol. 385v.

After conquering India, Iskandar wanders all over the world in his unsuccessful search for the secret of immortality. He heads towards the west, the direction of darkness, hoping to find the 'Fountain of Life'. Disguised as an ambassador, he travels as far as Andalusia, southern Spain.

ISKANDAR/ALEXANDER: EAST AND WEST

IN THE MEDIEVAL ISLAMIC TRADITION, Alexander the Great, known as Iskandar, was widely celebrated as a global hero and ruler of the whole world. Both European and Persian versions of the Macedonian king's legendary exploits drew on a popular Greek-language romance of the 3rd century AD, later translated into Latin and Arabic. In Persian narratives, Iskandar was accompanied on his journeys firstly by his friend and tutor Aristotle, and then by Khizr ('The Evergreen One'), a prophet who, in the Islamic tradition, had gained immortality. Combining traditions bequeathed by his travelling companions, the figure of Alexander/Iskandar therefore blended the philosophy of ancient Greece with the spirituality of the Persian world.

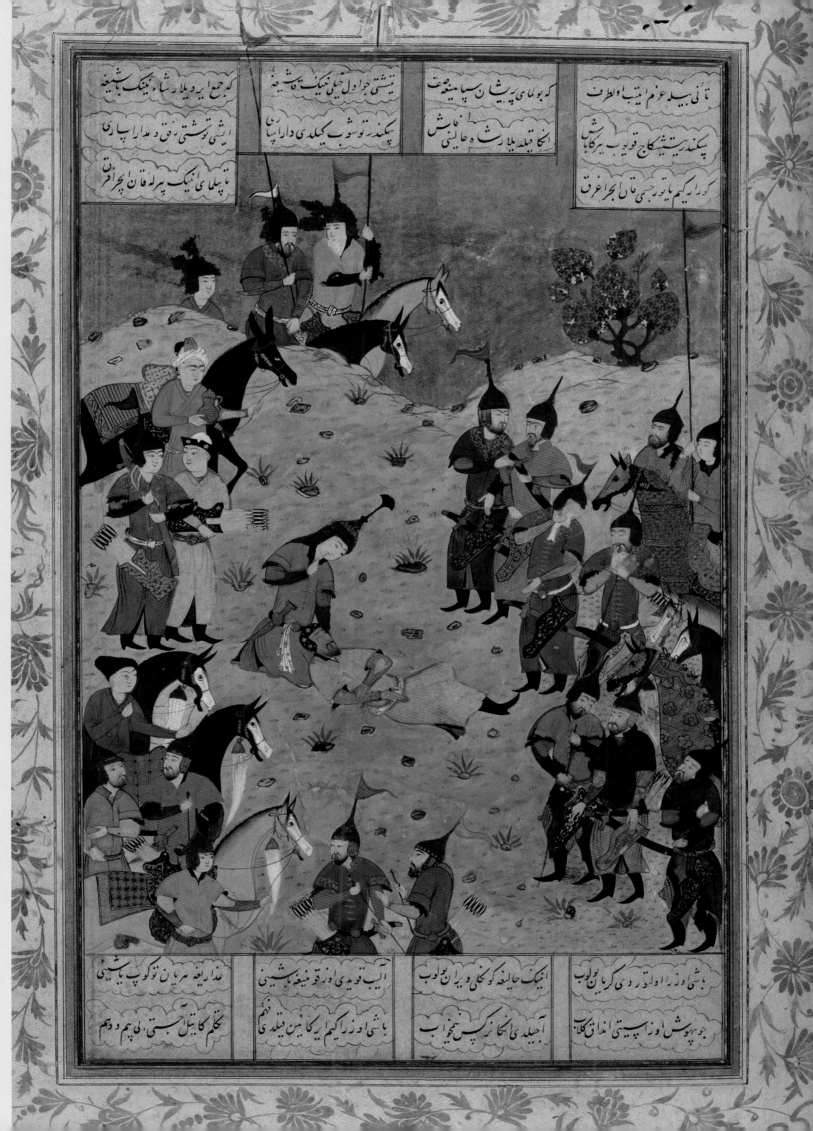

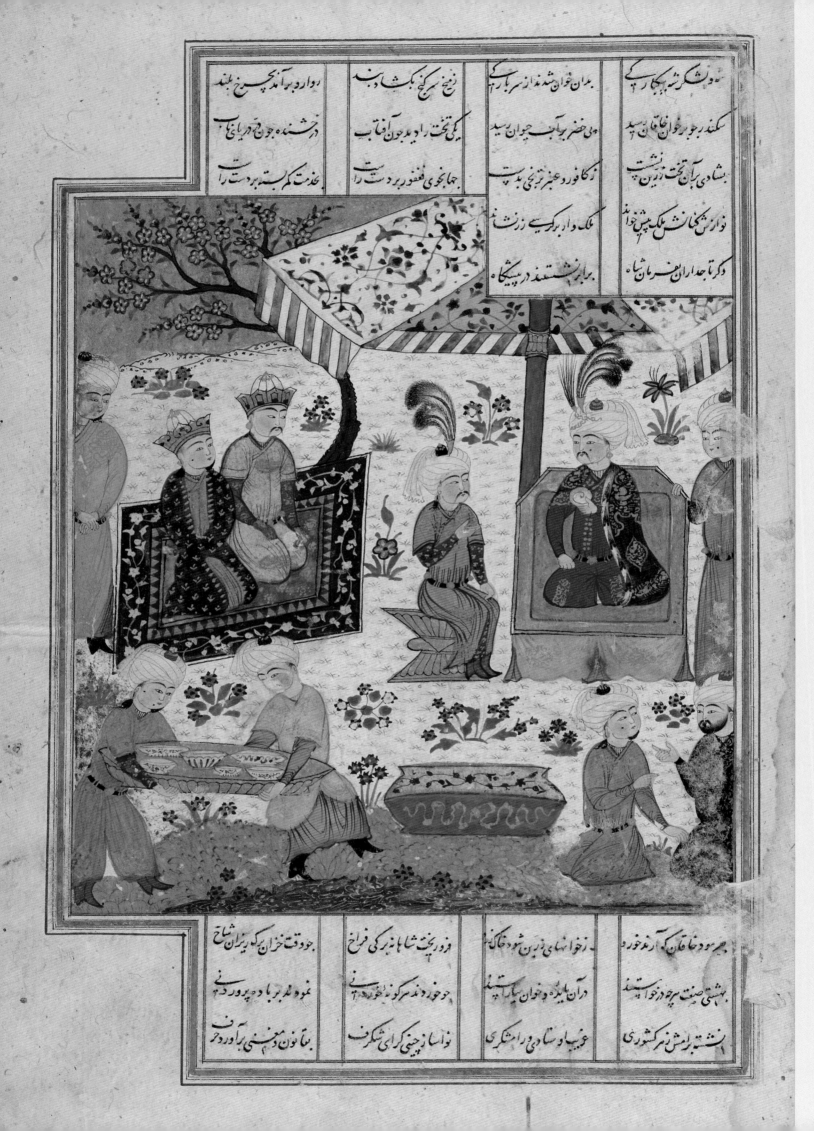

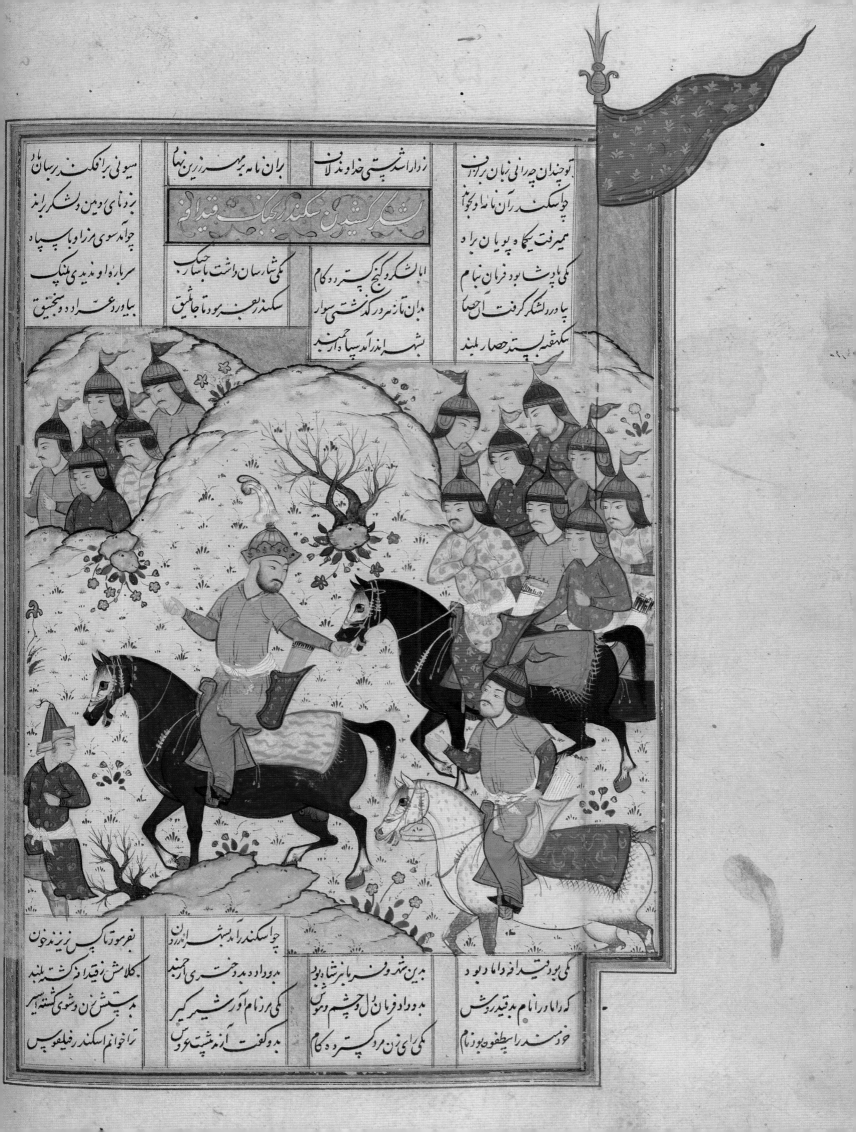

میوینی برانگگت ربران ماند	زان نامه مهر سرزرین نهاد	زوار اسد بستی خداوندلان	توجیدان چه رانی زبان بر دزن
برومای دین ولشکر برند			چواسکند رآن نامها بخوانا
چواده سوی مرزاو باسپاه	نکی شار رسان داشت باشکر	ابالشکر وکنج کسترده کام	میرفت یکماه پویان براه
سراره او ندیدی منگ	سکندر بعنبه بود تاجانین	مدان تاز نمرد کرد گذشتی سوار	نکی باد شاه بود فرمان نهام
بیاورد عراده وسنجین		شهنشه اندر آمد سپاه جمند	باور لشکر گرفت آن حصار
			سکهقه بسته در حصار ملند

Figure 4 (below)

ALEXANDER BORNE ALOFT IN A CAGE DRAWN BY GRIFFINS; ALEXANDER KILLING MYTHICAL BEASTS

From the unique manuscript of *Le Mireur du Monde*, vol. 1, copied before 1463, France. Bodleian Library, University of Oxford, MS. Douce 336, fols. 102v–103r.

An episode often depicted in medieval accounts of Alexander is his invention of a flying machine. Alexander ascends by tethering ravenous griffins (mythical winged beasts) to his carriage and securing portions of meat beyond their reach.

A similar scene appears in the *Shahnama* but in Firdausi's epic it is the legendary king Kay Kavus, and not Iskandar, who rises towards the heavens, this time with the aid of eagles.

This two-volume manuscript is the only known copy of a French text, *Le Mireur du Monde.* Its content differs from its earlier counterpart *Le Miroir du Monde* in that it is a chronicle of world history beginning with an account of Creation and continuing to about 200 BC.

Figure 5 (opposite)

ISKANDAR ENTHRONED RECEIVING A BEGGAR

From a manuscript of Nava'i, *Sadd-i Iskandar,* dated 960 (1553), Bukhara. Bodleian Library, University of Oxford, MS. Elliott 340, fol. 17v.

In the Persian tradition, the world-conqueror Iskandar not only attains the status of the 'Perfect Man,' a complete human being reflecting all possible levels of existence, but is also represented as a sage-like ruler. Personifying the wisdom of Western philosophy and enlightenment of Eastern spirituality, he dispenses justice to all his subjects with devotion and humility.

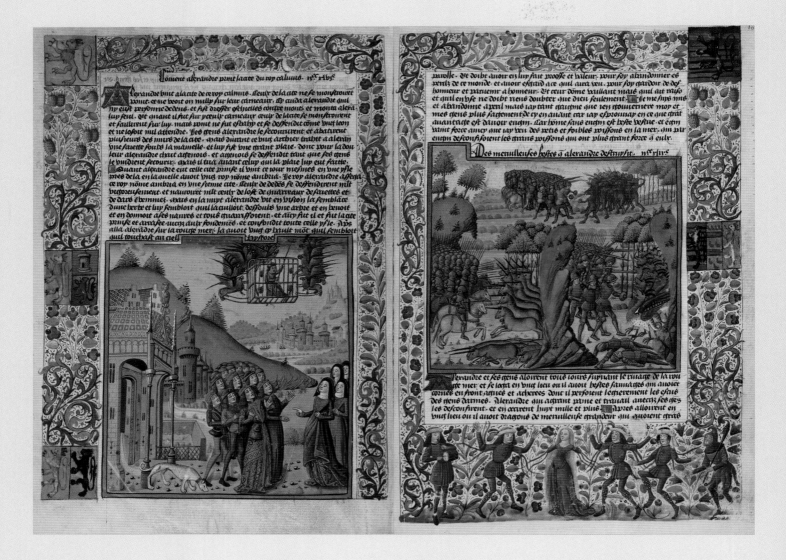

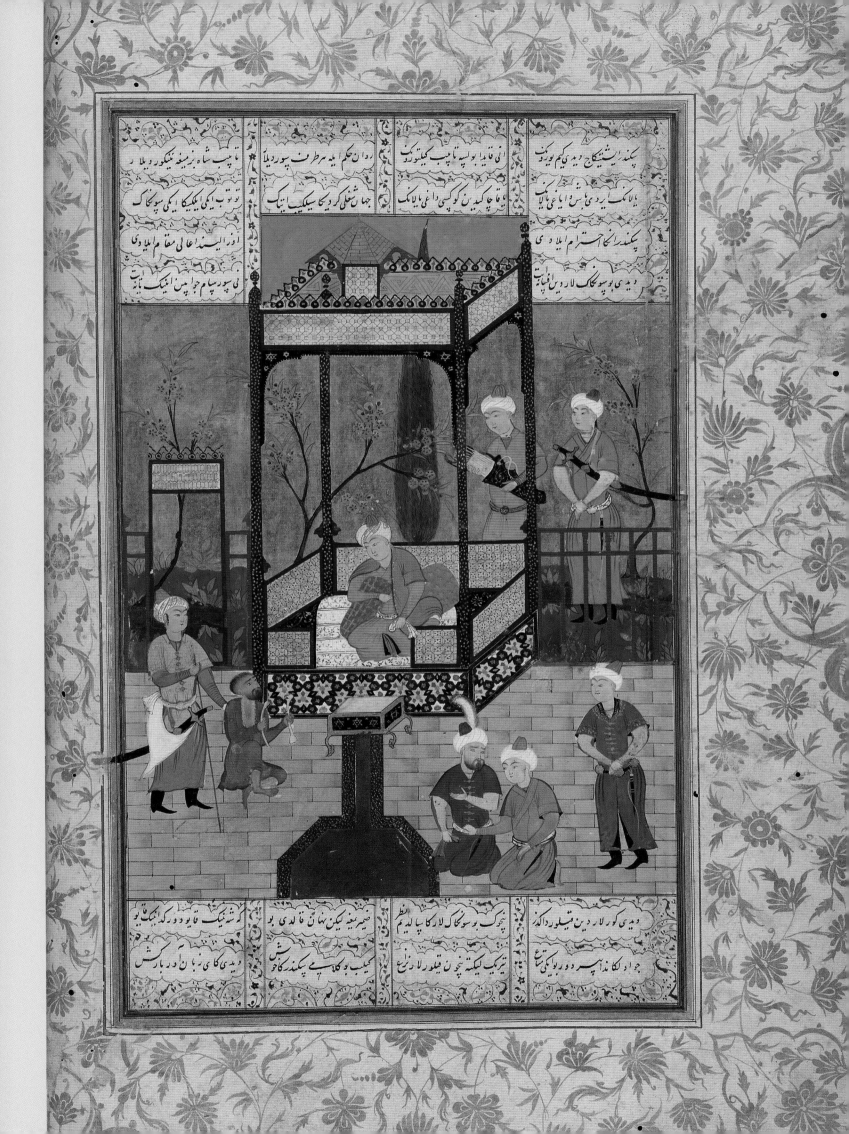

Cueur ne pourroit mie penser
Ne bouche donme recenser
De ma douleur la quarte part
A pou que le cueur ne me part
Quant de la rose me souvient
Que si esslongnee me convient
En tel point ay maint piece este
Et tant qu ainsi me vit maste
La dame de la haulte garde
Qui de sa tour aval esgarde
Raison fut la dame appelee
Lors sest de sa tour avalee
Si est tout droit amoy venue
El ne fut brune ne chanue
Ne fut trop haulte ne trop basse
Ne fut trop megre ne trop grasse
Les yeux qui en son chief estoient
Com deux estoilles reluisoient
Si ot on chief une couronne
Bien resembloit haulte personne
A son semblant et a son dit
Pert quel fut faite en paradis
Car nature ne sceust pas
Oeuvre faire de tel compas
Sachies se la lettre ne ment
Que Dieu la fist de maintenement
A sa semblance et a s ymaye
Et lui donna tel avantaye
Quelle a pouoir et seigneurie
De garder homme de folie
Pourueu quil soit tel qil la croie
Ainsi com je me dementoie
Atant dame Raison comance

Raison.

Beaulx amis folie et enfance
Tont mis en paine z en esmay
Mal viz oncq le beau temps de may
Qui fist ton cueur trop esgarer
Mal talas oncques vmbrarer
Ou vergier dont oyseuse porte
La clef dont el touuir laporte
Fol est qui saconte doyseuse
Saconitance est trop perilleuse
Elle ta trahy et deceu
Amour si ne teust ja beu
Se oiseuse ne teust conduit
Ou beau vergier qui est deduit
Se tu as folement ouure
Fay tant que soyes recouure
Et garde bien que tu ne croies
Le conseil parqui tu foloies
Beau folour qui se chastie
Et quant jennes home fait folie

THE TWO FACES OF LOVE

Devotion and Terror in Medieval and Renaissance Europe

Danijela Kambaskovic-Sawers

PLATO'S notion of two loves – the good love, *Urania*, the heavenly Aphrodite, and bad love, *Pandemia* or earthly love[1] – holds the key to two opposed concepts of love that are equally crucial for the thought and art of the Middle Ages and Renaissance in Western Europe. The first views love as a divine force and the only way for humans to transcend the limitations of this world; the second, as a dangerous condition, and a threat to humanity's sanity and salvation. This dichotomy runs deep in medieval and Renaissance thought and art, and it should come as no surprise that it is still with us today.

Plato considered love madness the highest form of human madness and the source of the highest good, personal as well as political:

> And in the divine kind [of madness] we distinguished four types: the inspiration of the prophet ... that of the mystic ... that of the poet and a fourth type, which we declare to be the highest, the madness of a lover. (*Phaedrus,* 265b)

Thus we find that the antiquity of Love is universally admitted, and in very truth he is the ancient source of all our highest good ... For neither family, nor privilege, nor wealth, nor anything but Love can light that beacon which a man must steer when he sets out to live the better life. How shall I describe [love], but [as] that contempt for the vile, and emulation of the good, without which neither cities nor citizens are capable of any great or noble work. (*Symposium,* 178d)

Since Plato's works were lost to Europe from after the fall of Rome until the 12th century, when they were reintroduced via Arabic translations, Plato's thought reached medieval thinkers through Neoplatonist writings. Plotinus, a 3rd-century philosopher, reinterpreted Plato's philosophy of love in synergy with early Christian doctrine, suggesting that *eudaimonia*, authentic human happiness, is found in the human consciousness and harmony of love and is not controlled by worldly fortune. In the 4th and 5th centuries, Macrobius foreshadowed Freud by interpreting dreams as an allegory of love and divinity, an approach that would be highly influential for the poetry of the Middle Ages. An early medieval Christian philosophy, probably containing remnants of Platonic philosophy and paganism, viewed all love, including sexual love, as a manifestation of the all-pervading love of God through which the Universe is governed.[2]

These are echoes of Plato's belief that love makes both the lover and the beloved divine, and that it should be embraced in a quest to ennoble the soul and reach self-awareness, creativity, and transcendence:

> The Lover, by virtue of Love's inspiration, is always nearer than his beloved to the Gods.
> (Plato, *Symposium*, 180b)

The influence of this idea was far-reaching, and the semantic link between the pleasure of the flesh, creativity and transcendence is present in countless artworks of the period.

Through Guillaume de Lorris and Jean de Meun's *Roman de la Rose*, completed in 1275, Macrobius' idea of using a dream allegory employing symbols that merge the sensual and the transcendent becomes the dominant mode of expression in the period (Figure 11.1).[3] The ubiquitous symbol of the rose, for instance, signifies not only the transient nature of a woman's virginity and the concealed, exquisite desirability of her sex but also divine bounty and magnificence. The rose is thus found in art depicting love and courtship, and also on facades of great European cathedrals such as that of Chartres. More than three centuries later, Shakespeare used the rose to hint at the feminised nature of his young man's sexual wiles, and to sing of his own idolatrous infatuation and need to submit the youth to the complex, creative and destructive control that a master perfumer exerts over roses to get to their essence:

> The canker blooms have full as deep a dye
> As the perfumed tincture of the roses . . .
> They live unwoo'd, and unrespected fade;
> Die to themselves. Sweet roses do not so;
> Of their sweet deaths are sweetest odours made.
> And so of you, beauteous and lovely youth,
> When that shall fade, my verse distills your truth.[4]

The symbol of the garden, found in the *Roman de la Rose* and many other works including *Romeo and Juliet,* signifies not only a secret, secluded place where lovers can escape the world to enjoy each other and create a world of their own but it also warns of the dangers lurking in the Garden of Eden, the place of human completeness and harmony, lost through humanity's choice of independence from divine injunction. Finally, it recommends ideals of female purity, as in the notion of *hortus conclusus,* an enclosed garden, code for the Virgin Mary's sacred womb. The rich symbol of the fountain recalls, on one hand, female sexual arousal and male fertility; on the other, by association with the fount at Mount Parnassus, where Apollo and the Muses gather to inspire poets, creativity; and finally, as commemorated by fonts in churches, God's mercy, baptismal purification of the soul and spiritual salvation. The erotic, the creative and the sublime are inextricably intertwined in medieval and Renaissance semiology, and these symbols had significant parallels in neighbouring cultures and faiths (see pp. 130–31).

Further, since love and its object are divine, the pursuit and depiction of love and suffering become associated with a quest for virtue. In the Middle Ages, storytelling and poetry-writing give shape to *pretz* and *valor*, 'honour' and 'courage', terms of 12th-century Provençal troubadour poetry used to denote the sexual and intellectual governing of the self, crucial to notions of idealised medieval virility.[5] Italian poets of the 13th-century literary movement, the *dolce stil nuovo*, argued that in a noble heart, love must reside. Writing about one's suffering becomes crucial to the poetics of courtly love, a European cultural fashion that swept through the continent in the 12th, 13th and 14th centuries and inspired writers such as Dante, Petrarch and Chaucer; the platonic concept of *enthousiasmos* (arousal, inspiration) as a creative, divine madness or poetic *furor* was also amply theorised, and favoured over the notion of writerly effort and skill, Platonic *pisteis*, by many great Renaissance thinkers, including Giordano Bruno, Marsilio Ficino, Pietro Bembo, Francesco Patrizzi da Cherso, as well as, in England, Sir Philip Sidney.[6]

Petrarchism, the major European poetic vogue from the 14th to the 17th century, was named after Francesco Petrarca (Francis Petrarch, 1304–74) – diplomat, philosopher, poet and cultural tour de force. For a time, while the Papal court was stationed in Avignon in the 14th century, Petrarch lived in Provence and was deeply influenced by the work of Provençal troubadour poetry and poets such as Daniel Arnaut, Peire Rogier and Jaufre Raudel, as well as by classical and Italian writers: Ovid, Cicero, Statius, Dante, Cecco d'Ascoli and Guido di Arezzo, to name but a few, were amongst his favourite teachers.[7] Petrarch was exceptionally prolific, and it was his particular genius to engage with his influences creatively and use their ideas to generate qualitatively new approaches. For instance, although it was Dante Alighieri (d. 1321) who wrote the first love sonnet sequence, *La Vita Nuova*,[8] Petrarch decided not to use Dante's approach of interspersing prose with the poems, but to base the collection only on poems; he made the poems more numerous and more complex, and had the courage to reveal to the reader the visceral quality of his longing. This gave the work, as well as the genre, its unique greatness. Petrarch's sequence was called simply *Il Canzoniere* ('Songbook').[9] It contained 366 poems, one for each day of a leap year, inspired by an unattainable woman Petrarch named Laura (the laurel tree, whose leaves signal poetic and military glory, is the most important symbol of the work).

Petrarch wrote and edited these poems for forty years of his life, invented poetic images that have become the stock-in-trade of all love poetry and started a literary vogue that swept across Europe for four centuries, inspiring poets such as Pietro Bembo, Torquato Tasso, Pierre Ronsard, Etienne Jodelle, Sir Thomas Wyatt, Sir Philip Sidney, Samuel Daniel, Michael Drayton, Edmund Spenser and, of course, William Shakespeare, all of whom sought to prove their poetic mettle by staying within parameters of the Petrarchan poetry, but making an original contribution to it. Petrarch's own poems are filled with tenderness and adoration for his beloved, but also seethe with sexual frustration, negativity, self-love and tacit violence, giving the work a masculine voice, vitality and interest:[10]

> You see my lady's heart is hard as stone
> . . . She does not deign to look down low enough
> to care about our words
>
> Little by little, she consumes and saps
> And like a lion above my heart there roars
>
> I saw a beast appear on my right side
> With a human face to make Jove flare with
> love,

Pursued by two swift hounds, one black,
 one white,
Who dug their teeth so deep
Into both sides of this noble beast
That in no time they forced her to the pass
Where, trapped within the stone,
Untimely death then vanquished this great
 beauty.[11]

In one of history's great mysteries, Geoffrey Chaucer – writing 100 years before the adoption of print in Europe and simultaneously with Petrarch – translated the first sonnet by Petrarch into English.[12] How did he get the sonnet? We know that Chaucer travelled in Italy and that Petrarch liked to share his sonnets with friends; while there is no evidence that the poets ever met, we are free to imagine the two great minds exchanging sonnet ideas in fluent Latin over a roasted partridge in a medieval Italian inn. Despite periodic waning and rekindling of interest, the Petrarchan sonnet vogue remained alive in England for another three centuries, finally dying out in the 1620s.

In the 15th century, the school of Florentine Neoplatonists led by Marsilio Ficino, who was also, in his turn, influenced by the works of Dante, Petrarch and the poets of the *dolce still nuovo*, wrote commentaries on Plato's work that redefined Platonic philosophy in ways which still resonate today. While Florentine Neoplatonists affirmed Plato's view of love and its pain as a creative force, they also changed his thought on love in two fundamental ways: by heterosexualising and desexualising it.

In Plato's work, the divine beloved[13] is male; by contrast, medieval and Renaissance beloveds are female. It is impossible to overstate the historical importance of this shift. Marsilio Ficino's Neoplatonism

Figure 11.3 (detail opposite)

Francesco Petrarca (Francis Petrarch), *Opera del preclarissimo poeta miser Francesco Petrarcha*. Milan: Ioanne Angelo Scinzenzeler, 1512. State Library of Victoria, Melbourne, RARESF 851.18 OP, fols. a(x)v–b(i)r.

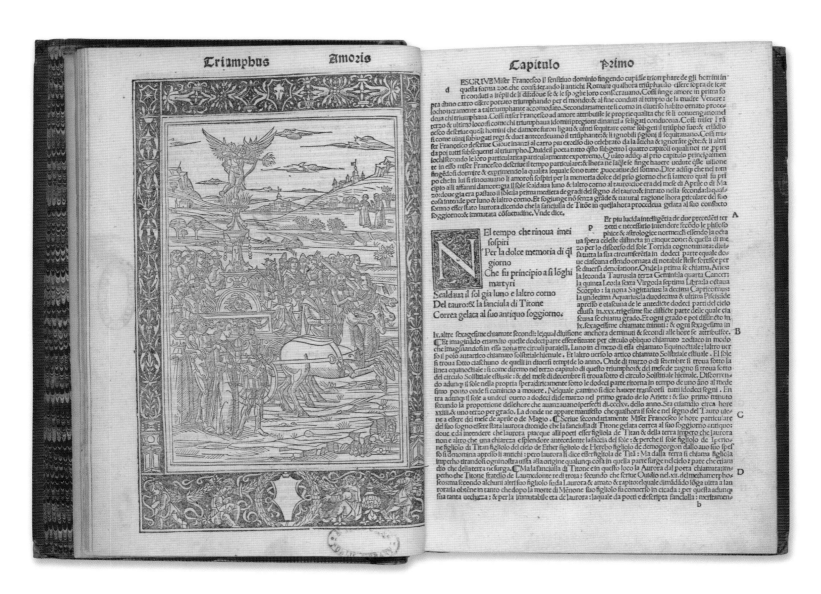

condemns love between men, celebrating their friendship instead, and attributes to women the power that compels the poet to seek higher forms of beauty. Nevertheless, Plato's *Pederasteia* and courtly love can still be usefully compared as they are both distinguishable from marriage by the focus they place on emotion – not procreation – as their main motivator.[14] On the other hand, although Neoplatonism accords the female beloved the same freedom as the male in the previous tradition – freedom from which she must be wooed by *words* – her female sex also carries an expectation of submission under the rules of a patriarchal society.[15]

Further, in Plato's writing 'bad' love is brief and meaningless, and leaves this earth without a trace, whereas his 'good' love is prolonged, caring and creative (*Symposium*, 183d, 184c, 185b; 209b). Significantly, *both are sexual*. Under the influence of Christianity, Neoplatonists rewrote this equation to read *base = sexual* and *virtuous = asexual*; although Ficino posited that love must be passionate in order to qualify as love (*eros*, not *caritas*), he also stipulated that it must be based on two senses only: sight and hearing. Sexual appetite is not love, but lust or frenzy identified with animality, a foolish perturbation of the spirit contrary to love, *rabbia Venerea*, venereal rabies or rabies of Venus. This appellation makes obvious the semantic elision governing the relationship between the physical and the emotional. Mario Equicola, one of Ficino's acolytes, went as far as to call it *la spurcitia del coito,* the filth of the coitus.[16] The societal power of this idea was such that we still use the expression 'Platonic love' today to suggest love that is sexless, not loving and powerfully creative as imagined by Plato.

Clearly, love and loss of equilibrium go together, and not everyone was happy to idealise love's suffering.

Fear of love is the second-most important attitude to love in medieval and Renaissance societies, diametrically opposite to the attitude that idealised it, and medical and theological treatises of the time consistently portrayed love as a condition that could lead to weakness and death. Galen describes the symptoms in the 2nd century and recommended sex as a cure, as did Constantine the African in the 11th century in *On Melancholia and Sexual Intercourse.*[17] Andreas Capellanus, Bernard de Gordon, Timothie Bright, Jacques Ferrand, Robert Burton, Pierre Petit and others[18] all catalogue love's torments and devote much attention to cures, which include rubbing the patient's genitals with gall of cramp fish, or beating him until he begins to rot. With similar results, Christian works on spirituality treat love suffering as lust, one of seven deadly sins, which should be resisted rather than sought. And since the story of Genesis links women's agency with temptation in the medieval mind, the joint workings of the medical and theological discourses contribute to love (and women) becoming viewed as a source of danger that virtuous men should avoid.[19] Thomas Adams' *Diseases of the Soule* (1620) and *Mystical Bedlam, or the World of Mad Men* (1621), Phineas Fletcher's *Joy in Tribulation* (1632) or Richard Overton's *Man's Mortalitie* (1643) all treat erotic love of women as a thing of the devil.[20] (This, of course, is in delightful contrast with the poetic discourse of courtly love and Petrarchism, which accord women beatific and salutary powers.) As a result, Renaissance love poetry is never at peace with itself and teems with frustration, pain and violence towards the woman it purports to adore. It is the vitality and power of this contrast that speaks to us of love across the centuries – and goes a certain way towards explaining love's eternal relevance.

Danijela Kambaskovic-Sawers is Assistant Professor, Shakespeare and Renaissance Studies at the University of Western Australia, Perth and Associate Investigator with the Australian Research Council Centre of Excellence for the History of Emotions 1100–1800. Her research interests include the intersections of medieval and early modern poetry, drama, religion, philosophy and medicine, theories of love, courtship, creativity and madness. Author of *Constructing Sonnet Sequences in the Late Middle Ages and Renaissance* (2010), she is also an award-winning poet.

INFERNO.
COMMEDIA DEL DIVINO POE
TA FIORENTINO DAN
TE ALIGHIERI
CAPITOLO
.I.

El mezo del camin di nostra uita
Mi ritrouai per una selua oscura,
Che la diritta uia era smarrita,
Ah quanto a dir qual era, è cosa dura
Questa selua seluaggia et aspra et forte,
Che nel pensier rinuoua la paura .
Tantè amara, che poco è piu morte .
Ma per trattar del ben, chi ui trouai,
Diro dellaltre cose, chio uho scorte .
I non so ben ridir, comio uentrai,
Tantèro pien di sonno in su quel punto,
Che la uerace uia abbandonai .
Ma po chi fui al pie dun colle giunto
La, oue terminaua quella ualle,
Che mhauea di paura il cor compunto,
Guardai in alto, et uidi le sue spalle
Vestite gia de raggi del pianeta,
Che mena dritto altrui per ogni calle.
Allhor fu la paura un poco queta,
Che nel lago del cor mèra durata
La notte chi passai con tanta pietà .
Et come quei che con lena affannata
Vscito fuor del pelago alla riua
Si uolge a lacqua perigliosa, et guata,
 b

Figure 11.4

Dante Alighieri, *Commedia di Dante.* Florence: Filippo Giunta, 1506.
State Library of Victoria, Melbourne, RARES 851.15D, fols. a(vi)v–b(i)r.

Notes:

1 *Symposium*, 180e; 181b, c; 183e, 184d, *Phaedrus* 497b, c. Plato, *Symposium* translated by M. Joyce and *Phaedrus* translated by R. Hackforth, in *The Collected Dialogues of Plato*, ed. Edith Hamilton and Huntington Cairns, Bollingen Series LXXI (Cambridge: Princeton University Press, 1961).

2 Paul Siegel, 'Christianity and the Religion of Love in Romeo and Juliet', *Shakespeare Quarterly* 12 (1961): 371–92.

3 For the link between Macrobius and the *Roman de la Rose,* see Charles Dahlberg, 'Macrobius and the Unity of the *Roman de la Rose*', *Studies in Philology* 58, 4 (Oct. 1961): 573–82.

4 Shakespeare, Sonnet 54, in *Shakespeare's Sonnets*, ed. Katherine Duncan-Jones (London: Arden Shakespeare, 2003 [1997]).

5 For courtly love viewed expressly as a convention meant to civilise the sexual impulse, see Georges Duby, 'On Courtly Love' in *Love and Marriage in the Middle Ages (Mâle moyen Age),* trans. Jane Dunnet (Cambridge: Polity Press, Blackwell, 1994). See also Gordon Braden, *Petrarchan Love and the Continental Renaissance* (New Haven, CT and London: Yale University Press, 2000).

6 Giordano Bruno, *Gli Eroici Furori* (1585), *Heroic Enthusiasts,* trans. L. Williams (Forgotten Books, http://www.forgottenbooks.org, 2007); Marsilio Ficino, *Philosophia Theologica* lib. 3, qtd by Concetta Carestia Greenfield in Chapter 13, Marsilio Ficino, *Humanist and Scholastic Poetics 1250–1500* (East Brunswick, NJ: Associated Universities Press, 1981); Francesco Patrizzi da Cherso, *Della Poetica . . .* La Deca Ammirabile, lib I, *Delle poetiche proprietadi,* Frane Petric o Pjesnickom Umijecu ur. Ljerka Schiffler (Zagreb: Institut za Filozofiju, 2007). I would like to thank Yasmin Haskell (University of Western Australia, Classics) for our discussions of Bruno's work on the theory of creativity; Sir Philip Sidney, *'The Defence of Poesy' and Selected Renaissance Literary Criticism* ed. Gavin Alexander (London: Penguin Books, 2004).

7 For a discussion of Petrarch's negative attitude to Dante, or *anti-dantismo,* see Zygmunt G. Baranski and Theodore

J. Cachey, Jr, eds., *Petrarch and Dante: Anti-Dantism, Metaphysics, Tradition* (Notre Dame: University of Notre Dame Press, 2009).

8 Dante Alighieri, *Vita Nuoua di Dante Alighieri. Con 15. canzoni del medesimo. E la vita di esso Dante scritta da Giouanni Boccaccio* (Florence: nella stamperia di Bartolomeo Sermartelli, 1576); Dante Alighieri, *La Vita Nuova* in *The Portable Dante*, trans. Paolo Milano (London: Penguin Books, 1977).

9 Francesco Petrarca, *Il Canzoniere*, or *Rerum vulgarium fragmenta*, ed. and trans. Mark Musa (Bloomington and Indianapolis: Indiana University Press, 1999). For critical editions, see Francesco Petrarca, *Il Canzoniere di Francesco Petrarca*, ed. Marco Santagata (Milan: A. Mondadori, 1996); Francesco Petrarca, *Rerum vulgarium fragmenta: codice Vat. lat. 3195: commentario all'edizione in fac-simile*, ed. Gino Belloni, Furio Brugnolo, H. Wayne Storey and Stefano Zamponi (Rome: Antenore, 2004).

10 As I have argued in greater detail, and in reference to six great sonnet sequence writers of the Petrarchan tradition, in Danijela Kambaskovic-Sawers, 'The Sonnet Sequence and the Charisma of Petrarchan Hatred', AUMLA, *Journal of the Australasian Universities Language and Literature Association*, 113 (May 2010): 1–27.

11 Petrarch, *Il Canzoniere*, 70, 256, 323.

12 Geoffrey Chaucer, 'Cantus Troili' from *Troilus and Criseide*, in *The Norton Anthology of Poetry*, ed. Margaret Ferguson et al., 5th edn (New York: W. W. Norton, 2005), 67. 'Cantus Troili' is a version of Petrarch's sonnet conventionally numbered 132 ('S'amor non è' / 'If it's not love'), trans. and ed. M. Musa, 216.

13 'But when one who is fresh from the mystery . . . beholds a godlike face or bodily form that truly expresses beauty . . . there comes upon him . . . reverence [as] at the sight of a God [and] . . . he would offer sacrifice to his beloved, as to a holy image of Deity': Plato, *Symposium,* 251b.

14 On the connection between the erotic and the rhetorical, see also Lynn Enterline, 'Embodied voices: Petrarch reading (himself reading) Ovid' in *Desire in the Renaissance, Psychoanalysis and Literature*, ed. Valeria Finuzzi and Regina Schwartz,

(Princeton, NJ: Princeton University Press, 1994), 120–45.

15 For a discussion of the commerce of marriage in the Middle Ages, see Eileen Power, *Medieval Women* (Cambridge: Cambridge University Press, 2000 [1975]) and Georges Duby, *Love and Marriage in the Middle Ages* (Chicago: University of Chicago Press, 1994).

16 Mario Equicola, *Libro di natura d'amore,* cited in Charles Nelson, *Renaissance Treatises on Love* (New York: Columbia University Press, 1955), 70.

17 C. Burnett and D. Jacquart, eds., *Constantine the African and ʿAlī ibn al-ʿAbbās al-Magūsī The Pantegni and Related Texts* (Leiden: Brill, 1994), 167.

18 Andreas Capellanus, *De amore et de amoris remedio* (Strassburg: C.W., 1473–1474); Andreas Capellanus, *On Love*, ed. and trans. P. G. Walsh (London: Duckworth, 1982). For a discussion of the impact of treatises on love-madness on society, see Michal Altbauer-Rudnik, 'Love, Madness and Social Order: Love Melancholy in France and England in the Late Sixteenth and Early Seventeenth Centuries', *Gesnerus* 63 (2006): 33–45.

19 Similar notions, although for different philosophical reasons and at different times, are observable in the philosophies of Stoicism and the Enlightenment, both of which philosophical streams add independently to the privileging of reason over emotion and skill over inspiration.

20 Thomas Adams, *Diseases of the soule a discourse diuine, morall, and physicall. By Tho. Adams.* (London: Printed by George Purslowe for Iohn Budge, 1616); Thomas Adams, *Mystical Bedlam, or the World of Mad-Men,* (London: Printed by George Purslowe, 1615); Phineas Fletcher, *Joy in Tribulation, or, Consolations for Afflicted Spirits.* (London: Printed for Iames Boler, 1632). *Man's Mortalitie* By R. O. [Richard Overton] (Amsterdam: John Canne, 1643).

Detail from Figure 11.1

The double sorwe of Troilus to tellen
That was the kyng Priamus sone of Troye
In lovynge how his aventures fellen
From wo to wele and after out of joie
My purpos is er that I parte fro ye
Thesiphone thou help me for tendyte
Thise woful vers that wepen as I wryte

To the clepe I thou goddesse of torment
Thou cruell furie sorwynge evere in peyne
Help me that am the sorowfull instrument
That helpeth loveres as I kan compleyne
For wel sit it the sothe forto seyne
A woful wight to have a drery feere
And to a sorowfull tale a sory chere

For I that god of loves servantz serve
Ne darr to love for myn unliklynesse
Preyen for spede all sholde I therfor sterve
So fer am I fram his help in derknesse
But natheles if this may don gladnesse
Unto any lovere and his cause availle
Have he my thonk and myn be this travaille

But ye loveres that bathen in gladnesse
If any drope of pitee in yow be
Remembreth yow on passed hevynesse
That ye have felt and on the adversite
Of othere folke and thynketh how that ye
Have felt that love durst you displese
Or ye have wonne hym with to grete an ese

And preyeth for thame that ben in the cas
Of troilus as ye may after here
That love thame bryng in hevene to solas
And ek for me preyeth to god so dere
That I have myght to shewe in som manere
Swich peyne and wo as loves folk endure
In Troilus unsely aventure

ROMANCE AND LOVE

in Chaucer's Troilus and Criseyde, The Squire's Tale *and* The Parliament of Fowls

Nicholas Perkins

IN A SOLITARY CHAMBER, away from the press of Trojan life under siege, one of the doomed city's princes cannot contain his love and bursts into song:

> If no love is, O God, what fele I so?
> And if love is, what thing and which is he?
> If love be good, from whennes cometh my woo?
> <div align="right">(whence; woe)</div>
> If it be wikke, a wonder thynketh me, (evil)
> When every torment and adversite
> That cometh of hym may to me savory thinke,
> <div align="right">(seems pleasurable)</div>
> For ay thurst I, the more that ich it drinke.[1]

Here in *Troilus and Criseyde* by Geoffrey Chaucer (c.1343–1400), we are invited to share the deepest emotions of Troilus, who has fallen in love with the widow and traitor's daughter Criseyde after seeing her across a crowded temple. Troilus' confusion and physical symptoms of lovesickness are still common currency to us. But his

apparently spontaneous outburst also translates a sonnet by the Italian writer Francis Petrarch (1304–74); it is one great poet's homage to another, an exploration of the craft of writing as much as the art of loving (see p. 145). Through moments like this, Chaucer engages with a European literary tradition stretching back to the classical poets, while vividly portraying a young man bursting with desire. Such multifaceted encounters are characteristic of Chaucer's poetry. He delighted in the extremes and uncertainties of love, in love's language and its pathos. He explored the choices that men and women must make, for better or (often) for worse. He also demonstrated how love becomes a political, bureaucratic and sometimes threatening process in a society where marriage was often the seal on a family alliance, and sexual desire a potentially disruptive, sinful drive. In *Troilus and Criseyde*'s astonishingly rich narrative, the two lovers face delay, secrecy, forced separation, and the machinations of gods and men (especially Criseyde's meddlesome Uncle Pandarus); when they make love in the climactic third book of the poem, their union seems all the more tender in the face of its destined tragic conclusion.

Troilus and Criseyde is Chaucer's most intimate and far-sighted meditation on love, romance and the workings of fortune, but they surface in many other works too, especially *The Canterbury Tales*. Several of the tales are romances – the most inventive literary form of the Middle Ages, and fundamental to Renaissance theatre, the novel, and today's fantasy fiction, from Middle-earth to Hogwarts. Chaucer's romances both enjoy and scrutinise the genre's conventions, including *The Franklin's Tale* of married love endangered by a rash promise, and *The Wife of Bath's Tale* in which a rapist knight must learn what women most desire. Amongst the Canterbury pilgrims, the young squire is described with gentle mockery as a 'lovyere and a lusty bacheler' (I. 80), who sings and pipes all day. His exuberant appearance is captured in a woodcut in William Thynne's 1532 edition of Chaucer's works (Figure 12.2). For this reason, the pilgrims expect a tale of love from him. Instead, it is love of spectacle and oriental exoticism that dominates the tale's opening, set in 'the land of Tartarye' (V. 9). King Cambyuskan is sent marvellous gifts by the king of 'Arabe and Inde' (V. 110), including a mechanical flying horse and a magic ring for his daughter Canacee, enabling her to understand what any bird is saying. Most readers take *The Squire's Tale* as a parody of certain bloated romances that swirl their protagonists from India to Ireland without regard for plot or cultural difference; the tale is tactfully interrupted by the Franklin, and we never hear its promised denouement. Before this, however, Canacee overhears a moving lament by a female falcon on the inconstancy of her avian lover, who 'semed welle of alle gentillesse; / Al were he ful of treson and falsnesse' (V. 505–6). The jilted falcon recognises Canacee as a truly compassionate listener, for 'pitee renneth soone in gentil herte' (V. 479), and Chaucer manages to derive real pathos from this meeting of two females from different species, sharing the pain of lost love.

In Chaucer's dream vision *The Parliament of Fowls*, love and devotion are again explored, this time through the competition between three male eagles for the hand (or rather, talon) of a beautiful female. One says he loves her the best; one that he has loved her longest; one that he will serve her most truly. Their speeches parody courtly debates of love familiar to Chaucer as a member and observer of the royal household. The parliament's 'lower' birds have no patience with this aristocratic indecision: 'Have don, and lat us wende! . . . When shal youre cursede pletynge have an ende?' (492, 495). To cries of 'Kek kek! kokkow! quek quek!' (499) the birds argue, until the female eagle asks for a year's delay, and the goddess Nature allows the other birds to mate and multiply. Chaucer's dreaming narrator awakes with a Valentine's Day song ringing in his ears.

For medieval and later readers, Chaucer's works provided an encyclopedic guide to love's joys and pains, its rituals, and the shadow of deceit or violence that often accompanies romance. One Scottish manuscript from the late 15th century combines *Troilus and Criseyde* with *The Parliament of Fowls*, further texts by Chaucer and others, and *The Kingis Quair* ('The King's Book'), a poem by King James I of Scotland (1394–1437), written while a prisoner in England and using Chaucerian motifs to allegorise James' own hopes for freedom and marriage. The manuscript belonged to Henry, third Lord Sinclair (d. 1513), and was altered at various times.[2] The opening folio has been recopied to include a picture illustrating the start of *Troilus and Criseyde* (Figure 12.1). The two lovers stand before a walled city, while Cupid casts his dart across the scene, reminding the book's readers that the fortunes of desire and romance are ultimately in the lap of capricious gods.

Notes:

1 *Troilus and Criseyde*, I. 400–6; all quotations are from Geoffrey Chaucer, *The Riverside Chaucer*, ed. Larry D. Benson (Oxford: Oxford University Press, 1988).

2 Julia Boffey, 'Bodleian Library, MS. Arch. Selden. B. 24 and Definitions of the "Household Book"', in *The English Medieval Book: Studies in Memory of Jeremy Griffiths*, ed. A. S. G. Edwards et al. (London: British Library, 2000), 125–34.

Nicholas Perkins is University Lecturer and Tutor in English at St Hugh's College, University of Oxford. His research interests include medieval romance and the presence of the medieval in modern culture. He is guest curator of the exhibition and accompanying publication, *The Romance of the Middle Ages* (2012), at the Bodleian Library, University of Oxford.

The Squiers prologue:

This childe Maurys was sythen Emperour
Made by the pope/and lyued chastenly
To Chrystes churche he dyd great honour
But I let al this story passen by
Of Custaunce is my tale specially
In olde Romayne restes men may fynde
Maurys lyfe/I beare it not in mynde

This kyng Alla/whan he his tyme sey
With this Custance/his holy wyfe so swete
To Englonde ben they come the right wey
Where as they lyue in ioye and in quyete
But spel whyle it lasteth I you hete
Ioye of this worlde/for tyme wol not abyde
Fro day to nyght/it chaungeth as the tyde

Who lyued euer in suche delyte a day
That he ne meued eyther in conscience
Or pyte/or talent of some syn astray
Enuye or pride/or passyon/or offence?
I ne say but for this ende/and this sentence
That spel whyle in ioye or in plesaunce
Lasteth the blysse of Alla with Custaunce

For deth/that taketh of hye t lowe his rente
Whan passed was a yere/euyn as I gesse
Out of this worlde kyng Alla he hente
For whom Custance hath ful gret heuynesse
Nowe let vs prayen god his soule blesse
And dame Custaunce/fynally to say
Towarde the towne of Rome gothe her way

To Rome is come this holy creature
And fyndeth her father hole and founde
Nowe is she scaped al her auenture
And whan that she her father hath yfounde
Downe on her knees gothe she to grounde
Wepyng for tendernesse in herte blythe
She herieth god/an hundred thousand sythe

In vertue and holy almesdede
They lyuen al/and neuer a sonder wende
Tyl dethe departen hem/this lyfe they lede
And fareth nowe wel/my tale is at any ende
Nowe Iesu chryst/that of his myght may sende
Ioye after wo/gouerne vs in his grace
And kepe vs al/that ben in this place.

¶ Thus endeth the man of lawes tale/and here foloweth the Squiers prologue.

Our hoste on his styropes stode anon
And said/good men herkeneth euerychon
This was a thrifty tale for the nones
Sir parysshe preest (qd he)for goddes bones
Tel vs a tale/as was thy forwarde yore
I se wel that ye lerned men in lore
Can moche good/by goddes dignyte
The parson him answerde/benedicite
What eyleth the man/so synfully to swere?
¶ Our host answerd/O Ienkyn/be ye there
Now good men (qd our host)herkeneth to me
I smell a loller in the wynde (quod he)
Abydeth for/goddes dygne passyon
For we shal haue a predycacion
This loller here/wol prechen vs somwhat
¶ Nay by my fathers soule/that shal he nat
Sayd the Squier/here shal he not preche
Here shal he no gospel glose ne teche
We leueth al in the great god (quod he)
He wolde sowen some diffyculte
O spunge cockel in our clene corne
And therfor hoste/I warne the byforne
My ioly body/shal a tale tell
And I shal ryngen you so mery a bell
That I shal waken al this companye
But it shal not ben of philosofye
Ne physyke/ne termes queynte of lawe
There is but lytel laten in my mawe.

¶ Here endeth the Squiers prologe/and hereafter foloweth his tale.

AT Sarra/in the londe of Tartary
There dwelt a kyng that warred Surry
Though which ther died many a doughty man
This noble kyng was called Cambuscan
Whiche in his tyme was of so great renoun
That there was no where in no regyoun
So excellent a lorde in al thyng
Him lacked naught that longed to a kyng
As of the secte/of whiche he was borne
He kept his lay/to whiche he was sworne
And therto he was hardy/wyse/and ryche
And pytous and iuste alway ylyche
Trewe of his worde/benygne and honorable
Of his corage/as any centre stable
Yonge/fresshe/t stronge/in armes desyrous
As any bacheler of al his hous
A fayre person he was/and fortunate
And kept alway so royal astate
That there was no where suche another man.
This noble kyng/this tartre/this Cambuscan
Had two sonnes by Elfeta his wyfe
Of whiche the eldest hyght Algarsyfe
That other was cleped Cambalko.
¶ A doughter had this worthy kyng also

That yongest was/and hyght Canace
But for to tel you al her beaute
It lyeth not in my tonge/ne in my connyng
I dare not vndertake so hye a thyng
Myn englysshe eke is insuffycient
It muste ben a rethor excellent
That couthe his colours/longyng for the arte
If he shulde discryue here euery parte
I am none suche/I mote speke as I can
And so byfel/that this Cambuscan
Hath twenty wynter borne his dyademe
As he was wont/fro yere to yere I deme
He let the feest of his natyuyte
Done cryen/throughout Sarra his cyte
The laste ydus of Marche/after the yere
Phebus the sonne/ful ioly was and clere
For he was nye his exaltation
In Martes face/and in his mansion
In Aryes/the colloryke/the hote sygne
Ful lusty was the wether and benygne
For whiche the foules/ayenst the sonne shene
What for the season/and the yonge grene
Ful loude songe here affections
Hem semed han getten hem protections
Ayens the swerde of wynter kene and colde
¶ This Cambuscan/of which I haue you tolde
In royal vestementes/sytte on his deys
With dyademe/ful hye in his paleys
And helde his feest so royal and so ryche
That in this worlde nas there non yliche
Of whiche/if I shal tel of al the array
Than wolde it occupye a somers day
And eke it nedeth not to deuyse
At euery course/the ordre of her seruyce
I wol not tel of her straunge sewes
Ne of her swannes/ne of her heronsewes
Eke in that londe/as tellen knyghtes olde
Ther is some meate/that is ful daynty holde
That in this londe men retche of it but small
There is no man that may reporten all.
I wyl not tarye you/for it is prime
And for it is no fruyte/but losse of tyme
Vnto my first purpose I wol haue recourse
¶ And so byfel that after the thirde course
Whyle that this kyng sytte thus in his noblay
Herkenyng his mynstralles her thynges play
Byfore hym at his borde delycyously

In at

Han seid such harm and shame now,
Witeth wel, if he gessed it,
Ye may wel demen in your wit,
He nolde nothing love you so,
Ne callen you his freend also,
But night and day he wolde wake,
The castel to destroye and take,
If it were sooth as ye devyse;
Or som man in som maner wyse
Might it warne him everydel,
Or by himself perceyven wel;
for sith he might not come and gon
As he was whylom wont to don,
He might it sone wite and see;
But now al otherwyse doth he.
Than have ye, sir, al outerly
Deserved helle, and jolyly
The deth of helle, douteles,
That thrallen folk so gilteles.

FALS-SEMBLANT proveth so
this thing
That he can noon answering,
And seeth alwey such apparaunce,
That nygh he fel in repentaunce,
And seide him: Sir, it may wel be.
Semblant, a good man semen ye;
And, Abstinence, ful wyse ye seme;
Of o talent you bothe I deme.

What counceil wole ye to me yeven?
Fals-Semblant.

RIGHT here anoon thou shalt be
shriven,
And sey thy sinne withoute more;
Of this shalt thou repente sore;
for I am preest, and have poustee
To shryve folk of most dignitee
That been, as wyde as world may dure.
Of al this world I have the cure,
And that had never yit persoun,
No vicarie of no maner toun.
And, God wot, I have of thee
A thousand tymes more pitee
Than hath thy preest parochial,
Though he thy freend be special.
I have avauntage, in o wyse,
That your prelates ben not so wyse
Ne half so lettred as am I.
I am licenced boldely
In divinitee to rede,
And to confessen, out of drede.
If ye wol you now confesse,
And leve your sinnes more and lesse,
Without abood, knele doun anon,
And you shal have absolucíon.
Here ends all that is done of The Romance
of the Rose.

THE PARLEMENT OF FOULES ❧❧ THE PROEM. ❧❧❧❧❧

Th

YF SO SHORT, THE CRAFT SO LONG
to lerne,
Thassay so hard, so sharp the conquering,
The dredful joy, that alwey slit so yerne,
Al this mene I by love, that my feling
Astonyeth with his wonderful worching
So sore ywis, that whan I on him thinke,
Nat wot I wel wher that I wake or winke.

For al be that I knowe not love in dede,
Ne wot how that he quyteth folk hir hyre,
Yet happeth me ful ofte in bokes rede
Of his miracles, and his cruel yre;
Ther rede I wel he wol be lord and syre,
I dar not seyn, his strokes been so sore,
But God save swich a lord! I can no more.

Of usage, what for luste what for lore,
On bokes rede I ofte, as I yow tolde.
But wherfor that I speke al this? not yore
Agon, hit happed me for to beholde
Upon a boke, was write with lettres olde;
And therupon, a certeyn thing to lerne,
The longe day ful faste I radde and yerne.

For out of olde feldes, as men seith,
Cometh al this newe corn fro yeer to yere;
And out of olde bokes, in good feith,
Cometh al this newe science that men lere.
But now to purpos as of this matere...
To rede forth hit gan me so delyte,
That al the day me thoughte but a lyte.

This book of which I make mencioun,
Entitled was al thus, as I shal telle,
Tullius of the dreme of Scipioun;

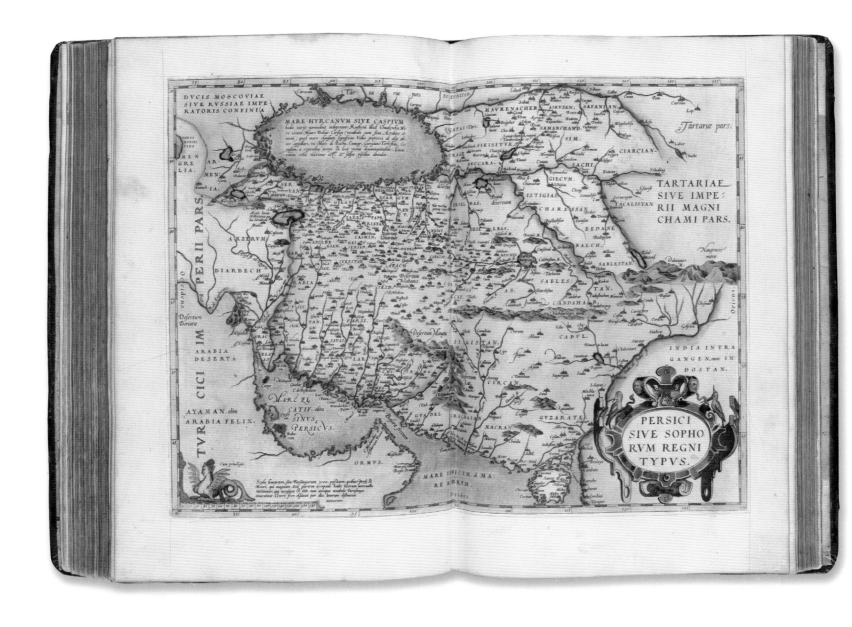

Figure 13.1

Abraham Ortelius, map of
Persia. From *Theatrum Orbis
Terrarum*. Antwerp: Coppens
de Diest, 1574.
State Library of Victoria,
Melbourne, RARESEF 912
OR8T, map follows fol. 64r.

In 1570 Abraham Ortelius
published his *Theatrum Orbis
Terrarum* ('Theatre of the
World'), which is generally
considered the world's first
modern atlas.

The first edition contained
70 maps, originally drawn by a
range of noted cartographers
and re-presented by Ortelius at
a uniform size. The map of
Persia, with its many identified
place names and landforms,
indicates the extent to which
Persia was known in the West
by this time. However, the
depiction of some features
such as the Caspian Sea reveals
that this knowledge was not yet
completely accurate.

IMAGINING PERSIA

European Travellers' Tales and Their Literary Offspring

Clare Williamson

The Asian Muse, a Stranger fair!
Becomes at length Britannia's care;
And Hafiz' lays, and Sadi's strains,
Resound along our Thames's plains.

JOHN SCOTT[1]

JOHN SCOTT'S tribute in 1782 to 'the ingenious Mr. [William] Jones's elegant translations and imitations of Eastern poetry' encapsulates the knowledge of and eagerness for Persian literature and culture that had been developing in the West over previous centuries. The idea of Persia had long held a fascination in Western minds, dating back to classical times and works such as Aeschylus' play, *The Persians* (5th century BC). From the Middle Ages onwards, knowledge of Persia and the Islamic world expanded as a result of greater contact through pilgrimage, diplomacy, trade and travel. And European writers increasingly reflected this awareness in plays, poetry and prose.

East and West met in Islamic Spain and Sicily, on the contested Holy Lands during the Crusades, and via various trade routes and economic centres, but textual evidence of cultural exchange in this early period is scarce. The 13th-century Persian poet Sa'di's claim to have been captured during the Crusades and Matthew Paris' description of the 1238 visit to England by a Persian emissary seeking aid against the Mongols invite conjecture as to the possible outcome of such contact.[2]

The works of Boccaccio, Dante and Chaucer suggest awareness of Islamic culture through either their content or literary forms and Petrarch was known to possess a copy of the *Codex Cumanicus*, the first Latin-Persian-Kumani (a Turkish dialect) dictionary.[3] Yet early European accounts of travel to Persia display elements of fantasy. Marco Polo, who gave Europe some of the earliest written descriptions of centres such as Tabriz and Kashan, also remarked on more remote regions as 'the abode of many evil spirits which amuse travellers to their destruction'.[4]

It wasn't until the Renaissance that a steady stream of European travellers had direct contact with Eastern culture in the major centres of Safavid Persia, Ottoman Turkey and Mughal India. The accounts that they published, often illustrated with views of cities,

depictions of costumes and detailed maps, led to an explosion of references, motifs and narratives in European literature that had a distinctly 'oriental' flavour.

There are few records of English travellers to Persia before the second half of the 16th century. Much of England's contact until this period was indirectly through Venice and Ottoman Turkey. While England and other European powers wished to maintain valuable trading partnerships with the Ottomans, the might of their empire was perceived as a threat. As a result, various missions to Persia aimed to form diplomatic and trading alliances there also. English merchants lacked direct access to Persia as established sea routes were dominated by Venice and Portugal. Keen to create new markets for English wool, they sought a route to Persia via Russia. In 1555 the Muscovy Company was formed, and in 1562 Anthony Jenkinson, bearing a letter from Queen Elizabeth to Shah Tahmasp, sailed via the Volga River and the Caspian Sea to reach Qazvin. The visit failed to secure a trade agreement as the shah was reluctant to deal with 'unbelievers'.[5]

Jenkinson's account of his travels is thought to be the source for a number of references in works by Christopher Marlowe, John Milton and William Shakespeare.[6] These include Marlowe's lines in his play, *Tamburlaine the Great* (c. 1587), about the Turko-Mongol emperor Timur ('the lame'):

> And Christian merchants, that with Russian stems,
> Plough up huge furrowes in the Caspian Sea.[7]

Ralph Fitch and his fellow travellers were the first recorded Englishmen to travel to Persia via the overland route from Tripoli to Aleppo and through the Euphrates Valley. In 1583 they sailed to Tripoli in the *Tiger*, a fact recorded by Fitch in his journal, published in Richard Hakluyt's *The Principall Navigations, Voiages and Discoveries of the English Nation* of 1598. The popularity of Hakluyt's volume seems apparent in the following line from William Shakespeare's *Macbeth*, 'Her husband's to Aleppo gone, master o' the *Tiger*'.[8]

References to Persia abound in Shakespeare's plays.[9] During the outward-looking reigns of both Queen Elizabeth I and Shah 'Abbas I, contact between East and West increased greatly. Persia was generally associated in the West with notions of luxury and wealth as a result of the importation of richly decorated goods for elite consumption. Shakespeare perhaps

alludes to the prestige of Persian cloth when King Lear says to Edgar, 'I do not like the fashion of your garments. You will say they are Persian; but let them be changed'.[10] This also appears to be a prescient reference to the fashion for Persian dress soon introduced by travellers such as Sir Anthony and Sir Robert Sherley and embraced by figures as influential on popular taste as King Charles II.

Parallels between Shakespeare's *Romeo and Juliet* and the classic Persian tale of Layla and Majnun can be discerned on a number of levels. With their shared narratives of young lovers separated by their families and their tragic fate, these two stories reveal the universality of their themes, which date at least as far back as the Roman story of Pyramus and Thisbe.

The most renowned travellers to Persia in the Elizabethan era were the brothers Sir Anthony and Sir Robert Sherley. They first arrived in Persia in 1598, under the leadership of Sir Anthony and without any royal sanction. Sir Anthony sought to encourage Shah 'Abbas to ally with European powers against the Ottomans and to foster trade between England and Persia. Unaware they lacked official appointment, Shah 'Abbas welcomed the Sherleys to his court and on a number of occasions appointed them as his envoys in delegations to European powers. Of Sir Anthony, the Shah is credited with having stated, 'whilst he hath been in these parts, we have eaten together of one dish and drunk of one cup, like two brethren'.[11]

It was the younger brother, Sir Robert, who spent the longest period in the shah's court and embraced Persian culture to the greatest degree. Sir Robert adopted Persian dress and married a Circassian Christian woman said to be a relative of one of the shah's wives. Together they made a number of journeys to Europe, where they were received with great interest, but also suspicion. Charles I resolved to send an ambassador of his own to Persia. In March 1627, Sir Dodmore Cotton set sail from England, accompanied by Sir Robert and Lady Sherley, Thomas Herbert, Robert Stodart and others. Stodart's journal, now held by the Bodleian Library, includes the following description of the feast served at the party's meeting with Shah 'Abbas on 25 May 1628:

> Here…my lord dined, his meate being carried
> all in beaten gould; the dishes wer soe bigg
> that they were as much as a man could carry

from the kiching to the place wher the meate was layde; on great dish was carried vpon a barrow of gould between two men.[12]

Negotiations with the shah proved unsuccessful and Sir Robert Sherley died on 13 July. While the long-term achievements of the Sherleys were minimal, their adventures caught the imagination of an array of writers, whose historical accounts and plays found eager audiences in England. As early as 1600, a pamphlet describing Sir Anthony's travels had appeared in London and in 1607 an account by Anthony Nixon was adapted for the stage as *The Travailes of the Three English Brothers, Sir Thomas, Sir Anthony, Mr. Robert Sherley*.[13]

Thomas Herbert's *A Relation of Some Yeares Travaile* (1634) documented his journey to the court of Shah 'Abbas with Sir Dodmore Cotton and Sir Robert Sherley. Highly observant of the luxuries of the Persian court, Herbert described the 'Ganymed boys in Vests of cloth of gold, rich bespangled Turbants and embroidered Sandals'.[14] His book also makes what is possibly the first reference in English to the Persian poets Sa'di and Hafiz.[15] Herbert's lively account inspired a number of plays about Shah 'Abbas such as Sir John Denham's *The Sophy* of 1642 and Robert Baron's *Mirza* of c. 1647.[16]

Under the tolerant reign of Shah 'Abbas, a number of Christian orders were permitted to establish missions and build churches in Persia. Missionaries sent detailed descriptions of Persian life back to Europe and, in order to attempt to win converts, they developed good Persian language skills.[17] In the 1630s chairs in Arabic were established at the universities of Cambridge and Oxford, and Persian studies commenced shortly thereafter. The first European grammar of Persian was published in Leiden in 1639, and was soon followed by the first text in England on the Persian language, John Greaves' *Elementa Linguae Persicae*. Sir Thomas Hyde, Professor of Arabic at Oxford and head of the Bodleian Library, translated an ode of Hafiz into Latin and also made the first translations into English of Omar Khayyam.[18] Sa'di's *Gulistan* and *Bustan* were also translated into a number of European languages in the 17th century.[19] Adam Olearius' translation into German of the *Gulistan*, published in 1654, would later be an important source for Goethe.[20] Olearius had travelled to Persia in 1637

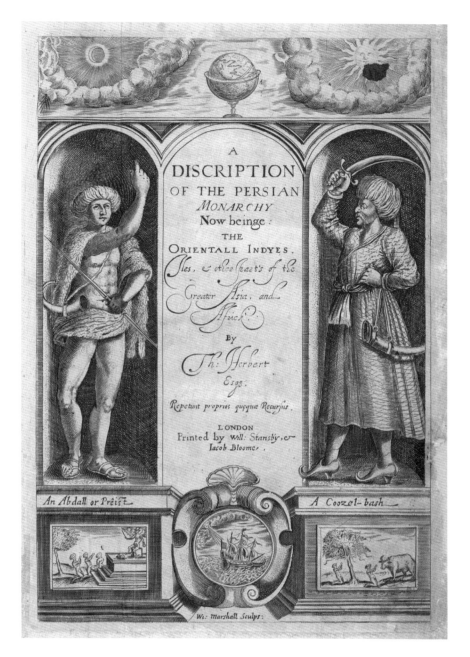

Figure 13.2

Sir Thomas Herbert, *A Relation of Some Yeares Travaile*. London: printed by William Stansby and Jacob Bloome, 1634. State Library of Victoria, Melbourne, RARES 910.4 H41.

This work contains two title pages. It is generally known by the title of *A Relation of Some Yeares Travaile* but also includes this illustrated title page with a second title.

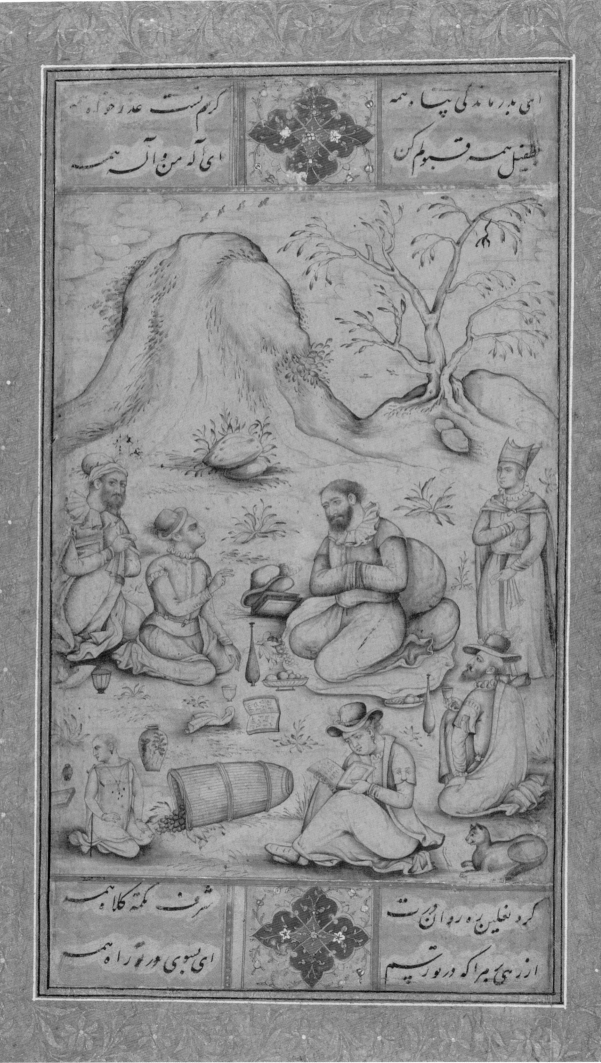

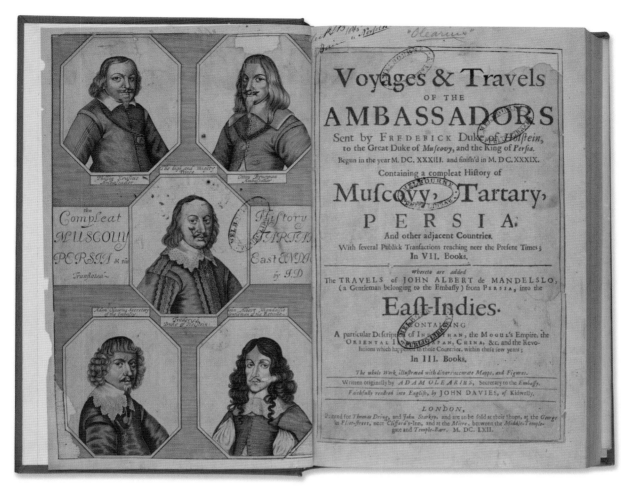

as secretary to the ambassador for the German state of Holstein and his popular travel account was published in French, Dutch, Italian and English as well as the original German.

A number of 17th-century French travellers pub-lished valuable descriptions of Persian life and culture. Jean de Thévenot's wealth enabled him to travel inde-pendently to satisfy his own curiosity. After extensive travels he journeyed to Persia in 1664 where he died in 1667. Both Jean-Baptiste Tavernier and Jean Chardin were jewel merchants and their trade gave them access to exclusive sections of Persian society. Chardin spent the equivalent of ten years in Persia, mostly in Isfahan, between 1665 and 1677.[21] His *Voyages* (1711) was praised by many later writers, including Montesquieu and Sir William Jones, for its detailed and insightful observations of Persian society.[22]

European knowledge of and access to Persian lit-erature owes much to the Orientalist Sir William Jones.

A graduate of the University of Oxford and a skilled linguist, Jones translated and championed the works of various Persian poets, stating 'we cannot with justice show less indulgence to a poet of Iran, than we all show to our immortal countryman Shakespeare'.[23] Jones advocated the study of Persian and found an audience among officers of the East India Company, many of whom were based in the subcontinent. These officers needed to know Persian as it was the language of business and administration in Mughal India. Jones' *Grammar of the Persian Language* (1771), a standard text well into the 19th century, included translations of Hafiz, Firdausi, Saʻdi and Jami.[24] His translations were popular among the Romantic poets and both Byron and Shelley were known to own his complete *Works*.[25]

Two other Orientalists who made important con-tributions to the study of Persian language and literature were the brothers Sir William Ouseley and Sir

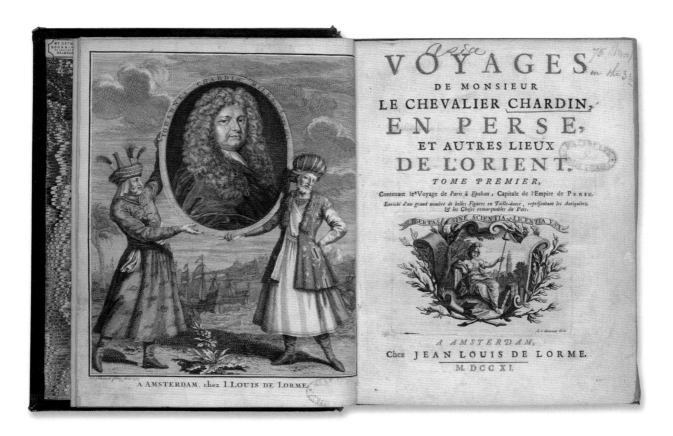

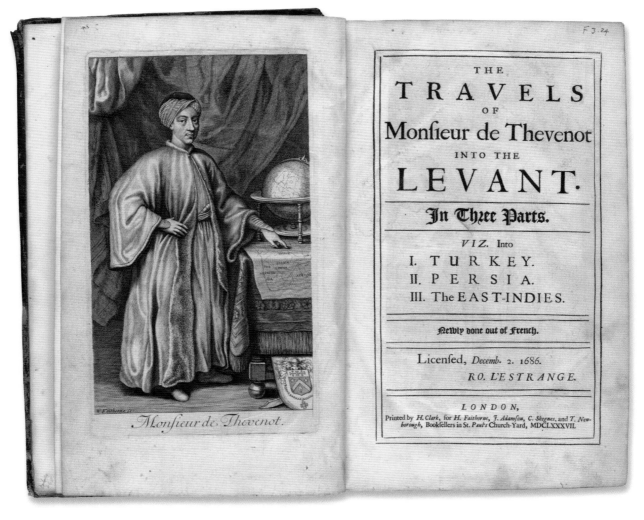

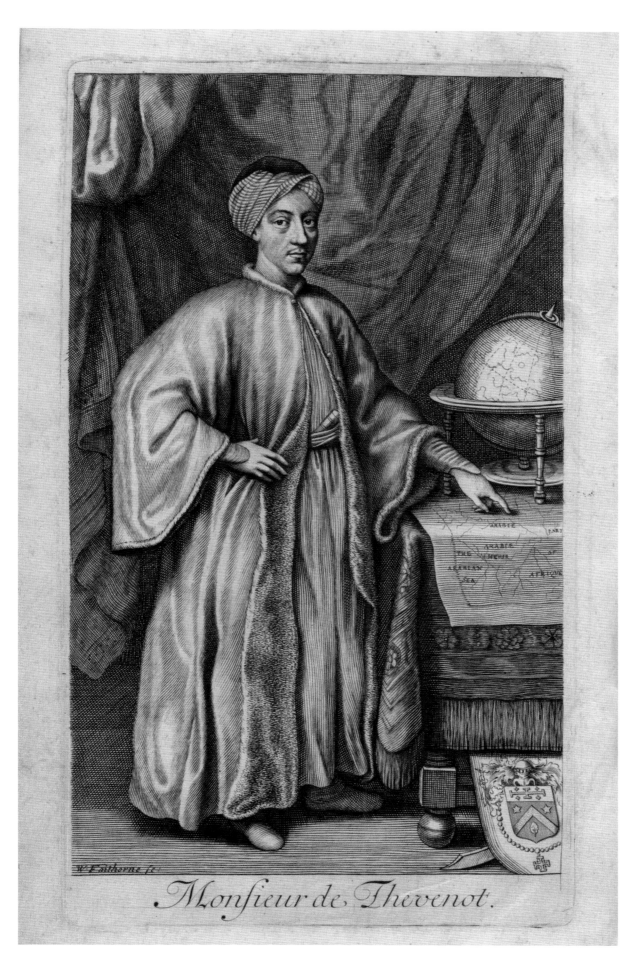

Monsieur de Thevenot.

Figure 13.5 (opposite, above)

Jean Chardin, *Voyages de Monsieur le Chevalier Chardin en Perse et autres lieux de l'Orient.* Amsterdam: Jean Louis de Lorme, 1711. State Library of Victoria, Melbourne, RARES 915.5 C37, vol. 1.

Figure 13.6 (opposite, below)

Jean de Thévenot, *The Travels of Monsieur de Thevenot into the Levant.* Translated by Archibald Lovell. London: H. Faithorne, J. Adamson, C. Skegnes, and T. Newborough, 1687. State Library of Victoria, Melbourne, RARESF 915 T34.

Gore Ouseley. Sir William translated numerous Persian works and published guides to the reading of Persian manuscripts, accounts of his travels to the region and the three-volume academic periodical *Oriental Collections* (1797–1800). Sir William had served as a military officer in India and later travelled to Persia as secretary to his brother's diplomatic mission. Sir Gore Ouseley travelled to India in 1787 as an entrepreneur, and while there studied Persian, Sanskrit and Arabic.[26] In 1810 he was appointed the first official British ambassador to Persia since the mission of Sir Dodmore Cotton. Sir Gore embraced Persian culture and named two of his children Wellesley Abbas and Eliza Shirin.[27]

The Ouseley brothers were great collectors of Persian and other manuscripts and the bulk of their Oriental collections are now held by the Bodleian Library. One of the items owned by Sir William Ouseley was the manuscript of Omar Khayyam's poetry, which was a primary source for Edward FitzGerald's landmark translation, and Isaac D'Israeli published his version of *Mejnoun and Leila* after first hearing the story read by Sir William from a Persian manuscript.[28] When serving as ambassador in Persia, Sir Gore Ouseley instituted that those occupying the position be permitted to acquire manuscripts and 'to expend a sum of money for that desirable purpose not exceeding 600 pounds per annum'.[29]

During the 18th century, a popular genre, known as the 'Oriental tale', emerged, first in France and then in England. This genre included both translations of traditional Eastern tales and imitations composed by European authors. The most famous of the translated tales is without doubt the collection most commonly known in English as *The Arabian Nights*. Comprising tales originally derived from Persian, Arabic, Indian and other sources, and based around the frame narrative of the Persian queen Sheherazade, these stories were first translated from the Arabic *Alf Layla wa Layla*, or '1000 Nights and One Night', into French by the linguist and traveller Antoine Galland and published as *Les mille et une nuits* ('The Thousand and One Nights') between 1704 and 1717. An anonymous English translation in 1708 was followed by versions by Edward William Lane (1859), Sir Richard Francis Burton (1885–88) and others, and the tales have been enormously popular in the English-speaking world ever since then.

While the tales were not published in English before the 18th century, certain elements, such as that of a magical ebony horse, parallel motifs in much earlier works, such as the brass horse in Chaucer's 'Squire's Tale' in his *Canterbury Tales*. The *Tales* are themselves a collection of stories based around a frame narrative not unlike the structure of *The Arabian Nights*.[30] The stories collected into *The Arabian Nights* had existed in oral form for many centuries, and it is possible that they were transmitted in this way.

Oriental tales that followed Galland's translation include François Pétis de la Croix' *Les mille et un jours* ('The Thousand and One Days', 1710–12) and Montesquieu's influential social satire, *Lettres persanes* ('Persian Letters', 1721).[31] While Pétis de la Croix described his work as a translation from a Persian manuscript, he may have contributed aspects such as its title and frame structure, which are strongly reminiscent of Galland's *Les mille et une nuits*.[32] Many tales that were composed in France and England at this time were given an 'oriental' flavour through the use of Persian, Turkish or Arabic words as well as imagery that suggested the luxury and exoticism Europeans commonly associated with the Eastern world. William Beckford's *Vathek*, first published in French (1782) and then in English (1786), epitomised the oriental tale and was highly influential on the later Romantics.

Increased access to knowledge about Persia and translations of Persian poetry in the 19th century encouraged writers such as Robert Southey and Thomas Moore to set tales in the East without them ever travelling to the region. Moore's *Lalla Rookh: An Oriental Romance* (1817) was enormously popular. Comprising four narrative poems connected by an overarching frame story, it ran to seven editions in its first year and was translated into many languages including, it was claimed, Persian.[33]

Lord Byron was an exception among English writers at this time. Byron had travelled throughout the Mediterranean, visiting Turkey in 1810, and with plans to travel to Persia and India. While Byron did not reach Persia, his time in the Ottoman empire exposed him to aspects of Sufism and Persianate culture. He was familiar with the writings of Sir William Jones and had read translations of Hafiz, Sa'di and Firdausi.[34]

Byron's *Turkish Tales* include *The Bride of Abydos* and *The Giaour* (both of 1813). These works make

Woodbury-Print by Waterlow & Sons Limited.]

Richard F. Burton

Figure 13.7 (above)

Title page and frontispiece with
portrait of Sir Richard Burton.
From *Lady Burton's Edition of
Her Husband's Arabian Nights*.
London: Waterlow and Sons,
1886.
State Library of Victoria,
Melbourne, S892.7 AR1B,
vol. 2.

Figure 13.8 (pages 166–67)

Thomas Moore, *Paradise and
the Peri*. London: Day and Son,
1860. Designed by Owen
Jones.
State Library of Victoria,
Melbourne, RARESF 821.75 P,
pp. 28–9.

Paradise and the Peri is the
second tale within Thomas
Moore's *Lalla Rookh*.

ah! once, how little did he think
an hour would come, when he should shrink
with horror from that dear embrace,
 those gentle arms, that were to him
holy as is the cradling place
 of Eden's infant cherubim!
And now he yields—now turns away,
shuddering as if the venom lay
all in those proffer'd lips alone—
those lips that, then so fearless grown,
never until that instant came
near his unask'd or without shame.
Oh! let me only breathe the air,
 the blessed air, that's breathed by thee,
and, whether on its wings it bear
 healing or death, 'tis sweet to me!
There,—drink my tears, while yet they fall,—
would that my bosom's blood were balm,
and, well thou know'st, I'd shed it all
 to give thy brow one minute's calm.
Nay, turn not from me that dear face—
am I not thine—thy own loved bride—

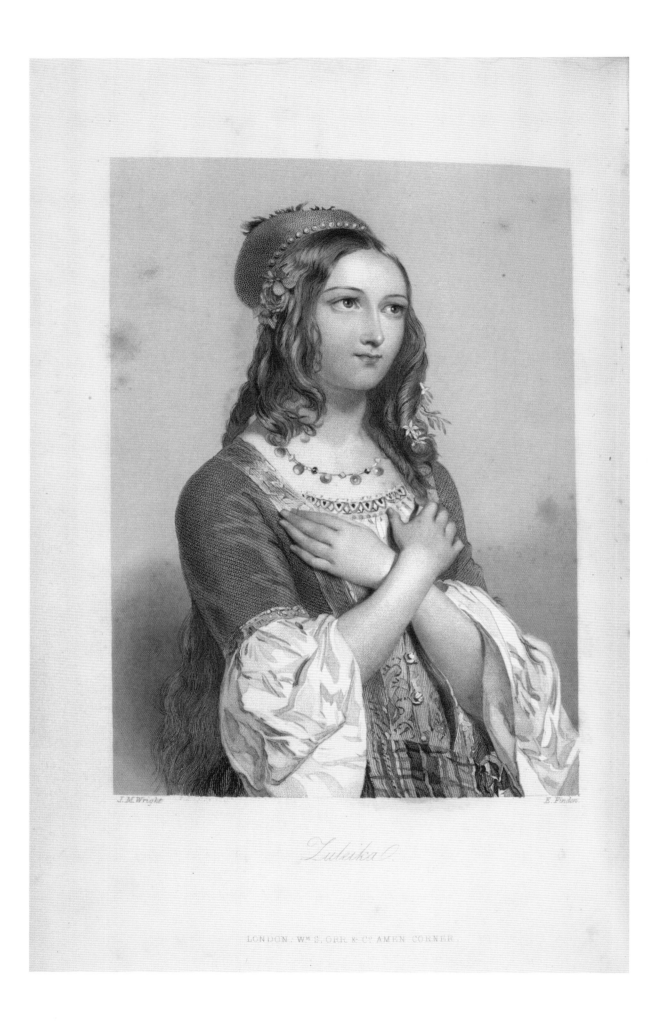

J.M.Wright

E. Finden

Zuleika.

TALES AND POEMS

BY

LORD BYRON.

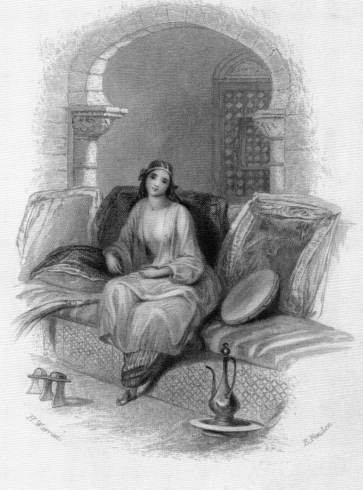

Leila.

LONDON:
Wᵐ S. ORR & Cº AMEN CORNER, PATERNOSTER ROW.
MDCCCXLVIII.

Figure 13.9 (pages 168–69)

Title page (right) and frontispiece (left) with depictions of Byron's characters 'Leila' and 'Zuleika'. Lord Byron, *Tales and Poems*. London: William S. Orr & Co., 1848. Illustrated by Henry Warren.
State Library of Victoria, Melbourne, RARES 821.7 B99T.

Figure 13.10 (above)

Johann Wolfgang von Goethe, *West-oestlicher Divan*. Stuttgart: Cotta, 1819.
Taylor Institution Library, Bodleian Libraries, University of Oxford, ARCH.8o.G.1819.

Figure 13.11 (opposite)

Rubáiyát of Omar Khayyám. Translated by Edward FitzGerald. London & Glasgow: Collins Clear-Type Press, 1963. Illustrated by Robert Stewart Sherriffs. Courtesy of Chris Beetles Gallery on behalf of the Sherriffs Estate.
State Library of Victoria, Melbourne, RARES 891.5511 UM1FS.

references to stories and motifs from Persian poetry such as 'Mejnoun's tale, or Sadi's song', and the Rose and the Nightingale. Byron even used their Persian names of *gul* and *bulbul*.[35] Names from Persian love stories, such as Zulaykha and Layla are also employed but they are given different characterisations from the Persian originals. The *Turkish Tales* were enormously popular: *The Giaour* alone sold 10,000 copies on the first day of its release and ran to fourteen editions in its first two years.[36]

In Germany at this time, Persian poetry had a profound influence on the work of Johann Wolfgang von Goethe. Goethe's *West-östlicher Divan* ('West-Eastern Divan') was published in 1819.[37] Examples of Persian literature had been available in German since the 17th century through the translations of scholars such as Adam Olearius. Joseph von Hammer-Purgstall's

translation of Hafiz' *Divan* appeared in 1812–13, and Goethe's collection of twelve 'Books' of poems echoed the work of that great Persian poet in particular, suggesting that the universal themes of Persian poetry transcend perceived East–West divisions. With titles such as the 'Book of Hafiz', the 'Book of Zuleika' and the 'Book of the Cupbearer', Goethe drew his readers' attention to his Persian sources.

In 19th-century England, 'Roses and bulbuls spattered the scented pages of mid-Victorian literature'.[38] The work that without doubt had the greatest cultural and social impact on English readers was Edward FitzGerald's *Rubaiyat of Omar Khayyam*. Verses by Omar Khayyam had been translated before, but it was FitzGerald's free translation that captured the imagination of English-language readers across the globe and continues to inspire many today.

Rubáiyát of
OMAR KHAYYÁM
Rendered into English verse by
EDWARD FITZGERALD

Edited by
GEORGE F. MAINE

Illustrated by
ROBERT STEWART
SHERRIFFS

COLLINS
LONDON AND GLASGOW

A 15th-century manuscript of Omar Khayyam's verses had been discovered at the Bodleian Library by FitzGerald's friend and Persian teacher, the Orientalist E. B. Cowell. Cowell had studied Persian at Oxford and had catalogued numerous Persian and other manuscripts for the Bodleian. For many years FitzGerald and Cowell shared a passion for Persian poetry and Fitz-Gerald also translated, with Cowell's assistance, Jami's *Salaman u Abasal* and 'Attar's *Mantiq al-Tayr* ('Conference of the Birds').

Cowell gave FitzGerald a copy of the Bodleian's manuscript of Omar Khayyam and, after taking up an academic position in India shortly afterwards, sent FitzGerald a copy of a second manuscript that he had located at the Asiatic Society of Bengal.[39]

FitzGerald's *Rubaiyat* was originally published anonymously by London bookseller Bernard Quaritch, with FitzGerald covering the printing costs. The majority of the edition of 250 languished largely unnoticed at Quaritch's shop until the Pre-Raphaelite poet Dante Gabriel Rossetti was shown a copy, purchased for a penny, by the Celtic scholar Whitley Stokes.[40] The *Rubaiyat* made an immediate impression on Rossetti who subsequently drew it to the notice of Algernon Charles Swinburne and other writers and artists of his circle. In 1863 John Ruskin enthused, 'I never did – till this day – read anything so glorious, to my mind as this poem'.[41]

FitzGerald issued three more editions of his *Rubaiyat* (1868, 1872, 1879), each substantially revised, and a fifth edition, based on his notes, was published posthumously in 1889. The *Rubaiyat* would become one of the best-selling works of poetry in the English-speaking world, and, in addition to other English translations, was also translated into many other languages. The work has been illustrated by many artists and has also inspired various musical compositions. Its popularity reached its peak around the beginning of the 20th century, at which time Omar Khayyam clubs in London and Boston attracted distinguished artists and writers as members.

While the popularity of the *Rubaiyat* has waned somewhat during the past century, enthusiasm for other Persian poets has risen. Reflecting the growing interest in Sufi thought, Rumi is today the best-selling poet in the United States, and the works of Hafiz continue to gain in popularity each year, a trend that bears out Sir

Arnold. T. Wilson's comment in 1925:

> the world was perhaps a happier and less bigoted place in the sixteenth and seventeenth century than in the twentieth, and we have something to learn from our forebears ...[42]

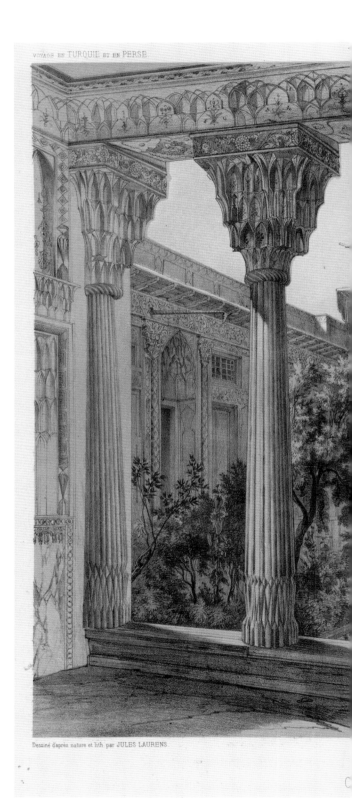

VOYAGE EN TURQUIE ET EN PERSE

Dessiné d'après nature et lith par JULES LAURENS.

Clare Williamson is Exhibitions Curator at the State Library of Victoria, Melbourne, and was previously a curator at the Queensland Art Gallery and the Australian Centre for Contemporary Art. Along with the State Library of Victoria's Rare Printed Collections Manager, Des Cowley, she co-authored *The World of the Book* (2007). She is co-curator of the exhibition *Love and Devotion: From Persia and Beyond*.

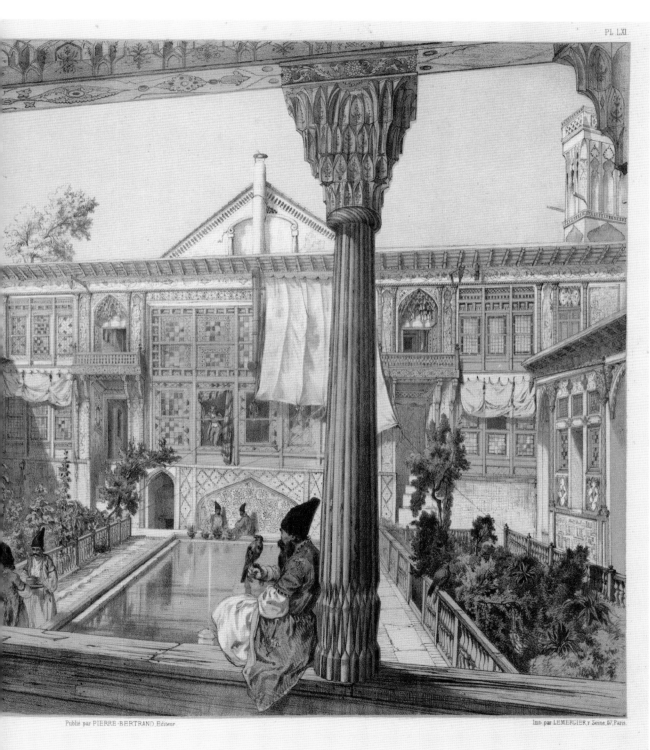

PL. LXI

Publié par PIERRE-BERTRAND, Éditeur

Imp. par LEMERCIER, r Seine, 57, Paris.

LAIS DE LA MISSION FRANÇAISE A TÉHÉRAN, EN 1848.

Figure 13.12

Jules Laurens, 'Cour du Palais de la Mission Française à Téhéran, en 1848'. From Xavier Hommaire de Hell, *Voyage en Turquie et en Perse: Atlas.* Paris: P. Bertrand, 1859. State Library of Victoria, Melbourne, RARESEF 915.5 H75, plate 61.

French engineer and geographer Xavier Hommaire de Hell travelled to Persia in 1847 with artist Jules Laurens. Through the French ambassador, Comte de Sartiges, he met Muhammad Shah Qajar and began a feasibility study into the construction of a canal to irrigate the Savajbulaq plain. But, having regularly suffered ill health, Hommaire de Hell died soon after, in Isfahan, at the age of thirty-five. His widow compiled the four-volume *Voyage en Turquie et en Perse* from his notes and from Jules Laurens' detailed drawings.

Detail from Figure 13.8

Notes:

1 *Poetical Works* (London: J. Buckland, 1782), 332.

2 John Yohannan, *The Poet Sa'di: A Persian Humanist* (Lanham, MD: University Press of America and Bibliotheca Persica, 1987), 10; Paris in John Yohannan, *Persian Poetry in England and America: A 200-Year History* (Delmar, NY: Caravan Books, 1977), x.

3 Hasan Javadi, *Persian Literary Influence on English Literature: with Special Reference to the Nineteenth Century* (Costa Mesa, CA: Mazda Publishers, 2005), 11. By this time, much of the West's exposure to the science and culture of the Islamic world was mediated through Arabic-language scholarship that had absorbed much from the cultures embraced by the realm of Islam.

4 Samuel C. Chew, *The Crescent and the Rose: Islam and England during the Renaissance* (New York: Octagon Books, 1974), 8.

5 Reported by Anthony Jenkinson, as quoted in Javadi, *Persian Literary Influence*, 15.

6 Yohannan, *Persian Poetry in England and America*, xii.

7 Laurence Lockhart, 'European Contacts with Persia, 1350–1736', in Peter Jackson and Laurence Lockhart, eds., *The Cambridge History of Iran*, vol. 6 (Cambridge: Cambridge University Press, 1986), 383.

8 Act I, scene 3, line 8 (Harmondsworth, UK: Penguin Books, 1967), 56. Laurence Lockhart, 'Persia as seen by the West', in A. J. Arberry, ed., *The Legacy of Persia* (Oxford: Clarendon Press, 1953), 344.

9 For a summary of these references, see Cyrus Ghani, *Shakespeare, Persia and the East* (Washington, DC: Mage Publishers, 2008).

10 William Shakespeare, *King Lear*, Act III, scene 6, lines 79–81 (Harmondsworth, UK: Penguin Books, 1972), 131.

11 E. Denison Ross, ed., *Sir Anthony Sherley and his Persian Adventure* (London: George Routledge & Sons, 1933), 95.

12 Robert Stodart, Journal, 25 May 1628, Bodleian Library, University of Oxford, MS. Carte 271.

13 *A True Report of Sir Anthonie Shierlies Journey Overland to Venice, from Thence by Sea to Antioch, Aleppo, and Babilon, and so to Casbine in Persia*, 1600; Chew, *The Crescent and the Rose*, 267; the play was written by John Day, William Rowley and George Wilkins. See Javadi, *Persian Literary Influence*, 22.

14 J. E. Heseltine, 'The Royame of Perse', in Arberry, *The Legacy of Persia*, 369.

15 Yohannan, *Persian Poetry in England and America*, xiii.

16 Chew, *The Crescent and the Rose*, 510, 512.

17 Lockhart, 'European Contacts with Persia', 398.

18 Yohannan, *Persian Poetry in England and America*, xv.

19 Franz Rosenthal, 'Literature', in Joseph Schacht and C. E. Bosworth, eds., *The Legacy of Islam*, 2nd edn (Oxford: Clarendon Press, 1974), 339.

20 Javadi, *Persian Literary Influence*, 42.

21 Lockhart, 'European Contacts with Persia', 399–400, for both de Thévenot and Chardin.

22 Javadi, *Persian Literary Influence*, 18.

23 See Yohannan, *Persian Poetry in England and America*, 29.

24 Yohannan, *Persian Poetry in England and America*, 5.

25 Parvin Loloi, 'Hafiz and the Language of Love in Nineteenth-Century English and American Poetry', in Leonard Lewisohn, ed., *Hafiz and the Religion of Love* (London: I. B. Tauris, 2010), 281.

26 Biographical information on Sir William and Sir Gore Ouseley sourced primarily from Peter Avery, 'Ouseley, William' and 'Ouseley, Gore', *Encyclopaedia Iranica*, online edition, 20 July 2004, available at:
http://www.iranicaonline.org/articles/ouseley-sir-william and http://www.iranicaonline.org/articles/ouseley-sir-gore.

27 Yohannan, *Persian Poetry in England and America*, 43.

28 Javadi, *Persian Literary Influence*, 120.

29 Yohannan, *Persian Poetry in England and America*, 43.

30 Yohannan, *Persian Poetry in England and America*, xi.

31 Javadi, *Persian Literary Influence*, 29–30.

32 Pétis de la Croix' role in the work has been debated. See, for example, Jan Rypka, *History of Iranian Literature* (Dordrecht, The Netherlands: D. Reidel Publishing Company, 1968), 666–8.

33 Linda Kelly, *Ireland's Minstrel: A Life of Tom Moore: Poet, Patriot and Byron's Friend* (London: I. B. Tauris, 2006), 132, 136.

34 Peter Cochran, ed., *Byron and Orientalism* (Newcastle, UK: Cambridge Scholars Press, 2006), 17.

35 Byron's notes to *The Bride of Abydos* describe 'Mejnoun and Leila' as 'the Romeo and Juliet of the East' and Sa'di as 'the moral poet of Persia'. Lord Byron, *Tales and Poems* (London: William S. Orr & Co., 1848), 119.

36 Javadi, *Persian Literary Influence*, 81.

37 Marianne von Willemer is also said to have composed some of the poems included in the *West-östlicher Divan*. Hamid Tafazoli, 'Goethe, Johann Wolfgang von', *Encyclopaedia Iranica*, vol. XI (New York: Bibliotheca Persica Press, 2001), 42.

38 A. J. Arberry, ed., *Persian Poems: An Anthology of Verse Translations* (London: Dent, 1954), v.

39 Yohannan, *Persian Poetry in England and America*, 99.

40 Edward FitzGerald, *Rubáiyát of Omar Khayyám: A Critical Edition*, ed. Christopher Decker (Charlottesville, VA: University Press of Virginia, 1997), xxxiv.

41 Robert Bernard Martin, *With Friends Possessed: A Life of Edward FitzGerald* (London: Faber & Faber, 1985), 219.

42 Sir A. T. Wilson, 'Some Early Travellers in Persia and the Persian Gulf', *Journal of the Central Asian Society* XII (1925): part I (reprinted Vaduz, Liechtenstein: Kraus Reprint, 1963), 82.

PERSIAN POETS AND THEIR STORIES

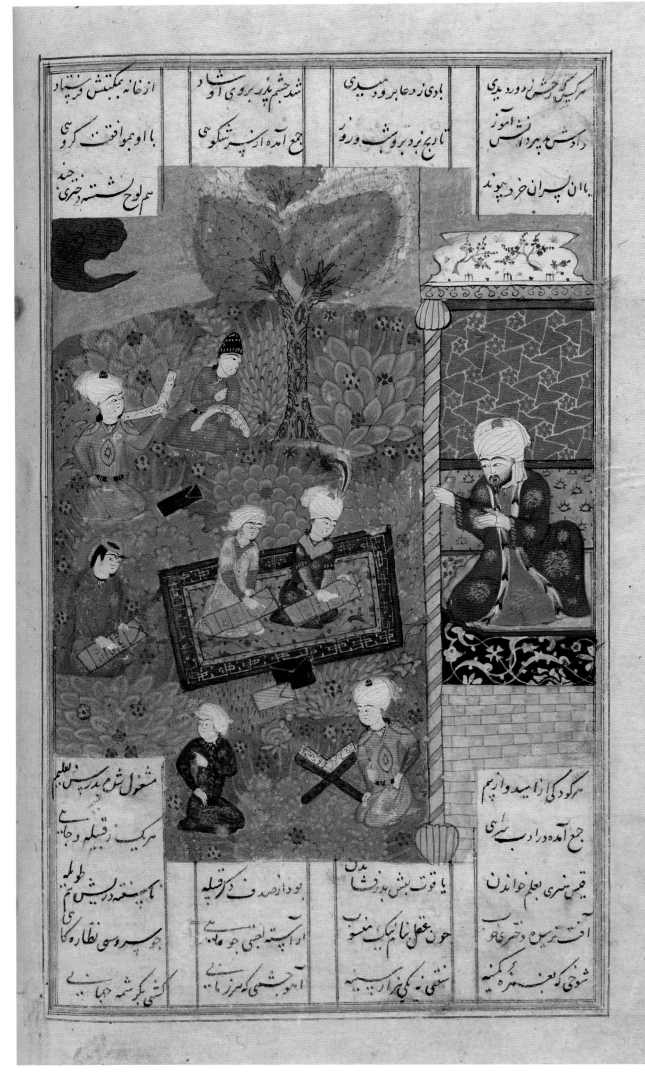

سرکس کہ خورش دورد پیدی
داد س بیرد از س آموز

یادی از دعا بر ورد میدی
تاریخ یزد بروش ورو

شد چشم پدر بروی او شاد
جمع آمده از سپہ شکوی

از خانہ حکمتش فرستاد
یا او هم وافقت کردی

یا ان پسران خرد پیوند

هم لوح رشته دختری

هر کودکی ازامید واریم
جمع آمده در ادب سائی
قیصر هنری بعلم خواندن
آفت ترین دختری جو
شوخی کہ بغمزه هزار کینہ

یا یوت بیش برو فشا
چو عقل بنام نیک منسب
سستی نہ یکی هزار سینہ

مشغول شرح بدرس فی العلم
هر یک زقبلہ و جا
نا بستہ درس یم طولہ
جو سرو سی نظاره کا

بود از صد ف درفشا
او آہستہ لبی جو میا
آمو جشی کہ هرزار سائی
کشتی کہ کرشمہ جہانی

A GLANCE AT THE HISTORY OF ROMANTIC VERSIFIED STORIES IN PERSIAN POETRY

Seyed Mohammad Torabi

PERSIAN LITERATURE is traditionally classified according to the three periods of Ancient Iran (751 to 330 BC), Middle Iran (250 BC to 643 AD), and New Iran (from 643 AD to the present).[1] Among the languages of ancient Iran, which include Medean, ancient Persian, Sakai and Avestan, it is in Gata that a part of the sacred text of the *Avesta* from Zarathustra (c. 7th or 6th century BC), the holy prophet of ancient Iran, is written: it is the most ancient work of Iranian literature, bearing tremendous historical, religious and literary significance.[2]

The Middle Iran period divides into the Arsacid or Parthian dynasty (250 BC to 226 AD), and about 400 years of Sasanid rule (226 to 650 AD). The language of Iran during the reign of the Arsacids is known as Parti or Arsacid Pahlavi; that of the Sasanid reign is called Middle Persian or Sasanid Pahlavi.[3] The few Arsacid literary works that survived were versified in later centuries. These include *Wis u Ramin*, *Ayatekar-i Zariran* and *Bozasef u Beloher*, among which *Wis u Ramin* is a love story,[4] whose verse translation from Pahlavi into Dari by Fakhru'd-Din As'ad Gurgani (c. 1054) undoubtedly inspired such poets as Nizami (1141–1209) in composing their amorous poems. Many more works have remained

from the Sasanids, testifying to the longevity of their literature and music and their treatment of love and devotion. Under the Sasanids, Greek and Indian sciences were translated into Pahlavi; poetry flourished, and prose began to be rhetorical and rhymed.[5] Furthermore, many of the Iranian heroic-mythological narratives, later versified by Firdausi in his *Shahnama*, were compiled under the Sasanids.[6]

In 643 AD, the New Iran period began with the invasion of Iran by the Arab Muslims and the fall of the Sasanian dynasty which had been ruled by a monarch and followed a state religion, Zoroastrianism. As a consequence of this invasion, the national language of Iran, Pahlavi, was prohibited and replaced, for about 200 years, with Arabic, the language of the Qur'an and Islam. A century after the invasion, Arab power began to decline and, as Iranian political independence increased, so did the drive for cultural independence. Dari, a dialect of eastern Iran under the Sasanids and Arsacids, which was richer than the other dialects and languages, emerged as the national language in Iran.[7] In Dari, Persian poetry, which was to fully flourish under the Samanids in the 9th and 10th centuries, was born.

Detail from Figure 14.12

Figure 14.1 (page 178)

Layla and Majnun at school.
From a manuscript of Nizami,
Khamsa, dated 909 (1504).
Bodleian Library, University
of Oxford, MS. Pers. d. 105,
fol. 125v.

Figure 14.2 (opposite)

Illuminated opening page.
From a disbound manuscript
of Firdausi, *Shahnama*, copied
for Ibrahim Sultan, c. 1430,
Shiraz.
Bodleian Library, University
of Oxford, MS. Ouseley Add.
176, fol. 17v.

The 10th and 11th centuries were the age of versifying epic tales in Iran.[8] There is a sequence of amorous episodes within these epic tales that Firdausi, in particular, has recounted with absolute mastery in the stories of the *Shahnama*, the 'Book of Kings'. Rudaki (d. 941 AD), the 'father' of Persian classical poetry, who may be compared with Geoffrey Chaucer (c. 1343–1400) in English literature, was the most famous lyric poet of this time.[9] He composed beautiful odes, and his *ghazals* were gradually emulated by the poets of later periods. Rudaki's era was followed by Daqiqi (d. 981 AD), a lyric-epic poet who himself saw the emergence of Firdausi (940–c. 1020), the creator of the most celebrated Iranian national epic ever, the *Shahnama*, in which several stories, including those of *Zal u Rudaba* and *Bizhan u Manizha* are concerned with love, and many more with devotion (see pp. 30–37). Although the predominant voice of Iranian poetry in this period was patriotic with a strong attempt to revive national identity, the *ghazal* as a form of lyric poetry developed and gained a distinguished status.

The period from the first quarter of the 11th century to the late 12th century was a time of the further growth of romantic poetry, romantic epic and the versification of love stories.[10] Ansari (d. 1089), Farrukhi (d. 1034), and Manuchihr (d. 1040) were lyric poets and their collections of poems mostly consisted of verse in *ghazal* form for odes with lyrical motifs. Ansari versified the love story of *Vamaq u Ezra*,[11] and 'Ayyuqi wrote *Varqa u Gulshah* (see Figure 1.9, p. 13), Nasir-i Khusrau (d. 1088) composed his poems to promote the Fatimi's (Isma'ilid) faith; and Omar Khayyam (d. 1123), who, centuries later, became the most famous Persian poet ever outside Iran (see pp. 1–2) wrote his quatrains to mock human existence and to encourage the appreciation of life. These poets were the most famous in their poetic style, termed 'Khurasani', after the north-east province where it originated. In this era, whenever the word 'love' is used in a poem, it denotes sensual and worldly love rather than divine or spiritual. Sensual love in the poetry of this period is of two types: the love between two men or that between a man and a woman. The love story of *Mahmud u Ayaz* is an instance of the former; the story of *Layla u Majnun* is of the latter.

By the end of the Seljuq Turkish suzerainty in Iran (12th–15th centuries), a variety of linguistic, literary,

بنام خداوند جان و خرد / کزین برتر اندیشه برنگذرد

خداوند نام و خداوند رای / خداوند روزی ده رهنمای

خداوند کیوان و گردان سپهر / فروزنده ماه و ناهید و مهر

ز نام و نشان و گمان برتر است / نگارنده بر شده گوهر است

به بینندگان آفریننده را / نبینی مرنجان دو بیننده را

نیابد بدو نیز اندیشه راه / که او برتر از نام و از جایگاه

سخن هر چه زین گوهران بگذرد / نیابد بدو راه جان و خرد

خرد گر سخن برگزیند همی / همان را گزیند که بیند همی

ستودن نداند کس او را چو هست / میان بندگی را ببایدت بست

خرد را و جان را همی سنجد اوی / در اندیشه سخته کی گنجد اوی

بدین آلت رای و جان و زبان / ستود آفریننده را کی توان

به هستیش باید که خستو شوی / ز گفتار بیکار یکسو شوی

پرستنده باشی و جوینده راه / بفرمانها بازرف کردن نگاه

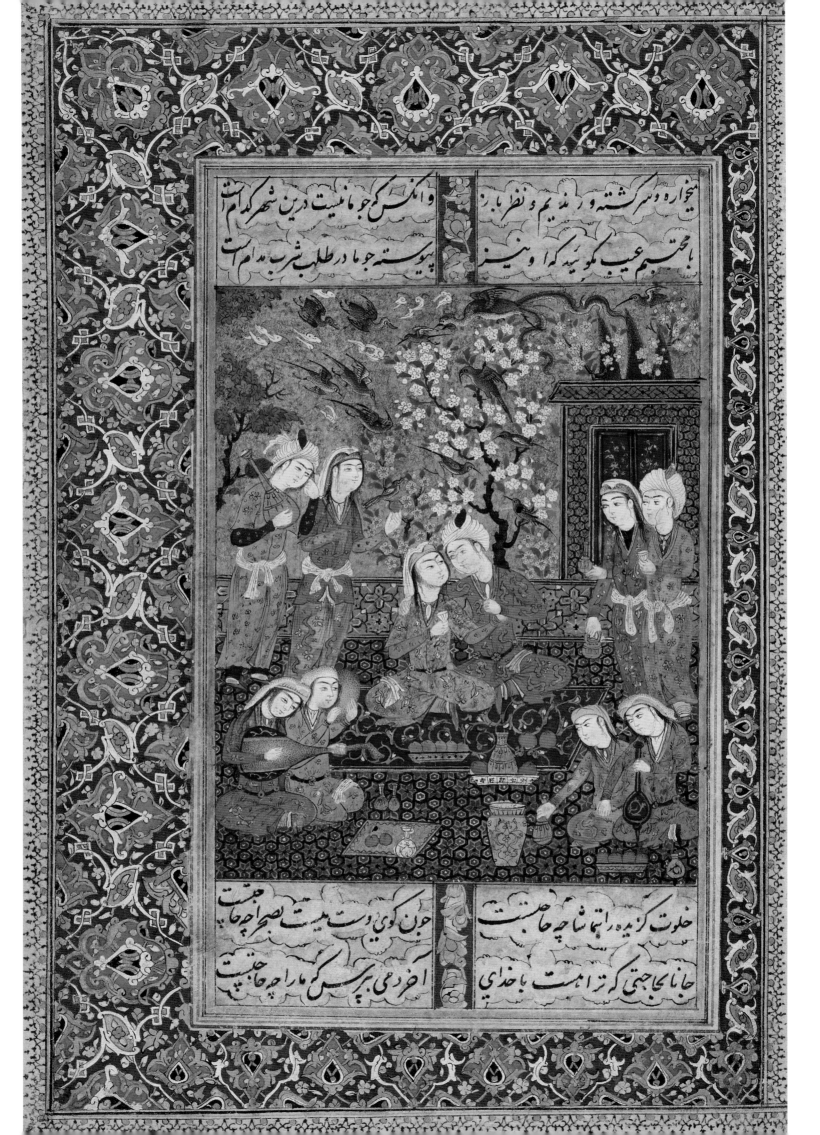

and cultural changes had occurred including the use of the vernacular as the medium of expression, the transference of the hub of poetry from north-east Iran to other regions, the growth of mysticism and asceticism in Iranian thought, and the predominance of descriptive *ghazal*.[12] These changes caused a shift in literary style from Khurasani to 'Iraqi, in which Khaqani (1126–99) and Anvari (d. 1190), who were among the founders of this style, began to express some very delicate ideas of spiritual love and devotion; a few decades later, Sa'di (1203–92), Khwaju (1282–1351), and Hafiz (1320–90) worked further to perfect this style. In the genre of the *ghazal*, the beloved who is usually a congenial, approachable female turns into an unyielding one with male attributes. Nizami from Ganja, who is a contemporary of Khaqani and Anvari, introduced romantic epic in his magnificently versified amorous stories named *Khamsa* ('Quintet') or *Panj Ganj* ('Five Treasures') in which three of them – *Layla u Majnun, Khusrau u Shirin*, and *Haft Gunbad* ('Seven Domes') or *Haft Paykar* ('Seven Portraits') – are entirely concerned with love and the two others – *Makhzanol-Asrar* ('The Storehouse of Mysteries') and *Iskandarnama* ('The Book of Alexander') – deal in part with amorous emotions.[13]

Nizami's poetry reached its zenith in his *Khamsa*. His poetical achievement was so tremendous that a number of Persian poets of the later periods imitated his style, writing numerous stories in verse in the hope of being recognised as his successor. Among such poets were Amir Khusrau from Delhi (1253–1325), and Khwaju from Kirman. Amir Khusrau wrote his *Shirin u Khusrau* in imitation of Nizami's *Khusrau u Shirin*; *Majnun u Layla* in imitation of Nizami's *Layla u Majnun*; and *Hasht Bihisht* ('Eight Gardens of Paradise') in imitation of Nizami's *Haft Gunbad*.

Amir Khusrau, a prolific poet, composed poetical stories of Indian provenance, dealing with local events such as *Davalrani u Khazarkhan*, which narrated the love between Khazarkhan, the prince Muhammad Shah Khalaji, and Divaldi, the daughter of the governor of Gujarat.[14] Khwaju, another prolific writer, created *Humay u Humayun, Gul u Nowruz* and *Goharnama*, to follow his predecessors, Nizami and Amir Khusrau, though certain traces of originality can be seen in his works.[15] Other followers of Nizami's poetic style were Salman-i Savaji (d.1371), who wrote *Feraqnama* and

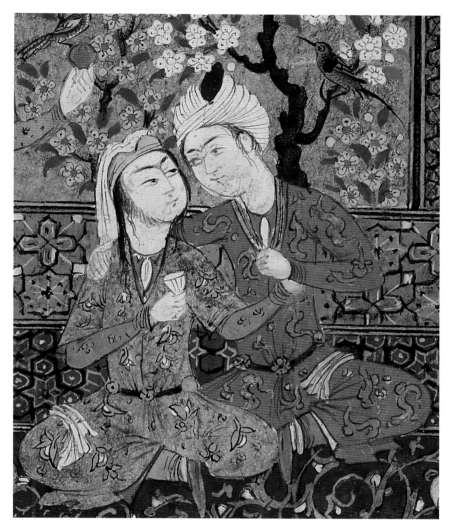

Detail from Figure 14.3

Figure 14.3 (opposite)

A prince and a princess feasting on a terrace. From a manuscript of Hafiz, *Divan*, copied before 1717.
Bodleian Library, University of Oxford, MS. Pers. e. 53, p. 29.

Figure 14.4 (pages 184–85)

A game of polo. From a manuscript of 'Assar-i Tabrizi, *Mihr u Mushtari*, copied c. 1550.
Bodleian Library, University of Oxford, MS. Ouseley Add. 21, fols. 134v–135r.

Figure 14.5 (page 186)

Majnun in the desert. Leaf from a disbound manuscript of Jami, *Haft Aurang*, copied c. 1570.
Bodleian Library, University of Oxford, MS. Elliott 149, fol. 252r.

Figure 14.6 (page 187)

Khusrau spies Shirin bathing. From a manuscript of Nizami, *Khamsa*, dated 956 (1549).
Bodleian Library, University of Oxford, MS. Pers. c. 42, fol. 42v.

183

دو سرو سایه بخش خها منظر
به چمیدند با سر باروکبر

دگر ره مهر جو کان زلف به روی
برون برد از بر شاه جهان کوی

بجوکان گوی را پروین جهانید
جو آتش کوی را بپار امید زوند

جهان بر کوی میزد آن کروبین مخفت
بهای وسوی دگر کوی سوکرد

سواری هم از این رو سم ان رو
نزد جوکان خود و یکبار بر کوی

بیامد پش خسرو سوی کروه
زمیدان سعادت کوی بردو

چوجوکان زلف و چشش سر نهاد
فلک جون کوی از زلف بر روش او ما

چوشه نزد یک خسرو شد پیاده
زاسب نزد یک حضر و شد شاه زاده

بیامد پش رانش را بوسید
ملک فری گیانش را بوسیت

ستقو وش بپجد و کروش سواره
درو خار از میان یکیسم نظاره

عزنوی در میان مردم افتا
رنغری و بستانی خواسته غزم

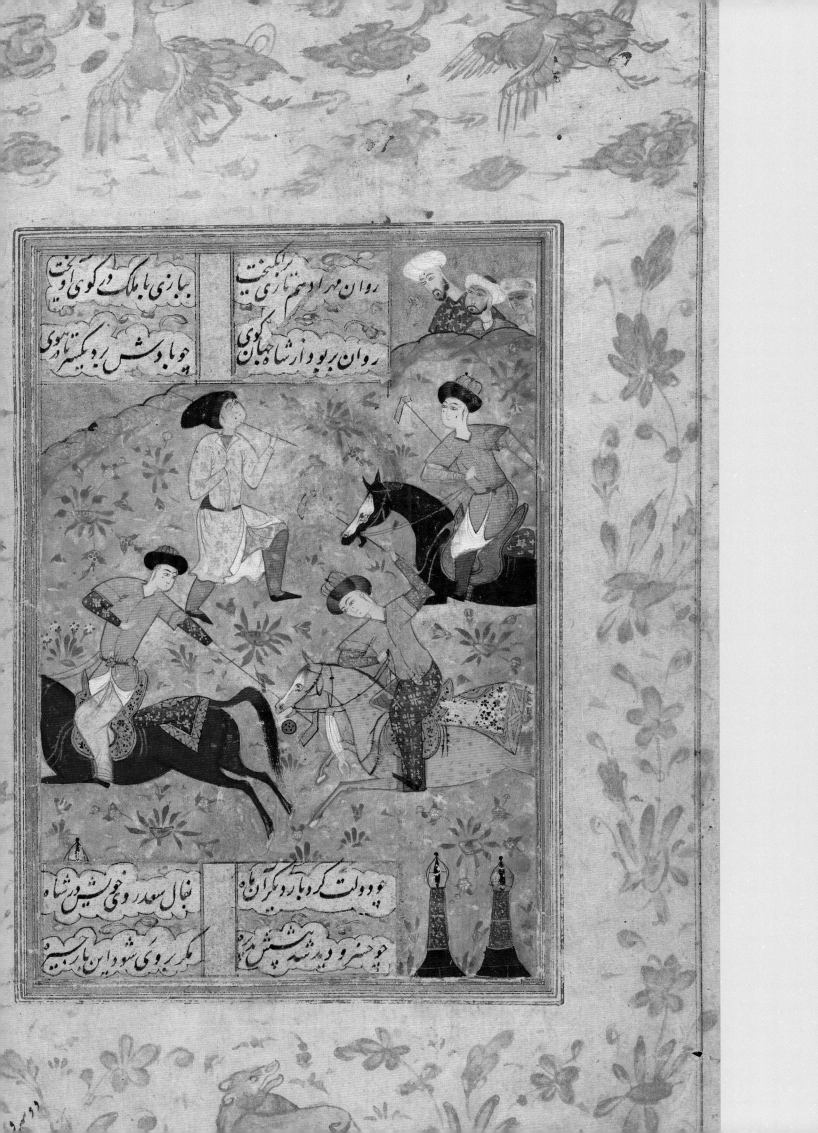

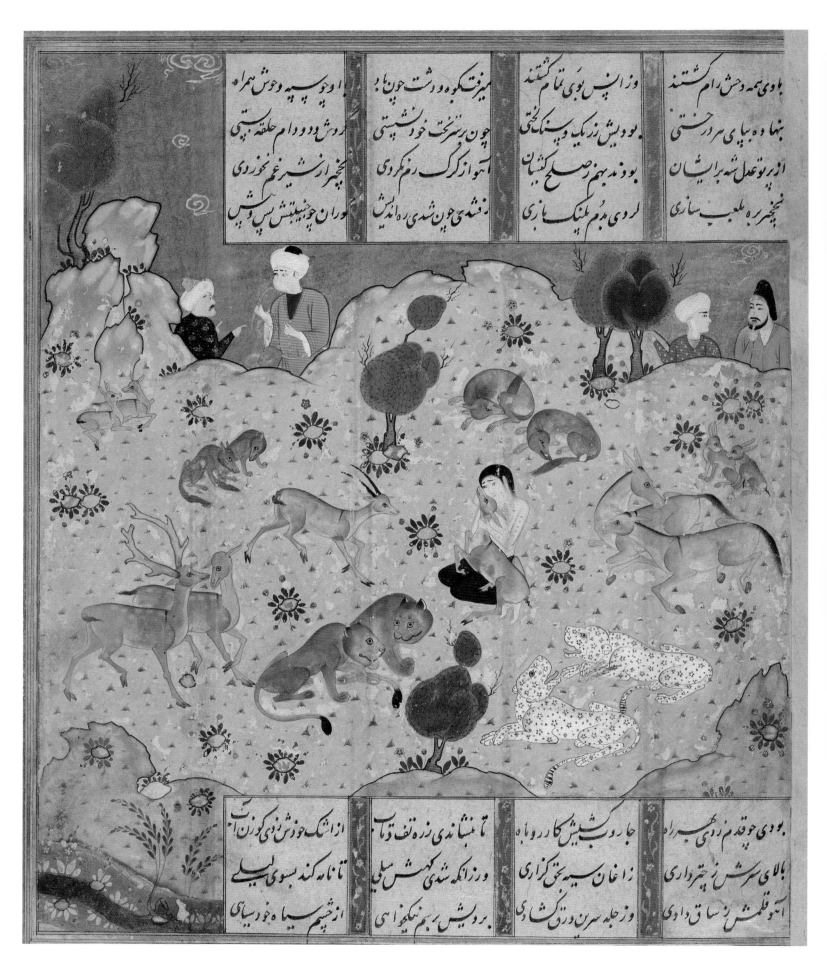

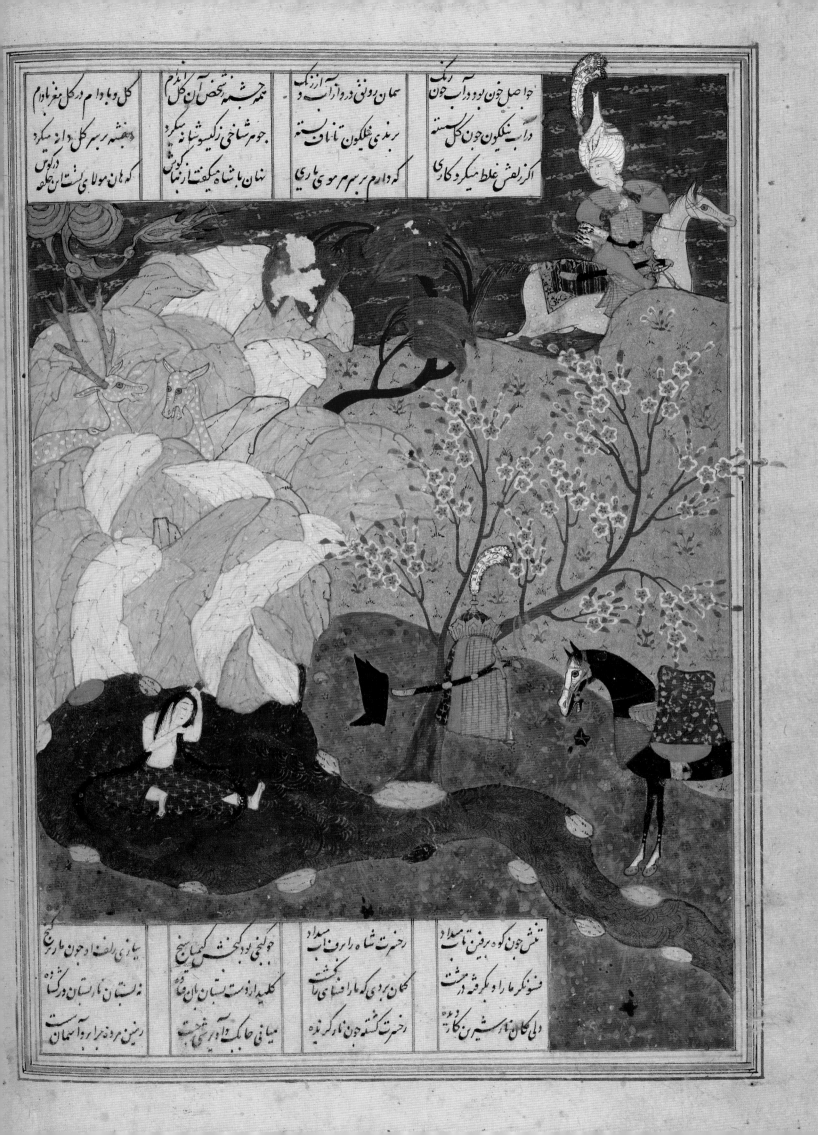

Jamshid u Khorshid,[16] and 'Assar-i Tabrizi (d. 1377 or 1382), in whose *Mihr u Mushtari* there may be observed both the features of Nizami's literary style as well as a degree of creativity.[17]

The love stories in these poetical works, being versified inside or outside Iran, have certain commonalities: descriptions of the appearances and characters of the major figures, heroes and heroines; the grief of separation (*anduhe hejran*) and being away from one's love; epistolary love affairs, with the number of love letters amounting to ten, traditionally called *dah nameha*.[18] Despite Nizami's literary dominance, it is worth mentioning that such poets as San'ai (d. 1131) and 'Attar (c. 1145–c. 1221) presented a new poetic style marked by Sufism, which was followed by Rumi (1207–73), 'Iraqi (d. 1288), Hafiz (d. 1390) and Jami (1414–92). Rumi, known by Persians as *Maulana* ('our Lord'), the greatest mystical poet ever, flourished in this period as the time was ripe for the treatment of divine or spiritual love, considered as the love between God and his servant(s), or between his pious servants. While Rumi's verse (in *Divan-i Shams*) is the manifest representation of the former, there also exist several examples of the latter in the controversial love poems between Rumi and his famous mentor, Shams-i Tabrizi.

The Mongol invasion of Iran by Genghis Khan in the early 13th century, which continued during the rule of his descendants such as Hulegu (r. 1254–65) and Timur, known to Europeans as Tamerlane (r. 1370–1405), utterly destroyed cities, schools and libraries, causing a fundamental change in Iranian culture and civilization. Sufism and asceticism gained momentum during Mongolian rule, and poetry and prose were supposed to reflect humankind's cynicism and disillusionment. Through literature, people were encouraged to abandon the pleasures of sensual life for the spiritual. The transience of the physical world and, consequently, the preference for the hereafter became the predominant images in presenting the world of Islam. Sa'di's maxim – 'the ephemeral is not love-worthy'[19] – is typical of the prevalent ambience. Sa'di, the prince of Persian prose, Rumi, the greatest mystical poet, Hafiz, the most famous writer of *ghazal* verse and Obayd-i Zakani (1300–69), a satirist and a vociferous critic of social corruption, are among the leading poets of this period.

Timur's successors mainly appreciated Persian literature and fine arts, yet under Timurid Turko-Mongol rule, Persian language and literature declined in comparison to the extensive patronage of the decorative arts, including that of the book; in this period of Iranian history and culture, illustrators, painters, and calligraphers were welcomed at the 15th century courts of Shahrukh, Baysungur and Husayn Bayqara.[20] The poets, who once drew on delicate allusions and elaborate imagery, now expressed their vision in syntactically shorter structures. This process, eventually, developed into a new style, 'Hindi'. Jami, the leading poet of the Timurid era, imitated Nizami's elegant use of the *masnavi* form (poetry in rhyming couplets) of love stories.

Despite efforts by Timurid poets to present new subjects and motifs in romantic poetry, they mostly followed Nizami, Khusrau and their imitators of the 14th and 15th centuries; still, one can perceive the precision of meaning and the cultural subtlety of the period in their works. In the Timurid era, Katibi (d. 1436) wrote his two stories: *Nozer u Manzur* and *Delrobay*; Fattahi Nishapuri (d. 1448) versified *Dastur 'Ushshaq* ('Rules of Lovers') and also *Husn u Dil*, a poetical allusion to the love between Husn (Beauty) and Dil (Heart) (see pp. 103–5). The best love stories of this period, however, belong to the famous Sufi poet Jami: *Yusuf u Zulaykha* and *Layla u Majnun* in emulation of Nizami's *Khusrau u Shirin* and *Layla u Majnun*.

Maktabi Shirazi (d. 1510) also wrote a version of *Layla u Majnun*, and Mahmud 'Arifi Heravi wrote *Guy u Chaugan* ('Ball and Mallet') in 1438 about the love of a dervish for a prince; the same story was versified by Hilali (d. 1530) in the form of a love story called *Shah u Dervish*. In the same period, the love stories of *Sham u Parvane* and *Sehr u Halal* were written by 'Ali Shirazi (1450–1535) who brought new literary techniques and themes to his works. By the end of the Timurid period, Hatifi Kharjirdi (d. 1521) had created his *Khamsa* following the style of Nizami in *Shirin u Khusrau*, *Layla u Majnun* and *Haft Manzar* ('Seven Visages'). Like Kharjirdi, Mirza Qasim Gunabadi (d. after 1581) had composed *Shirin u Khusrau*, *Layla u Majnun*, and *Ashiq u Mashuq*. Nizam Estarabadi, another leading figure of the period, had written *Bilqis u Sulayman* on the love of Bilqis, the Princess of Saba, for Sulayman, figures known to Europeans through the Biblical account of the Queen of Sheba and King Solomon.[21]

Figure 14.7 (opposite)

Prose introduction. From a manuscript of Rumi, *Masnavi*, dated 1063 (1652). Bodleian Library, University of Oxford, MS. Elliott 264, fol. 18v.

Figure 14.8 (page 190)

Khusrau and Shirin conversing in the hunting field. From a manuscript of Nizami, *Khamsa*, copied c. 1570. Bodleian Library, University of Oxford, MS. Ouseley 316, fol. 57r.

Figure 14.9 (page 191)

Shirin visiting Farhad's milk conduit. From a manuscript of Nizami, *Khamsa,* copied c. 1570. Bodleian Library, University of Oxford, MS. Ouseley 316, fol. 81v.

هذا الكتاب المثنوي وهو اصول اصول اصول الدين في كشف اسرار الوصول واليقين وهو فقه الله

ينبوع الله الازهر و برهان الله الاطهر نوره كمشكوة فيها مصباح يشرق اشراقاً انواراً من الاصباح

وهو جنان الجنان ذوالعيون والاعصان فيها عين يسمى عند ابناء هذا السبيل سلسبيلا وعند اصحاب الكشف

والمقامات خيراً مقاماً و احسن مقيلاً الابرار منه يشربون ويأكلون ويشربون والاحرار منه يفرحون ويطربون

وهو كنيل مصر لعراب للصابرين ويوم وحسرة على آل فرعون والكافرين كما قال الله تعالى يسيل بهذ يسيل بهذ وهب

كبيراً وهو سقاء الصدور و جلاء الاحزان وكشف القرآن وسعة الارزاق وتطيب الاخلاق باري

سفرة كرام بررة تبيون بان لايسه الا المطهرون تنزيل من رب العالمين لا يأتيه الباطل من بين

يديه ولا يرصده وريبه فالله خير حافظاً وهو ارحم الرحمن والغائب اضرلقيه الله تعالى واقصر على اهله

التقبيل والتقليل بذل على الكبير والجرعة بذل على العذير والجفنة تنزل على البدر الكبير يقول العبد الضعيف

المحتاج الى رحمة الله تعالى محمد بن محمد بن الحسن اللهي تقبل الله تعالى منه اجتهدت في تطويل المنظوم المثنوي

المعنوي المشتمل على الغرائب و النوادر و غرر المقالات و درر المقالات وطريقة الزهاد و حديقة ا

وقيصرة المباني وكثرة المعاني لاشد دعاء سيدي وسندي معتمدي ومكان الروح من جسدي و دبرة نوري وي

وهو شيخ قدوة العارفين امام الهدى واليقين معيث الورى ابن القلوب والهي و ديعة الله من خلقه

وصفوتي من بريته و صلاة لعينه وحياء عند صفوة مفتاح خزائن القدس امين كنز الغنى ابو الفضائل حسام

الحق والدين حسن بن محمد بن حسن المعروف بابن اخي ترك ابو يزيد ابو يوسف جنيد الزمان هذد بقي بن صدق بقي بن صدق

یکی گفت کین است شاه پرویز نیز
کف و سال و مه بلبند درم ریز
طریق دوستی را ساز دادند
یکی گفت کز شاخ باز دادند
جوانم شنیدم ز دیوار باک
فتاد ند از زین بر سر خاک

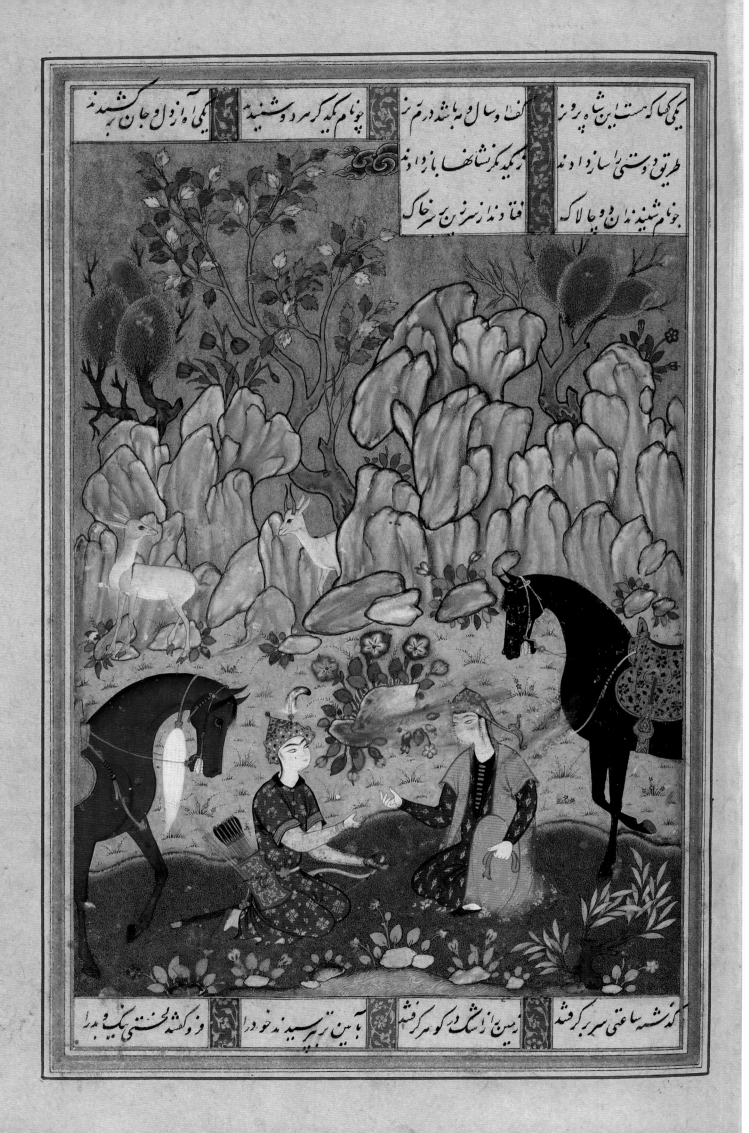

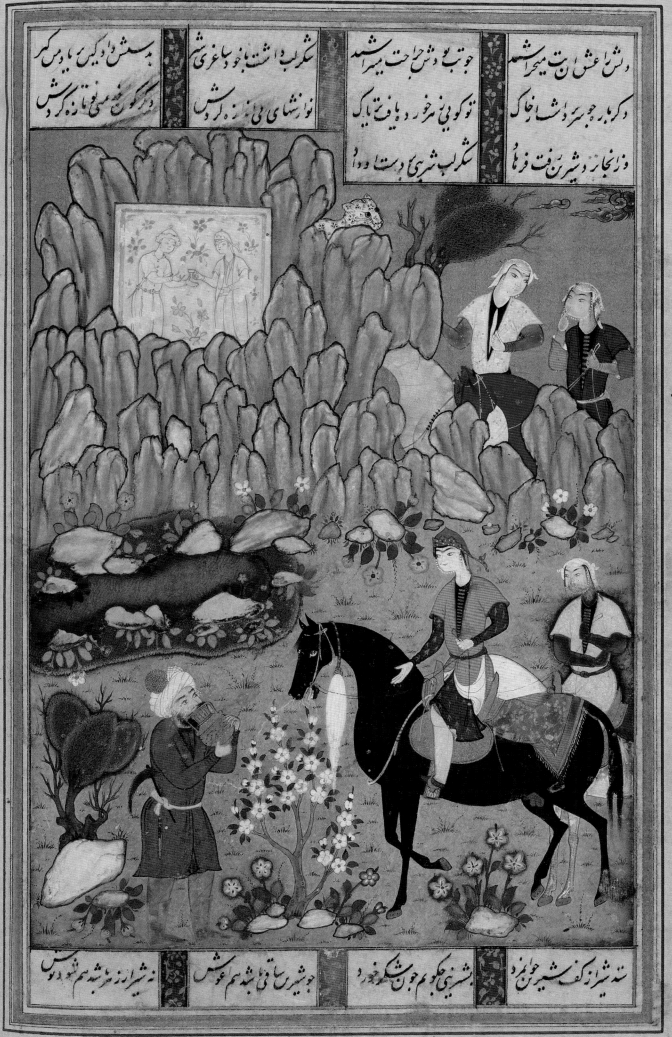

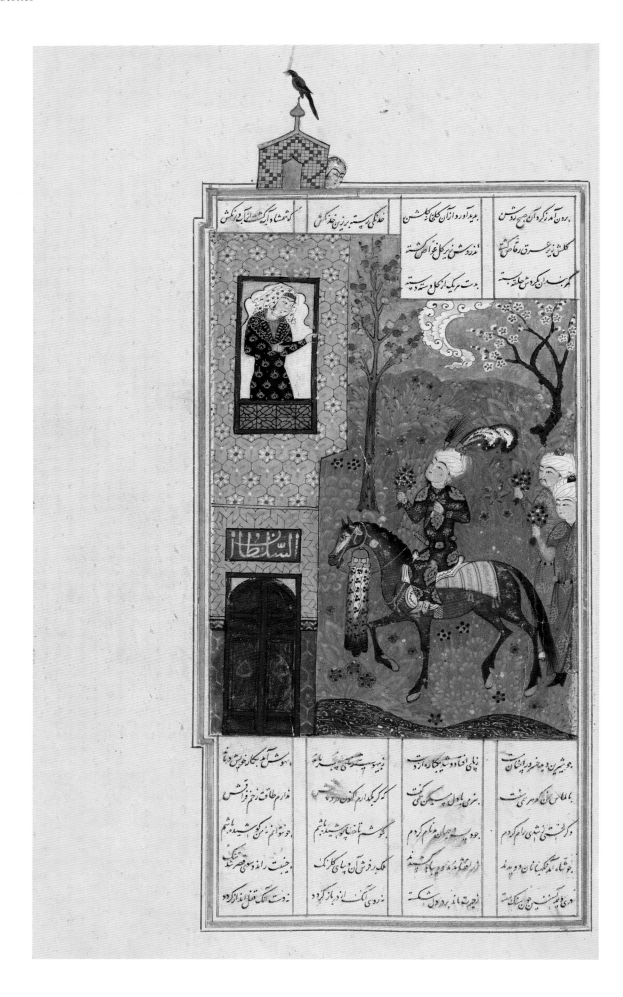

Figure 14.10 (detail opposite)

Khusrau approaching Shirin's
castle. From a manuscript of
Nizami, *Khamsa*, dated 907
(1501).
Bodleian Library, University
of Oxford, MS. Elliott 192,
fol. 81r.

The rule of the Safavid dynasty (16th–18th centuries) introduced the Shi'ite branch of Islam to its territories and marked the beginning of an inauspicious era for the Persian language in general and for Persian poetry in particular. Azari, an ancient Persian dialect spoken in Azerbaijan, in north-west Iran, was replaced by a Turkish dialect.[22] As a result of monarchical discouragement of the Persian language, many Iranian poets emigrated to India and elsewhere. Persian language and literature were increasingly welcomed in India and in the Ottoman empire.[23]

Versification of the love stories continued under the Safavids but the stories were shorter, less elaborate, and of a less literary value in comparison with those of Jami and Hatifi. But some of these works were rather original, such as *Suz u Godaz* by Nava'i Khabushani, or had Indian origins such as *Nal va Daman* by Fayzi. The general characteristic of all these works is that they took their inspiration from Nizami, Amir Khusrau, Jami and Hatifi.[24]

In the mid-18th century, a number of poets in Isfahan such as Mostaq (d. 1756) and Azar (d. 1780) began to show their dissatisfaction with the 'Hindi' style, expressing their preference for earlier styles such as 'Iraqi and Khurasani. The new style was called Sabk-i Bazgast-i Adabi, or 'literary revival style',[25] a trend that remained in vogue until the Constitutional Movement of 1906 in Iran. While some poets, including Vesal (1782–1845), Qa'ani (1807–55) and Forugi (1797–1857), remained faithful to the 'Hindi' style, it was Iraj-i Mirza (1873–1925) who wrote his *ghazal* and *masnavi* verse most fluently and with greatest versatility near the end of Qajar rule (1796–1925). In

addition to these, Iraj borrowed his *Zohre u Manuchihr* from the love poem of *Venus and Adonis* by William Shakespeare, who himself had drawn upon Greek mythology. Iraj borrowed from the first part of this love poem concerning the amorous emotions between Venus and Adonis, changed their names to Zohre and Manuchihr, and set the scenery of his poem in the mountainous areas of Iran.[26] While Parvin-i E'teshami (d. 1941) and Malek-os So'ara Bahar (d. 1951) were writing poems in the most brilliant form of the classical style, others such as Raf'at (d. 1920), Lahuti (d. 1957), and Shams-i Kasmai (d. 1961) were considered to be the followers of the Enlightenment and its consequential changes.[27]

The poet who bravely broke with traditions in both form and content was known as Nima Yusij (d. 1959).[28] Nima, known as the father of New Poetry, has been imitated by several renowned modern poets, some of whom have not shunned other new forms.[29]

The 1979 Islamic Revolution overthrew the last dynasty in Iran and led to the establishment of an Islamic regime. The eight-year war between Iraq and Iran (1980–88) as well as the nature of political changes themselves have established a certain tone for the creation of numerous literary works (both in fiction and poetry) with new motifs and approaches. The novel enjoys a vogue and several works of fiction have been dramatised. For the best part of a millennium, the history of the literature of this part of the world has been as Sir Arthur Houtum-Schindler once said: the name of Iran reminds us of a people who walk on precious carpets and speak in a poetic language.[30]

Figure 14.11 (opposite)

Majnun faints when Layla visits him in the wilderness.
From a manuscript of a work attributed to Gazurgahi, *Majalis al-'Ushshaq*, dated 959 (1552).
Bodleian Library, University of Oxford, MS. Ouseley Add. 24, fol. 66v.

Seyed Mohammad Torabi received his BA, MA and PhD in Persian Literature from the University of Tehran. He has taught for 38 years in Iran and at universities in Sarajevo, Venice, and Beijing. He was a lecturer in Persian Language, Literature and Iranian Studies at the Australian National University 2000–6 and 2010–11.

ظاهر المعه آن عشق است که پرتو بر مجنون انداخته که لیلی بسر او آمده بود او سر در کریبان حیرت

داشته و در دریای خود در غواصی می نموده کفته شبرو برا که منم لیلی از زیر زمین مستی آواز شنیده

که دع عنک فان جبک شغلنی عنک یعنی برو از سر من و بکذار مرا ابر من که از عشق تو مرا روای تو

تو نماند کاسی که حضرت عطار باخود آمدی و از لجه دریای حیرت بکنار افتادی آن جوابزا و دیدی

روی بر روی نشسته این غزل را خواندی مسعر ای عمت روز و شب تبهایی

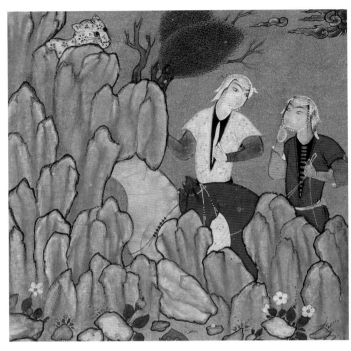

Detail from Figure 14.9

Figure 14.12 (opposite)

The ghost of Nizami welcomes Nava'i, introduced to him by Jami in the dream garden of the great Persian poets of the past. From a manuscript of Nava'i, *Sadd-i Iskandar*, one volume of a *Khamsa*, dated 890 (1485). Bodleian Library, University of Oxford, MS. Elliott 339, fol. 95v.

In this illustration of *Sadd-i Iskandar* ('Alexander's Wall') the great poets of the Persian past are gathered in an other-worldly outdoor setting with the tools of their trade arranged in front of them. Nizami of Ganja, the original writer of the *Khamsa*, is placed in the centre of the group, hands outstretched, in a gesture of welcome to the minister, Nava'i, who has written this version of *Sadd-i Iskandar* in Chaghatay Turkish. He sits with his hands modestly covered by his green robe as Jami introduces him to the great master. The artist is named between the columns of text as Qasim 'Ali.

Notes:

1 Seyed Mohammad Torabi, *Negāhi be Tārikh va Adabiyyāte Iran* (Tehran: Qoqnous, 2005), 31–2.
2 M. Mo'in, *Mazdayasnā va Ta'sire an dar Adabe Fārsi* (Tehran: Tehran University Press, 1326 [1948]), 36, 195; Iosif Mikhailovich Oranskii, *Moqaddame-ye Feqhol- logha-ye Irani*, trans. Karim Keshavarz (Tehran: Payam, 1358 [1980]), 72–7.
3 Oranskii, 18.
4 Torabi, 49–50.
5 Hasan Pirniya, *Iran-i Bāstān*, vol. 3 (Tehran: Donyaye Ketab, 1375 [1997]), 2753–89; Zarrinkoob, *Tarikhe Mardome Iran* (Tehran: Amirkabir, 1364 [1986]), 423–6, 515; Girshman, *Iran az Aghaz ta Islam,* trans. M. Mo'in (Tehran: Entesharat-e Elmi Farhangi, 1366 [1988]), 345–6.
6 Z. Safa, *Hamāse Sarāy dar Iran* (Tehran: Amirkabir, 1973), 27–8.
7 Torabi, 108–111.
8 Safa, *Hamāse Sarāy dar Iran*, 103–7.
9 G. Yousofi, *Cheshmeye Rowshan* (Tehran, Elmi, 1371 [1993]), 17–18.
10 Safa, *Tārikhe Adabiyyāt*, vol. 1, 366.
11 Safa, *Tārikhe Adabiyyāt*, vol. 1, 561–2, 601–2.
12 Torabi, 189–204.
13 Safa, *Tārikh Adabiyyāt*, vol. 2, 798–824.
14 Safa, *Tārikh Adabiyyāt*, vol. 3, part 2, 780–6.
15 Safa, *Tārikh Adabiyyāt*, vol. 3, part 2, 897–900. See also Edward G. Browne, *Literary History of Persia*, vol. 2 (Cambridge: Cambridge University Press, 1964), 301–12.
16 Browne, *Literary History,* 344–58.
17 Herman Etteh, *The History of Persian Literature*, trans. Rezā Zādeh Shafaq (Shiraz: Pahlavi University Press, 1352 [1974]), 181–2; Safa, *Tārikh Adabiyyāt*, vol. 3, part 2, 1026–8.
18 Safa, *Tārikh Adabiyyāt*, vol. 4, 330. Safa, vol. 5, part 1, 428–32.
19 Sa'di, *Golestan*, ed. Mazāher Mosaffa (Tehran: Kanoon-i Ma'refat, 1339 [1961]), 13–14.
20 Safa, *Tārikh Adabiyyāt*, vol. 4, 161–2.
21 Safa, *Tārikh Adabiyyāt*, vol. 4, 191–2.
22 Some of these works are as follows: *Naz u Niyaz*, *Vamaq u Azra*, and *Layla u Majnun* by Zamiri Isfahani (d. 1566); *Layla u Majnun* and *Khusrau u Shirin* by Qasimi Gunabadi (d. 1574); *Farhad u Shirin* and *Nazer u Mansur* by Vahshi Bafqi (d. 1583); *Nal va Daman* and *Sulayman u Belqis* by Fayzi Fayyazi (d. 1596); and *Mahmud u Ayaz* by Zolali Khansari (d. 1616). Among the other poets who composed love stories in this period are 'Abdi Bay-i Shirazi (d. 1580), Binesh-i Kashmiri (d. 1674), Hayati Gilani (d. 1619), Mir Mo'men Arshi (d. 1680), Salim-i Tehrani (d. 1674) Talib-i Amoli (d. 1626), Hakim Rokna Masih (d. 1656), Safa, *Tārikh Adabiyyāt*, vol. 4, 428–32.
23 Among the adherents of the revival style were Saba (d. 1823) and Sahab (d. 1811) who adopted 'Iraqi style, and Sorus (d. 1873) and Mahmud Kan (d. 1899) who imitated 'Khurasani' style. Safa, *Tārikh Adabiyyāt*, vol. 4, 486–97.
24 Safa, *Tārikh Adabiyyāt*, vol. 4, 593–602.
25 Yahyā Ārīānpūr, *Az Ṣabā tā Nīmā*, vol. 1 (Tehran: Zavvar, 1382 [2004]), 13–44.
26 Yahyā Ārīānpūr, *Az Ṣabā tā Nīmā*, vol. 2, 383–419.
27 Followers of Nima include Foruğ (d. 1966), Sepehri (d. 1972), Akawan (d. 1990), Shamlu (d. 2000), Moshiri (d. 2000), Naderpur (d. 1999), Ebtehaj (b. 1928), Shafiie-Kadkhani (b. 1939). Ārīānpūr, *Az Ṣabā tā Nīmā*, vol. 2, 436–66.
28 Ārīānpūr, *Az Ṣabā tā Nīmā*, vol. 2, 466–80.
29 Hamid Zarrinkoob, *Chashmandāze She're Now-e Farsi* (Tehran: Tous, 1979), 79–269.
30 Jawād Hadidi, *Lectures Given in Four Seminars on Ferdowsi* (Mašhad: Mašhad University Press, 1978), 315–20.

Page 198

Khusrau spies Shirin bathing. From a manuscript of Hafiz, *Divan*, dated 943 (1537). Bodleian Library, University of Oxford, MS. Ouseley Add. 16, fol. 162v.

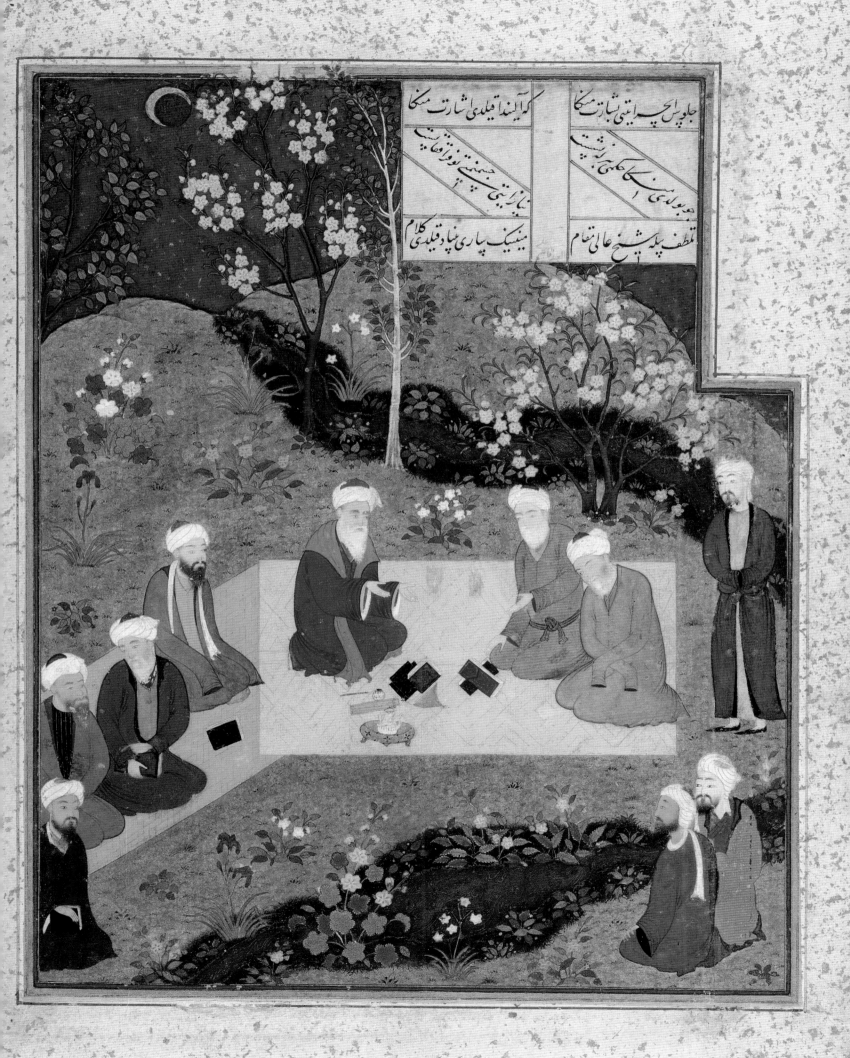

گفتند خلایق که تویی یوسف ثانی
چون نیک بدیدم بحقیقت به از آنی

شیرین تر از آنی بشکر خنده که گویم
ای خسرو خوبان که تو شیرین جهانی

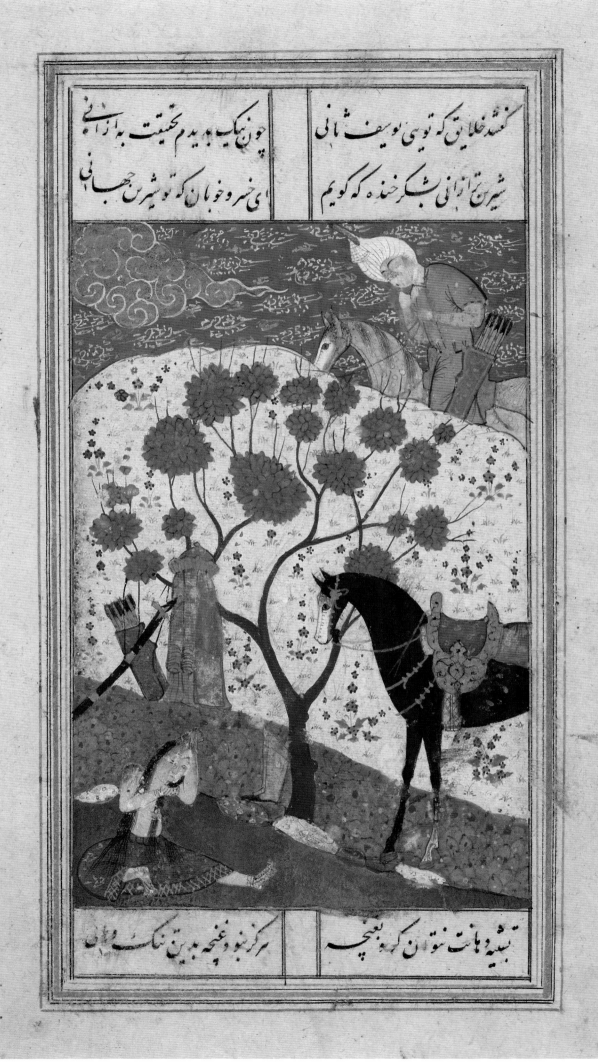

نبشته بهات نتوان کرد بعنجه
سرکز بنود و غنچه بدین تنگ دهانی

LITERARY WORKS, SELECTED CHARACTERS AND SUMMARIES OF THE MAJOR STORIES

Avesta

The earliest work of Iranian literature, deriving from Zarathustra, the holy prophet of ancient Iran and dating from the 7th or 6th century BC.

Baharistan ('Garden of Spring')

A poetic work by Jami (1414–92) modelled on Sa'di's *Gulistan* ('The Rose Garden'), a series of stories and personal anecdotes written more than a century earlier.

Bahram Gur

A hero of the *Shahnama* who also appears later in several romances. His character is based on a real Sasanian king, Bahram V (r. 420–38 AD), nicknamed *gur* (onager or wild ass) because of his love of hunting. Literary episodes highlight not only his skill as a hunter, but also his amorous adventures and feats of bravery.

Bahram Gur and Azada

One of the adventures of Bahram Gur described in the *Shahnama* and frequently illustrated by painters is the scene in which he hunts with the slave girl, Azada. She challenges him to a series of feats, including pinning a deer's hind leg to its ear, but remains unimpressed when Bahram Gur succeeds, so he throws her to the ground to be trampled by his camel. Subsequent poets retold the story in varying detail.

Bahram Gur and Fitna

The poet Nizami renamed Azada as Fitna (meaning rebellious).

She attributes Bahram Gur's feats to mere practice, so he orders one of his men to kill her, but she finds a place to hide. Years later she impresses Bahram Gur and regains his affections by her strength in carrying a bull up many flights of stairs.

Bahram Gur and Dilaram

In his version of the story, Amir Khusrau called the female protagonist Dilaram (heart's repose) and had Bahram Gur abandon her when she derides his skill. She becomes a musician, so accomplished that she can enchant animals. Bahram Gur hears of her artistry, comes to hear her play, and seeks her forgiveness.

Bizhan and Manizha

One of the three main love stories of the *Shahnama*. While hunting far from home Bizhan meets Manizha, a princess, who seduces him and boldly takes him to her father's palace, where the lovers are discovered and Bizhan is imprisoned in a pit, later to be rescued by Rustam.

Bustan ('The Orchard')

An elegant versified epic by Sa'di made up of stories of earthly and spiritual love, fables and moral instruction.

Conference of the Birds (*'Mantiq al-Tayr'*)

The best-known work of the poet, 'Attar, written in *masnavi* form to a length of almost 5000 couplets. The main story recounts the journey of thirty birds in search of the Simurgh, a mythical bird, which is a symbol of Divinity. Within this framework are several short romantic tales.

Dilsuznama ('Book of Compassion')

A mystical version of the popular love story of the 'Rose and the Nightingale' written by Badiʿ al-Din Manuchihr al-Tajiri al-Tabrizi, a little-known Persian poet of the 14th century.

Divan-i Kabir

Rumi's major compilation of more than 30,000 verses of ecstatic love poetry written in the years after his meeting with the dervish Shams of Tabriz.

Giv

A hero of the *Shahnama* who wanders alone for seven years in enemy territory in search of Kay Khusrau, the grandson of King Kay Kavus, and returns him to Iran and his rightful place in line for the throne.

Gulistan ('The Rose Garden')

A didactic work by Saʿdi written in elegant prose and verse outlining rules for good conduct in life for ordinary men and women, and for royalty.

Haft Gunbad ('Seven Domes')

An alternative name for *Haft Paykar.*

Haft Paykar ('Seven Portraits')

Nizami extended the story and character of Bahram Gur in his cycle of seven tales in which the hero is entertained by seven princesses in seven pavilions on each of the seven days of the week. The colours of each structure also correspond to the constellations and various zones of the Earth. *Haft Paykar* is one of the five works collected in Nizami's *Khamsa.*

Hasht Bihisht ('Eight Gardens of Paradise')

An epic poem by Amir Khusrau of Delhi that is modelled on Nizami's *Haft Paykar* with its astrological and mystical symbolism. Amir Khusrau's title refers to the Islamic notion of eight paradises and the promise of eternity.

Husn u Dil ('Beauty and Heart')

An allegory written by Fattahi (d. 1448) that was widely copied in India, especially in the Deccan.

Intikhab-i Hadiqa ('Extracts from the Hadiqa')

A work by 'Attar based on a longer work by Sanaʾi, *Hadiqat al-Haqiqah*, ('The Walled Garden of Truth').

Iskandar (Alexander)

Alexander the Great, as he is known in the West, appears as Iskandar in historical and literary works in the Persian tradition, some of which are derived from pre-Islamic sources. He is portrayed in the *Shahnama* as the pre-eminent world-conqueror and perhaps the greatest hero of them all, gaining celebrity status in the process of becoming a world leader and acquiring an overlay of sage-like wisdom. Iskandar searches for immortality discovering strange lands and people along the way, building an iron wall to keep out Gog and Magog and meeting powerful leaders as far away as Chinese Turkestan. Eventually, in a much-illustrated episode, he learns of his impending death from a talking tree.

Khamsa ('Quintet' or 'Five Stories')

A compilation of five literary works written by Nizami of Ganja in the early 13th century. The first is short and didactic; the second, the romantic tale of Khusrau and Shirin; the third, the love story of Layla and Majnun; the fourth, *Haft Paykar* ('Seven Portraits'); the fifth and last work of the *Khamsa* is the *Iskandarnama*, the didactic story of Alexander the Great and his exploits in the Islamic world where he arrives as a king and world-conqueror and eventually becomes a sage and a prophet.

Khusrau u Shirin

Originating in the *Shahnama,* the love story of Khusrau and Shirin is one of the five romantic tales of Nizami's *Khamsa*. It relates the story of the long courtship of a real-life Sasanian king, Khusrau Parviz (r. 590–627 AD), and a beautiful Armenian princess, Shirin. In Nizami's romance, there is a subplot in the form of a love triangle, with Shirin briefly enamoured of Farhad who carves a milk-carrying tunnel through a mountainside for her, only to jump to his own death when he is duped into thinking Shirin has died. Eventually, Khusrau and Shirin marry but happiness eludes them as Khusrau is imprisoned and dies, and Shirin takes her own life.

Layla u Majnun

Lord Byron, the 19th-century English poet, described the tragic love story of Layla and Majnun as the 'Romeo and Juliet of the East'. Originating in the Arab world, the tale recounts the plight of a boy and girl who meet and fall in love, whose parents forbid them to marry, and who subsequently live unhappily ever after. Layla is married to a nobleman, while Majnun, crazed with obsessive love, retreats to the wilderness with only animals for companions. Layla, whose love for him has never wavered, dies of a broken heart, and Majnun follows her in death, mourning at her tomb. Nizami included the beautiful version in his *Khamsa* at the end of the 12th century, a translation of which is credited with inspiring British guitarist and singer Eric Clapton to write his hit song 'Layla' in 1970.

Majalis al-ʿUshshaq ('Meetings of Lovers')

A work compiled at the Timurid court of Sultan Husayn Bayqara (r. 1470–1506), to whom for many years its authorship was attributed. Recent scholars mostly concur with some contemporaries of the Timurid sultan who claimed the work was written by the ruler's close companion, Kamal al-Din Husayn Gazurgahi, who

also served as a religious official. The work retells classic Persian love stories and also contains romantic accounts of the love affairs of famous mystics and royal figures.

Masnavi of Rumi

The Sufi poet's monumental work, written in six volumes towards the end of his life. Its verses range from mystic religious poetry and interpretations of the Qur'an to tales from folklore and earthy stories that acted as parables referencing the ultimate mystery of the union with the Divine to which his verses allude.

One Thousand and One Nights ('*Alf Layla wa Layla*')

A collection of stories from a range of sources in the Arab, Persian, Turkic and Indian worlds that were known in Arabic language from as early as the 9th century. The framing story of the Persian queen Sheherazade was derived from a Sasanian Persian work, *Hazar Afsana* ('A Thousand Tales'). European translations began in the early 18th century with Antoine Galland's translation into French.

Rustam

The main non-royal, lone knight figure of the *Shahnama* who performs a number of heroic rescues and is the protagonist in a series of amorous and tragic episodes.

Rustam and Tahmina

A story from the *Shahnama* in which Rustam, a guest of the king of Samangan, is woken by his host's beautiful daughter, Tahmina, who asks him to father her child. Rustam obliges, but leaves the palace soon after, unaware he has fathered a son, Suhrab.

Rustam and Suhrab

A tragic episode from the *Shahnama* in which, years after Rustam has unknowingly fathered a child with Tahmina, he slays a brave young man in battle, discovering too late that his opponent is his son, Suhrab.

Rustam and the White Div

In the *Shahnama* Rustam faces seven perils in his mission to rescue the king Kay Kavus from his demon captors. One of his feats is to fight the White Div so that he can remove the demon's liver and reverse the spell that has caused Kay Kavus to become blind.

Sabʿa Sayyara ('Seven Planets')

A version of Nizami's *Haft Paykar* written by Mir ʿAli Shir Navaʾi in Chaghatay Turkish in the 15th century.

Shahnama

The 'Book of Kings' recounts the real and mythological history of Iran up to the fall of the Sasanian dynasty in the mid-7th century. It draws on heroic narratives that flourished under Sasanian rule, a time during which Greek and Indian texts were translated and absorbed into Iranian culture. The heroes and stories of the *Shahnama* had lasting appeal, inspiring poets up to the present day to recount and embellish its tales, making its characters, both male and female, central figures in the creation of Iranian culture and identity.

Siyavush and the ordeal by fire

A story from the *Shahnama* of a legendary prince who proves his innocence by riding through fire after being accused by his stepmother of attempted seduction.

Varqa u Gulshah

A romantic story of young Arab lovers recounted by the Persian poet ʿAyyuqi in the 10th century. The story did not experience enduring popularity, possibly because it was not included in Nizami's *Khamsa*, a work considered by some scholars as critical in ensuring the lasting significance of the stories that made up the quintet.

Wis u Ramin

An ancient love story known in the Parthian era that pre-dated the Sasanian Dynasty of 226–650 AD. It was translated into verse by the poet Gurgani in the mid-11th century and became a model for later writers.

Yusuf u Zulaykha

One of the greatest mystical love stories in Islamic literature, a tale of human love and its transformation into divine love. The plot is archetypal: a handsome and virtuous young man resists the inappropriate advances of an older woman. The tale is told in the Biblical book of Genesis as the story of Joseph who is sold into slavery and resists the seductive approaches of the wife of his master, Potiphar. The story later appeared in the Qur'an where it is introduced as 'the most beautiful story' and Yusuf, a prophet, is described by the women of Egypt as 'not a man but a noble angel'. At least eighteen Persian poets wrote their own versions of the story, each adding details of their own. Rumi mentioned the tale frequently in his poetry, Saʿdi wrote a version in the 13th century, and Jami wrote it as a mystical allegory in 1484. In his epic version, the story ends as Zulaykha and the now prosperous Yusuf meet after many years and marry.

Zal and Rudaba

A romantic story in the *Shahnama* in which the protagonists fall in love after hearing descriptions of each others' physical appearances. In a much copied and illustrated episode, Rudaba lets down her long hair to allow Zal to climb up to join her in the upper storey of her pavilion. Eventually they become the parents of the hero Rustam.

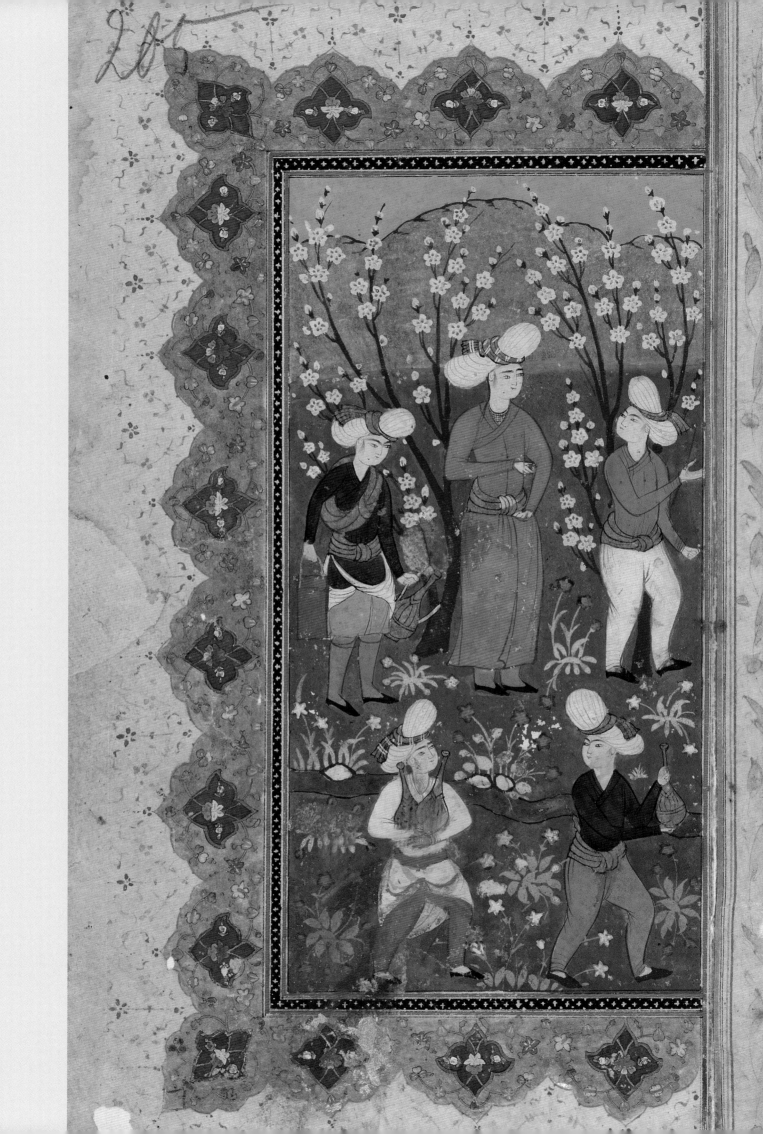

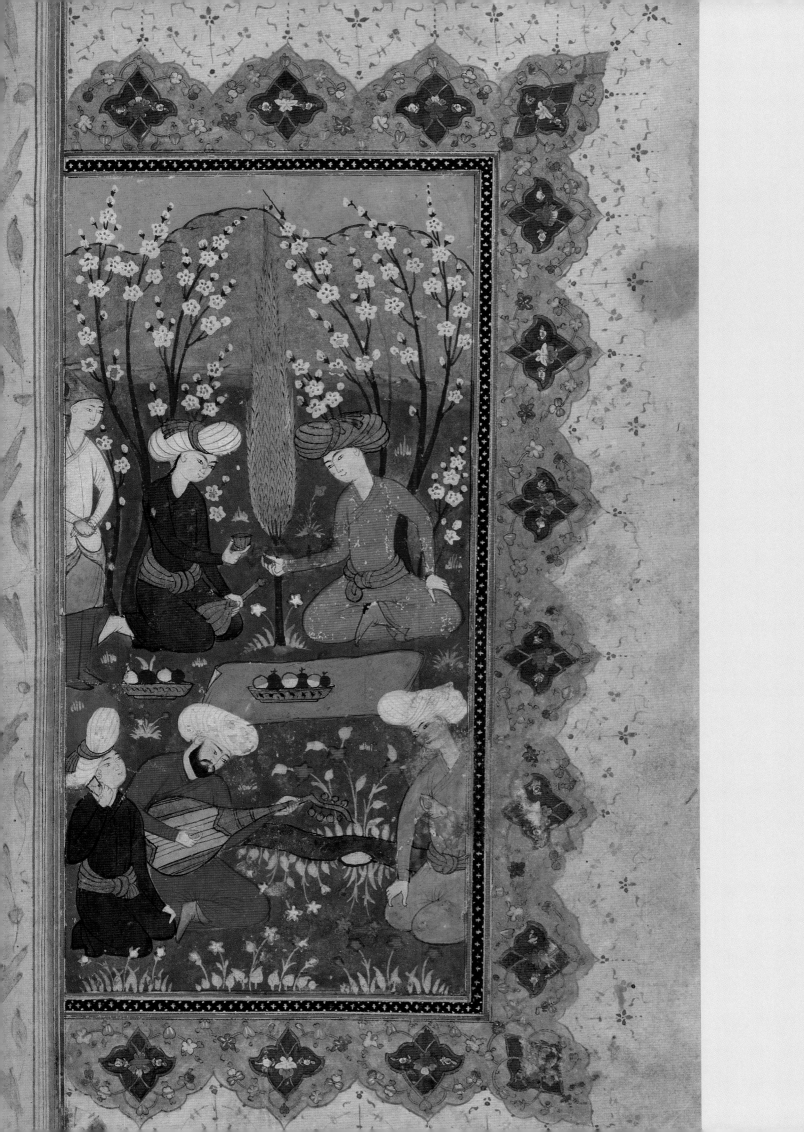

BIOGRAPHIES OF THE MAJOR PERSIAN POETS AND WRITERS

Rudaki (d. 941 AD)

The 'father' of Persian classical poetry, who wrote the first simple lyrics in the new Persian literary language at the Samanid court at Bukhara. He was much emulated by successive writers.

Abu'l Qasim Firdausi (d. circa 1020)

A native of Tus, near Mashhad, in north-eastern Iran, who dedicated his life to the writing of the *Shahnama*, his epic history and account of the legends of ancient Persia. When complete, it was presented to Mahmud of Ghazna (r. 999–1030), the newly ascendant Turkic ruler of the eastern Iranian territories in Central Asia, whose dazzling court became a haven for poets and artists of all kinds.

'Ayyuqi (d. 1040)

Composed the romantic epic *Varqa u Gulshah,* a charming love story that was, nevertheless, not widely recounted by poets who followed.

Fakhru'd-Din As'ad Gurgani (d. circa 1054)

Translated *Wis u Ramin*, a love story originating in the Parthian (Arsacid) Dynasty (250 BC–226 AD) into Dari, a version of Persian that became the new language of literature. The work inspired later poets such as Nizami but, like *Varqa u Gulshah*, did not go on to enjoy lasting popularity.

Omar Khayyam (d. 1123)

Wrote the original verses that were later published in English as the *Rubaiyat of Omar Khayyam*. He became one of the most famous of all Persian poets outside Iran when Edward FitzGerald translated quatrains from a manuscript in the collection of the Bodleian Library at the University of Oxford in the 19th century. In his home city of Nishapur in eastern Iran, Khayyam had been better known as a high-ranking astronomer and mathematician, rather than for the brief, and sometimes witty, epigrams he penned in the manner of pre-Islamic folk poetry.

Sana'i (d. 1131)

Wrote at the court at Ghazna, becoming the forerunner of a new style of poetry marked by Sufism and mystic ideals. One of his best-known works was a didactic poem *Hadiqat al-Haqiqah* ('The Walled Garden of Truth'), written in *masnavi* form.

Anvari (d. 1190)

A prominent figure among the early poets who began to express ideas about spiritual love in *qasida* form written in a new style that inspired others such as Sa'di and Khwaju. Until he developed his interest in this kind of writing, Anvari (whose pen name was derived from the word for 'luminous') made his living writing panegyric verse for various patrons.

Nizami (d. 1209)

Using a pen name associated with the word for 'order', Nizami, who came from Ganja in the north of Iran, introduced romantic epic in verse with his collection of five works known as the *Khamsa* ('Quintet'). Three of the five – *Layla u Majnun*, *Khusrau u Shirin* and *Haft Paykar* ('Seven Portraits') – proved to be especially inspirational for the generations of poets who followed. The other two works, *Makhzanol-Asrar* ('The Storehouse of Mysteries') and *Iskandarnama* ('The Book of Alexander') contain romantic episodes but did not become part of the canon of classic Persian love stories.

'Attar (d. circa 1221)

His pen-name means 'a perfume dealer', a reference to his former career as an apothecary in his hometown of Nishapur in north-eastern Iran, a renowned centre of artistic and literary activity. He became known for his mystical narratives in *masnavi* form, especially *Mantiq al-Tayr* ('Conference of the Birds').

Jalal al-Din Rumi (d. 1273)

A mystic Sufi poet who was born in Balkh, Central Asia, and worked and died in Konya, Anatolia. Known to Persians as

Maulana ('our Lord'), he wrote a lyrical *Divan* of more than 30,000 verses and a six-volume didactic work known as the *Masnavi*. After his death, his followers founded the Mevlevi order of dervishes, whose ecstatic devotional movements gained them the name of the 'Whirling Dervishes' in the West.

Sa'di (d. 1292)

A native of Shiraz, whose pen name refers to his eventual patron, Prince Sa'd ibn Zangi. His earlier life was marked by extensive travel outside Iran, including a reputed period of imprisonment by Crusaders. One of the foremost practitioners of the art of the *ghazal*, Sa'di's lyrical works and his *Bustan* and *Gulistan*, are revered to this day in Iran, where his tomb has become a shrine for literary pilgrims.

Shabistari of Tabriz (d. 1320)

Wrote *Gulshan-i Raz*, the 'Rose Garden of Mystery', succinctly outlining the stages of development of the 'Perfect Man' as outlined by the spiritual master, Ibn 'Arabi (d. 1240), a concept that became central to the thinking of most Sufi orders.

Amir Khusrau (d. 1325)

A native of Delhi, often referred to as 'the parrot of India'. Considered one of the greatest of the Indian poets who wrote in Persian, he reworked Nizami's *Khusrau u Shirin*, *Layla u Majnun*, and *Haft Paykar*, renaming the latter *Hasht Bihisht* ('Eight Gardens of Paradise').

Hafiz (d. 1390)

Of Shiraz, he was a close follower of the poetic work of 'Attar. Highly developed spiritually, his pen name, Hafiz, means 'a person who has learnt to recite the Qur'an by heart'. He is known for his sensuous lyrical works in *ghazal* form, and his tomb in Shiraz is still visited by many admirers, who regard him as the greatest of all the Persian lyric poets.

Badi' al-Din al-Munichihr al-Tajiri al-Tabrizi (d. early 15th century)

A poet from Tabriz in north-western Iran who is known to have travelled with his merchant father in Anatolia in the late 14th century. He wrote a mystical treatment of the popular love story of the Rose and Nightingale, the *Dilsuznama*, or 'Book of Compassion'.

Gazurgahi (d. 1470)

Kamal al-Din Husayn Gazurgahi, the writer to whom most modern scholars attribute the *Majalis al-'Ushshaq* ('Meetings of Lovers'), a mystical treatise written at the Herat court of Sultan Husayn Bayqara and widely copied in Ottoman Turkey.

'Abd al-Rahman Jami (d. 1492)

A scholar and theologian who followed the mystic teachings of Ibn 'Arabi. Regarded by many as the last of the great classical Persian poets, his major work was the compilation of seven stories known as *Haft Aurang* ('Seven Thrones'), of which his mystical allegory, *Yusuf u Zulaykha,* is regarded by many as the best example of a mystical love story in all Islamic literature.

Nava'i (d. 1501)

Born as Mir 'Ali Shir, the foster brother and eventually powerful courtier and close friend of Sultan Husayn Bayqara at the Timurid court of Herat. He wrote in Persian and in his native Chaghatay Turkish, with such musicality that he acquired the pen name Nava'i, which means 'melody maker'.

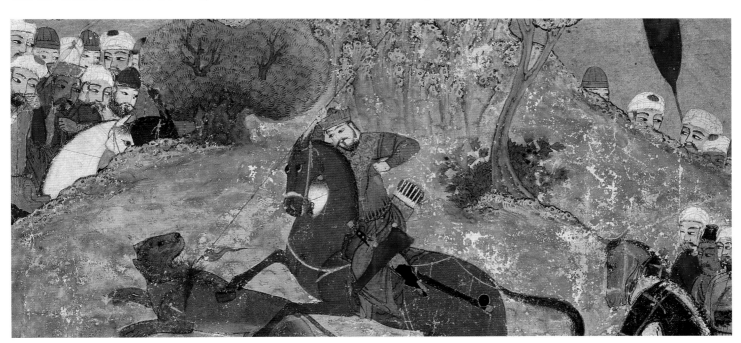

Detail from page iii

قبول کرده هردو برخاستند و خنا که قاعده باشد جست کشتی میازاچت به بستده دو

دو شاخ گل بر یکدیگر بچید ند آخر الامرشاهزاده جهانیان زیادتی کرده آن زغا را

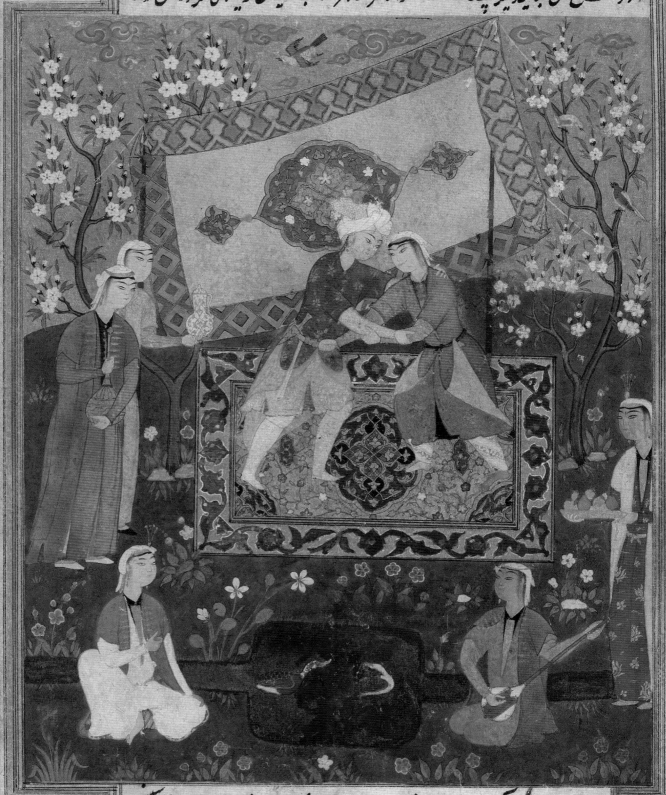

بر سر دست آورده بر زمین زد چون دختر پیشا و پادشاه زاده از روسی

وی برخاست و دیگر باره پیش دست طلبید شاهزاده گفت ای دختر بوعده را

TIMELINE OF SELECTED EVENTS, PEOPLE AND TEXTS

Detail from Figure 14.5

7th–6th century BC	Sacred Iranian text *Avesta* of Zarathustra develops in this period.
c. 550–330 BC	The Achaemenid Empire of the ancient Persians, at its greatest extent under Darius I (550–486 BC) rules parts of Asia, Africa and Europe, extending from the Indus Valley in the east to Thrace in the west.
323 BC	Death of Alexander the Great, who after earlier capturing the great Persian capital, Persepolis, and killing the Achaemenid king, Darius III, installs himself as the Persian *shahanshah*, 'king of kings'.
250 BC–c. 226 AD	Parthian Dynasty rules Iran, an era in which Middle Persian, or Pahlavi, is the national language, later to be replaced by Arabic after the fall of the Sasanian dynasty.
c. 226–650 AD	Era of the Sasanian Dynasty, eventually defeated by the Muslim Arabs, after which the 'New Iran' period of Persian literature begins.
622 AD	The Hegira, or migration of the Prophet Muhammad and his followers from Mecca to Medina in the Arabian Peninsula, the event that marks the beginning of the Islamic calendar.
632 AD	Death of the Prophet Muhammad.
650 AD	The written text of the Qur'an is established.
651 AD	Muslim conquest of western Iran.
711 AD	Muslim forces invade southern Spain from North Africa.
751 AD	The technology of paper-making is brought to the Islamic world after Arab forces capture Chinese artisans in Central Asia.
941 AD	Death of Rudaki, the 'father' of classical Persian poetry.
977–1186	Turkic Ghaznavid Dynasty rules in Iran, Central Asia and northern India.
1010	Completion of the *Shahnama* by Abu'l Qasim Firdausi.
1038–1307	Seljuq Dynasty, of Central Asian Turkic origin, rules in Persia and Iraq (with capitals in Isfahan and Baghdad) until 1157 and in Anatolia from their capital, Konya, until the 14th century; an era of great intellectual and artistic growth in the Persianate world that sees the versification of epic tales and the growth of romantic poetry.
1091	Christians conquer Sicily, after two centuries of Islamic rule; many Muslim writers and artists stay living and working alongside their Norman rulers.
1099	Crusaders capture Jerusalem and settle in parts of the Holy Land and Syria.
1111	Death of Ahmad al-Ghazali, a mystical thinker whose philosophy of love influences later Persian poets who from this era onwards increasingly attach mystical ideas of spiritual love and devotion to what have previously been simple tales of earthly romance or praise for a princely ruler.
1123	Death of Omar Khayyam.
1209	Death of the poet Nizami of Ganja.
1220	Mongol invasion of eastern Iran results in a period of significant change in which Central Asian and Chinese elements are incorporated into Persian culture and the subsequent fusion is admired and emulated across Eurasia.
c. 1221	Death of the poet 'Attar.
1240	Death in Damascus of Ibn 'Arabi, the great Sufi master who was born in Spain.
1253	Estimated date of oldest known surviving illustrated Persian manuscript, a copy of 'Ayyuqi's *Varqa u Gulshah*, produced in Konya, Anatolia, under Seljuq rule.

1258	Mongol invaders capture Baghdad and the rule of the Ilkhanid Mongol dynasty over Persian territories lasts until the mid-14th century.
1271	Marco Polo, a native of a Croatian protectorate of Venice, sets out to travel through Persia on his way to visit the Great Khan at Xanadu.
1273	Death of poet and mystic Jalal al-Din Rumi.
1292	Death of the poet Sa'di.
1300	The Ottoman Turks gain a foothold in Anatolia, crossing into Europe in 1357 and building an empire that lasts until 1923.
1300	*Nasta'liq* script develops through the 14th century as the usual means of recording Persian poetry.
1321	Death of Italian poet Dante Alighieri, whose masterpiece, *La Divina Commedia,* makes use of symbols shared with Persian mystical poets.
1325	Death of the poet Amir Khusrau, the 'Parrot of India'.
1370	The Central Asian ruler, Timur ('Tamerlane'), establishes control in Samarqand, later conquering Iran, Iraq, parts of the Caucasus and northern India, establishing the Timurid Empire that lasts until 1506.
1374	Death of Francesco Petrarch, philosopher and poet, author of *Il Canzoniere* ('Songbook') that contains 366 love poems that are hugely influential on later writers throughout Europe, including William Shakespeare.
1390	Death of Muhammad Shamsuddin 'Hafiz', admired in the East and West as perhaps the greatest of the Persian lyric poets.
1400	Death of Geoffrey Chaucer, English writer of poetic romances.
1404	The Spanish knight Ruy Gonzalez de Clavijo travels through Persia on his way to visit Tamerlane's court at Samarqand on behalf of Henry III of Castile.
c. 1440	Johannes Gutenberg invents printing using moveable type, leading to the mass production of books in Europe.
1453	The Ottoman Turks conquer Constantinople, making the imperial city their capital, Istanbul.
1492	Death of 'Abd al-Rahman Jami, remembered as the last of the great classical Persian poets.
1501	Death of Nava'i, patron and poet of Herat.
1501–1736	Reign of the Safavid Dynasty who introduce Shi'ism as the state religion of Iran. The importance of poetry declines in Iran proper and increases in Mughal India and Ottoman Turkey.
1526	Babur founds the Mughal Empire in northern India – at its height until 1707 and finally ending in 1857.
c. 1562	Elizabeth I of England fails in her attempt to secure a trade agreement with Safavid Iran, but journal accounts of English travellers inspire writers such as Christopher Marlowe, John Milton and William Shakespeare.
1598	Sir Anthony and Sir Robert Sherley, the most renowned travellers to Persia in the Elizabethan era, arrive in Qazvin where they are received by Shah 'Abbas I.
1600	The British East India Company begins trading in India and co-operates with the Safavid Persian rulers soon after.
1602	The Bodleian Library opens at the University of Oxford with a collection that already includes a Qur'an, and the same year acquires by gift a Persian and Turkish language manuscript, followed in 1640 by a work from Mughal India.
1616	Death of William Shakespeare whose love sonnets and other works, especially *Romeo and Juliet*, written 1591–95, contain parallels with Persian themes and stories.
17th century	Poems by Hafiz and Sa'di translated into a number of European languages.
1704	Antoine Galland begins publishing his French translation of *Alf Layla wa Layla (Les mille et une nuits)*; English version follows soon after, later known as *One Thousand and One Nights*.
1771	Sir William Jones publishes *A Grammar of the Persian Language* in English.
1819	Goethe publishes his *West-östlicher Divan* ('West-Eastern Divan') in German.
1856	Australia's first free public library opens, the Melbourne Public Library, later renamed the State Library of Victoria.
1859	Edward FitzGerald translates and publishes verses by Omar Khayyam written in 11th-century Iran, using a manuscript from the Bodleian Library as his major source.
1873	Nasir al-Din Shah is the first Persian ruler since Alexander the Great to travel to Europe.

MAP SHOWING IRAN AND THE GEOGRAPHICAL EXTENT OF THE PERSIAN CULTURAL SPHERE c. 1600

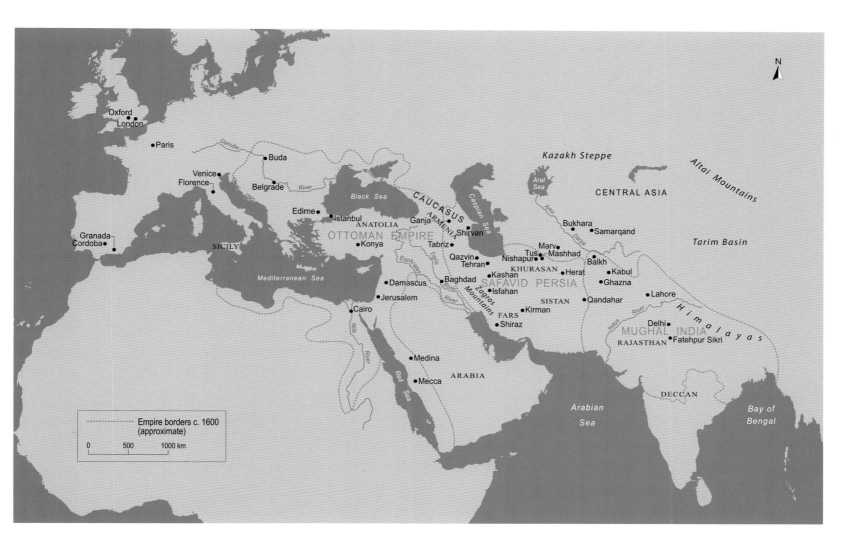

It was during the rule of the Safavids in Iran (1501–1736), the Ottomans in Turkey (1300–1923) and the Mughals in India (1526–1707) that most of the manuscripts illustrated in this book were produced. The selected places and regions shown on the map were significant either in the development of Persian literature and arts of the book, or as centres where cultural parallels and intersections with European literature have been noted in the essays in this book.

Pages 202–03	Page 206	Pages 212–13	Pages 218–19
A princely picnic. From a manuscript of ʿAbd al-Vasiʿ al-Jabali, *Divan*, copied c. 1600–05. Bodleian Library, University of Oxford, MS. Ouseley Add. 19, fols. 204v–205r.	A wrestling match between Piltan and Pilkan. From a manuscript of *Kitab-i Dastan* ('Book of Romances'), dated 972 (1565). Bodleian Library, University of Oxford, MS. Ouseley Add. 1, fol. 6r.	Double illuminated title page. From a manuscript of Saʿdi, *Kulliyat*, copied c. 1515. Bodleian Library, University of Oxford, MS. Fraser 73, vol. 1, fols. 2v–3r.	Bahram Gur visits the Tartar lady in the Green Pavilion. From a manuscript of Navaʾi, *Sabʿa Sayyara*, one volume of a *Khamsa*, dated 960 (1553), Bukhara. Bodleian Library, University of Oxford, MS. Elliott 318, fols. 34v–35r.

GLOSSARY

badi' — Literary technique of ornamentation by means of symbolic vocabulary and references

badr — The full moon – The crescent moon is referred to as *hilal*. The moon is a symbol of human beauty in Persian poetry, and also of the unattainable beauty of the Divine.

bayt — In Persian poetry, a unit of two rhyming half-lines of verse (*hemistichs*) equivalent to a couplet in the European literary tradition, and closely related to musical rhythms

Beloved — A term used by Sufi poets for the Divine as the object of spiritual love, and also for a human being who reflects divine attributes

bhang — A preparation, usually in the form of a drink, made from cannabis; used in South Asia since at least the first millennium BC as an aid in healing and in spiritual practices

bulbul — Nightingale

chinar — A variety of plane tree

dervish — A follower of the Sufi path who wanders from place to place

dihqan — A hereditary land-owner

div — A demon, derived from Zoroastrian cosmology

divan — A collection of poems

fal — Divination

ghazal — A short lyrical poem, similar to an ode, with a repetitive mono-rhyming scheme – It is usually composed of seven to twelve verses, but can be longer or shorter. The theme of the *ghazal* is love, both worldly and divine, and the universal emotions that surround the condition.

gul — A flower or rose

gunbad — Dome

gur — An onager or wild ass, a favourite target for hunters in Persian epics and poems

hadith — A tradition accepted as correct behaviour or thinking, derived from behaviour or sayings of the Prophet Muhammad

Hegira — The migration of the Prophet Muhammad and his followers from Mecca to Medina in 622 AD, the date from which the Islamic calendar is calculated

hortus conclusus — An enclosed garden, often depicted in medieval European literature and illuminated manuscripts, just as it was in the Persianate world, as a setting for love

hudhud — The hoopoe, the crested bird that is elected to lead the thirty birds on their pilgrimage to find the mythical Simurgh in 'Attar's *Conference of the Birds*

'ifrit — A spirit or *jinn*

imam — An adult male who leads a congregation of a mosque in prayer

'ishq — Passionate love or devotion

'ishq-i haqiqi — Love of the Divine, or true love

'ishq-i majazi — Love of anything other than the Divine: that is, metaphorical love, capable of leading to love of the Divine

Isma'ili — A branch of Shi'i Islam that was predominant in the medieval era, but is now second in size to the mainstream Twelvers

Isra' — The night journey of the Prophet Muhammad described in Sura 17 of the Qur'an and in later literature, in which he travels on the mythological horse, Buraq

javab — A literary device, an 'answer' or 'response' to someone else's work

Jemshid — A legendary Persian monarch, the supposed inventor of wine – Wine parties are often referred to in poetry as a 'party of Jemshid'. In the Qur'an, a prisoner sees himself in a dream pressing wine, which may be understood as a metaphor for spiritual devotion.

jinn — A spirit

khamsa — A quintet: five stories

kitab — A book

kufic — An early script whose graphic lines made it easily adaptable for inscriptions of text carved on buildings and other media

mahabba — The Arabic word for both earthly and spiritual love

majnun — Mad, crazy (literally, 'possessed by *jinn*')

maqta' — The last verse or several verses of a *qasida* in which the poet praises himself using his *takhullus*, or pen name

masnavi — In Persian literature a poem of indefinite length with a meter of eleven syllables, and a rhyme that can change with each line; usually, but not exclusively, devoted to didactic or spiritual themes

Maulana — 'Our lord', a term of respect for a spiritual leader

mihrab — An arch or niche-shaped architectural feature in the wall of a mosque that serves as the *qibla*, indicating the direction of Mecca towards which the congregation pray

Mi'raj	The term used for the mystical ascent of the Prophet Muhammad to the heavens
muraqqa'	A luxurious album of illustrations and calligraphy
musahib	Linked by spirit, not blood; a 'blood' brother
nafs	The base or lower faculties of human beings, the ego
nama	A history, or a body of writing
naqqashhana	The workshop or studio for artists and illuminators attached to the royal court
naskhi	A script widely used in Arabic manuscripts or in manuscripts of Persian prose, characterised by its clarity
nasta'liq	A script developed in the 14th century that became, in the course of the next 200 years, the hand usually used by calligraphers for copying Persian poetry, and sometimes for prose as well, and characterised by a diagonal slope or elongation of some letters
nathr	Prose (literally, 'scattered')
nazm	Poetry (literally, 'ordering')
ney	A reed flute
nilgai	An Asian antelope, native to northern and central India
nisba	An addition to a person's name referring to a person's place of origin, profession or special characteristic
Nowruz	The spring equinox, the time of year when the Persian New Year is celebrated
paladin	A warrior knight
peri	A fairy
qadi	A judge
qasida	A form of lyrical poetry adopted by Persian poets from the Arab literary tradition (literally, 'intention') – Superficially it resembles the *ghazal* with similar strong rhyme and regular meter, but typically running to 100 lines or more. The *qasida* was characterised by a last verse, or several verses, known as the *maqta'*, in which the poet praised himself and included his *takhullus* or pen name.
qizilbash	Tribal supporters of the Shi'a Safavid rulers who wore a distinctive, elongated red head-dress wrapped with a turban with twelve folds, the *taj-i Haydari*, often depicted in manuscript illustrations (literally, 'red-head')
Qur'an	The holy book of Islam revealed to the Prophet Muhammad
rebec	A round-bodied, stringed instrument played with a bow
ruba'i	A four-line verse, or quatrain, with a consistent rhyme scheme and succinct expression of an idea or emotion
saqi	The young man or courtier who poured the wine and passed the wine cup at literary gatherings and court parties
sarlau	A completely illuminated page at the beginning of a manuscript, often on the verso of the *shamsa* folio, or marking the beginning of a new section of a manuscript (compare with the *'unvan*)
senmurv	A mythical creature with the head of a dog
shah	The title traditionally used by Persian kings or rulers
shahi-sevani	Devotion to the figure or office of the shah during the Safavid period
shamsa	From the Arabic word for 'sun'; an illuminated device at the beginning of a decorated manuscript, usually round like a rosette or ogival in shape, and occasionally lobed – The *shamsa* usually contains the title or a dedication to its patron or both.
shaykh	A term of respect used to describe a wise person, a religious scholar, a leader of a tribe or of a religious group (literally, 'elder')
simurgh	A magnificent, multicoloured and resplendently feathered mythical bird; in the *Shahnama* it protects Rustam's family; sometimes used as a symbol of the Divine, as in 'Attar's *Conference of the Birds*
Sufi	An Islamic mystic
Sufism	The mystical tradition of Islam aimed at the pursuit of the living reality of spiritual life and the inner experience of the Divine
sultan	From the Arabic word for strength or ruler; a title used by rulers of the Ghaznavid, Seljuq, Ottoman and Mamluq empires
sura	A chapter of the Qur'an
takhullus	The pen name used by a poet, especially in the last couplet of a *qasida*, where it was customary for the writer to refer to himself or herself, often in terms of humility or artistic or spiritual servitude – The use of the poet's name in this form served as a kind of signature.
tazmin	Emulation, imitation of or response to other writers' texts as a poetic technique and demonstration of literary skill – Persian poets aimed to place their work in a literary continuum that connected them to the past as well as the future.
Timurid	The adjective used to describe both the political and artistic characteristics of the dynasty begun by Tamerlane (r. 1370–1405), the great Central Asian conqueror, whose capital was at Samarqand – In the late 14th century, he incorporated large parts of Iran, the Caucasus, Iraq and Syria into his territories and the artistic and cultural achievements of his successors were admired by the Mughals and Ottomans.
'ulama	The learned class or religious clerics, sometimes criticised or ridiculed by mystic poets
'unvan	An ornamented heading or top section in the shape of a horizontal rectangle on a page in an illuminated manuscript that usually refers to the text that follows
Vaqvaq	A mythical talking tree with leaves shaped like the heads of all the creatures of the world – The term is used to describe page borders or decorative trees depicted with heads of animals, humans and demons.
zakat	The religious obligation of all Muslims to give alms and support charity
Zoroastrianism	The religion founded in the 6th century BC in Iran based on the teachings of the prophet Zoroaster (or Zarathustra) who recognised Ahura Mazda as the supreme Divinity – Zoroastrianism was the majority religion of Iran until largely replaced by Islam in the mid-7th century AD.

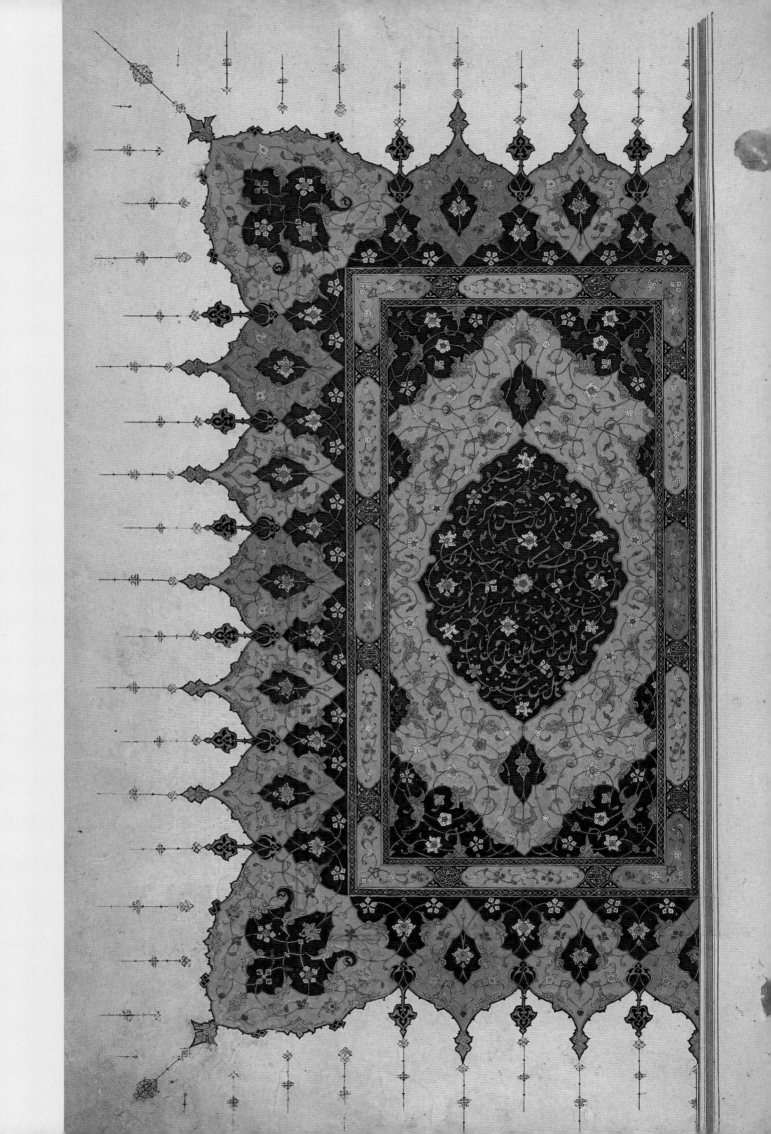

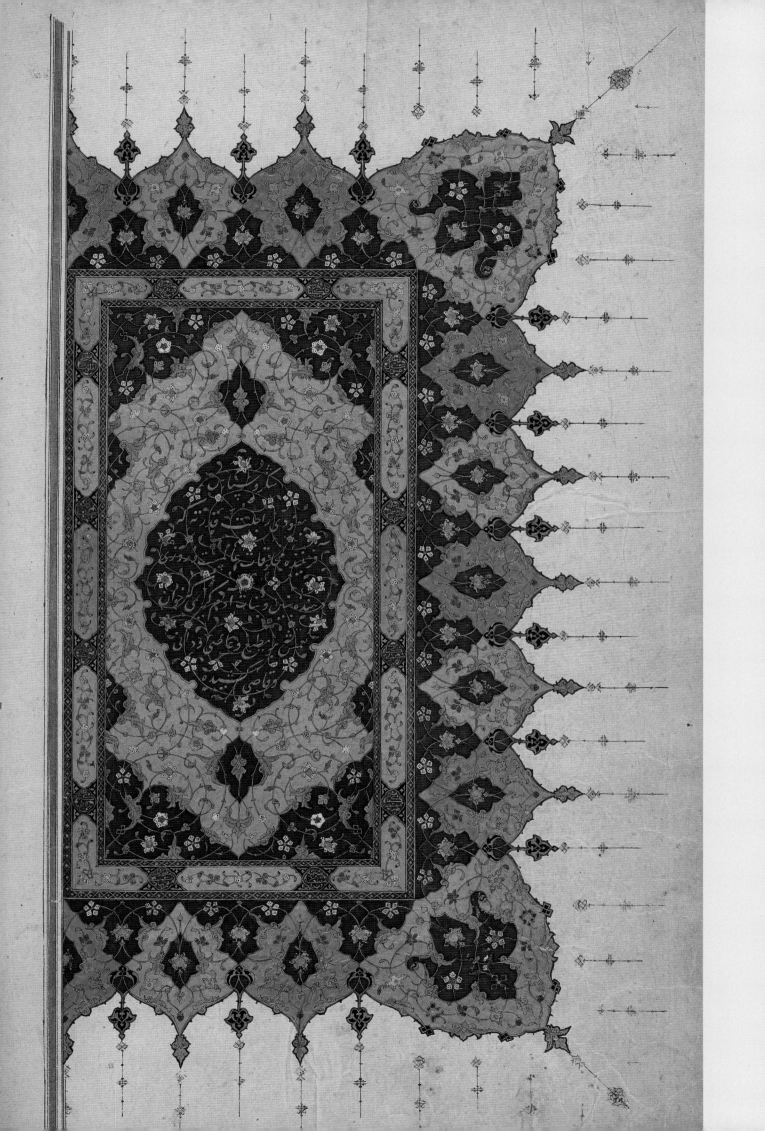

LIST OF ILLUSTRATIONS

Detail from Figure 14.3

Bodleian Library, University of Oxford, MS. Ouseley 316, fol. 199v.

Fig. 3.3: Bahram Gur listens as Dilaram enchants the animals. From a manuscript of Amir Khusrau, *Khamsa*, dated 1007–08 (1599–1600).
State Library of Victoria, Melbourne, RARESF 745.670955 AM5K, fol. 172v.

Fig. 4.1: Bahram Gur hunting with Dilaram. From a manuscript of Nava'i, *Sab'a Sayyara*, one volume of a *Khamsa*, dated 960 (1553), Bukhara.
Bodleian Library, University of Oxford, MS. Elliott 318, fol. 18r.

Fig. 4.2: Bahram Gur visits the lady from Khwarazm in the Blue Pavilion on Wednesday. From a manuscript of Nava'i, *Sab'a Sayyara*, one volume of a *Khamsa,* dated 960 (1553), Bukhara.
Bodleian Library, University of Oxford, MS. Elliott 318, fol. 47r.

Fig. 5.1: Maulana Muhammad Tabadkhani and other dervishes dancing. From a manuscript of a work attributed to Gazurgahi, *Majalis al-'Ushshaq*, dated 959 (1552).
Bodleian Library, University of Oxford, MS. Ouseley Add. 24, fol. 119r.

Fig. 5.2: Ibn 'Arabi riding towards two young men. From a manuscript of a work attributed to Gazurgahi, *Majalis al-'Ushshaq*, dated 959 (1552).
Bodleian Library, University of Oxford, MS. Ouseley Add. 24, fol. 69r.

Fig. 5.3: Rumi at the blacksmith's shop. From a manuscript of a work attributed to Gazurgahi, *Majalis al-'Ushshaq*, dated 959 (1552).
Bodleian Library, University of Oxford, MS. Ouseley Add. 24, fol.78v.

Fig. 5.4: Illuminated pages with opening lines of Book I. From a manuscript of Rumi, *Masnavi*, copied before 1465.
Bodleian Library, University of Oxford, MS. Elliott 251, fols. 3v–4r.

Fig. 5.5: A scene from the story of Joseph and Potiphar's wife. From a German-language Bible, Genesis 39. Nuremberg, Anton Koberger, 1483, vol. 1, fol. 23r.
State Library of Victoria, RARESEF 093 C833K.

Fig. 5.6: The interpretation of Zulaykha's dream. From a manuscript of Jami, *Yusuf u Zulaykha*, dated 940 (1533).
Bodleian Library, University of Oxford, MS. Hyde 10, fol. 39v.

Fig. 5.7: Zulaykha, having seen Yusuf in a dream, is mad with love for him. Leaf from a disbound manuscript of Jami, *Haft Aurang*, copied c.1570.
Bodleian Library, University of Oxford, MS. Elliott 149, fol. 179r.

Fig. 5.8: Yusuf sold as a slave. From a manuscript of Jami, *Yusuf u Zulaykha*, dated 940 (1533).
Bodleian Library, University of Oxford, MS. Hyde 10, fol. 72v.

Fig. 5.9: Zulaykha's maids overcome by the beauty of Yusuf. From a manuscript of Jami, *Yusuf u Zulaykha*, dated 977 (1569).
Bodleian Library, University of Oxford, MS. Greaves 1, fols. 103v–104r.

Fig. 5.10: Yusuf tempted by Zulaykha. Leaf from a disbound manuscript of Jami, *Haft Aurang*, copied c.1570
Bodleian Library, University of Oxford, MS. Elliott 149, fol. 199v.

Fig. 6.1: 'Attar conversing in a courtyard. From a manuscript of a work attributed to Gazurgahi, *Majalis al-'Ushshaq*, dated 959 (1552).
Bodleian Library, University of Oxford, MS. Ouseley Add. 24, fol. 65v.

Fig. 6.2: The Hoopoe tells the birds about the Simurgh. From a manuscript of 'Attar, *Mantiq al-Tayr*, dated 898 (1493).
Bodleian Library, University of Oxford, MS. Elliott 246, fol. 25v.

Fig. 6.3: The Virgin in the centre of the rose, surrounded by saints and children in the petals, *Paradiso*, Canto XXXII. From a manuscript of Dante Alighieri, *La Divina Commedia*, copied c.1350–75, Italy.
Bodleian Library, University of Oxford, MS. Holkham misc. 48, p. 145.

Fig. 7.1: The mystic, Ahmad al-Ghazali, conversing with a young man in a landscape. From a manuscript of a work attributed to Gazurgahi, *Majalis al-'Ushshaq*, dated 959 (1552).
Bodleian Library, University of Oxford, MS. Ouseley Add. 24, fol. 42r.

Fig. 7.2: Solomon tricks Bilqis into wading into a simulated stream made of glass. From a manuscript of a work attributed to Gazurgahi, *Majalis al-'Ushshaq*, dated 959 (1552).
Bodleian Library, University of Oxford, MS. Ouseley Add. 24, fol. 127v.

Fig. 7.3: Hakim Sana'i leaves his shoes with the butcher boy. From a manuscript of a work attributed to Gazurgahi, *Majalis al-'Ushshaq*, dated 959 (1552).
Bodleian Library, University of Oxford, MS. Ouseley Add. 24, fol. 44v.

Fig. 7.4: Hakim Sana'i brings goats to the butcher boy. From a manuscript of a work attributed to Gazurgahi, *Majalis al-'Ushshaq*, copied c.1580.
Topkapi Palace Museum, Istanbul, H.829, fol. 50v.

Fig. 8.1: The demon Kabus. From a manuscript of *Kitab al-Bulhan*, in Arabic, mostly 14th century.
Bodleian Library, University of Oxford, MS. Bodl. Or. 133, fol. 28r.

Fig. 8.2: The interpretation of Zulaykha's dream. From a manuscript of Jami, *Yusuf u Zulaykha*, dated 977 (1569).
Bodleian Library, University of Oxford, MS. Greaves 1, fol. 34v.

Fig. 8.3: The constellations of Canis Minor, Argo Navis, Draco, Crater, Corvus and Centaurus in the southern hemisphere. From an Ottoman Turkish translation of Zakariyya ibn Muhammad ibn Mahmud al-Qazvini, *Kitab 'Aja'ib al-Makhluqat wa-Ghara'ib al-Mawjudat*, copied late 16th or early 17th century.
Bodleian Library, University of Oxford, MS. Turk. d. 2, fols. 40v–41r.

Fig. 8.4: The East and West winds. From an Ottoman Turkish translation of Zakariyya ibn Muhammad ibn Mahmud al-Qazvini, *Kitab 'Aaja'ib al-Makhluqat wa-Ghara'ib al-Mawjudat*, copied late16th or early 17th century.
Bodleian Library, University of Oxford, MS. Turk. d. 2, fol. 101v.

Fig. 9.1: The dervish and the king. Leaf from a disbound manuscript of Jami, *Baharistan*, copied for Mughal Emperor Akbar, dated year 39, Ilahi era, reign of Akbar (1595), Lahore, painted by La'l.
Bodleian Library, University of Oxford, MS. Elliott, 254, fol. 17v.

Fig. 9.2: A prince reading in a garden. From a Mughal album, image painted c.1640–50.
Bodleian Library, University of Oxford, MS. Douce Or. a.1, fol. 46r.

Fig. 9.3: Beauty is shown the portrait of Heart. Leaf from a dispersed manuscript of Fattahi, *Husn u Dil*, copied c.1570–75. Bound in an 18th-century Mughal album.
Bodleian Library, University of Oxford, MS. Pers. b.1, fol. 28v.

Fig. 9.4: The youth and the singing-girl. Leaf from a disbound manuscript of Jami, *Baharistan*, copied for Mughal Emperor Akbar, dated year 39, Ilahi era, reign of Akbar (1595), Lahore, painted by Madhu.
Bodleian Library, University of Oxford, MS. Elliott 254, fol. 35v.

Fig. 9.5: Majnun among the animals; the youth thrown to the king's dogs is unharmed. From a Mughal manuscript of Nizami, *Layla u Majnun*, copied c.1590, painted by Dhanwan and Asi, respectively.
Bodleian Library, University of Oxford, MS. Pers. d. 102, pp. 65–66.

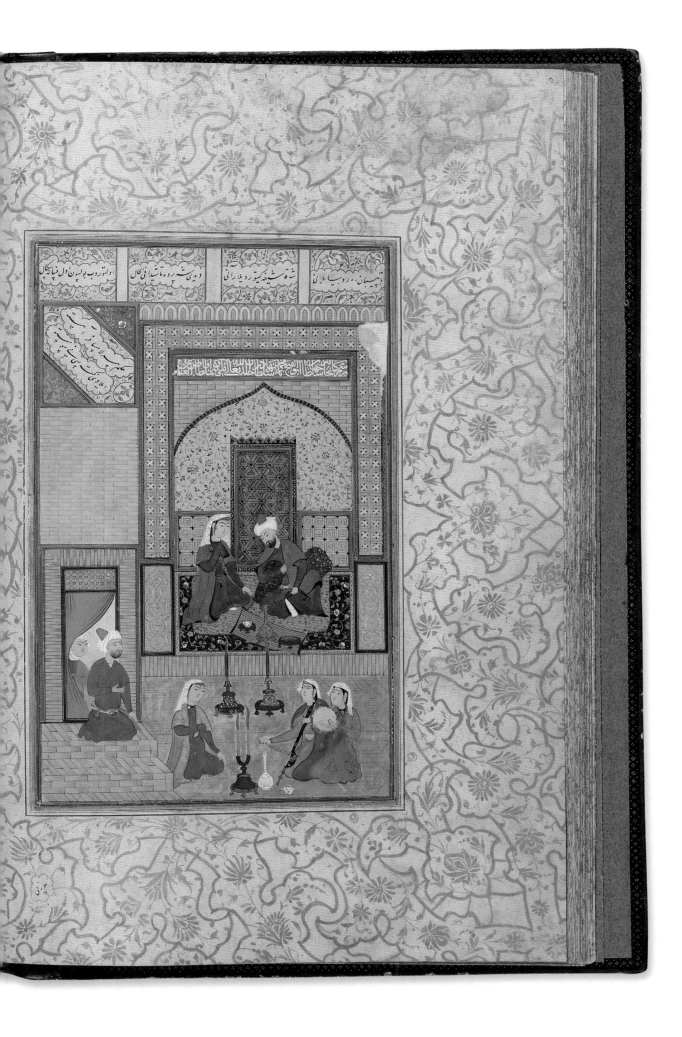

219

SELECT BIBLIOGRAPHY

Detail from page ii

*The essays contained in this book draw on original research by the various authors who have used
a broad range of sources. The following list is intended as both a record of some of the key texts consulted
and a preliminary guide for those readers wishing to explore the subject further.*

Abdullaeva, F. 'Ferdowsi: A Male Chauvinist or a Feminist?' in Manfred Milz et al., *Painting the Persian Book of Kings Today: Ancient Text and Modern Images.* Cambridge: Talking Trees Books, 2010.

Abdullaeva, Firuza, and Charles Melville. *The Persian Book of Kings: Ibrahim Sultan's* Shahnama. Oxford: Bodleian Library, University of Oxford, 2008.

Aidani, Mammad. *Welcoming the Stranger: Narratives of Identity and Belonging in an Iranian Diaspora.* Breinigsville, PA: Common Ground Publishing, 2010.

Andrews, Walter G., and Mehmet Kalpaklı. *The Age of Beloveds: Love and the Beloved in Early-Modern Ottoman and European Culture and Society.* Durham, NC: Duke University Press, 2005.

Arberry, A. J. (ed.). *The Legacy of Persia.* Oxford: Clarendon Press, 1953.

Arberry, A. J. *Mystical Poems of Rumi.* Chicago: University of Chicago Press, 1974.

Arberry, A. J. (ed.). *Persian Poems: An Anthology of Verse Translations.* London: Dent, 1954.

'Attar. *The Conference of the Birds*, trans. Peter Avery. London: Islamic Texts Society, 1998.

Attar, Farid ud-Din. *The Conference of the Birds*, trans. Afkham Darbandi and Dick Davis. London: Penguin Books, 1984.

Ballaster, Ros. *Fabulous Orients: Fictions of the East in England 1662–1785.* Oxford and New York: Oxford University Press, 2005.

Barry, Michael. *Figurative Art in Medieval Islam.* Paris: Flammarion, 2004.

Boyle, J. A. (ed.). *The Cambridge History of Iran*, vol. 5. Cambridge: Cambridge University Press, 1968.

Brend, Barbara. *Muhammad Juki's* Shahnamah *of Firdausi.* London: Royal Asiatic Society and Philip Wilson Publishers, 2010.dff

Brend, Barbara. *Perspectives on Persian Painting: Illustrations to Amīr Khusrau's* Khamsah. London: RoutledgeCurzon, 2003.

Brend, Barbara, and Charles Melville. *Epic of the Persian Kings: The Art of Ferdowsi's* Shahnameh. London: I. B. Tauris, 2010.

Canby, Sheila R. *The Golden Age of Persian Art, 1501–1722.* London: British Museum, 1999.

Canfield, Robert L. 'The Turco-Persian Tradition', in Ergun Çaşatay and Doğan Kuban (eds.). *The Turkic Speaking Peoples: 2000 Years of Art and Culture from Inner Asia to the Balkans.* Munich: Prestel, 2008, 148–58.

Carboni, Stefano. 'The London Qazwini: An early 14th century copy of the Aja'ib al-makhluqat'. *Islamic Art* III (1988–1989): 15–31.

Chaucer, Geoffrey. *The Riverside Chaucer*, ed. Larry D. Benson. Oxford: Oxford University Press, 1988.

Chew, Samuel C. *The Crescent and the Rose: Islam and England during the Renaissance.* New York: Octagon Books, 1974.

Chittick, W. *The Sufi Path of Knowledge.* Albany, NY: State University of New York Press, 1989.

Curatola, Giovanni, and Gianroberto Scarcia. *The Art and Architecture of Persia*, trans. Marguerite Shore. New York and London: Abbeville Press, 2004.

Dale, Stephen F. *The Muslim Empires of the Ottomans, Safavids and Mughals.* Cambridge: Cambridge University Press, 2010.

Derin, Süleyman. *Love in Sufism: From Rabia to Ibn al-Farid.* Istanbul: Insan Publications, 2008.

Dickson, Martin Bernard, and Stuart Cary Welch. *The Houghton* Shahnameh. Cambridge, MA, and London: Harvard University Press, 1981.

Encyclopaedia Iranica, ed. E. Yarshater. London and New York: Routledge and Kegan Paul, 1982–ongoing. Online edition: www.iranica.com.

Ferdowsi, Abolqasem. Shahnameh: *The Persian Book of Kings*, trans. Dick Davis. New York: Penguin Books, 2006.

Firdausi. *The Shāhnáma of Firdausí*, trans. Arthur George Warner and Edmond Warner, 9 vols. London, 1905–25, repr. London: Routledge, 2000.

FitzGerald, Edward. *Rubáiyát of Omar Khayyám: A Critical Edition*, ed. Christopher Decker. Charlottesville, VA: University Press of Virginia, 1997.

Flood, Finbarr B. *Objects of Translation: Material Culture and Medieval 'Hindu-Muslim' Encounter.* Princeton, NJ: Princeton University Press, 2009.

Frye, R. N. (ed.). *The Cambridge History of Iran*, vol. 4. Cambridge: Cambridge University Press, 1975.

Grube, Ernst. 'A Bibliography of Iconography in Islamic Art', in *Image and Meaning in Islamic Art*, Robert Hillenbrand (ed.). London: Altajir Trust, 2005.

Hillenbrand, Robert. 'The Message of Misfortune: Words and Images in Sa'di's Gulistan', in *Silk and Stone: The Art of Asia, The Third HALI Annual*, ed. Jill Tilden. London: Hali Publications Limited, 1996.

Hodgson, Marshall G. S. *The Venture of Islam: Conscience and History in a World Civilization*. 3 vols. Chicago and London: Chicago University Press, 1977.

Holbrook, Victoria Rowe. *The Unreadable Shores of Love: Turkish Modernity and Mystic Romance*. Austin, TX: University of Texas Press, 1994.

Jackson, Peter, and Laurence Lockhart (eds.). *The Cambridge History of Iran*, vol. 6. Cambridge: Cambridge University Press, 1986.

Jamal, Mahmood (ed. and trans.). *Islamic Mystical Poetry: Sufi Verse from the Early Mystics to Rumi*. Harmondsworth, UK: Penguin Books, 2009.

Javadi, Hasan. *Persian Literary Influence on English Literature: With Special Reference to the Nineteenth Century*. Costa Mesa, CA: Mazda Publishers, 2005.

Kambaskovic-Sawers, Danijela. *Constructing Sonnet Sequences in the Late Middle Ages and Renaissance: A Study of Six Poets*. Lewiston-Lampeter, Wales: Edwin Mellen Press, 2010.

Katouzian, Homa. *The Persians: Ancient, Medieval and Modern Iran*. New Haven, CT, and London: Yale University Press, 2009.

Khaleghi-Motlagh, Djalal (ed.). *Abu'l-Qasem Ferdowsi: The* Shahnameh *(Book of Kings)*. Costa Mesa, CA and New York: Mazda with Bibliotheca Persica, 1988–2008.

Lentz, Thomas W., and Glenn D. Lowry. *Timur and the Princely Vision: Persian Art and Culture in the Fifteenth Century*. Los Angeles: Los Angeles County Museum of Art, 1989.

Lewisohn, Leonard (ed.). *Hafiz and the Religion of Love in Classical Persian Poetry*. London: I.B. Tauris, 2010.

Lewisohn, Leonard, and Christopher Shackle. *'Attar and the Persian Sufi Tradition*. London: I.B. Tauris, 2006.

Lowry, Glenn D., with Susan Nemazee. *A Jeweller's Eye: Islamic Arts of the Book from the Vever Collection*. Washington, DC: Arthur M. Sackler Gallery with University of Washington Press, 1988.

Mannani, Manijeh. 'The Sacred and Erotic Poetry of Jalal al-Din Rumi and John Donne: A Comparison', in *Canadian Review of Comparative Literature* (December 2000): 625–44.

Meisami, Julie Scott. *Nizami: The Haft Paykar: A Medieval Persian Romance*. Oxford: Oxford University Press, 1995.

Meisami, Julie Scott. *Structure and Meaning in Medieval Arabic and Persian Poetry*. London: Routledge Curzon, 2003.

Melville, Charles (ed.). *Safavid Persia: The History and Politics of an Islamic Society*. London and New York: I.B. Tauris in association with the Centre of Middle Eastern Studies, University of Cambridge, 1996.

Menocal, Maria Rosa. *The Arabic Role in Medieval Literary History: A Forgotten Heritage*. Philadelphia, PA: University of Pennsylvania Press, 1987.

Menocal, Maria Rosa. *Shards of Love: Exile and the Origins of the Lyric*. Durham, NC: Duke University Press, 1994.

Nicholson, Reynold A. *Mystics of Islam*. London: G. Bell & Sons, 1914, reprinted, London: Routledge & Kegan Paul, 1979.

Nizami Ganjavi, *The Story of Layla and Majnun*, trans. and ed. R. Gelpke. Oxford: Cassirer, 1966.

Renard, John. *Islam and the Heroic Image*. Columbia, SC: University of South Carolina Press, 1993.

Robinson, Basil W. *A Descriptive Catalogue of the Persian Paintings in the Bodleian Library*. Oxford: Oxford University Press, 1958.

Rumi. *The Mathnawi of Jalalu'ddin Rumi*, trans. Reynold A. Nicholson. London: Luzac and Co., 1926 (1968).

Rypka, Jan. *History of Iranian Literature*. Dordrecht, The Netherlands: D. Reidel Publishing Co., 1968.

Schacht, Joseph, with C. E. Bosworth (eds.). *The Legacy of Islam*. 2nd edn. Oxford: Clarendon Press, 1974.

Schimmel, Annemarie. *As through a Veil: Mystical Poetry in Islam*. New York: Columbia University Press, 1982.

Schimmel, Annemarie. *Mystical Dimensions of Islam*. Chapel Hill, NC: University of North Carolina Press, 1975.

Schimmel, Annemarie. *A Two-colored Brocade: The Imagery of Persian Poetry*. Chapel Hill, NC: University of North Carolina Press, 1992.

Sharma, S. *Amir Khusrau. The Poet of Sultans and Sufis*. Makers of the Muslim World series. Oxford: Oneworld, 2005.

Sims, Eleanor with Boris I. Marshak and Ernst J. Grube. *Peerless Images: Persian Painting and Its Sources*. New Haven, CT, and London: Yale University Press, 2002.

Thiesen, Finn. *A Manual of Classic Persian Prosody*. Wiesbaden, Germany: Harrassowitz, 1982.

Topsfield, Andrew. *Paintings from Mughal India*. Oxford: Bodleian Library, 2008.

Torabi, Seyed Mohammad. *Negähi be Tärikh va Adabiyyäte Iran*. Tehran: Qoqnous, 2005.

Uluç, Lâle. *Turkman Governors, Shiraz Artisans and Ottoman Collectors: Arts of the Book in 16th Century Shiraz*. Istanbul: Iş Bankası Kültür Yayınları, 2006.

van Ruymbeke, Christine. 'Firdausi's *Dastan-i Khusrau va Shirin*: Not Much of a Love Story!' in *Shahnama Studies*, I, ed. Charles Melville. Cambridge: Centre of Middle Eastern and Islamic Studies, 2006, 125–47.

Vyvyan, John. *The Rose of Love*. London: Chatto and Windus, 1960.

Wright, Elaine. *Muraqqa': Imperial Mughal Albums from the Chester Beatty Library, Dublin*. Alexandria, VA: Art Services International, 2008.

Yohannan, John D. *Persian Poetry in England and America: A 200-Year History*. Delmar, NY: Caravan Books, 1977.

Pages 222–23

Hunting scene. From a manuscript of 'Abd al-Vasi' al-Jabali, *Divan*, copied c.1600–05. Bodleian Library, University of Oxford, MS. Ouseley Add. 19, fols. 1v–2r.

Page 224

Shamsa. From a manuscript of Rumi, *Masnavi*, copied before 1465. Bodleian Library, University of Oxford, MS. Elliott 251, fol. 1v.

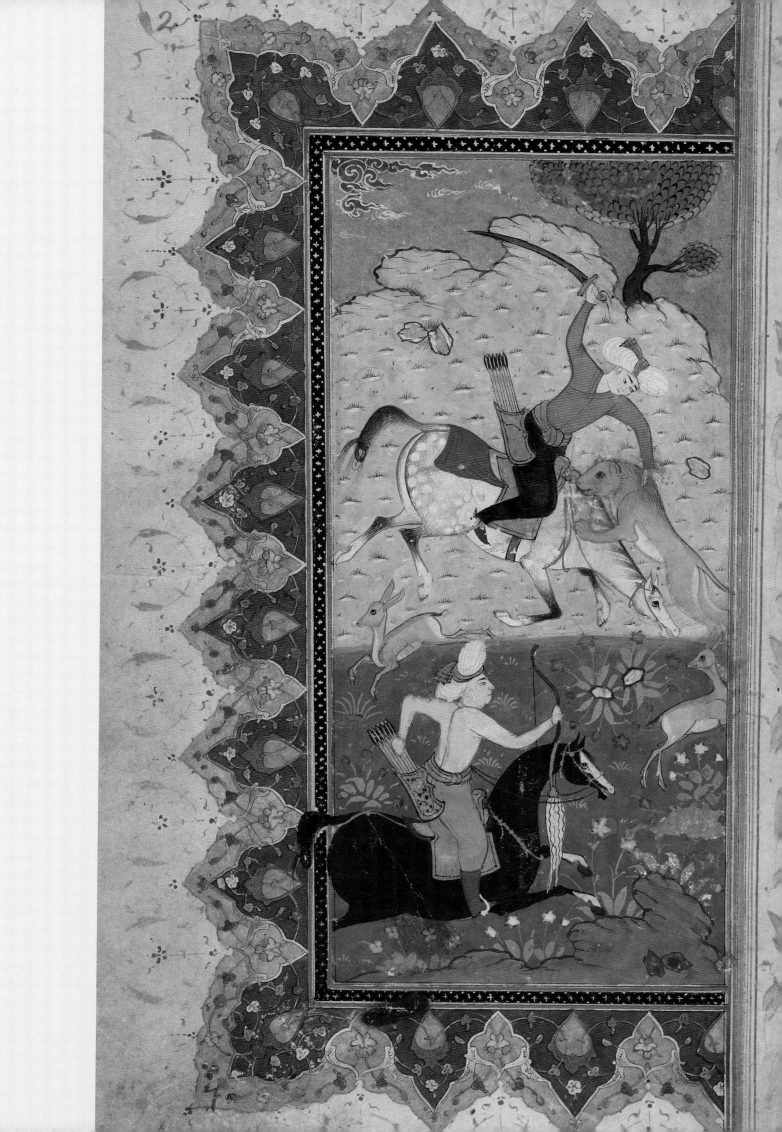

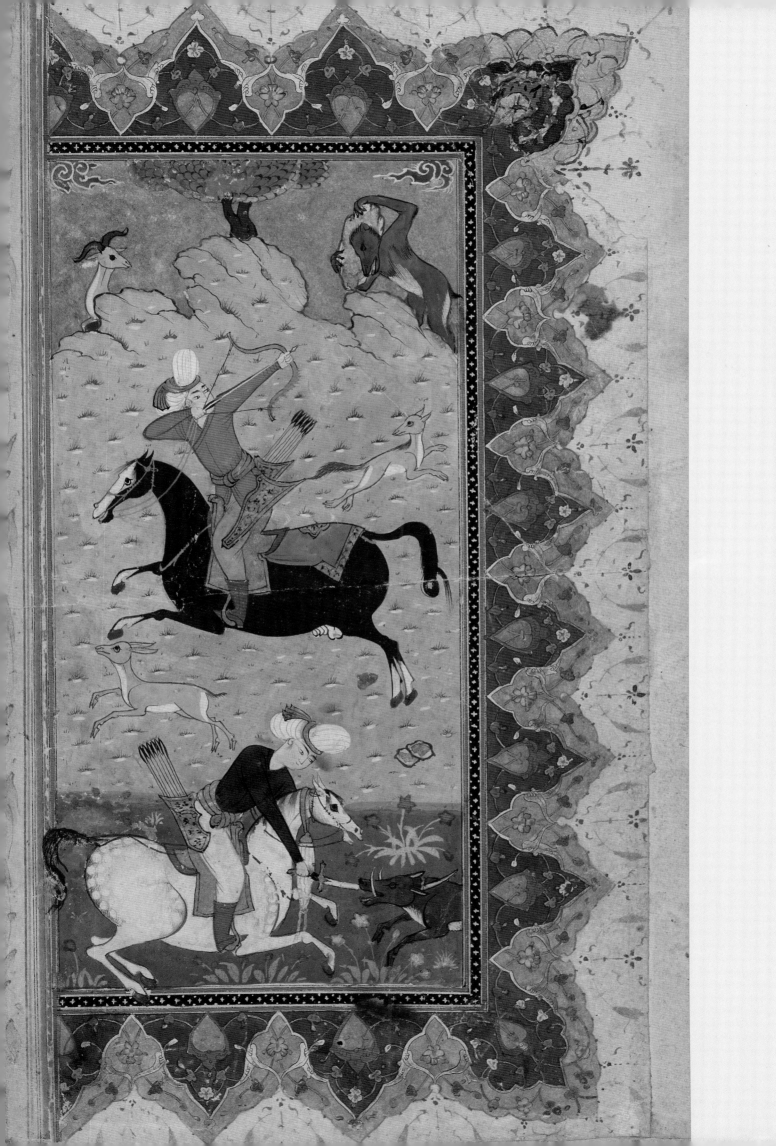